C000054612

THE PAGAN DREAM OF THE RENAISSANCE

The Pagan Dream
of the Renaissance

JOSCELYN GODWIN

PHANES PRESS

An Alexandria Book

Author's Acknowledgment:
I am grateful to Colgate University's Research Council for a Major
Grant in support of this book.

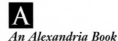

An Alexandria Book

Alexandria Books explore intersections—
the meeting points between cosmology,
philosophy, myth, culture, and the creative spirit.
www.cosmopolis.com

PHANES PRESS, INC.
PO Box 6114
Grand Rapids, MI 49516
www.phanes.com

9 8 7 6 5 4 3 2 1

Printed in the United States of America
∞ This edition is printed on acid-free paper
that meets the American National Standards Institute Z39.48 Standard.

Library of Congress Cataloging-in-Publication Data
Godwin, Joscelyn.
The pagan dream of the Renaissance / Joscelyn Godwin.
p. cm.
"An Alexandria Book"
Includes bibliographical references and index.
ISBN 1-890482-84-6 (alk. paper)
I. Mythology, Classical. 2. Renaissance. I. Title
BL727 .G63 2002
292'.007'04—dc21
2002029314

Contents

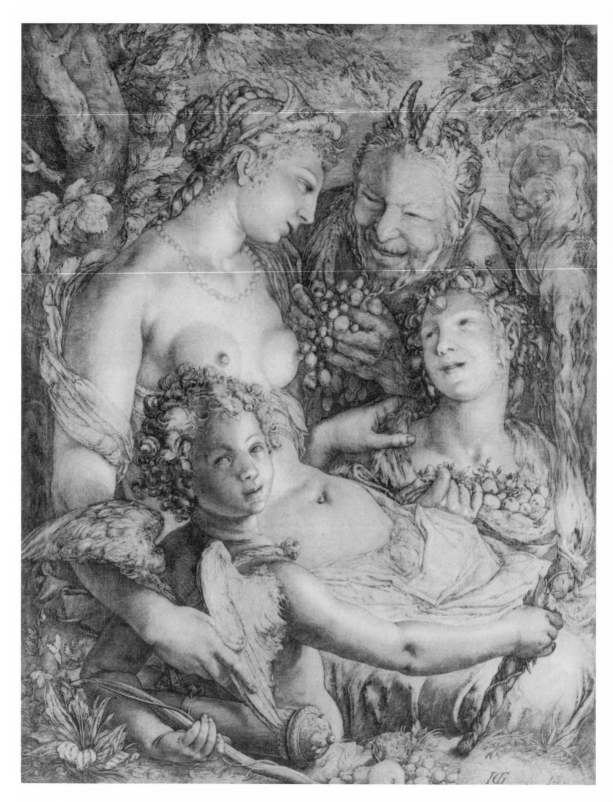

Seduction by the Gods

THE PAGAN DIVINITIES are a hardy breed. After being subverted by Homer, atomized by Lucretius, and toppled from their pedestals by the Christians, one would have thought them finished. There was certainly a long period of European history in which no one believed in the existence of Jupiter, Juno, and their Olympian court. "Believed," however, and "existence": these are loaded terms which do not always exclude their opposites. This book is about a state of mind and soul that arose in fifteenth-century Italy, spread through Europe along certain clearly-defined fault-lines, and persisted for about two hundred years, during which, although no one believed in the gods, many people acted as though they existed. Those privileged to create their own surroundings chose to have the gods painted on their furniture and walls, made statues of them, read and declaimed about them, and impersonated them in pageants and plays. A naïve visitor to a Renaissance palace or villa might well conclude that its owners were votaries of Apollo, Venus, Hercules, and a host of attendants in human and semihuman forms. Yet if he stepped into the chapel, a very different set of images would meet his eye, and he might wonder what exactly was going on.

The irruption of the pagan pantheon caused a bifurcation in the European psyche. Werner Gundersheimer, writing about the period of Ercole I d'Este (Duke of Ferrara from 1476–1505), sums up the situation with a certain wry cynicism:

> For many rulers throughout European history at least, the gods simply had to receive their due mainly by means of ritual and ceremony. Their portion might be large, but once it had been provided, one could go on to other things. To be sure, one had to pay a small additional price for the privilege of compartmentalization, and that was the psychic cost of some measure of guilt [. . .] But religion itself even offers compartmentalized ways of coming to terms with one's guilt, and most people can live with a fair amount of it in any case. Such considerations help in understanding the almost jarringly "modern" juxtapositions of secular and religious, pagan and Christian, mystical and cynical, savage and civilized, comic and serious that characterize the Herculean period.[1]

LEFT: "Without Ceres and Bacchus, Venus would freeze." Hendrick Goltzius, *Sine Cerere et Libero friget Venus*. Philadelphia Museum of Art: Purchased with the Mr. and Mrs. Walter H. Annenberg Fund for Major Acquisitions, the Henry P. McIlhenny Fund in memory of Frances P. McIlhenny. By permission.

The "gods" of this quotation, who had to receive their ceremonial dues, were none other than the Holy Trinity and the Christian saints. The "other things" that one could go on to enjoy after duty was done, were the unchristian activities, ranging from killing one's neighbors to making images of heathen gods and delighting in them. We shall pay more attention to the latter: to the joy and expansion of soul, and the philosophical elevation of the intellect, that were the reward of this truant religion that was not a faith—being beyond belief—but which beguiled the imagination and engorged the senses.

I do not suppose that anyone in the fifteenth or sixteenth centuries was a pagan, in the sense of rejecting Christianity and adopting a pre-Christian religion. As Lucien Febvre sternly put it, after 400 pages of irrefutable argument, "It is absurd and puerile, therefore, to think that the unbelief of men in the sixteenth century, insofar as it was a reality, was in any way comparable to our own. It is absurd, and it is anachronistic."[2] What I do suggest is that some people during this period "dreamed" of being pagans. In their waking life they accepted the absurdities acknowledged as the essence and *credenda* of Christianity,[3] all the while nurturing a longing for the world of antiquity and a secret affinity for the divinities of that world. No one confessed, no one described this urge, for it was never dragged beneath the searchlight of consciousness or the scrutiny of the Inquisition. It would have been suicidal, were it even possible, for anyone in Christian Europe to articulate it. But that was all the more reason for it to manifest in the favorite language of the unconscious, and of dreams: that of images.

This book sets out to show how the dream of an alternative, pagan cosmos entered the European imagination through the visual and performing arts. With the exception of the *Hypnerotomachia* I have steered away from the literary sources, for several reasons. First, the literary aspects of the pagan Renaissance have been all but fished dry by the historians of art and of ideas.[4] The present work does not aspire to that illustrious company, but if readers are interested in sources and influences, they will know where to look. Second, the educated but non-specialized audience for whom this book is intended knows the Renaissance mainly as a visual, not a literary phenomenon. Any intimate contact with it is likely to be had through looking at works of art, traveling to cities, villas, gardens, etc., rather than through reading, especially since most of the sources remain in Latin or other non-English languages. Most importantly, this is a study of the Imagination, as we have to call it in English (the French call it *l'imaginaire*, or, following Henry Corbin, the *mundus imaginalis*): of archetypal images that reside in consciousness, prior to their verbal formulations. I am not offering

theories or interpretations, merely drawing attention to these images and sketching something of the world into which they came and the people who cultivated and loved them. I invite the reader to explore these chambers, grottoes, and gardens, these pageants and operas in which the pagan gods and heroes took on a temporary reality; to enjoy the illusion of their presence, until the curtain falls and we return to the twenty-first century.

One day in 1434, in the north Italian town of Ferrara, a young humanist wrote to his brother about an entertainment he had just seen:

> There was a festival today, a splendid celebration with dancing in the prince's hall. The dancers were masked, as the occasion and season demanded, and no novelty was lacking to delight the mind. This joyous and memorable affair was distinguished by the divine ingenuity of Marrasio. You will now see ranks of higher and lower beings taking over the Savior's place. [*In Salvatoris locum accedere nunc superorum et inferorum cernes ordines.*]
>
> First of all came Apollo with his blazing rays; the gilded robe reaching to his heels was fit for the god himself; thus you would recognize him as Apollo. Then came Bacchus with lurching gait, as if "neither hand nor foot performed its office," as the comedian says [Terence, *Eunuch* 5.5.3], with long horns and holding a thyrsus in his hand; they said that Marrasio played this part. Hoary-bearded Aesculapius followed shortly behind. Then it was well worthwhile to see furious Mars with his drawn sword and flashing armor, marching along with Bellona. After these came Mercury with wings on his feet. When Priapus arrived, all the birds flew away in terror; there was a reed-pipe fixed on his head, by means of which he lured his companion to matrimony [?]. The fair form of Venus with her golden apple was not absent; Cupid followed his mother, no otherwise than as the poets depict him, shooting both leaden and golden arrows. Quite a few people were terrified by the raging Furies—Clotho, Lachesis, and Atropos—who, if it is to be believed, weave the lives of men. Then there was Hercules, clad in his lionskin and grasping his club, who had Cerberus by the neck. And there were many others which it would be tedious to enumerate.[5]

The 1430s were very early days for such a flamboyant display of pagan divinities, almost none of whom had been represented in painting or sculpture for a thousand years. Hercules had been an occasional interloper among the biblical figures of the Middle Ages, admitted on the grounds that he represented the virtue of Fortitude. No such excuse could be made for Venus, Dionysus, and, heaven forbid, Priapus.

Giovanni Marrasio, the impresario of the Ferrara pageant, would have had no visual models for his recreation of the gods and goddesses. He would have based their costumes and attributes on literary sources such as Boccaccio's *Genealogy of the Gods*, in which the fourteenth-century poet, novelist, and scholar had scoured the literature of (mostly late) antiquity for information on the pagan pantheon. As the fifteenth century proceeded, these figures would develop standardized appearances, and some of them would shed their symbolic costumes to become exemplars for the revived art-form of the nude.

The nudity of pagan gods and goddesses is one of their essential qualities. In metaphysical terms it symbolizes perfection. Being free of mortal dross, the gods have nothing to be ashamed of, and no need for man-made garments. In the biblical context that would have escaped no one at the time, the nudity of the gods is like that of Adam and Eve before the Fall, before they knew that they were naked, and hid themselves (Genesis 3:10). This was Michelangelo's rationale for painting the inhabitants of heaven, restored to their prelapsarian wholeness, as a naturist assembly. But there is a third level, which no one can avoid noticing although not everyone admits or mentions it: that nude paintings and sculptures are erotic, and lascivious in their effects on both men and women. The naked body had occasionally been painted and even sculpted in Western Medieval art (almost never in Byzantium), but strictly for didactic and allegorical purposes, such as depicting the Creation and Fall. Only now did it become seductive.

As Kenneth Clark showed in his book *The Nude*,[6] the now familiar nudes of Donatello, Pollaiuolo, Signorelli, etc., were by no means "natural" in the sense of having been copied from life. Like their Greco-Roman models, they obeyed a subtle canon of proportion and anatomy, and it was the rediscovery of this canon that made Renaissance nudes look so different from those of the Middle Ages. For instance, in the medieval female form, the distance between the breasts is about half of the distance from breasts to navel. The classical preference is to make these two distances equal. Few of us resemble canonical nudes when we take our clothes off, but to the Platonist this is no detriment to their realism. Their perfect proportions are not copied from us, but from the models of the human body "laid up in heaven,"[7] following pure mathematical laws as everything in the heavens is supposed to do.

The story has often been told of how a nude figure of Venus leaning on a dolphin was dug up in Siena in the year 1345.[8] It was greatly admired and set up in the place of honor in the town square, but within two years the city fathers had misgivings. They feared that this reverence for a pagan idol was responsible for all the mis-

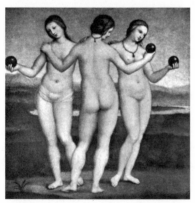

It was the rediscovery of the ancient canon of proportion that made Renaissance nudes look so different from those of the Middle Ages. ABOVE: *Three Graces*, from a late fifteenth-century French manuscript (Bibliothèque Nationale). BELOW: Raphael, *The Three Graces*.

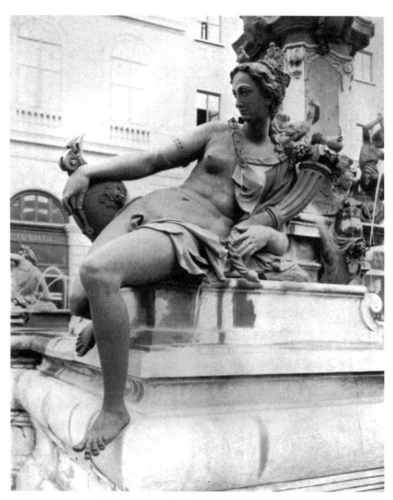

In vain did the Bishop complain of the presence of pagan deities in the market place. Fountain figure from the Augustbrunnen, Augsburg.

fortunes and immorality of the town. So the Venus was taken down, and some say that she was smashed into little pieces and buried on the territory of Florence, Siena's rival state, exporting her evil influence. This instinctive admiration of, presumably, a Roman copy of a Greek original was a harbinger of things to come. Artificial or not, there was something about the proportions of classical sculptures that must have seemed attractive to fourteenth-century viewers, just as they do to us. In contrast to this, consider what happened in Augsburg about two hundred years later. A statue of Saint Ulrich was removed from the fountain in the Fish Market and replaced by a fine effigy of Neptune, the first life-size bronze nude in German art. In vain did the Bishop and Chapter complain to Emperor Charles V that their saint had been usurped by a pagan *Abgott* (anti-god). Their only comfort was to take it as proof of the iniquity of Protestantism.[9]

Art historians have established the revival of antiquity in painting and sculpture required two things: the use of antique subject-

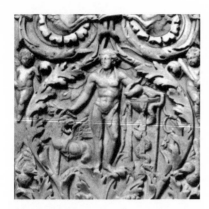

Apollo, third century. Roman marble relief.

The unknown sculptor has penetrated the essence of classical art, not merely imitated its appearance. *Hercules* on the Porta della Mandorla, Florence Cathedral.

matter, which was easy, given the labors of the literati; and the recapturing of antique style, which was much more difficult. The first instances of the latter are isolated and rather mysterious. Among the lush, late Gothic foliage of the north door (Porta della Mandorla) of Florence Cathedral there stand two nude figures, hardly larger than a hand: Hercules (emblem of Fortitude) and a female figure interpreted as an allegory of Abundance. They were carved between 1391 and 1396 by an unknown artist who through some miracle, in the words of John Hunisak, "has penetrated the essence of classical art, not merely imitated aspects of its external appearance."[10]

A few years later, Lorenzo Ghiberti (1378–1455) set another puzzle for historians when he included an impeccable Greco-Roman torso in his competition panel, *The Sacrifice of Isaac*, for the eastern doors of the Florentine Baptistery (1402).[11] Hunisak sees there "all of the swelling life, smoothness, and fluidity of transition from one anatomical part to another that we found in the Porta della Mandorla Hercules."[12] But although Ghiberti won the competition, he did not develop this prototype any further, nor did any other artist seize on its implications.

Even more mysterious is the origin and intention of the first free-standing nude statue since antiquity: the celebrated bronze *David* of Donatello (1386–1466). Scholars have dated it variously from the mid-1420s to the 1460s,[13] which only goes to show how isolated it is. There is no lineage of artistic development leading up to it, and no sign of its having been copied or emulated before the 1470s. Besides, this so-called David with his foot on the head of Goliath may possibly have been intended as a young Mercury, who has just killed the hundred-eyed giant Argos. That gives him a better excuse for his jaunty hat, his fashionably classical boots, and nothing in between. His smooth, androgynous body, on the other hand, has more than a little of Dionysus about it.[14] He may have been called David simply to make him acceptable to a more conventionally-minded public, or to suit republican sentiments, which saw the city of Florence as battling the Goliath of whomever their current enemy was (Milan, the Emperor, the Medici, etc.). It is a pity that he has not ended up, as intended, standing upon the porphyry fountain in the courtyard of the Palazzo Vecchio, that sanctum of Hermetic ambiguity.

The bronze *David* is a landmark because it blatantly links the revival of the antique with seductiveness. Everyone senses the aura of sexuality, finding it attractive or repellent according to taste. The fascination of the Sienese for their antique Venus suggests that they felt it there, too, as no doubt did more discreet connoisseurs of classical sculpture. In the next chapter, which deals with the

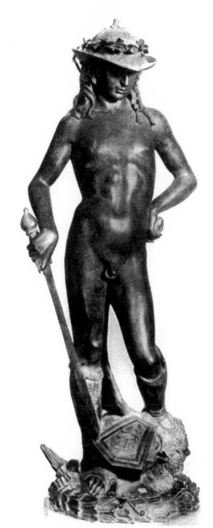

Everyone senses the aura of sexuality, finding it attractive or repellent according to taste. Donatello, *David*.

Hypnerotomachia Poliphili, we will see how the erotic and the antique were blended to create a mood and an obsession that had never existed before in Europe. Underlying the process there must have been a profound evolution in the European unconscious, which first allowed and then embraced the new subject matter. As Clark put it, "How pleasure in the human body once more became a permissible subject of art is the unexplained miracle of the Italian Renaissance."[15]

Part of the miracle was due to Plato, whose *Symposium* and *Phaedrus*, especially,[16] exalt physical beauty and the eros it arouses as the first sprouting of wings that will lift the soul to the contemplation of universal beauty. Almost everything described in this book has a Platonic dimension to it, as an earthly symbol pointing to spiritual realities. One might say the same of Christian art, except that there are very different philosophies behind the Renaissance nude and, for example, the Byzantine icon. The purpose of the latter is to open a window for the soul, in conjunction with liturgy or prayer, so that the soul can pass through, or the divine grace descend. The icon is not an art-object, except in an age when museums have supplanted the churches, and spiritual horizons have been lowered to the aesthetic level. The icon of Christ, the Virgin, or a saint is a physical object whose existence—like that of the body itself—is justified only by its sacramental purpose. The same is true of the stained-glass windows in Gothic cathedrals, or of musical plainchant. One is not supposed to love them for themselves—indeed it was taught that merely sensuous enjoyment is a sin—but for the spiritual benefits that they facilitate.

The Renaissance paintings and sculptures, on the other hand, were admired as being beautiful in themselves. Their Platonic significance might have been the topic of discussion in the learned academies, but they had value also for those unable to make the philosophic ascent, who are the majority of art-lovers (in itself a novel concept). Renaissance art fosters a religion of incarnation that sees the divine presence in nature and in the body, rather than one of excarnation which yearns to be free from both. Even though incarnation is at the core of Christian doctrine, this development of it easily leads to heresy. There is the danger of pantheism, which holds that the world itself is God; of Pelagianism, which denies original sin and allows man to be his own savior; and even of polytheism.

Of course these are only "dangers" to those who are concerned with maintaining orthodoxy, i.e., ensuring that other people think and believe as they do. The Roman Catholic Church, in its universality, found room for both impulses. The moment of capitulation was the commission of the Neoplatonist Michelangelo to decorate

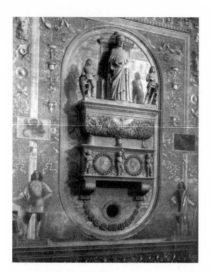

Even if the author of the *Hypnerotomachia* did not have a hand in its commission or design, he must have approved of it. Tomb of Agostino d'Onigo, Church of San Nicolo, Treviso.

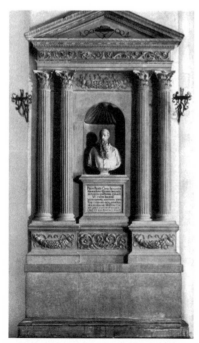

It would have been unthinkable, even vulgar, to start the journey to Paradise from anything else. Palladio, Tomb of Cardinal Bembo, Santo, Padua.

the Sistine Chapel. From then onwards, all the resources of the new art, with its sensuality, its realism, and its immediacy, were enrolled in the Catholic cause, and would serve as psychological weapons of the Counter-Reformation against the beauty-hating Protestants. But there are those who insist that Rome had already surrendered her spiritual sovereignty, and that her embrace of a pagan aesthetic was just another stage of decadence, from which the Eastern churches have ever held aloof. The ghastliness of the Sistine Chapel ceiling in the eyes of an Eastern Orthodox believer can barely be imagined by those who have been brought up to revere Michelangelo's labours.

This excursus has shown that there are many sides to the present question. It is not just a matter of pagan versus Christian, Augustinian versus Platonist, Protestant versus Catholic. The irruption of the ancient gods touched everyone above a certain social level, and left its residue as much in Milton as in Monteverdi. It was protean by nature, hard to define and impossible to fix. In a word, it was dreamlike.

Long before Michelangelo, a pagan aesthetic had insinuated itself into church by way of funeral monuments. In the early fifteenth century the patrician families of Florence started a fashion for being buried in wall-tombs in which, as Anne Schultz remarks, "Surprisingly, no reference at all is made to the religion of the defunct."[17] Instead, the tombs would imitate Roman sarcophagi and borrow from them the genii or erotes (both represented as winged children) holding wreaths and garlands; dolphins and the sacrificial symbol of bucrania (ox-skulls); and in the case of the Sassetti tombs in Santa Trinità (1491), Caesars, centaurs, tripods, and scenes of pagan sacrifice. Perhaps they were excused with moral platitudes consistent with their location in a church. For instance, as Siro Innocenti points out in his analysis of the Sassetti Chapel, the centaur is probably Chiron, tutor of heroes and expert in the arts, who served in the Renaissance as a symbol of practical wisdom: a suitable motif for a banker's tomb. The winged genii (soon to be sentimentalized as the ubiquitous "cherubs") symbolize souls, hence the rebirth of the deceased after his or her earthly death.[18] On a more lavish scale is the grandiose wall-tomb of Agostino d'Onigo (1500) in San Nicolo, Treviso. It overwhelms the sanctuary with its oval cartouche, incorporating not one but two Roman sarcophagi and not a shred of Christian imagery. Agostino's statue, by Antonio Rizzo, stands flanked by his bodyguards, while two more attendants are painted by Lorenzo Lotto on the wall, beneath colorful trophies and candelabra. If one recalls that this Dominican friary was the periodic residence of Francesco Colonna, the creator

of the *Hypnerotomachia Poliphili* (see Chapter 2), it is hard to dissociate the monument from his sense of style, and his tendency to excess in paganizing decoration. Even if he did not have a hand in its commission or design, he must have approved of it.

These humanists had the best of both worlds: the Greco-Roman aesthetic, rated far superior to that of the intervening or "middle" ages, plus the reassurances of Christianity and its sense of grateful superiority over heathendom. The tomb of Cardinal Pietro Bembo (1470–1547) in the Santo, Padua, is a more restrained assertion of this attitude. Apart from the bust, it is entirely without figural ornament, but being designed by Palladio[19] it is rigorously beautiful and harmonious, like a miniature temple. For a cardinal who was the arbiter of Latinity and good taste, it would have been unthinkable, even vulgar, to start the journey to Paradise from anything less.

The zenith of Florentine funerary art was reached not in Italy but in Poland: in the Sigismund Chapel in Wawel Cathedral, Cracow. An otherwise unknown Florentine sculptor, Bartolommeo Berrecci, was commissioned to build and decorate a funerary chapel for King Sigismund I (reg. 1506–48). He finished it in 1533 and signed his name in triumphant letters round the dome. Swarming around the royal tombs are tritons or mermen who are abducting protesting nereids; dolphins, satyrs and satyresses, grotesque beings turning into rinceaux (spiralling leaf-forms); and right above the altar, the figure of Venus Anadyomene. Jan Białostocki, the authority on East European Renaissance art, felt obliged to excuse this display of exuberant paganism: "Although there are always sceptics who discount the spiritual meaning of tritons with nereids on their backs," he writes, "most Classical scholars seem to have returned to the opinion of the older school of archaeologists that tritons and nereids in Classical art expressed the idea of the journey of the soul to the paradise of the ancients—the Isles of the Blessed."[20] Even the violence falls into place, if the true subject is the wrenching of the soul from the body. The *Hypnerotomachia Poliphili* pays memorable homage to the same topos. There the narrator's voyage across the sea to Venus's realm is interrupted by a noisy homage of sea-gods, marine monsters, and singing nereids. In the cosmology of Neoplatonism, the ocean that was believed to surround the one and only continent stands for the spheres adjacent to earth, which the blessed soul has to pass through on its ascent to the heavens. The marine fauna then symbolize the airy spirits and dwellers in the upper atmosphere who help the soul on its difficult passage, while the music that almost always accompanies them is the music of the spheres.[21] Białostocki writes that "for the Humanists, Venus stood for the highest spiritual values. In

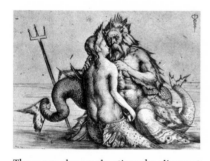

There are always skeptics who discount the spiritual meaning of tritons with nereids on their backs. Jacopo de' Barbari, *Triton and Nereid*.

Antiquity she was also considered, among other things, as leader of the souls of the departed."[22] But not only of the departed. In the teaching of Socrates, the practice of philosophy consists in a voluntary separation of the soul from the body, made during life in order that the obligatory separation at death will be less traumatic and more profitable.

Venus herself is the patroness of the movement with which this book deals. Her appearance in Siena was premature, and contrasts with the rapture that later excavations of her statues evoked. At a popular level, she evidently filled a need for the Goddess, who had been banished from the Jewish, Christian, and Muslim pantheons but who nevertheless continues to exist for her devotees. The late middle ages had witnessed her appearance incognito as the Virgin Mary, to whom so many simple (and not so simple) folk offered their heartfelt devotion. In music, especially, the Marian liturgy gave rise to the most complex and exquisite developments, such as the motets of the Netherlanders and of the English school during the fifty years around 1500. The miracles that were attested in response to this devotion were without number. During the same period, the mainspring of all the secular arts was Courtly Love, which served as both an intensification and a refinement of erotic feeling. It is a commonplace of cultural history that Marian devotion and the cult of Courtly Love became interwoven and, in some respects, indistinguishable. Another commonplace is that the ecstasies of both male and female mystics, to the post-Freudian observer, have a distinctly sexual tone. My contention is that these basic human impulses, the erotic and the spiritual, which between them are responsible for two-thirds of the art that normal people admire, came together in the pagan dream, and that their union was recognized and welcomed, whereas in the Christian context such union was a cause for embarrassment and neurosis.

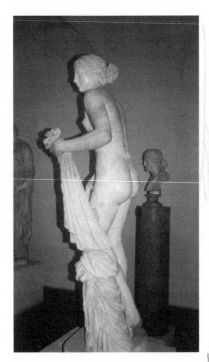

She evidently filled a need for the Goddess, who had been banished from the Jewish, Christian, and Muslim pantheons. *Venus*, Roman marble statue, circa second century B.C.

The pagan revival was born in Italy, but its roots, like those of Roman culture, were Greek. The actual land of Greece would remain but a Platonic idea in the European imagination from its conquest by the Turks in 1460 until its liberation in 1831. This was tragic, because the first half of the fifteenth century had seen a remarkable vivacity in Byzantine culture, learning, spirituality, and the arts, which might have led to a Renaissance civilization centered on Greek-speaking Constantinople. In one respect, the last gasp of Byzantium was the first deep breath of the Italian Renaissance. One of the leaders of the Byzantine revival was George Gemistos (1355/1360–1452), surnamed Plethon from his devotion to Plato. After a long career as legislator, theologian, and philosopher, he came to Italy in 1437 as an emissary of the Eastern Church

to the Councils of Ferrara and Florence. In the process, he inspired Cosimo de' Medici (Cosimo the Elder "Pater Patriae," 1389–1464) with the notion of a *prisca theologia*, an ancient theology common to all peoples, not just to the Jews and Christians. Cosimo was fired by this idea to commission the translations of Plato's works and the *Corpus Hermeticum* from Marsilio Ficino, and to found the Platonic Academy, which met for many years in the Medici villa of Careggi on the northwest outskirts of Florence.

There is more to Plethon's influence.[23] Even as he sailed to Italy, it so chanced that he had as shipmate one of the most brilliant minds of the Western world, the German-born Cardinal Nicholas of Kues (otherwise "Cusanus," 1401–64), who had been to Constantinople to make arrangements for the coming council. Cusanus's philosophy as he later developed it, of learned ignorance, the coincidence of opposites, the reconciliation of different faiths, the omnipresence of God, the divinely creative power of the human mind, the unity of being, and the dissolution of the rigid hierarchies of Scholastic thought, was the metaphysical revolution that made possible the reabsorption of Platonism and the ancient theology by Ficino, Pico della Mirandola, and the Hermeticists.

As for Plethon, he seems to have cultivated a private, solar religion in which there was no discord between the theurgy of the Neoplatonists, mystical Christianity, Sufism, and the revelation of the pseudo-Zoroastrian *Chaldaean Oracles*. When in old age he came to write his (mostly lost) *Laws* as prescriptions for an ideal society, he couched them in pagan terms, decreeing worship of the Greek gods. For this he was condemned posthumously as a heretic. But it was surely just a matter of style, like Bembo's tomb, or like Leon Battista Alberti (1404–72) writing in his *De Architectura* about how to build temples to Zeus and Diana. A man as canny as Plethon must have realized that the gods, especially in Greece, had metamorphosed into Christian saints—even to the extent of keeping their animal sacrifices.

The charge of heresy was never far away from the more intense cultivators of pagan fantasies. Among the latter were the members of the first Roman Academy, which flourished under the humanist popes Nicholas V Parentucelli (reg. 1447–55) and Pius II Piccolomini (reg. 1458–64).[24] It was a loosely-constituted group that met at the home of Giulio Pomponio Leto (1424–98), Professor of Rhetoric at the University of Rome and a passionate enthusiast for the Roman past. The members of the Academy were mostly his ex-pupils. Many of them were also familiars of Cardinal Johannes Bessarion (?1395–1472), the pupil of Plethon who had accepted a red hat from Rome and made his pleasant villa on the Appian Way a haven for

"To Pomponio Leto, who lived as long as the Fates allowed." Pseudo-antique inscription placed on the Appian Way.

humanists. Prominent among the Academicians were Bartolommeo dei Sacchi, called Platina (1421–81), an alumnus of Vittorino da Feltre's school in Mantua, formerly Vatican Librarian and Abbreviator in the Papal Chancery; and Filippo Buonaccorsi, called Callimachus (1437–96), secretary to the Cardinal of Ravenna.

Information on what the Roman Academy did is tantalizingly scarce, but what is certain is that it got on the wrong side of Pope Paul II Barbo (reg. 1464–71). Rumor had it that the Academicians had become so enamored of ancient Rome that they were conspiring to overturn papal rule and revive the Republic. One rumor led to another. In the words of the Milanese ambassador to the Vatican, writing to his master Galeazzo Maria Sforza:

> For some time now they have had a certain sect consisting of quite a few persons, always growing and including members of all conditions, most of them relatives of cardinals and prelates. They hold the opinion that there is no other world than this one, and that when the body dies, the soul dies, too; and that nothing is worth anything except for pleasure and sensuality. They are followers of Epicurus and Aristippus as far as they can be without making a scandal, not out of fear of God but of the world's justice, having in all things respect for the body, because they hold the soul to be nothing. And therefore they are given solely to enjoyment, eating meat in Lent and never going to Mass, taking no notice of vigils or of saints and holding in thorough contempt the Pope, the Cardinals, and the Universal Catholic Church.[25]

In March 1468 the Pope ordered their arrest. Platina was seized while dining with his young patron Cardinal Francesco Gonzaga (1445–83). Pomponio was in Venice at the time, but the long arm of papal authority brought him back for interrogation. Bessarion was in time to warn some of the others, including Callimachus who fled to Greece. The charge of heresy was added to that of conspiracy, and the Academicians were imprisoned for about a year and, says Platina, repeatedly tortured. They blamed Callimachus for their misfortunes.

Platina had already fallen foul of Paul II in 1464, when the Pope dismissed the Papal Abbreviators (a clique of sinecured secretaries which also included Alberti). The disgruntled scholar organized a twenty-night vigil outside the Pope's antechamber, and was eventually cooled off with a winter in Sant'Angelo prison. But Platina had a scholar's revenge, for he wrote an authoritative *History of the Popes* in which he was able to tell his story and damn the Pope for posterity. In vain would the pious Ludwig Pastor protest: "There was certainly some ground for the charges brought against the Aca-

demicians of contempt for the Christian religion, its servants and its precepts, of the worship of heathen divinities and the practice of the most repulsive vices of ancient times."[26] In other words, they had a low opinion of this Pope and of the conduct of the church, and some of them were homosexual. Apparently they also frequented the Catacombs, where they wrote their Latinized names on the walls, giving Pomponio the epithet "Pontifex Maximus." This seems to have been the extent of their sins, and although their experience was traumatic, Palermino points out that none of them was convicted, and most were able to continue their careers. The Roman Academy itself started up again under Sixtus IV della Rovere (reg. 1471–84). Yet the episode shows how narrow was the path trodden by those touched by the pagan spirit.

A happier event illustrates this delicate moment in the recovery of antiquity, and gives an idea of how Pomponio and his friends may have amused themselves. On September 22, 1464, the painter Andrea Mantegna (1431–1506) traveled from Mantua to Lake Garda with his friends Felice Feliciano, Giovanni Marcanova, and Samuele da Tradare. Their purpose was to seek out Roman remains at sites like Toscolano and to copy inscriptions. While they were about it they wore laurel wreaths, gave each other classical names and titles, rowed on the lake singing to the accompaniment of lutes (which they probably called lyres), and carved inscriptions of their own.[27] They sound as though they were acting out a scene from the *Hypnerotomachia*, set at around the same time (May 1, 1467, to be precise), in which Poliphilo found solace from his lovesickness by exploring the ruins of an ancient cemetery, and studying the Latin and Greek inscriptions on its stelae and sarcophagi.

The nostalgia for the Greco-Roman world, first felt in Italy, found its earliest echoes in some improbable places. Buonaccorsi/ Callimachus, after his escape from the Roman Academy disaster, passed through Greece, Cyprus, Rhodes, Egypt, and Constantinople, where the Turkish occupation evidently gave him less trouble than the Pope would have done.[28] He came to rest in Poland, where he was engaged as tutor to the sons of King Casimir IV Jagellon (reg. 1447–92) and as royal secretary. This "man of bad character and an insane state of mind" (said his old friends Pomponio and Platina) became a chief envoy of humanism to Eastern Europe, cofounding with Conrad Celtes a Polish Academy (the Sodalitas Litteraria Vistulana), which in turn spawned Rhenish, Danubian, and Baltic Academies. The Jagellon children included Jan Olbracht, who succeeded his father as king of Poland; Vladislav, who was king of Bohemia from 1471, then succeeded the great humanist Matthias Corvinus as king of Hungary; and Sigismund,

who was never expected to be king and was consequently given a more artistic and literary education. As it happened, Sigismund did become king of Poland, and it was he for whom Berrecci built the funerary chapel in Cracow, mentioned above. So powerful was its impact on Polish architecture that centrally-planned chapels sprang up throughout the land.[29] Even so, it was the forms rather than the spirit of the new Italian art that flourished in Eastern Europe. As Białostocki says, "little or no effort was spent on the basic problems of space composition, the new ways of rendering human anatomy and the new forms of beauty, or the humanistic attitude to nature and the world of antiquity."[30]

Another channel led from Italy straight to Fontainebleau, not far south of Paris, where King François I (reg. 1515–47) summoned Italian artists to decorate his château. Rosso Fiorentino (1494–1540) came there from Venice in 1530, and in the course of the decade completed the extraordinary decorative scheme of the Galérie François I, with its stuccoes, painting, strapwork, and other manneristic ornaments. Whatever its esoteric meaning,[31] it is one of the most persuasive recreations of ancient Roman decorative excess. Another Italian, Francesco Primaticcio (1504–70), came in 1532 after working under Giulio Romano on the Palazzo del Te in Mantua (see Chapter 4), and served three subsequent French monarchs. His major work, ruined by later renovations, was the Galerie d'Ulisse at Fontainebleau. Primaticcio also made plaster casts of the most famous antique sculptures in Rome, and, with the help of Jacopo Vignola (1507–73), made bronze reproductions from them. They included the *Apollo Belvedere*, *Commodus as Hercules*, the *Capitoline Venus, Laocoön, Sleeping Ariadne*, the *River Tiber*, two *Pans* and two *Sphinxes, Mercury*, and the *River Nile*.[32] Janet Cox-Rearick calls the Fontainebleau bronzes a "crucial milestone in the evolution of European taste and culture,"[33] because of the seed they sowed in France. Last but not least, in 1539 François I engineered the release from the papal prisons of the goldsmith and sculptor Benevenuto Cellini (1500–71). His masterpiece was to have been a set of man-sized silver statues of the twelve Olympian gods and goddesses, which would have stood in the Galérie François I looking like the statues in the palace of Homer's King Alcinous (*Odyssey* 7.100). These Italians introduced a languid, elongated type of figure, influenced by Parmigianino, which spread to the capital and soon came to be seen as the epitome of French taste.

Sculpture has certain advantages as a vehicle for the movement with which I am concerned. It has always been the classical medium *par excellence*, not only because most ancient painting has been lost, but because of the sense of living presence that only a sculpture gives. It carries the weight of millennia of idolatry, of

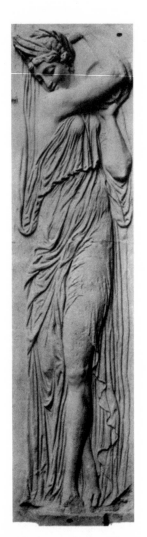

A languid, elongated type of figure came to be seen as the epitome of French taste. Jean Goujon, *Fontaine des Innocents*, Paris.

CHAPTER 1

wonder-working images, of sacred statues fallen from the sky, and of three-dimensional forms so beautiful that, like Pygmalion's *Galatea*, they ought to speak and make love. In the Galérie François I, and in Primaticcio's Salle de la duchesse d'Etampes, it is the tall stucco figures that make the most powerful impression, looming above one like inhabitants of the intermediate realm. As for the Fontainebleau bronzes, they are not mere reproductions of the classical marbles, but repaired, polished, and unbreakable recreations, which would be copied again and again in smaller formats, so that desk-top Laocoöns became as common as Eiffel Towers.

Another line of influence led to the German-speaking lands loosely grouped under the Holy Roman Empire of the Habsburgs. The romantic, impoverished Emperor Maximilian I (reg. 1493–1519) took seriously his holiness and *romanitas*, and did his best to surround himself with the appropriate trappings. Unable to realize them in fact, he did the next best thing by commissioning them on paper. One magnificent series of woodcuts, *The Triumphs of Maximilian*, shows a series of floats, chariots, exotic beasts, musicians, and gaudily-dressed soldiers and flunkeys, all marching to celebrate the Emperor's world-dominating dignity. This was the German answer to the *Triumphs of Caesar*, an archeological fantasy painted by Mantegna in the 1480s (see Chapter 9) and well-known through engravings, tapestries, and painted copies. Maximilian's other great woodcut, likewise a reinterpretation of Roman models, is the *Ehrenpforte*, a triumphal arch covered with symbols and emblems, which when assembled from its 192 printed sheets makes an image eleven feet high. The Emperor also planned his own tomb. It was just as improbable in conception as any of the engravings, but it was actually finished in three dimensions, and in the solid medium of bronze, thanks to the piety of his descendant Archduke Ferdinand II of the Tirol (of whom much more, later). Lined up on either side of the Hofkapelle in Innsbruck are over-lifesized statues of the ancestors whom Maximilian claimed, to justify the hereditary rule of the Habsburg dynasty. Most of them are in full armor, bristling with spikes and weaponry and executed with a truly German attention to detail. As Jeffrey Chipps Smith says, "These silent sentinels also eerily seem alive on certain occasions."[34] While not in the least pagan, Maximilian's tomb does set an unbeatable standard for one of our recurrent themes, that of surrounding oneself with images of Great Men, the *lares et penates* of one's carnal or spiritual family.

One would not expect the pagan impulse to have had much success in those parts of Germany that became Protestant after the Reformation, but there is one artist, Lucas Cranach the Elder (1472–1553), for whom the patronage of a Lutheran court opened new

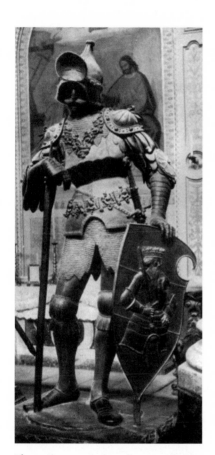

These silent sentinels eerily seem alive on certain occasions. Theodor of Bern, Tomb figure of Maximilian I, Hofkirche, Innsbruck.

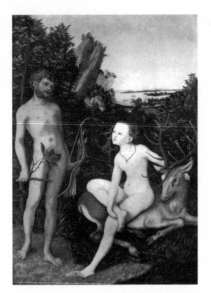

Cranach integrated his nude figures into landscapes of fairy-tale charm. Lucas Cranach, *Apollo and Diana*.

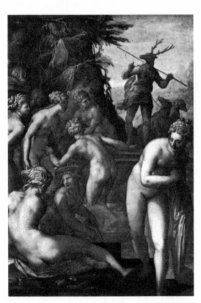

The viewer, by enjoying the painting, is also spying on Diana's bath. Giovanbattista Naldini, *Metamorphosis of Actaeon*.

vistas. As a mainly religious painter working for Frederick the Wise of Saxony, Cranach found the encouragement to indulge his flair for a particular kind of cool eroticism. Like his Venetian contemporaries, he integrated his nude figures into landscapes of fairy-tale charm, weaving a spell that no German artist would ever recapture. Lest one should take them too seriously, Cranach sometimes gave his Venuses accessories like ridiculously feathered hats. Eroticism—other people's, that is—always teeters on the brink of comedy. In the *Hypnerotomachia*, too, there is an undercurrent of self-mocking humor, as Poliphilo, the male protagonist, sees the absurdity and the helplessness of his situation, being in a state of perpetual arousal thanks to the presence of irresistible nymphs. To reassure the good folk who kept Cranach in business, some of his women carry moral warnings. In a much-copied example he shows Venus with Cupid, who has been stung by bees, and in case we do not get the message, it is written in capital letters: "As the child was stealing honey from the comb, a bee stung his fingertips. Thus our pleasure is brief and perishable: what we desire is mingled with sorrow and hurts us." But the figure of Venus is painted so as to give just that pleasure.

One might call this the Actaeon problem.[35] The myth of the hunter Actaeon has him stumbling upon the rare sight of Diana and her nymphs bathing in a forest fountain. Diana sees him and angrily splashes him, whereupon he metamorphoses into a stag and is killed by his own hounds. The subject was a favorite among sixteenth-century artists and their patrons. It afforded the pleasure of painting as many nymphs as one liked, yet with a wholesome and simplistic moral: that for men to look lustfully at women drags them down to the animal level. Thus the joke is on the viewer, who by enjoying the painting is also spying on Diana's bath, and sharing in Actaeon's offense. Is it, however, an offense, or was Actaeon's punishment unjust? Does his painful metamorphosis, like the flaying of Marsyas, have a redeeming, spiritual meaning? Is it esoterically about using sexuality as a path towards the initiatic death of the ego? It all depends on one's point of view.

A fourth stream of influence led from Italy to the Netherlands, thanks to a handful of artists who made the Italian journey and returned with their minds and sketchbooks brimming with ideas.[36] The first of these was Jan Gossaert (also known as Mabuse, c.1472–c.1534), who in 1508–09 went to Italy with his patron Philip of Burgundy in order to make copies of antique sculpture. Among the cities he visited were Verona, Mantua, Florence, and Rome. On his return he developed a distinctive line in large classical figures, usually nude, placed in improbable settings of his own invention, which must have had a shocking effect on those who saw them.

On his return from Italy, he developed a distinctive line in large classical figures, which must have had a shocking effect on those who saw them. Jan Gossaert, *Mars, Venus and Amor*.

Maarten van Heemskerck (1498–1574) was also touched by the Italian spirit, and his early works show how avid he was for whatever he could find and put to use in his homeland. He went to Italy in 1532, and documented the monuments of Rome in drawings that are a priceless historical record. Towards the end of his stay, in 1535, he produced a *summa* of all he had seen, learned, and imagined there in the gigantic *Landscape with the Rape of Helen*, now in Baltimore (see next page). In six square yards of canvas there is room for all the serpentine paths, gardens, rotundas, twisted columns, river gods, topiary, triumphal arches, acqueducts, pyramids, goats, peasants, fountains, prancing steeds, and overgrown ruins that anyone could desire. Few paintings better convey the thrilling experience of a northerner let loose in Italy, driven to the brink of surrealism by his passion for an imagined past. The same passion inspired the late works of Hendrik Goltzius (1558–1617), an indefatigable engraver of other people's work (often adapted or blended with his own), who probably did more than anyone else to set pagan images before the eyes of the bourgeois of Europe. His print sets include the *Seven Virtues* as manneristic nudes, *Roman Heroes*, eight male and seven female *Deities*, *Nine Muses*, and many single sheets, especially of Hercules, Roman statues, and *The Wedding of Cupid and Psyche* (after Bartolomeus Spranger). In later life he turned to painting, and to a technique unique to himself, simulating the lines of engraving with a pen on a large canvas, heightened with color (see page vi). Emperor Rudolf II owned Goltzius's *Venus, Ceres, and Bacchus*, an almost miraculous work in this medium, and marveled at how it was done.

In other regions of Europe, the pieces were not in place for the development of the movement in question. The reasons for this varied. The southeastern fringes of Europe (Hungary after 1536 and the Balkans) were too much menaced, even overwhelmed, by the Ottoman Turks for these hedonistic and essentially self-indulgent activities to have much of a chance. In Spain, hyper-Catholic orthodoxy and the intensity of Counter-Reformation zeal nipped any paganizing tendencies in the bud—one might almost say until the death of Franco, by which time it was rather late in the day for a renaissance of classical paganism. King Philip II (reg. 1556–98), it is true, owned Correggio's "Loves of Jupiter"(*Leda, Danae, Io,* and *Ganymede*), as a gift from Federigo II Gonzaga.[37] After he had let them pass to his secretary Perez, he commissioned a series from Titian to replace them. But this only shows the complexity of Philip's character; his little fling with erotic mythology had no effect whatever on the subject matter of Spanish art.

In England, all things Catholic and Italian became suspect after Henry VIII's break with Rome, and the English Renaissance was

Few paintings better convey the thrilling experience of a northerner let loose in Italy. Martin Heemskerck, *Panoramic Landscape with the Abduction of Helen.* The Walters Art Museum, Baltimore. By permission.

postponed *sine die*. Classical themes were introduced in a tentative, decorative fashion, mainly based on prints that entered via the Netherlands, but there was no body of native artists and craftsmen trained in the new style—especially in its canon of anatomy and in scientific perspective—who were able to clothe classical subject matter in classical form.[38]

After this sketch-map of the territory, we concentrate in the next chapter on the work already several times cited, the *Hypnerotomachia Poliphili* (1499) by Francesco Colonna. This is the central exhibit of our study, which, as will become plain, is really about the phenomenon of "Poliphilism" in European culture. But I am not attempting to trace influences, least of all literary ones: rather a mood, a longing, and a hunger for a particular sort of beauty, which existed before Colonna's work and for a century or more after it. For a few people today it still exists, albeit in diluted forms, for one cannot entirely discard the burden of half a millennium of history.

The Strife of Love in a Dream

HYPNEROTOMACHIA POLIPHILI, the literary masterpiece of Francesco Colonna (1433–1527), may not be the best novel ever written, but it has been called the most beautiful book ever printed, and on the rare occasions when copies appear for sale, collectors pay fabulous prices for them. As a physical object, the book is extraordinary. It was printed in 1499 by Aldus Manutius (1450–1515), the Venetian scholar-printer who specialized in editions of the newly-discovered Greek and Latin classics. The *Hypnerotomachia*, being a modern Italian novel, was not part of Aldus's program, but was printed on commission from Leonardo Grassi (or Crasso), who bore most of the expense and dedicated the work to Guidobaldo da Montefeltro, Duke of Urbino (1465–1508).

The famous press outdid itself in the design of this large volume, and in its decoration—also an anomaly for Aldine books—with 172 illustrations printed from woodblocks. Connoisseurs of typography have long admired the way that the illustrations are integrated with the text. Some of them are in frames placed at the top, middle, or bottom of the page. Others are unframed, and the text runs beside them, or even around them. Sometimes a two-part picture runs across both pages. The text itself is set in ingenious ways. Often it tapers and ends with a trio of stars. Sometimes it echoes the shape of the picture opposite, or makes a symbolic form such as a chalice. The typeface itself is the purest Roman: the miniscules derive from the Renaissance revival of Carolingian script, and the capital letters from ancient inscriptions.

During the Incunabula period (i.e., from the birth of printing through 1500), old habits of thought still held sway in the book trade. The printer would essentially do the work of the scribe in the manuscript period, producing a text on unbound quires that were shipped in barrels to booksellers.[1] It was up to them, or to their customers, to commission the decorations, if any, and to have the sheets bound in vellum or leather, according to taste and means. With this in mind, the printer often left out the initial letters of the chapters, to be filled in more or less elaborately by hand.

The *Hypnerotomachia Poliphili* is one of the first printed books to disdain this tradition. It came complete with a multitude of black-

and-white illustrations that needed no illumination, though a few owners had their copies touched up.[2] Ironically enough, this prized incunabulum heralded the cheap, mass production of illustrated books.

Those who bought and read the work were soon plunged into a fantasy world of hallucinatory depth—if they could understand it. For the *Hypnerotomachia Poliphili* is not written in the normal Italian of the day, nor in the language of Dante and Petrarch, but in a syntactically contorted prose overflowing with superlatives, diminutives, and redundant adjectives, and peppered with words that only the most up-to-date classical scholars would have recognized, for they are borrowed from recondite Latin authors or even adapted from Greek. It goes to the brink of reinventing the Italian language, both syntactically and by a stupefying enrichment of its vocabulary. Only an extremely persistent and obsessive writer could have sustained this effort, as Colonna does, for over 450 pages.

The *Hypnerotomachia* is divided into two parts, of which the first is very much the longer and more interesting. It tells the story in the first person of Poliphilo's search for the woman he has fallen in love with, and of their journey together to the Island of Cytherea, ruled by the goddess Venus. The title *Hypnerotomachia* is one of Colonna's invented words, made up from the Greek words for sleep, love, and strife. The complete title would read thus: *The Sleep-Love-Strife of Poliphilo, in Which it is Shown that All Human Things Are but a Dream, and Many Other Things Worthy of Knowledge and Memory*. Poliphilo's striving, his quest, journey, and consummation, are, in fact, nothing but a dream. The "strife" is his effort to gain the woman he loves, which he achieves only after much suffering and inner turmoil. The dream also includes the second book of the novel, in which we hear the woman's point of view. Polia is then the narrator, going in detail into her own history and feelings. But there is no saying whether she was ever a real woman, or only a sort of thing in Poliphilo's dream.

However, if "all human things are but a dream," they are still "worthy of knowledge and memory," and Colonna's dream-couple of Poliphilo and Polia enjoy the privilege of all great fictional characters: they are more real to the reader than most actual men and women of their time. The *mundus imaginalis* (World of the Imagination—see Chapter 11), which for most of us is as vague and undervalued as a dream, is where all artists worthy of the name go to gather their material. What distinguishes them is that they can capture the elusive creatures of that world, travel through its impossible places, and bring back a semblance of them to awe and delight the rest of us.

The great exemplar of this creative process in post-classical literature is Dante's *Divine Comedy*, which was also a deliberate exercise in creating a new literary language (in that case, to elevate the Tuscan dialect to parity with Latin). Dante's work is a summation of the Christian world-view, taking its narrator on a visionary journey through Hell, Purgatory, and Heaven, and meeting on the way everyone of any historical or topical significance. By the end of the *Paradiso*, the reader has traversed the entire universe of time and space as though in a stupendous dream: a dream, for the medieval Christian, of something more real than the waking state, since it lasts for all eternity.

Dante had the great advantage of using scholastic philosophy and the dogmas of the Church to act as scaffolding for his triple universe. He also knew as much as anyone of his time about the Greco-Roman world, and included everything he considered important about it, but always subsumed within the Christian world-view. In the *Hypnerotomachia Poliphili*, a prose epic on the same scale, the contributions of the two sources are reversed. Colonna drew primarily on his knowledge of the classical world, which was much greater than Dante's, thanks to the archeological and literary discoveries of the Renaissance. But he could not draw on a constant tradition: the link with Antiquity had been broken. He had to reinvent those things that Dante took for granted: a celestial geography, a moral system, a psychology (meaning the science of the *psyche* or soul), a theology, and a history of mankind. Whereas Dante took in the classical world and its values in the great sweep of his Christian poem, Colonna kept every reference to Christianity firmly out of his novel. Being by profession a Dominican friar, he could not avoid the thought-patterns of scholasticism or reminiscences of liturgical rites and language. But as far as he could, he made a determined attempt to create a Divine Comedy of the pagan revival, and that makes his work, for all its flaws, unique.

Poliphilo's quest passes through the three stages that can be likened to Inferno, Purgatorio, and Paradiso. It begins towards dawn, when Poliphilo has already spent a sleepless night agonizing over his unrequited love for Polia. He falls asleep and immediately wakens in a dense wood, like the one in which Dante began his visionary adventure. Poliphilo suffers from thorns and briars, disoriented wandering, fear of savage beasts and an ever-increasing thirst. He is led astray by phantom music, scared by a wolf, and pursued by a winged dragon into a maze of subterranean vaults. He passes through the bowels of the mountains and, when all seems lost, emerges into a pleasant land, populated by immortals. This is the end of his physical sufferings. His inner turmoil is unassuaged, but he is much cheered to find that this magical land is full of fas-

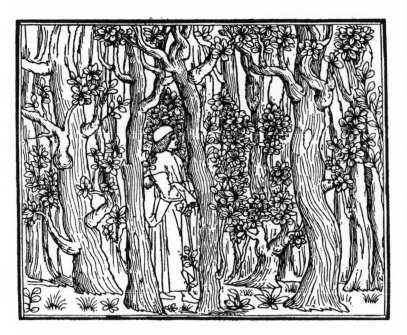

Poliphilo wakens in a dense wood, like the one in which Dante began his visionary adventure. Poliphilo in the wood, from the *Hypnerotomachia*, 1499.

cinating architecture. From now on, descriptions of the buildings, ruins, and other ancient remains take up a large proportion of the text.

The first monument Poliphilo examines is a stupendous pyramid-portal, one of the most famous images in the book. He describes it in minute detail, as he climbs through the mouth of the Medusa mask and up inside to the base of the obelisk. After passing through the portal, he meets some of the nymphs who inhabit this land, and they kindly take him under their care. First they bring him to a magnificent bathhouse in which they proceed to bathe, and after some coaxing persuade him to join them. In scarcely veiled language, he tells us how embarrassed he was because of being aroused by the sight of the naked nymphs. They find it hilarious and tease him mercilessly. At the bathhouse, Poliphilo admires two sculpted fountains. One represents a sleeping nymph whose breasts dispense hot and cold water, protected by a satyr. The other shows two nymphs holding up a child who, when Poliphilo steps on a certain flagstone, pisses in his face. This reduces his companions to helpless laughter.

Poliphilo's initiation continues with a visit to the ruler of this land, Queen Eleutherylida. The company, among whom Poliphilo is the only male, devours an eight-course dinner, then watches a chess game played with ballet dancers for the pieces, all described with extreme richness and circumstantial detail. Although her name means "free will," everything that happens around the Queen is fanatically orderly and ritualistic. There is no chatting at her banquet, only musical accompaniment. The feasters are fed like baby

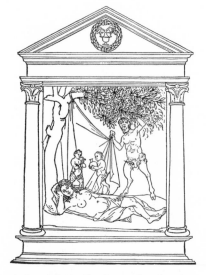

A fountain in the form of a sleeping nymph whose breasts dispense hot and cold water. Fountain of the Nymph and Satyr, from the *Hypnerotomachia*.

CHAPTER 2

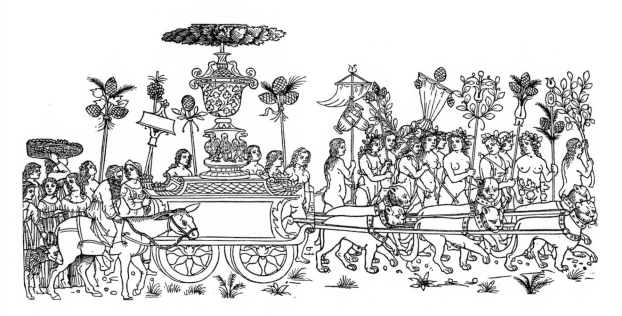

The Triumph of Semele carries the vine of her son Dionysus, among a crowd of naked maenads, with Silenus on his donkey bringing up the rear. Triumph of Semele, from the *Hypnerotomachia*.

birds, by having food put into their mouths by the exquisite maids-in-waiting. There is no choice of what and how much to eat.[3] The mosaics around the room suggest the reason why: everything is ruled by the planets. Their innate qualities or virtues control their "children"—the people born under their influence—and thus, taken in combination, produce harmony. Filled to overflowing with aesthetic excess and erotic stimulation, Poliphilo is permitted to choose his destiny. He is led to a cliff face containing three doors, each inscribed in four languages. One offers him the spiritual rewards of an ascetic life. The second offers worldly glory. The third leads to the Mother of Love. In fact, he has no choice: helpless in the face of his own nature, he takes the third one.

After his die is cast, Poliphilo is met by a nymph who so much reminds him of Polia that he cannot help falling in love with her. Together they witness a series of triumphs that have as their theme the Loves of Zeus. First is Europa, carried away by Zeus in the form of a bull. The float or chariot bearing this image is drawn by six centaurs playing musical instruments, and accompanied by a host of nymphs and youths carrying banners and trophies. Next comes the triumph of Leda, with whom Zeus coupled in the form of a swan, drawn by six elephants; then that of Danaë, whom Zeus impregnated in a shower of gold, drawn by six unicorns. The triumph of Semele does not show her—she was vaporized when Zeus appeared in his true form—but carries the vine of her son Dionysus, among a crowd of naked maenads, with Silenus on his donkey bringing up the rear. The theme of these triumphs is that all beings, even the chief of the gods, are subject to Love: *Amor vincit*

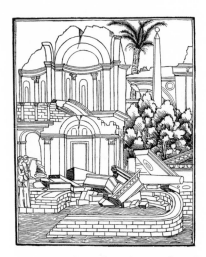

Scrambling through undergrowth and marble-strewn ground, Poliphilo finds one example after another of elegant decoration. Ruins, from the *Hypnerotomachia*.

omnia. Moving further down the social scale, the next triumph is that of Vertumnus and Pomona, the god of gardening and the goddess of orchards, drawn by satyrs. This leads to a rustic sacrifice to Priapus, the god of fertility, to whom a crowd of nymphs sacrifices an ass, while breaking vessels of milk, wine, and blood at the base of his ithyphallic statue. The woodcuts, for all their detail, are only a pale reflection of all these colorful scenes that Colonna describes in his purple prose.

The nymph next leads Poliphilo to the Temple of Venus, where she confesses that she is indeed none other than Polia, his beloved. The High Priestess enters with a cortege of female acolytes and conducts an elaborate service that is partly based on ancient Roman rites, and partly a parody of Catholic ritual. This is a marriage rite for Poliphilo and Polia, accompanied by signs and wonders like the miraculous blossoming of a fruit tree. The couple eat the fruit from it, blending the imagery of Holy Communion with that of the Garden of Eden.

Now the lovers go alone to the seashore to await the coming of Cupid and his boat, which is to ferry them to the Island of Cytherea, Venus's own realm. This is still Poliphilo's purgatorial phase, in which he has been tormented by loss, uncertainty, and remorse connected with Polia, and raging desire aroused by the nymphs. It is a far cry from the solemn sufferers who struggle up Dante's Mountain of Purgatory. But in the moral economy of Colonna's universe, Poliphilo is not a sinner. In the whole novel there is no suggestion of sin, unless one counts Polia's excessive attachment to chastity, for which she is punished by nightmares and a scolding from her nurse.

When Poliphilo's uncontrollable lust fills his mind with images of rape, Polia wisely arouses his other passion—the love of Antiquity—and sends him to examine the classical grave monuments and broken ruins of temples. Scrambling through undergrowth and marble-strewn ground, he finds one example after another of elegant decoration, bas-reliefs, and lettering. The inscriptions in Latin, and less frequently in Greek, all tell of the misfortunes of lovers, spurned by each other or driven together to a premature end. Poliphilo becomes so enwrapped in his antiquarian studies that he quite forgets about Polia. Then in a panic he remembers her and, his mind full of horrible imaginings, rushes back to where he left her sitting serenely by the shore.

In due course Cupid arrives in the form of a naked boy with gold-dusted, peacock-feathered wings. His boat is rowed by six exquisite nymphs, while he helps it onward by spreading his wings to act as sails. Colonna's Cupid may be a child, but he is extremely knowing and, for all his immaturity, already has a history of sub-

jection to his own powers. As legend tells, he wounded himself with his own arrow, and fell in love with Psyche. It should be mentioned that there is a fairly obvious Christian interpretation to all of this, which some may believe to have been Brother Francesco's true intention: Jupiter, Venus, and Cupid, if their loves are translated from profane to sacred, can easily be allegories of God the Father, the Virgin, and Jesus Christ. Cupid's love for Psyche is then none other than Christ's love for the human soul.

On the way to Cytherea, Cupid and his passengers are greeted by the marine gods and goddesses in an unforgettable scene of boisterous merriment:

> Now the sea-gods arrived. Nereus, with lovely Chloris and their children Ino and Melicerta, came dashing in their chariots over the foamless waves to worship the divine child. Then wave-born Melantho or Poseidon with his shaggy azure beard and his sharp trident, drawn by great seals; and the blue Tritons, trumpeting with their sonorous shells whose bellowing clangour resounded through the aether. Then came a troop of Dircaean nymphs, and the Nereids mounted on speedy and outstretched dolphins, those followers of the North Wind, carriers of Arion, who favour the name "Snubnose." And there were whales, and the monstrous Cephiso.
>
> Now ancient Father Ocean came, and presented in order his wife Tethys and their children [. . .] There was Proteus, drawn by hippocamps, and Glaucus the fisherman with his lover Scylla, and the other fishlike monsters with many sea-horses and mermen. They dived into the tide with an astonishing slap, creating a wash as they broke the turbulent white water and submerged, then they burst out again in their monstrous fishy forms, and made due reverence and solemn homage with tremendous cries to the elect voyagers. Next there came a flock of shore-birds and white swans, some swimming and others flying in the air, to add the charming concert of their high voices. All gave praise and glory as subjects of the omnipotent gods, paying grateful and abundant homage, making a joyful noise as they moved nimbly in the water, breathing through their gills, dancing and leaping with their fins and flippers and whistling with a wondrous din.[4]

Venus's realm is a circular garden-island blessed with every perfection of nature and architecture, at whose center stands a great theater, and in the middle of this, the Fountain or Bath of Venus herself. Poliphilo proceeds in Cupid's train, enumerating as he goes the many different types of gardens with their trees and plants, all named, haunted by pairs of happy lovers and tame beasts. A particular specialty of Venus's gardeners (who of course are never seen

at work) is topiary, the art of clipping hedges of yew and box into shapes. As the company nears the theater, Poliphilo describes the Triumph of Cupid himself. The God of Love sits blindfolded on a Roman two-wheeled chariot, drawn by two giant lizards. Two satyrs accompany it, bearing ithyphallic herms that are illustrated in detail, lest we miss the point.

The climax of the novel is set in a circular theater, with an audience of dancing and singing nymphs. At the Bath of Venus in the very center, Poliphilo and Polia have an epiphany of the goddess in her nudity, which Colonna expresses in language suggestive of defloration and orgasm. Then the god Mars arrives, strips off his armor, and enters the bath with the goddess, whereupon the company discreetly withdraws. Poliphilo and Polia settle down with their nymph attendants in an enclosed garden near the Fountain of Adonis, where Polia is persuaded to tell her own story. Thus the first book ends.

What makes Poliphilo's dream so vivid, and so important as a witness to the obsessions of Colonna's time, is the fact that hero and author are repeatedly distracted from their love-quest by the monuments that they encounter. Even before Poliphilo meets the dragon, he has spent several pages describing three gigantic statues: a bronze horse which a crowd of infants is trying to ride, a recumbent colossus of metal, and an elephant of obsidian with an obelisk on its back. Here is part of Poliphilo's description of the colossus, which demonstrates Colonna's visual imagination, his inventive ingenuity, and, at the end, his contempt for the lesser achievements of his own age. He must have been writing this at the very time when Michelangelo and Leonardo were making their surreptitious dissections of human bodies:

> This colossus lay on its back, cast from metal with miraculous skill; it was of a middle-aged man, who held his head somewhat raised on a pillow. He seemed to be ill, with indications of sighing and groaning about his open mouth, and his length was sixty paces [300 feet]. With the aid of his hair one could climb upon his chest, then reach his lamenting mouth by way of the dense, twisted hairs of his beard. This opening was completely empty; and so, urged on by curiosity, I proceeded without further consideration down the stairs that were in his throat, thence into his stomach, and so by intricate passageways, and in some terror, to all the other parts of his internal viscera. Then oh! what a marvellous idea! I could see all the parts from the inside, as if in a transparent human body. Moreover, I saw that every part was inscribed with its proper name in three languages, Chaldaean, Greek and Latin. Everything was there that is found inside the natural body: nerves, bones, veins,

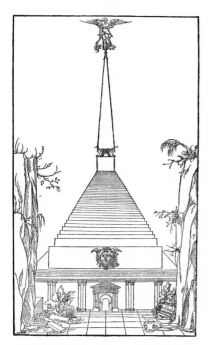

This architectural fantasy blocks the entire end of a valley, joining the two flanking mountains. Pyramid, from the *Hypnerotomachia*, French ed.

muscles and flesh, together with every sort of disease, its cause, cure and remedy. All the closely-packed organs had little entrances giving easy access, and were illuminated by small tunnels distributed in suitable places around the body. No part was inferior to its natural model. And when I came to the heart, I could read about how sighs are generated from love, and could see the place where love gravely hurts it. All this moved me deeply, so that I uttered a loud sigh from the bottom of my heart invoking Polia—and instantly heard the whole machine resonating, to my considerable fright. What an object it was, surpassing the finest invention, as even a man ignorant of anatomy could appreciate! O mighty geniuses of the past! O truly golden age, when Virtue went hand in hand with Fortune! But you have bequeathed to our own age only Ignorance, and its rival Avarice.[5]

Poliphilo's awe before the three great statues is nothing in comparison to his reaction at the pyramid-portal. This original architectural fantasy blocks the whole end of a valley, joining the two flanking mountains. Its lower story is Roman in style, with a portal of strict geometrical design, while above there rises a stepped pyramid, an obelisk placed on bronze corner-supports (like the ones re-erected in Rome), and a rotating, musical statue. Like the modern visitor to certain unexplained and oversized relics of ancient ingenuity—the plinth of the Temple of Jupiter at Baalbek, for example, with its 600-ton blocks, the Tomb of Theodoric at Ravenna, with its 300-ton monolithic domed roof, or the Pyramids of Giza—Poliphilo wonders how on earth they were made. "What vehicles did they use? What sort of carriers, wagons, and rollers served to carry off such an enormity of stones? On what support were they coupled and united? What mass of cemented foundations underlay the tall obelisk and the immense pyramid?"[6] But the situation of a dream frees him to imagine structures that surpass all reality.

There are two things that plunge Colonna, or his mouthpiece Poliphilo, into an ecstasy of admiration. One of them is the contemplation of the works of Antiquity, ranging from implausibly titanic monuments such as this pyramid-portal to the simple lineaments of a broken vase. The other, as one might expect in a love-quest, is feminine beauty. We have seen in his description of the anatomical colossus how he pictures every detail. Here he dwells with equal attention on two of the six nymphs who row Cupid's boat:

The last pair, Adea and Cypria, were dressed in a splendid honey colour, with a loose and intricate weave pierced by numerous tiny slashes, with gold leaves placed underneath at the outer fringes.

Where the arms joined, there was a sideways opening in the garment from which issued the naked ivory arms, showing as white as curdled milk, with all the requisite ornaments and nymphal accessories. The fresh and wanton breeze revealed, according to its motions, now the form of the rounded, firm and chaste belly and the pretty pubis, now the plump hips, and now the tremulous buttocks. Then it revealed the shoes on their long, slender feet, tightly laced with little horn closures. These were exquisitely crafted of blue, green and red silk, with a moon-shaped opening above the instep, minutely bordered and neatly latched with golden hooks and eyes. Some had gilded sandals or slippers with silken laces tipped with gold and threaded alternately around flat, round golden buttons; and there were many other ornaments of lascivious and virginal ingenuity, invented to gladden the senses with elaborate pleasure.[7]

One of the few things known about Francesco Colonna, the friar of SS. Giovanni e Paolo in Venice, is that he was a craftsman. While acting as sacristan for his monastery, he made the doors for the Choir, and in 1515 he was commissioned to make a silver crown for a statue of the Virgin. The *Hypnerotomachia Poliphili* shows that, given a different course of life, he could have made much more. For example, to return to the theme of architecture, he was a great inventor of centrally-planned buildings. This was a Renaissance obsession, as witness Leonardo's drawings of imaginary churches, and Michelangelo's original plan for St. Peter's. Perhaps because of the prominence of the Pantheon and other circular buildings in Rome, it was imagined that the Ancients had been much more given to this form than they actually were. But although many projects were drawn up, and despite the medieval tradition of circular chapels built by the Order of Knights Templar, none was built between Brunelleschi's Rotonda di Santa Maria degli Angeli in Florence (1434, unfinished) and Bramante's Tempietto at San Pietro in Montorio, Rome (1499–1502).

The architecture of the *Hypnerotomachia* is almost exclusively radial, rather than axial. The bathhouse is octagonal, with pilasters on every face supporting a frieze carved with putti and garlands, an octagonal dome inlaid with crystal panels, and a spire topped with a globe and another musical statue. Queen Eleutherylida entertains Poliphilo in a square, open-roofed court paved with sixty-four chessboard squares of green and coral-colored jasper. The four walls are each divided into seven bays, showing respectively the seven planets with their innate qualities, the seven triumphs of the subjects ruled by the planets, the seven harmonies of the planets, and seven nymphs, representing the opera-

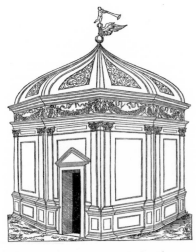

It has an octagonal dome inlaid with crystal panels, and a spire topped with a globe and a musical statue. Bathhouse, from the *Hypnerotomachia*, French ed.

CHAPTER 2

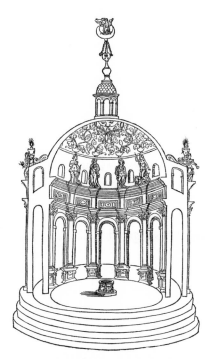

Several later architects seem to have taken their inspiration from it. Temple of Venus Physizoa, from the *Hypnerotomachia*. French ed.

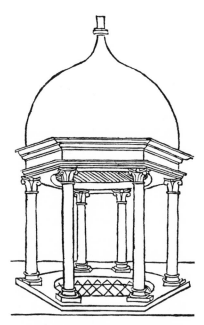

A small hexagonal temple of reddish porphyry, with an ogival dome made from a single rock. Temple of Pluto and Persephone, from the *Hypnerotomachia*.

tion of the planetary virtues. It is not by chance that the ordering of the space draws on all four arts of the Quadrivium: Arithmetic, Geometry, Music, and Astronomy, the mathematical arts that ensure the coherence of architecture and its relation to the macrocosm.

From there Poliphilo passes on to view a circular water-labyrinth, in which people in boats follow an allegorical and moralizing course. It seems to be imagined as a miniaturized structure, rather as the symbolic "Rometta" of the Villa d'Este (see Chapter 8) depicted a cluster of Roman buildings in reduced size. Next he comes to a circular arcade of a hundred arches, built of brick and all grown over with greenery; each arch contains a golden statue of a nymph on a pedestal of porphyry, every one different in her garments and attributes. This, too, would have its imitations in the garden design of the centuries to follow. In the middle of this arcade is a three-sided obelisk, which he interprets as a Hermetic trinitarian symbol.

The most complete of Colonna's imaginary buildings is the Temple of Venus Physizoa, which he describes in such sufficient detail that it cries out to be built. (The church of the Salute in Venice and the Radcliffe Camera in Oxford are two interpretations of it.) When Poliphilo glimpses it from afar, he sees the octagonal lantern on top of the dome, but the building as a whole is decagonal. The 1499 edition of the *Hypnerotomachia Poliphili* offered a schematic diagram of the interior, to which the French 1546 edition added a more detailed realization of the outside. Among the interior decorations, says Poliphilo,

> I admired a marvellous depiction in vermiculate mosaic of the months of the year with their properties and attributes. Above them ran the Zodiac, with the movements of the sun and the system of the moon's monthly phases from new to horned, half and full, and its orbit by which the months are measured. There were also the courses of the wandering sun, the winter and the summer solstice, the changes of night and day, the fourfold procession of the seasons, the nature of the fixed and errant stars with their influences.[8]

Moreover, above the internal columns there are statues in white stone of Apollo and the Nine Muses. A doorway between two of the columns leads to an adjoining, circular chapel, which is the site of the miraculous ritual in which Poliphilo and Polia are married.

During the long digression that describes Poliphilo's rummaging among the tombs and inscribed stelae of an ancient cemetery, the one intact building he discovers is a small hexagonal one of reddish porphyry, with an ogival dome made (like Theodoric's

Tomb) from a single rock, covering a subterranean vault. This design, too, would become a favorite ornament for gardens. As for the Island of Cytherea, the whole thing is circular, with an intricate spider's web pattern of concentric gardens and twenty radial paths. In the middle is a circular theater, obviously inspired by the Coliseum of Rome, with thirty-two vaults, and in the very center, the Fountain of Venus.

This last fantasy-building, in which Poliphilo rends the door-curtain to reveal the naked goddess in her bath, is seven-sided on the outside, circular within, with its columns each made from a different gemstone. Those on the right enclose a sculpture of a male infant, mysteriously visible within the transparent substance; those on the left reveal a female infant, and the seventh column, a hermaphrodite. Inside the building, the frieze shows the twelve signs of the zodiac, carved in relief, and above these are pedestals holding golden statues of the seven planets.

The buildings and gardens of Poliphilo's dream are a complete repertory of radial symmetry. There are examples of threefold division (the obelisk in the arcade), fourfold (the pyramid and the courtyards), fivefold (in the decagonal Venus Temple, the twenty radial paths of the Island, and the hundred arches of the arcade), sixfold (the little temple in the cemetery), sevenfold (the Fountain of Venus), and eightfold (the lantern of the Venus Temple and the bath-house). These geometrical plans often correspond to numerically-based decorative schemes, among which we have mentioned the four seasons, the seven planets, the nine Muses (with Apollo making ten), and the twelve signs of the zodiac.

Perhaps the most striking aspect of Poliphilo's dream world is the actual appearance in it of the gods and goddesses, notably Cupid and his mother Venus, who reappears in Book Two when Poliphilo's soul ascends to petition her in heaven. At Venus's Fountain there are two other gods in attendance, Bacchus and Ceres. This is how Poliphilo describes them:

> On the top step there lazed a lascivious creature in human form, a nocturnal god who presented himself insolently with the look of a petulant and spoiled girl. His chest was visible as far as the diaphragm, and he had horns on his head, which was wound with a twisted wreath of vine-leaves, ornamented by tendrils and bunches of juicy grapes; and he leaned on two speedy tigers.
>
> Similarly, on the left a handsome matron was comfortably seated, wearing a crown of yellow wheat on the curls above her broad brow. This illustrious personage was supported by two scaly serpents.[9]

However unlikely the presence of Bacchus and Ceres may sound,

Colonna had to honor the well-known adage which we have already seen illustrated by Goltzius: "Without Ceres and Bacchus, Venus grows cold,"[10] meaning that one cannot feel amorous without first satisfying the stomach with bread and wine. Colonna still belonged to the old-style iconographers who insisted on putting in all the attributes they had garnered from classical mythology.

The second book of the *Hypnerotomachia* is mostly narrated by Polia, for the entertainment of the nymphs. Poliphilo is present as a silent observer as Polia relates for page after page his conversations with her and the letters that he wrote during his unsuccessful wooing. She tells in much detail of her noble Roman ancestors and her family's history in the city of Treviso, and of how she reached the flower of her age in the year 1462. With this mention of a contemporary date we enter a different world and a different mood from Poliphilo's dream—although, strictly speaking, the Polia who speaks is only a dream figure, and consequently all she says could be merely his fantasy. The style of Book Two is entirely different from the hyperbolic descriptions of Book One, sometimes resembling the popular, ribald tales of Boccaccio, and sometimes seeming like an exercise in rhetoric. It was almost certainly written earlier, and then incorporated into Colonna's epic scheme.

Polia tells how she fell ill of the plague, but promised the goddess Diana that if she recovered, she would dedicate her life to service in Diana's temple. She did so, and duly entered on a life of chastity. But Poliphilo had caught a glimpse of her and fallen in love at first sight. With much difficulty he tracked her down, watched, and then approached her when she was praying alone in the temple and declared his love. She, true to her vows, was deaf to his pleas. She sent him away, ignored his letters, and, when he returned, treated him with such cold disdain that he collapsed lifeless before her. Polia dragged away his body by the feet and hid it in a corner of the temple. Nothing about this would have been discordant with a contemporary situation: Diana's temple, both as described and as pictured, is a scarcely-disguised Italian convent, and Polia is a novice nun.

Having, as it were, died, Poliphilo's soul now ascended to the realm of the gods and besought Venus, through the mediation of her son Cupid, to have mercy on him and make Polia love him. The goddess consented. The image or soul of Polia was brought forth, and Cupid shot an arrow into its breast. Poliphilo's soul was permitted to return to its body. Meanwhile on earth, Polia had spent a very disagreeable night. She had had appalling nightmares of Cupid dismembering naked women and feeding their limbs to beasts, and of two ruffians who broke in and were about to rape her. Her kindly nurse interpreted the dreams as warnings about

· Polia dragged away his body and hid it in a corner of the temple. Polia hides Poliphilo's body, from the *Hypnerotomachia*.

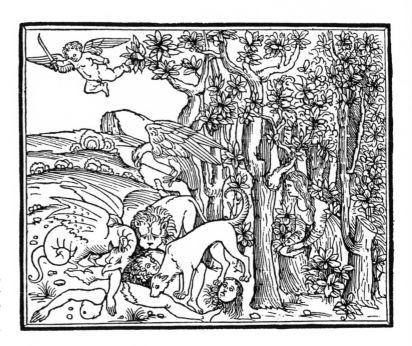

Appalling nightmares of Cupid dismembering naked women and feeding their limbs to beasts. Polia's dream, from the *Hypnerotomachia*.

refusing the duties of love, and told her a cautionary tale about another young woman who had done this, and ended up married to an impotent old man and killing herself. Lest it be thought that Colonna's powers of description are restricted to a besotted aestheticism, here is part of the nurse's description of the husband:

His breath had the air of a putrid sewer or a fetid bog. His gaping mouth was adorned with pallid, wrinkled lips and a feeble voice, and all that was left of his teeth were two upper ones, chipped and pitted like pumice-stone, and four below, two on each side, which wobbled in their seats. His white beard, coarse as the hair of a long-eared ass, stuck out like wasp-stings. His scarlet eyes were wet and teary, his pug-nose had gaping nostrils, forested, snotty and slimy, and was perpetually snoring, so that all night long it seemed as if a great bellows were blowing. His face was hideous, his head covered with white scabies, his cheeks varicose and his eyes topped with swollen lids. His neck with its wrinkled skin was deformed and veined like that of a bog-turtle. His trembling hands had no strength in them, and the rest of his body was putrid, morbid, sickly and sluggish. When he moved, his garments gave out a stench of stale piss. Now listen to me, my child . . .[11]

Properly scared by all of this, Polia returns to the Temple of Diana, drags Poliphilo's body out of hiding, and tries to revive it. Little does she know that this is the very moment at which Cupid in heaven has wounded her soul, and Venus has sent Poliphilo's

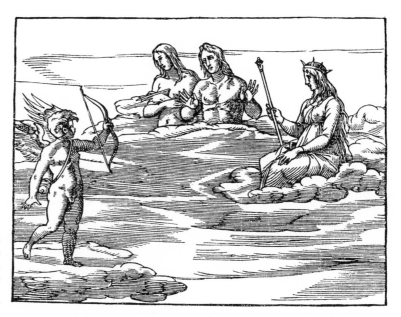

At the very moment at which Cupid in heaven wounded Polia, Venus sent Poliphilo's soul back to earth. Cupid shoots his arrow at Polia, from the *Hypnerotomachia*, French ed.

soul back to earth. Consequently he comes back to life in her arms, and she falls instantly in love with him. Her virgin sisters angrily drive the couple out of Diana's temple, and they take refuge in the Temple of Venus, where the priestess is only too happy to hear their story and to approve their union. That is the end of Polia's story. The nymphs thank her and disperse, leaving her and Poliphilo alone by the Fountain of Adonis.

Then, winding her immaculate, milk-white arms in an embrace around my neck, she kissed me, gently nibbling me with her coral mouth. And I quickly responded to her swelling tongue, tasting a sugary moisture that brought me to death's door; and I was straightway enveloped in extreme tenderness, and kissed her with a bite sweet as honey. She, more aroused, encircled me like a garland, and as she squeezed me in her amorous embrace, I saw a roseate blush strongly suffusing her naturally snowy cheeks; while on her stretched skin, a mixture of scarlet rose with the calm glow of ivory was shining with the utmost grace and beauty. The extreme pleasure caused tears like transparent crystal to form in her bright eyes, or like pearls finer and rounder than Euriale's or than those that Aurora distils as morning dew upon the roses. This deified, celestial image then dissolved in the air, like the smoke, perfumed with musk and ambergris, that rises to the ether from a stick of incense, to the great delight of the heavenly spirits as they smell the strangely fragrant fumes. Quickly she vanished from my sight, together with my alluring dream, and in her rapid flight she said, "Poliphilo, my

dear lover, farewell!"[12]

With that we can surmise that Brother Francesco's experience of women's love was not limited to his dreams.

Emanuela Kretzulesco-Quaranta concludes her study of the *Hypnerotomachia*'s influence on Renaissance gardens by proposing "three dogmas of Poliphilo" concealed within their symbolism: 1. The future Resurrection of the flesh; 2. The Unity and Trinity of God; 3. The Divinity of the Act that Creates Life.[13] But why would such anodyne and suspiciously Christian dogmas be in need of concealment? If I had to name three dogmas based on my reading of the book, they would be:

1. All human things are but a dream.
2. Nature is the thing most worthy of worship and celebration.
3. Love conquers all.

The first, which I have already commented on superficially, implies that something else exists that is not a dream, but a waking state; and that it is not "human." Such thoughts point clearly to Plato's philosophy. They put one in mind of the Myth of the Cave in the *Republic*, and the Myth of the True Earth in the *Phaedo*.[14] Both of them picture a higher world, or state, attainable by the philosopher when he realizes the unreality of the world that most humans take for granted. The novel turns the terms around, because Poliphilo's dream depicts the pilgrim's attainment of this more noble, beautiful, and unfallen world, whereas the world to which he wakens at the end of the book is the drab one of everyday life.

The second dogma is the meaning of the cult of Venus into which the lovers Poliphilo and Polia are initiated. All is harmony, beauty, order, and desire, from the loves of the gods themselves, through the cosmic cycles and hierarchies pictured in the buildings (Zodiac, Planets, Elements, Seasons, Hours, Ages, etc.), down to the stones and flowers that Colonna lovingly enumerates. Unlike Platonic philosophy, Venus's cult does not ask for eroticism to be transcended or sublimated. The goddess herself, like the divine principles of Hinduism, is seen in sexual congress with her consort Mars.

There is a profound paradox in the contradiction of these two principles: that the world is unreal, and that it is nevertheless sacred. I can only resolve it by introducing the human subject as the determining factor. The world for the majority of humans is dreamlike and unreal, and they do not perceive Nature in her true, uncorrupted state. But for the philosopher who has glimpsed the real

world, and achieved a waking state worthy of the name, Nature reveals her perfection and her treasures. No one in Colonna's time would have put it like this, except half a world away in Japan, where it is a fundamental notion of Zen Buddhism.

The third dogma, which is written on the banner of Cupid's ship and celebrated in the Triumphs, is the great theme of Poliphilo's quest, pursued in a perpetual fire of erotic excitement. It carries him through a series of initiatic experiences, culminating in the epiphany of Venus as the celestial creative principle. Christians know her as the creative Logos, which also has the attribute of Love, but they hope to reach it not via Eros but by the stonier path of universal Charity.

Scholars have written much, and will write more, on the influences that flowed into the *Hypnerotomachia* and on those that flowed out. The present study is not about this, but about developments and unfoldings in the World of the Imagination, which to an extent is timeless, just as our own knowledge of the works of the past transcends the lapse of years. Read and viewed in this way, Colonna's work, with its passionate, erotic love of classical antiquity, seems to gather in a single, intricate knotwork all the threads of the early Renaissance: the elitist thrill of humanistic learning; the uneasy compromises with scholastic philosophy and Catholic doctrine; the eager excavation of treasures; the reappraisal of ruins and broken fragments; the tragic sense of lost greatness and the consequent creation of a parenthesized "Middle Ages;" the fueling of this nostalgia by a new view of the human body and a new sense of living Nature; and above all the decision no longer to feel guilty about loving the stuff and surfaces of this world. It is all there. And as one looks forward beyond the troubled years of the early sixteenth century, it seems that the aesthetic movement known as Mannerism has also been latent within Colonna's dream. How easily the pictures adapt themselves to the canons of beauty of the school of Fontainebleau! Here are the prototypes of all those geometric gardens with their fountains, kiosks, canals, topiary, statues, baths, arboreta, orchards, and flowerbeds; those wedding processions and triumphal entries with their musical instruments and learned emblems of the gods; those chapels made from inlaid precious stones; those cycles of fresco painting showing the Loves of Jupiter, the Seven Planets, the Four Seasons, the Signs of the Zodiac, and the Nine Muses. Yes, they were there before, but in a more tentative and experimental way. Now the commitment to them is total.

Re-ordering the World

Letting the pure, canonical forms speak for themselves, Alberti allowed only the bare minimum of decorative elements. Doorway of the Tempio Malatestiano, Rimini.

THE *Hypnerotomachia* was an attempt to re-make the world in a form nearer to the heart's desire. To this end, Colonna furnished it with a different history and geography, a different population, and different gods. Given those premises, it was a consistent and rational world, obedient to its own laws. Many other artefacts and enterprises treated in this book qualify as re-orderings of the world, though few have the scope and consistency of that epic novel. Of course the world cannot simply be altered by royal or democratic fiat, but models can be made of how it might or should be. Most artworks to which we give the name of "epic" are such models. So were the decorative schemes, the festivals and pageants so beloved of the author of the *Hypnerotomachia*, which presented images of good government and cosmic order.

This chapter treats four examples in different media: sculpture (the Tempio Malatestiano in Rimini), engraving (the *Tarocchi of Mantegna*), drawing (the *Florentine Picture Chronicle*), and painting (the Hall of the Months in the Schifanoia Palace, Ferrara). Each one is an all-embracing statement about weighty matters such as human and cosmic time, the order of the universe, the soul's destiny; and each one turned for its imagery to the emerging fashion of classicism.

The Tempio Malatestiano leads directly from the classicizing tombs that were described in Chapter 1, and from their allusions to Neoplatonic doctrines of the soul's journey. While those tombs were interlopers in a Gothic and Christian environment, the Tempio Malatestiano was a much more ambitious attempt to transform the environment itself: by remaking a medieval church into a temple virtually emptied of Christian symbols, and a mausoleum immortalizing the Lord of Rimini, his wife Isotta, and the poets, philosophers, and humanists of his court.

The man responsible for the transformation was Sigismondo Pandolfo Malatesta (1419–68). He has gone down in history as a Renaissance villain who rivalled the Borgias for vice and cruelty, and arrogantly filled a church with the images of his private, anti-Christian cult. The accusations made against him in his lifetime include murdering his first two wives, a rich menu of sexual sins, sacrilege, and atheism. However, the catalogue of Sigismondo's

A faded painting of Sigismondo, kneeling before his patron saint. Piero della Francesca, *Sigismondo Malatesta*.

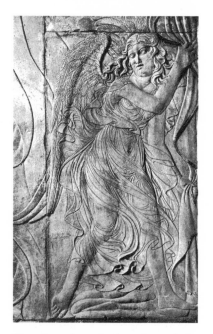

They show the svelte forms beneath the diaphanous garments. Relief by Agostino di Duccio, Tempio Malatestiano.

misdeeds was drawn up by his enemies, including his rival, the conspicuously virtuous Federigo da Montefeltro (of whom we will hear more in Chapter 5),[1] so there is no obligation to believe it all. In 1461–62 Pope Pius II, with the bureaucratic assistance of Cardinal Nicholas of Cusa, took the extraordinary step of holding a trial of Sigismondo in absentia, which officially and infallibly consigned him to hell, while yet alive. The Pope specifically mentioned that "he has filled [San Francesco] with heathen works, so that it looks like a temple not for Christians but for infidels to worship demons in."[2]

To design the exterior, and perhaps the interior too, Sigismondo engaged Leon Battista Alberti (1404–72), the greatest art-theorist and, when he put his hand to it, perhaps the greatest architect of his generation. Beginning in 1447, Alberti encased the church of San Francesco in a classical shell inspired by the Romanesque church of San Miniato in Florence and the Arch of Caesar Augustus in Rome.[3] Letting the pure, canonical forms speak for themselves, he allowed only the bare minimum of decorative elements: fillets and pilasters carved in low relief with rinceaux, and panels of the symbolically-laden hard stones, green serpentine and blood-red porphyry (see Chapter 6). The interior was clad in Istrian limestone and carved with a multitude of figural decorations by Matteo Pasti and Agostino di Duccio. Perhaps only Donatello had hitherto treated the subtle medium of low relief with such depth and expressivity. Agostino and Matteo evoke the elements of air and water with a delicacy worthy of the ethereal realms that they symbolize. They show the svelte forms beneath the diaphanous garments, lending to some of the figures a sensuality that made one critic, Adrian Stokes, wonder if, having much the same face, they did not all stand for Sigismondo's beloved third bride, Isotta degli Atti (1432/3–1474).[4] Because of Sigismondo's turbulent circumstances, work ceased after ten years, and the temple was never finished, as intended, with a great hemispherical dome. But enough was done both inside and out to make it one of the glories of early Renaissance sculpture and architecture, and to immortalize its builder.

Many scholars have been inspired by the harmonious beauty of the Tempio Malatestiano to describe and explain its iconography. The most interesting and sustained interpretation, in my opinion, is that of Maurice Shapiro, whose doctoral thesis argued that the iconology of the interior is a Christian Neoplatonic treatise on death and the afterlife. Besides defending the much-maligned Sigismondo, a summary of Shapiro's theory will also serve to introduce some of the metaphysical underpinnings of the pagan revival.

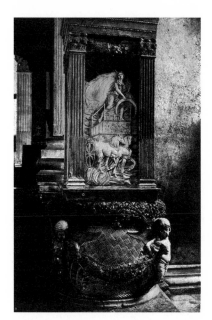

Plaited beehives represent Homer's tubs of honey, luring souls into generation. Above: Diana the Moon-goddess in her chariot. Tempio Malatestiano.

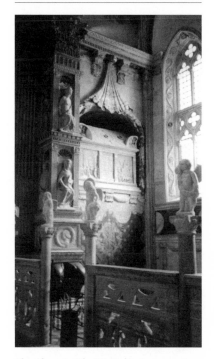

The Chapel of the Sibyls has been resplendently restored, highlighting the white stone with gold leaf and lapis blue. Tempio Malatestiano.

The key to this interpretation is one of the best-known and shortest works of the Neoplatonic corpus: *On the Cave of the Nymphs in the Odyssey* by Porphyry (233–305), a disciple of Plotinus. This is a commentary on the passage in Book 13 of the *Odyssey* that describes the place where Odysseus returns to his native island of Ithaca:

> An olive with spreading branches stands at the head of the Ithacensian port; and near it is a cave both pleasant and obscure, which is sacred to the nymphs who are called Naiads. Within the cavern, bowls and capacious amphora are formed from stone, in which the bees deposit their delicious honey. There are likewise within the cave long stony beams, on which the nymphs weave purple webs wonderful to the sight. Perpetual waters flow within the grotto. But there are two gates: one towards the north gives entrance to mortals descending: but the other towards the south which is more divine, is impervious to mankind; and alone affords a passage to ascending immortals.[5]

Porphyry explains, with much learning, that this cave is none other than the world, and that the nymphs are the beings who clothe the souls entering incarnation with their new, physical bodies. The purple webs are the flesh, woven on the stone loom of the skeleton. Honey is a symbol both of purification (because it was used for mummification) and of the sweet lure of sexual intercourse which is the immediate cause of the soul's incarnation. The northern entrance to the cave, ruled by the watery zodiacal sign of Cancer is the way down into bodily existence, while the southern one, ruled by the dry sign of Capricorn, is the way to transcendence and immortality, taken by the gods and by men worthy of their company.

Shapiro takes the eight chapels of the Tempio one by one, proceeding from west to east and alternately from south to north:

1. *Chapel of Saint Sigismund.* Shapiro thinks that Alberti, who was much more than an architect, may have been responsible for the whole interior iconography, as well as for the external architecture. This chapel, dedicated to Sigismondo's patron saint, was the earliest one to be decorated. Its relief panels illustrate the seven Virtues, dominated by Justice: the primary virtue required of a great lord. Leon Battista Alberti was writing on this subject in *De Architectura* at exactly the time (1445–50) when the chapel was being planned and constructed.[6] Here as in every chapel, the ogive arch carries a prominent inscription with Sigismondo's name.

2. *Chapel of the Sibyls.* These ten prophetic women form a bridge

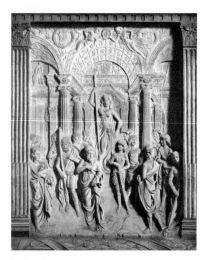

The Genius of Athens. Tempio Malatestiano.

from the pagan to the Christian world, for they were deemed to have prophesied the birth and passion of Christ. The chapel has been resplendently restored, highlighting the white stone with gold leaf and lapis blue. The tomb intended for Sigismondo has two relief panels that have puzzled interpreters, which Shapiro identifies as the Triumph of Rome and the Genius of Athens. There is also a large profile medallion of Sigismondo above his heraldic supporters, a magnificent pair of black basalt elephants.

3, 4. A pair of closed cells with decorated jambs show saints and Old Testament heroes. These constitute a statement, consistent with Neoplatonism and with the more recent opinion of Dante, that the ethical man of action deserves beatitude just as much as the contemplative man, the virtuous warrior as much as the monk. In Chapel 3 is a faded painting by Piero della Francesca showing Sigismondo kneeling before his patron saint. Chapel 4, appropriately, is now a war memorial.

5. *Chapel of the Musical Angels.* The relief panels show putti with musical and other attributes, illustrating the verses of Psalm 150, e.g., "Praise [God] with the sound of the trumpet; praise him with the psaltery and harp."

6. *Chapel of the Spiritelli.* More putti are playing games, celebrating make-believe triumphs and sea-journeys. They represent the three classes of airy souls named by Saint Augustine (*City of God* 7.6): Heroes, Lares, and Genii. Shapiro explains the dense symbolism of this chapel:

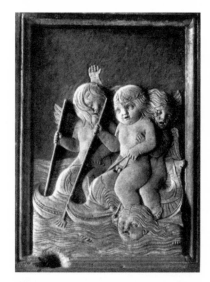

The putti are playing games, celebrating make-believe triumphs and sea-journeys. They represent the three classes of airy souls. Tempio Malatestiano.

> The program of the Chapel is a complex of seemingly contradictory elements. The theory of daimones and the theory of perturbations are interwoven with the more general idea of Manes to form a pagan treatise on the mind and the soul in life and death. At the same time, the order of the panels is such as to image a progress toward the Highest Good, an idea rooted in classical writings to be sure, but made popular by Christian thought. As we saw, it is really impossible to separate the symbolism of the Chapel from Christian ideas. On still another level, the program incorporates the inevitable reference to the Lord of Rimini, but in associating the whole scheme with his favorite virtue of fortitude and in naming as the proper goal of men's striving a characteristic ideal: the Hero.[7]

My remarks on the symbolism of sea-journeys in Chapter 1 may supplement this difficult quotation, which bears on the ascent and descent of the soul, the hindrances it has to overcome ("perturba-

Saturn-Chronos, devourer of his offspring. Tempio Malatestiano.

Rimini under the sign of Cancer becomes the seat of the Sun, assimilated to Delos, homeland of Apollo. Tempio Malatestiano.

tions"), and the beings who symbolize both the airy denizens and the hierarchy of souls themselves. If Porphyry is the source, says Shapiro, "then it can be demonstrated that the Chapels of the Planets and the Muses, instead of an overweening and pagan apotheosis, represent an allegory of the purified soul, attentive only to that which is beyond material nature, freed from birth and death, and lodged in the Platonic intelligible."[8]

7. *Chapel of the Planets.* This is also the Chapel of Saint Francis, whose Order was attracted to mysticism and to light. It combines three programs: a cosmological series of planets and signs of the zodiac, a Christian moralizing program, and Porphyry's allegory of the descent of souls. Allusions to Homer appear in the baskets (Homer's tubs of honey, here turned to plaited beehives), fruit wreaths, the tall poles of stone (looms), pierced red and white marble balustrades (webs of flesh), putti and seraphs (souls), olive wreath (Homer's olive tree), and Cancer (door of mortals).[9] The planets appear appropriately here because it is their position at birth that imprints the entering soul with its natal horoscope. Conversely—since Porphyry envisages a two-way traffic through the cave—the planetary spheres are the next stages, after the spheres of air and fire, through which the ascending soul passes on its way to God.

Here I will add a corroborating passage from another knowing interpreter of the Tempio, Gioia Mori, who writes of the depiction of Cancer as a great crab hovering in the sky above the city of Rimini:

> Cities, too, according to ancient astrology, are under the influence of a contellation, and Rimini is under the sign of Scorpio. Here, instead, it is shown under the sign of Sigismondo, born 19 June 1419, the day of the summer solstice, under the sign of Cancer, considered "Gate of the Sun," the moment of the descent of man onto the earth according to Macrobius's *Commentary on the Dream of Scipio.* The figuration of Rimini under the sign of Cancer is thus an image of the descent-theophany of Pandolfo-Sun from heaven to earth to govern the city of Rimini, which becomes the seat of the Sun, assimilated to Delos, homeland of Apollo.[10]

8. *Chapel of the Muses.* Like the Chapel of the Planets opposite, this stands for Homer's cave, only now it is the door of the gods (Capricorn). The eighteen relief figures are the Nine Muses, symbols of beatified souls;[11] the Seven Liberal Arts, standing for the divinization of the soul through the love of learning which leads to true wisdom; Proserpine, harvester of souls; and Apollo, hy-

Proserpine, harvester of souls. Tempio Malatestiano.

Sigismondo exhumed Plethon's bones and brought them home to rest among his court humanists. Tempio Malatestiano.

postasis of the Sun.[12]

Shapiro introduced his work with the caveat: "No one who has not actually worked in the field of Renaissance iconology can imagine the Infant Mortality Rate of hypotheses—even of plausible ones." Yet if a certain key, when applied to a work of art, opens up a self-contained system of references, in which even insignificant details take on meaning, it may be worth trying. The designer of the Tempio Malatestiano had obviously drawn on commonplace sources such as Saint Augustine and Boccaccio, but until Porphyry was called to witness, the iconology as a whole did not make much sense.

Shapiro does not mention that there is another pair of chapels before the sanctuary is reached, which were not decorated, presumably because funds ran out at that point. They must have been included in the intended program, and one wonders what images were to appear in them. Perhaps they would have included the Nine Orders of Angels, for that is what follows in the hierarchy of being, and maybe Christian saints as well. Then the sanctuary itself, beneath the dome, would have stood for the mystery of the Godhead.

If one can accept the Neoplatonic interpretation, then Sigismondo's temple is the supreme monument to an early enthusiasm for the Neoplatonists, fully two decades before Marsilio Ficino (1433–99) started to translate them into Latin. The question remains of whether a work of the 1440s could possibly have been inspired by Porphyry's Greek original, rather than by Macrobius's Latin digest.[13] In favor of access to an original source is Sigismondo's philo-Hellenism, and his remarkable devotion to George Gemistos Plethon, whom we met in Chapter 1. Sigismondo invited Plethon to settle permanently in Italy, offering him a home in the court at Rimini, but the old philosopher declined and returned to Greece. However, that was not the end of the affair. In 1464 Sigismondo was in Greece, on a military campaign against the Turkish invaders. He made a detour to Mistra, exhumed Plethon's bones, and brought them home to rest among his court humanists in a niche on the south side of his temple.[14] There one can read the following inscription:

Sigismondo Pandolfo Malatesta, during the Peloponnesian War against the King of the Turks, on account of his immense love of learned men, caused to be brought and placed herein the remains of Gemistos of Byzantium, in his time the Prince of Philosophers. 1465.

The meaning that Maurice Shapiro has teased out of the images

of the Tempio Malatestiano would have been impenetrable to all but a handful of learned admirers. This is no argument against it, any more than to the acknowledged presence of Porphyrian references in Renaissance gardens.[15] A Renaissance prince had no interest in educating the public on topics that were far too deep for them, and too dangerous to commonplace Christian faith. It is not as though he could be buttonholed by journalists, insisting to know what he meant by this or that. Anyone could see that the figures were mostly "angels," and some could recognize the planets, which are an innocuous part of the Christian cosmography. Besides, were not the Gothic cathedrals also repositories of alchemical and esoteric lore?

My second example of a determined effort to map out the hierarchy of being is the set of fifty engravings known as the *Tarocchi of Mantegna* and dated to the 1460s. This is neither a Tarot, nor drawn by Andrea Mantegna, but that is the name it goes by. Whereas the well-known Tarot cards, probably invented in north Italy early in the fifteenth century,[16] are a pack of fifty-six playing-cards (in four suits of fourteen each), plus twenty-two trumps with symbolic pictures, the *Tarocchi of Mantegna* are all "trumps," as it were. They combine the medieval idea of a "great chain of being" with the classical personifications of the arts, sciences, and heavenly bodies. The fifty cards are arranged in five suits of ten cards each, lettered in one engraved set A, B, C, D, E, and in another A, B, C, D, S (hence the names given to the two sets: the original "E series" and the derivative "S series").[17] Here are their titles, in the original spelling that betrays a northeastern Italian dialect, and arranged in descending order:

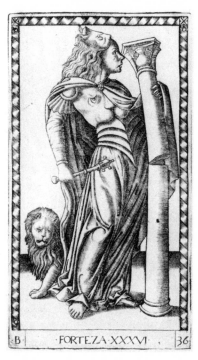

Fortitude makes a stab at military style, with a lion motif on her head and breast. Tarocchi of Mantegna.

A. *The Spheres*
XXXXX Prima Causa [First Cause]
XXXXVIIII Primum Mobile [First Mover]
XXXXVIII Octava Spera [Eighth Sphere]
XXXXVII Saturno
XXXXVI Iupiter
XXXXV Marte
XXXXIIII Sol
XXXXIII Venus
XXXXII Mercurio
XXXXI Luna

B. *The Virtues*
XXXX Fede [Faith]
XXXVIIII Speranza [Hope]

The Muses were equated to the spirits or intelligences that govern the planetary spheres. Tarocchi of Mantegna.

XXXVIII Charita [Charity]
XXXVII Iusticia [Justice]
XXXVI Forteza [Fortitude]
XXXV Prudencia [Prudence]
XXXIIII Temperancia [Temperance]
XXXIII Cosmico [Cosmos]
XXXII Chronico [Time]
XXXI Iliaco [Sun]

C. *The Liberal Arts*
XXX Theologia
XXVIIII Astrologia
XXVIII Philosofia
XXVII Poesia
XXVI Musicha
XXV Aritmetricha
XXIIII Geometria
XXIII Rhetorica
XXII Lo[g]ica
XXI Grammatica

D. *The Muses*
XX Apollo
XVIIII Clio
XVIII Euterpe
XVII Melpomene
XVI Talia
XV Polimnia
XIIII Erato
XIII Terpsicore
XII Urania
XI Caliope

E. or S. *The Human Conditions*
X Papa [Pope]
VIIII Imperator [Emperor]
VIII Re [King]
VII Doxe [Doge]
VI Chavalier [Knight]
V Zintilomo [Gentleman]
IIII Merchadante [Merchant]
III Artixan [Artisan]
II Fameio [Laborer]
I Misero [Pauper]

She sits piping by a fountain that is surely the Castalian Spring, pouring out the waters of inspiration. Tarocchi of Mantegna.

The consecutive numbering shows that the fifty entities are conceived as a hierarchy, from God down to the most miserable of mortals, but the categories of the suits complicate the matter. The lowest suit of Human Conditions is ordered clearly enough, and so is the highest suit, which rises up the sequence of planetary spheres to culminate in the First Cause, which is to all intents and purposes God. But what is hierarchical about the suits of Muses, Liberal Arts, and Virtues, which fill the numbers between earthly mankind and the sphere of the moon? The answer seems to lie again in the ascent of the soul. Given this, the three decades from 11 to 40 fall into place as the necessary preparation. They represent things that the soul must acquire or master before it is fit to start on the heavenly ladder.

First come the nine Muses, with their leader Apollo. Although each one traditionally rules one of the arts or sciences, this is not shown here. Urania, the Muse of Astronomy, does hold a compass, but all the rest have musical instruments except Clio, Muse of History, who is shown riding on a swan. The artist has equipped all but Thalia with spheres, which seems to derive from the favorite source of medieval Muse-lore, Martianus Capella's *Marriage of Philology with Mercury*. There they were equated to the spirits or intelligences that govern the planetary spheres, and the earth. (In the Tarocchi, Thalia, being assigned to earth, sits sphereless on the ground.) However, the Tarocchi is going to show the planetary spheres much later in the sequence (nos. 41–47), whereas the Muses are placed beneath even the Liberal Arts. Perhaps these musical ladies are not studying, but merely playing. They inspire the arts of recreation and entertainment, such as lyric and epic poetry, dance, and the various types of music. In the gardens of the following century, Muses would often be equated to nymphs,[18] and that is what they look like here, playing out of doors with their plain Grecian garments and their flowing hair. The engraver has done his best to make them attractive.

The third suit is the Liberal Arts, also based on personifications in Martianus Capella. The Seven Liberal Arts of medieval education comprised the Trivium of three verbal arts, and the Quadrivium of four mathematical ones. Since the suits of the Tarocchi go in tens, the designer has added three more: Poetry, Philosophy, and Theology, which was known as the "queen of the arts." The allegorical figures are either stern, elderly women, or nymphs who seem to be sisters to the Muses. Poetry, who might have come in either category, sits piping by a fountain that is surely the Castalian Spring, pouring out the waters of inspiration. If we pursue the idea of the soul's development, then these Arts would be appropriate for the second stage, representing intellectual work.

Chronico holds the Oroboros serpent which signifies the cycles of unending Time. Tarocchi of Mantegna.

The next suit, mainly devoted to the Virtues, begins with the anomalous trio of Iliaco, Chronico, and Cosmico. They are the only males among the allegorical figures: winged young men in short tunics, standing against a background of trees. Iliaco (from Greek *helios*, sun) might be the spirit of the sun, but the sphere of the sun itself comes again at no. 44. Jean Seznec calls him the Genius of Light.[19] Chronico holds the Ouroboros serpent which signifies the cycles of unending Time. Cosmico holds a sphere divided into heaven and earth: he is the complementary symbol of Space. They seem to belong much higher up, and perhaps they are only included here among the virtues to make up a suit of ten. The Virtues themselves are the third and highest field of the soul's activity. They are the traditional seven—four Cardinal and three Theological—and their personifications are suitably earnest. In place of the sleeveless, bunched-up dresses of the lower ranks, these wear tight sleeves and heavily draped togas, or else long gowns beneath cloaks: costumes that would serve equally well for Apostles or Prophets. Fortitude makes a stab at military style, with a lion motif on her head and breast. Prudence has the face of an old man at the back of her head, to signify experience, and the attributes of a mirror (to know herself, or to divine the future) and a wise "serpent."

When the soul possesses all the virtues, it is ready to break free of earth and start its ascent through the spheres of the seven heavens. The Hermetic treatise *Poimandres* describes how after death the soul passes, if it can, through each planetary sphere until its journey culminates in the Eighth Sphere (that of the fixed stars), where it joins the company of the elect. This concept, deriving from Egyptian esotericism, had recently reached Europe through the *Corpus Hermeticum*, translated into Latin by Marsilio Ficino in 1463. A Christian version of it was already well known, and given its classic form by Dante. But the planetary heavens of the *Paradiso* are not places of purgation, but residences of souls who are already elected to Paradise. The difference is extremely significant. In Christian doctrine, the soul gets one chance to be saved or damned for all eternity. Its only place of progress is on earth, which in the *Divine Comedy* included the Mountain of Purgatory in the unexplored southern hemisphere. Therefore the planets are not needed as a field for the soul to progress and be tested: true to the Aristotelian dogma of their quintessential perfection, they are already part of Paradise. In Hermetic doctrine, on the other hand, if the soul cannot pass the tests of the seven planets and attain the Eighth Sphere, it falls back into generation: hell on earth, maybe, but only a temporary one. We have already heard from Porphyry of the comings and goings of souls, the vast majority of which must

He is based partly on the medieval tradition, but also on a drawing of a classical Mercury made in Greece. Tarocchi of Mantegna.

be assumed not to have made the grade.

The personifications of the Planets in the Tarocchi are mostly not drawn from Greco-Roman models, but from a hotch-potch work of circa 1400, *Libellus de imaginibus deorum*. Jean Seznec, in his wonderful study *The Survival of the Pagan Gods*, has traced the influence of this and other medieval manuals, and the process by which their overloaded attributes were gradually purged from Renaissance iconography. He shows, for example, how the Mercury of the Tarocchi is based partly on the medieval tradition, but also on a drawing of a classical Mercury made in Greece by Cyriacus of Ancona.[20] Jupiter has his eagle, an arrow to serve as thunderbolt, and his favorite Ganymede, but he sits in a mandorla with his feet on a rainbow, just as Christ or Mary appear in Gothic cathedrals.

Beyond the sphere of Saturn comes the Eighth Sphere, which in the Ptolemaic cosmos carries all the fixed stars, including the zodiacal belt. With this and the following figure of the Primum Mobile, the Tarocchi engraver transcends his own limitations and rises to another artistic level, marked by a perfect filling of the picture-space and by unpredictable but expressive details, such as the little finger and raised foot of Primum Mobile, the crossed wings of Octava Spera (recalling the X of the *Timaeus*[21]). Finally, to depict Prima Causa he abandons the human figure altogether and draws a cosmological diagram, enabling one to review the entire scheme.

The images of the Tarocchi are satisfying to contemplate, though their inconsistent quality bespeaks several different artists and engravers. There is a kinship with the relief panels of the Tempio Malatestiano: both contain sets of single, full-length figures in elegant drapery, free from the excess of attributes that had cluttered earlier representations of classical beings, and many of the allegories are the same.

Were the Tarocchi also used as a game? There is an intriguing theory that they were invented by Pope Pius II and Nicholas of Cusa, already mentioned as the twin nemeses of Sigismondo Malatesta. Together with their Greek colleague Cardinal Bessarion, they used them to pass the time while they were waiting for the members of a church conclave to arrive. This was in Mantua, from June 1459 to July 1460.[22] Symbolic games were popular in this era. Claudia Cieri Via, in her preface to a facsimile edition, mentions a "Game of the Apostles and Our Lord," a "Game of the Seven Virtues," a "Game of Planets," and a "Game of the Triumphs of Petrarch."[23] Moreover, Nicholas of Cusa invented around this time a "Game of Globes" consisting of a large board picturing the sun in the center of ten concentric circles.[24] The game is played by throwing onto the board a hollowed-out ball which rolls in a spiral, hoping that it will come to rest in the center. Cusanus wrote a long

With the final plates, the engraver transcends his own limitations and rises to another artistic level. Tarocchi of Mantegna.

treatise about his game, but omitted to include the exact rules or the meanings of the ten circles, except that they were a "figure of the universe." Be that as it may, the Tarocchi would lend themselves to various learned and improving games, and especially (as Westfehling suggests[25]) to a sort of patience or solitaire, in which one tries to restore a shuffled pack to its correct order.

The questions of attribution that concern art historians are not of much interest in the present work, but it is worth hearing two experts on the subject for the sake of their asides. Giannino Giovannoni argues for the traditionally magical city of Mantua as the home of the Tarocchi, and for Mantegna himself as the original designer of a prototype pack, done at the time of the conclave (1459–60). This was probably a more complete series than the printed one, rich in iconography and sustained by a rigorous ideological and philosophical scheme.[26] According to Giovannoni, Mantegna returned to his old designs when planning his own funerary chapel in San Andrea, Mantua, for there, in the vault (painted by his pupils, 1506–7), are figures of Virtues and Muses that correspond closely to the Tarocchi in motifs and attributes. This scholar also interprets the chapel figures in the context of the journey and fate of the soul after death, as taught by Hermetic and Neoplatonic philosophy.

Elena Calandra, on the other hand, argues that everything about the Tarocchi engravings speaks of Ferrara. She finds their essential model in the illuminated Bible (1455–61) of Borso d'Este; she sees in them the mood of Ercole de Roberti and Cosimo Tura, with their mystical anxiety, their "cold epidermis, but inner dynamism"; their broad brows, thick curled hair, long clothes with quivering draperies. She calls them "almost lunar creatures," framed by archeological references and perhaps under the influence of the Jewish kabbalistic culture that was strong in mid-century Ferrara.[27]

There may be another clue here. In Cusanus's treatise on the Game of Globes, he develops a system of linked groups of nine globes plus one, in evident relationship with the ten Sephiroth of the Kabbalah. The four higher suits of the Tarocchi could be related to the Kabbalistic Four Worlds, each of them containing ten Sephiroth. The total of fifty cards (7 x 7 + 1) is the number of "Jubilee," the state of union with God that is reflected in the fifty-year cycle of Jewish social life (forgiving all debts in the fiftieth year), as well as in the ascent up the great chain of being to the First Cause. I leave it to others to press these parallels further, in the hope of cracking the code of the Tarocchi—if there is such a code. But they should be wary of inflating a pet theory to cosmic dimensions, forcing the facts to cohabit in a Procrustean bed. That is the occupational hazard of esoteric studies, to which the academic method,

for all its own hazards, provides a counterbalance.

Returning for a moment to the Tarocchi, it is significant that the lowest suit of cards also depicts the stations of human life, into which God, Fate, or the goddess Fortuna consigns every man or woman. Nicholas of Cusa, in his treatise on the Game of Globes, says that Fortuna is a "natural necessity," and none other than *anima mundi*, the Soul of the World. As that great soul includes our individual souls, so it restricts our absolute freedom, but we cannot blame our adversity either on it, says Cusanus, nor on our stars. In the language of the game, we each throw our own ball onto the board and are responsible for where it ends up.[28]

Humanists such as Cusanus and Ficino readily took up the challenge of reconciling Neoplatonism and Hermetism with their philosophical Christianity. Both of these ancient schools were ascetic by inclination, spurning the body and its *eros* in favor of the contemplative life and the spiritual ascent. But just as in Christendom there has been perpetual tension between the world-rejecting teachings of its founder and the natural human drives for self-assertion, sensuality, and power, so this new influx from the pagan world fostered both tendencies. On the one hand there was the learned iconology, the systematic and hierarchical conception, the moral and spiritual lessons to be extracted and meditated upon. Medieval encyclopedism and the *Ovid moralisé* provided a basis of long practice for this approach, which was typically that of the scholar and professional cleric. On the other hand there was the new language of sculpture and painting, tangible and erotic as never before, through which the pagan divinities took on a presence and a direct relationship with the viewer. They breathed the unfamiliar air of a time when the earth was not merely the bottom rung of the ladder of being, but a place where the gods walked and made love to humans; a time before Plato and the oriental theologies muddied the waters with their contempt for earthly things, their *soma-sema* [body=tomb] doctrine. This tendency had a natural appeal to the aristocratic and warrior caste, which did not want to be told that it was sinful and in need of priestly mediation, nor that it should give all it had to the poor and take the lowest place at table. As this study proceeds, we too will vacillate between the two tendencies, the spiritual and the sensuous, for only thus can we grasp the richness of the movement I am attempting to chronicle.

The third example is not a hierarchical but a historical re-ordering of the known world: the *Florentine Picture Chronicle*, which is a book of drawings by an unknown artist of the 1460s, now in the British Museum. The artist was formerly thought to be Maso Finiguerra,[29] but is more likely to have been Maso's follower Baccio Baldini (d.

1487), a Florentine engraver known for his cycles of *Sibyls, Prophets,* and *Children of the Planets*.[30] Whoever the "FPC artist" was, he shows all the signs of a goldsmith's or metal-worker's training, strong in repetitive and decorative detail but tending, as Jay Levenson writes, to "flat, weak composition, overwhelmed by ornament."[31] Even if the work does not meet aesthetic standards derived, with the benefit of hindsight, from the masters of the High Renaissance, the FPC drawings, like the Tarocchi engravings, have a charm of their own.

The Picture Chronicle, as its name conveys, has no text, except for the identification of the figures by name. The haywire spelling and signs of Florentine dialect (especially the use of H for C) betray the fact that the artist was, to put it kindly, no scholar. Nobody knows what motivated him to fill these hundred or so pages with intricate drawings. It seems too early for them to have been commissioned as models for an illustrated printed book, like the *Nuremberg Chronicle* of 1493. Most likely the FPC artist worked for his own pleasure, developing an idiosyncratic and hybrid style in dedicated isolation, as we may imagine Francesco Colonna writing the *Hypnerotomachia*. The last drawing is incomplete, but what interrupted the project, no one can say.

The work as it stands speaks eloquently enough. Evidently the FPC artist's ambition was to depict all the most important characters, episodes, and cities of history. He must have had as guide one or more of the innumerable medieval attempts to make the Old Testament account square with pagan histories and mythologies.[32] Here is a list of the FPC subjects, with the non-biblical ones distinguished by bold type:

First Age
Adam and Eve—Cain and Abel—Adah, Seth—Methusaleh, Jubal—Lamech, Enoch, Tubal Cain

Second Age
Noah—Noah's Ark—Shem, Ham, Japhet—Heber, Nimrod—Tower of Babel—Ragau, Saruch—Semiramis and the city of Babylon—City of Nineveh

Third Age
Abraham and Isaac—Jacob and Esau—**Zoroaster**—**Inachus, Prometheus**—Pharaoh—Triumph of Joseph—**Cecrops and the city of Athens**—Moses—Job—Aaron—Caleb—Joshua and the city of Jericho—**Orpheus**—**Saturn and the city of Sutri**—**Jupiter and the Isle of Crete**—**The Persian Sibyl**—**The City of Troy**—**The Libyan Sibyl** and Gideon—**Hercules and Antaeus**—**The Delphian Sibyl**

and the Temple of Peace—Theseus and the Amazon—The Erythraean Sibyl—Death of Hercules—Jephthah sacrificing his daughter—King Midas—Temple of Themis—Pyrrha and Deucalion—Theseus and Ariadne—Minos—Oromasdes raising the dead—Hostanes evoking demons—Mercurius King of Egypt—Linus and Musaeus—Apollo Medicus—Aesculapius and Machaon—Agamemnon and Menelaus—Priam and Hecuba—Paris and Helen—Jason and Medea—Andromache and her children—Ulysses and Diomedes—Pyrrhus slaying Polyxena—Pluto and Proserpine—Samuel, Aegisthus—Death of Absalom—Death of Dido—Temple of Solomon—Solomon and the Queen of Sheba—Samuel, Elisha—Two Sibyls—Jonah and the Whale—Nebuchadnezzar and the three Children—Samson—Aeneas—The Cumaean Sibyl—David and Goliath—Codrus, King of Athens—Daniel with Susannah and the Elders—Death of Aeschylus—Palamedes, Talthybius—Paris, Troilus—Cassandra, Penthesilea—Aeneas, Turnus, Latinus—Romulus and Remus—Virgil, Aristotle—Amos, Hosea—Julius Caesar and the city of Florence—Sardanapalus—Numa Pompilius, Isaiah—Cyrus slaying the son

He is a very fashion-plate, with his elegant contrapposto stance and his bouffant hairstyle. Jason and Medea, from the Florentine Picture Chronicle.

of Tomyris—Tomyris with the head of Cyrus—Death of Milo.

The potential scope of the work can be judged by the fact that there were three more ages of the world after these, according to the authority of Isidore of Seville (early seventh century): the Fourth Age, from David to the Babylonian Captivity; the Fifth, from the Captivity to the Birth of Christ; and the Sixth, from the Birth of Christ onwards.[33] If he intended to cover them all, the FPC artist had bitten off much more than he could chew! He started out by giving his characters dates, calculated from the Creation, but by the end he had lost all control of their chronology, even by the standards of popular histories. Two details deserve mention before we turn to the pictures themselves. First, the surprising inclusion of the gods Saturn, Jupiter, and Pluto is due to the euhemeristic principle of mythology that was generally accepted in the middle ages: the Greco-Roman gods were believed to have been ancient kings and heroes who had become deified. Secondly, we again meet the Sibyls, as in the Tempio Malatestiano. Known to the Romans as legendary prophetic women, they had been endowed with a large literature of forged prophecies, to the advantage first of Judaism, then of Christianity. At first they were ten in number, then two more were added to match other twelvefold sets (prophets, apostles, etc.) One of them, the Tiburtine Sibyl, will reappear in Chapter 8 as the patroness of the Villa d'Este.

So far there is nothing original about the re-ordering of Hebrew and pagan histories in the Picture Chronicle. What is original is the quality of imagination that the FPC artist has contributed to his task. Consider first his drawing of Jason and Medea. Jason is in the kind of outfit that might have graced Marrasio's pageant of 1434 (see Chapter 1). The pattern of leaves covering his thighs and the monsters' heads at his knees are pure goldsmithery. It is unclear whether his belly is bare, or whether his costume includes the lower half of a Roman "anatomical cuirass." In either case, he is a very fashion-plate, with his elegant *contrapposto* stance and his bouffant hairstyle. Medea is equally seductive. Instead of the Burgundian horned headdress ludicrously worn by some of the FPC artist's women, she clips a pair of wings to her topknot and lets her hair fly freely down, upwards, and behind. If Jason's stance suggests the *David* of Verocchio grown ten years older, then Medea comes straight from Botticelli—or, to be precise, from those Roman sarcophagi which gave inspiration to all of these artists.

The FPC artist never tired of inventing costumes for his characters, especially helmets and headdresses which would do credit to any parade. Very likely costume design was part of his job, as it was of greater artists than he. The drawing of the Trojan prophet-

An example of theatrical over-statement typical of this milieu. Cassandra, from the Florentine Picture Chronicle.

A display of miniature bodies that spring from the rocks. Deucalion and Pyrrha, from the Florentine Picture Chronicle.

ess Cassandra and the warrior-queen Penthesilea is an example of theatrical over-statement typical of this milieu. The fifteenth-century public had no better idea of ancient chronology, or of the history of costume, than the general public today: antique was antique, and that was that. If they knew the stories of the Trojan War, it was more likely to have been from the medieval romances than from the *Aeneid*, much less the *Iliad*—just as today's public gleans its mythology from films. Our artist was no more learned, but had to bring the characters to life on the basis of whatever scraps of information he had. And bring them to life he did. Surely he knew that he was overdoing things (and sometimes there is humor and irony in his work), but this was part of the point: Jason, Cassandra, and the rest were of heroic stature, and deserved to be costumed accordingly. Thus their world, which was the imagined world of classical antiquity, took on the glamor of the theater.

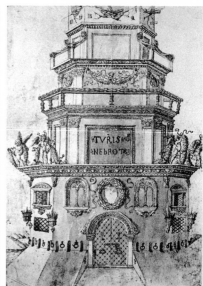

Without exception, these are centrally-planned buildings, a phenomenon already noted in the *Hypnerotomachia*. Aaron, Temple of Solomon, and Tower of Babel, from the Florentine Picture Chronicle.

The FPC artist was under more restrictions when he came to depict the Old Testament characters. Up to Tubal Cain, who concludes the First Age, their only clothing is animal pelts. From Noah onwards, the Patriarchs wear the traditional long robes and beards, but the young men are in something approaching current Florentine style, with smocks or tunics and floppy boots. The warriors and secular kings, beginning with Nimrod, immediately don "classical" armor, i.e. the parade costumes inspired by Roman models. Thus "antiquity," no matter of what nation or period, is identified by the artist's fantasy of classical style.

It is also identified by the nude. The FPC artist attempts this on several occasions, beginning with a very creditable Adam and Eve. He knew some of Antonio Pollaiuolo's work, and copied it in his drawing of Hercules lifting Antaeus from the ground: a theme that would have a long and profitable career, especially in sculpture. But when he lacked a model he became quite careless, as in the display of miniature bodies that spring from the rocks thrown by Deucalion and Pyrrha. The amateurishness of these shows that he was not at home in the genre, although game to try it.

The exuberance of the FPC artist's costume is paralleled in architecture, which is the other field in which he exercises his fertile imagination. When he tries to depict cities, he produces a worse jumble than his medieval predecessors; it looks as though he has never studied perspective. But he operates differently when concentrating on a single building, such as the Tower of Babel, Aaron's Tabernacle, the Temple of Peace, the Temple of Themis, the Temple of Solomon, and the Temple of Venus in which Priam primly abducts a hennin-crowned Helen. Without exception, these are cen-

trally-planned buildings, a phenomenon already noted in the buildings described and illustrated in the *Hypnerotomachia* (see Chapter 2). Just as the anatomical cuirass and the Roman helmet, however exaggerated, could not be mistaken for medieval armor, central symmetry carried a message of difference from the Gothic norm of axial symmetry, and a consequent aura of antiquity. The moldings and decorations on the buildings carried the same message, though here the FPC artist was on the borderline between late Gothic ornamentation in his curling leaf-forms and the formal and symbolic language of classicism: round arches, Corinthian capitals, entablatures with egg-and-dart and dentil moldings, consoles and scrolls, putti, swags and garlands, urns, balusters, and dolphins. A good sampling of these features graces the Tower of Babel, whose lower story is clearly the work of Florentine palazzo architects, circa 1440.

Since such anachronisms did not trouble either the artist or his audience, we are in the presence of a deliberate re-creation of the past in the image of Greco-Roman antiquity. The intellectual conception of history is one thing: that depends on one's level of knowledge and sophistication. The imagining of history is another. The story told by the FPC artist is as plain as a comic book. First there was the primitive, antediluvian age, when people dressed in skins. After the Flood came Antiquity, which set a fashion in architecture and costume that lasted unchanged from Nimrod to the Caesars. More learned and sophisticated artists like Mantegna would soon correct this naive and misleading view of ancient Rome, to say nothing of ancient Israel, Egypt, or Babylon; but even so, the Renaissance view of history remained mythic.

Like a barometer, the FPC artist was sensitive to changes in the air of Florence. He was drawing his chronicle at the same time as Ficino was translating first Mercurius (=Hermes) Trismegistus, then Plato, and cultivating in the refined atmosphere of the Platonic Academy a reverence for the *prisca theologia*. Our artist seems to have caught the notion of the "ancient theologians," for he includes several of those who figure on Ficino's list:—Zoroaster, Hermes, Musaeus and his pupil Orpheus—as well as several who do not: Oromasdes (the Persian god Ahura Mazda), the Persian magus Ostanes, and the Greek Apollo in his function as god of medicine. Oromasdes is shown raising a woman from a tomb, Orpheus charming the animals with his music, and Musaeus also as a musician. Thrice-Great Hermes, in one of the most widely-reproduced of the FPC artist's drawings, seems to be showing to an astonished Hercules one of his homunculi or animated statues, as mentioned in the *Asclepius*. Zoroaster, Ostanes, and Apollo are all accompanied by demons, who hand them books or advise them in their magical work. Apollo, who is euhemerized as a physician with

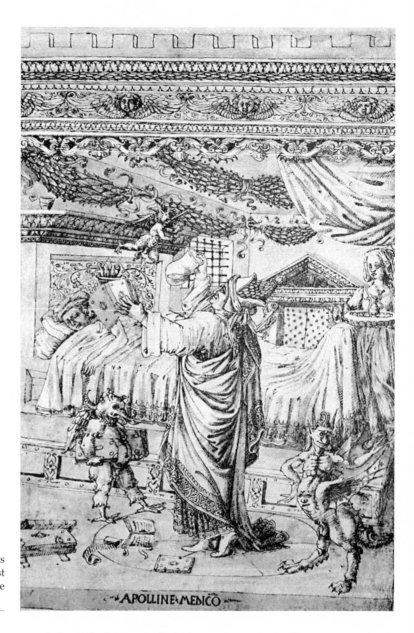

The sickroom is a riot of garlanded swags and cornices, in the very latest—or most antique—style. Apollo Medicus, from the Florentine Picture Chronicle.

occult knowledge, stands in a magic circle by his patient's bedside, grimoire in one hand, and in the other a urinal, the traditional tool of diagnosis. Two small, domestic-looking demons strut at his feet. The artist has obviously enjoyed drawing all this, but his real enthusiasm has gone into the interior décor of the sickroom: it is a riot of garlanded swags and cornices, in the very latest—or the most antique—style.

The FPC artist's presentation of these ancient magi was on the borderline between the medieval condemnation of all pagan rites as satanic, and the revisionist view of the Renaissance, which al-

The sole remnant of room after room of glorious frescoes, totally secular in their iconography. Hall of the Months, Palazzo Schifanoia, Ferrara.

lowed that the Gentiles too had received divine revelation. His conception was not intellectualized, for as indicated he was barely literate; but that makes his Chronicle all the more valuable as a sign of his times and of the assumptions that were, as I said, in the air.

For our final example, we move to the court of Ferrara under Borso d'Este (reg. 1450–71). This was the scene of another early integration of the ancient gods into a cosmographical scheme, in the Hall of the Months in Palazzo Schifanoia (circa 1470). At some point the paintings were plastered over, and when they were uncovered in the 1820s only half of them survived. What remains is a sample of room upon room of glorious frescoes, totally secular in their iconography,[34] that the Este marquesses and dukes commissioned from their talented stable of painters. Probably Francesco Cossa, Ercole de Roberti, Cosimo Tura, and their assistants were all involved in the Schifanoia project.

The hall is decorated with a scheme based on the twelve signs

Here we seem to see the demure ladies of the Tarocchi in full color, and in action. Hall of the Months.

of the zodiac, as rulers of the twelve months of the year. In the top row is a cycle of triumphs, in which the divinity of each month rides on a carriage or float. In traditional astrology there are only seven planets ruling twelve signs (Mars—Aries and Scorpio; Venus—Taurus and Libra; Mercury—Gemini and Virgo; Moon—Cancer; Sun—Leo; Jupiter—Sagittarius and Pisces; Saturn—Capricorn and Aquarius). The designer of the Schifanoia program chose instead to picture the lesser-known rulerships given by the Roman astrologer Manilius, and favored by the Neoplatonic philosophers. These Olympians coincide partly but not wholly with the planets, thus: Minerva—Aries; Venus—Taurus; Apollo—Gemini; Mercury—Cancer; Jupiter—Leo; Ceres—Virgo; Vulcan—Libra; Mars—Scorpio; Diana—Sagittarius; Vesta—Capricorn; Juno—Aquarius; Neptune—Pisces.[35]

In the upper row of the Schifanoia frescoes, the triumphs of these divinities are accompanied by people in contemporary dress, engaged in activities suitable to each divinity. Here we seem to see the demure ladies of the Tarocchi in full color, and in action. In the middle row are the symbols of the zodiac, and the "decans," mnemonic figures based on the other constellations visible during the various seasons of the year.[36] In the bottom row, nearest the viewer, are genre scenes of peasants (like the medieval theme of the Labors of the Months) and of the court. Borso himself figures prominently in these, smiling but dignified among his chosen entourage of chaste young men.

The Schifanoia hall, whose Triumph of Venus, especially, has survived to the admiration of many a viewer, illustrates the Hermetic axiom "As above, so below." But it does so in an unusual way, that requires some explanation of the astronomy and astrology behind it. Astronomically speaking, the journey of the earth around the sun makes the latter appear to travel in a circle, once a year, against a revolving background of fixed stars. These stars are conventionally grouped into a zodiac (or "zoo") of twelve animal constellations. Astrologically speaking, as the sun stays for a month in each constellation, his rays are affected by the qualities of that sign and have a corresponding effect on the earth. Thus the zodiac is hierarchically above the planets, and indeed its stars belong, in the Ptolemaic system, to the Eighth Sphere, which is the region of the Blest. In classical times, it was Sol himself who rode in a chariot drawn by four horses; each day he rose in the east and set in the west. Every year he made a circuit in the opposite direction, spending a month rising and setting in each of the twelve signs of the zodiac. In the Middle Ages (for instance, in Books of Hours), the other planets were likewise assigned chariots, for they, too, rise and set daily, and pass at various speeds through each zodiacal

constellation in turn, modifying their influences accordingly.

At Schifanoia the concept is quite different. First, it is not the seven planets who ride in their chariots, but the twelve gods and goddesses who, in the divine hierarchy as well as in the pictorial space, are superior to the signs of the zodiac. These are the supermundane divinities of Platonic and Neoplatonic theology. Socrates alludes to them and their chariots in Plato's *Phaedrus*:

> Jupiter, the mighty leader of the heavens, driving his winged chariot, begins the divine procession, adorning and disposing all things with providential care. The army of Gods and demons, distributed into eleven parts, follows his course; but Vesta alone remains in the habitation of the Gods. But each of the other Gods belonging to the twelve, presides over the office committed to his charge.[37]

Who, then, are the men, women, and children who surround the chariots of the twelve super-mundane gods? The *Phaedrus* has an answer: "And this is the law of Adrastia [Necessity], that whatever soul attending on divinity has beheld anything of reality shall be free from damage, till another period takes place: and that if she is always able to accomplish this, she shall be perpetually free from the incursions of evil."[38] In other words, the virtuous soul, having successfully passed the Eighth Sphere thanks to having "beheld reality," enjoys the particular bliss of its patron god or goddess, until another cosmic period comes around.

The Schifanoia scheme is completed by the scenes of daily life in the bottom register, subject indirectly to the divinities (or the Platonic Forms) and directly influenced by the stars. Peasants and courtiers live out the annual round, each in their appointed roles. Instead of a triumphing divinity, it is Borso d'Este who presides over these scenes set in his dominion. As a good ruler, he ensures that the earthly life of all his subjects is conducted in conformity with the heavenly order.

Aside from their Platonic and eschatological significance, the Schifanoia triumphs resembled real parades that were staged in Ferrara and many other Italian cities, like the one that Marrasio produced in 1434, and which I will say more about in Chapter 9. Painters, of course, have a licence that is denied to the stage-manager: they can show a heavy chariot drawn by two swans, or for that matter by dragons. But the essence of the matter lies in the threefold connection between heavenly archetypes, painting, and pageantry. Both of the latter were quasi-sacramental actions, in which the archetypes were brought down to the sensible world, represented by humans who dressed up as gods and goddesses for the benefit of the viewers.

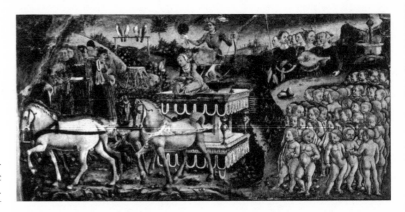

Virtuous souls enjoy the bliss of their patron god or goddess, until another cosmic period comes around. Hall of the Months.

Scattered in a wide circle around Ferrara, the Este family had no fewer than nineteen establishments, ranging from palaces to hunting-boxes. From all evidence, these were sumptuously decorated by the artists of the Ferrarese school, and apart from the chapels, their paintings showed either pagan mythologies or courtly pursuits—or both, as in the case of Schifanoia.[39] Belriguardo, the grandest of all the country houses, contained a Green Room, a Room of Diamonds, and a Room of the Sibyls painted in 1448 by Niccolò Parrigato, which showed each Sibyl with her prophetic message. The chapel was decorated by Tura, and there was also a secret garden whose walls were frescoed with scenes from the myth of Psyche. Werner Gundersheimer calls these "perhaps one of the most elaborate and detailed representations of a classical myth ever created in European art."[40] Another room at Belriguardo displayed the Triumphs of Hymenaeus (god of marriage) in an example of flagrantly erotic paganism.[41] The Schifanoia Months and the Muses that survive from the villa of Belfiore (see Chapter 5), precious as they are, are but a few fragments washed up from the wreck of a whole culture, which if it were still in place would cause Ferrara to rival Florence in our textbooks as the capital of the early Renaissance.

The Enchantment of Public Spaces

CHAPTER 4

AT FIRST GLANCE, the performances in various media staged by the Medici and other ruling houses may seem as mendacious as election promises, but there were several essential differences between their time and ours. There was still an acceptance of nonphysical realities and of the efficacy of sacraments, ritual, and magic as a bridge to these. There was no conception of democracy or of soliciting popular approval; the universe was seen as a hierarchy and society as reflecting it, and the duty of the populace was to admire and obey. There was a love of beauty, which did not need any defense or debate, and a willingness to spend lavishly on it.

Of all the works commissioned from artists, the decorations of palaces were paramount in representing a ruler to his subjects, his foreign visitors, and, if he was lucky enough to welcome them there, his superiors. None but a few tedious friars deplored extravagance and display; people talked openly about how much everything cost, without betraying themselves, as in today's society, as ill-bred or nouveaux riches. These considerations should be kept in mind as we approach the ambitious decorative programs with which Renaissance princes—including those of the Church—adorned their buildings and enhanced their self-image.

The previous chapter has given examples of the kind of thinking that went into these decorative schemes. It preferred to order things in sets or cycles, sets being linear and hierarchical like the planets, and cycles being circular and repetitive like the zodiac. They could be either of people or of things, but in the latter case, the things were personified. In Chapter 3 we met the Thirty Decans, the Twelve Signs of the Zodiac, the Twelve Olympian Gods, the Twelve Months, the Ten Sibyls, the Nine Muses, the Seven Planets, the Seven Virtues, the Seven Liberal Arts, and a large selection of Great Men (and Women). Most of these had their origin in the classical world, though they did not immediately reassume their classical aspect and attire.

Decorative schemes based on cosmic sets and cycles are appropriate for buildings, because architecture is midway between the microcosm of the human being and the macrocosm of the natural universe. A building is a sort of mesocosm, enclosing the human

The administration of justice and public affairs went on under these great reminders of the divine and cosmic order. Wall-paintings in the Salone della Ragione, Padua.

body but enclosed in its turn. That is why so many architects allude with domes and apses to the hemispherical vault of the heavens, and also why buildings tend to incorporate cosmic measures and proportions. To decorate a building with a meaningful set of images is to acknowledge the presence of meaning in the universe, while modern architecture illustrates the contrary position.

Obviously this did not begin with the Renaissance of the fifteenth century. Beside church imagery, which is too obvious for discussion, there was already a tradition of decorating public places with the kind of motifs I have mentioned. One monumental example is the Palazzo della Ragione or "Salone" in Padua, one of the largest enclosed spaces in Italy (78 x 27 x 27 m.). It was decorated by Giotto in the early fourteenth century, and mostly repainted with reproductions soon after a fire in 1420 had damaged the originals. The program of 333 compartments shows the Decans, the Paranatellonta (extra-zodiacal constellations), the Signs of the Zodiac, the Twelve Apostles, the Activities or Labors of the Months, the Planetary Rulerships of the zodiac (some of the seven planets occuring twice, because they rule two signs), the Virtues, the Liberal Arts, the Mechanical Arts, the Virgin Mary and the Patron Saints of Padua, and the animal emblems of various law specialties.[1] Moreover, the dimensions of the Salone were almost a triple cube, which was symbolically (if not mathematically) reflected in the number 333. Thus the administration of justice and public affairs went on under these great reminders of the divine and cosmic order, which sanctified or enchanted the space as surely as the im-

ages and proportions of a cathedral.

A comparable program from the very end of the Middle Ages has left its faded remains in the Palazzo Trinci, in Foligno. Between 1420 and 1424, Ottaviano Nelli painted the Camera delle Stelle (Chamber of the Stars) with a program based not on twelvefold correspondences, as in Padua, but on sevenfold ones: those of the Planets with the Liberal Arts, and the more unusual sets of the Seven Times of Day and the Seven Stages of Human Life. Elsewhere in the palace are gigantic figures of Scipio, Fabius Maximus, Marius, Romulus, David, Hector, Caesar, Alexander, and King Arthur.[2] These recall the medieval tradition of the "Nine Worthies" (Joshua, David, Judas Maccabeus; Hector, Alexander, Caesar; Arthur, Charlemagne, Godfrey of Bouillon) often depicted in tapestries, from which developed various attempts to combine biblical and classical heroes (as we have seen in the *Florentine Picture Chronicle*).

It is one thing to surround oneself with inspiring images of Great Men, and to bask in their reflected glory or in some fantasy of descent from them, but it is quite another to present one's self as the iconographic center of the mesocosm. This was usually done in a more discreet way. For example, between 1458 and 1464 Pier Maria Rossi, Count of Berceto, had a hall in his castle of Roccabianca frescoed with the story of Griselda on the walls, and on the ceiling a map of the heavens as they were on the day of his birth, March 25, 1413.[3] Only those in the know would have had any idea of this. The cupola of the Old Sacristy in San Lorenzo, Florence, is another star map, painted during the lifetime of the Elder Cosimo in the lapis and gold of the night sky. Scholars have tried to date it: to July 9, 1422, when the altar was consecrated; to July 16, 1416, birthday of Cosimo's eldest son, Piero; to July 6, 1439, date of the end of the Council of Florence.[4] Since its restoration in the 1980's it has been dated to July 4, 1442, but while the dating is now certain, its significance is not—an object lesson in skepticism regarding attempts to draw esoteric meanings out of works of art.

The decorations of the Villa Farnesina, Rome, built by the papal banker Agostino Chigi (1465–1520) and painted in 1510–11 by Baldassare Peruzzi (1481–1536), were vaunted immediately in two vanity publications,[5] drawing attention to the mass of astrological imagery in the room now known as the Sala di Galatea. Janet Cox-Rearick calls this "the first Renaissance work in which the fame of a living individual was declared as predestined in the stars."[6] People go there now to look at the truly enchanting fresco for which the room is named, Raphael's *Galatea*, rather than to crane their necks and study the dozens of panels in which the arrangement of planets, zodiacal signs, and paranatellonta reveals to the initiated

the date of Agostino's birth. In 1934 the iconographer Fritz Saxl calculated the date as December 1, 1466: a brilliant approximation that was validated by the later discovery of Agostino's baptismal certificate. This gave November 30, 1466, with the hour of birth as 21:30; a detail that post facto scholarship was able to identify coded into the fresco through the position of the Moon and the ascendant.

This display was mild in comparison to the astrological program of Chigi's friend Pope Leo X (reg. 1513–21), son of Lorenzo the Magnificent. Marsilio Ficino was said to have predicted his destiny when Leo was still a boy. Another prophet, Cardinal Egidio da Viterbo (1469–1532), staked his hopes on Leo after they had failed under the previous pope, Julius II (reg. 1503–13). Egidio had devised a system of historical ages, kabbalistic in origin, based on the number ten, and he reckoned that the present age, which he ascribed to the constellation of Leo, was the tenth and last. The accession of a pope with the right name and number was almost too good to be true, especially when Egidius factored into the equation the significant polar constellations of the Great Bear and the ship Argo: for Leo's mother was an Orsini (from Latin *ursa*, a bear), and the Pope, as successor of Peter the Fisherman, was charged with guiding the Ship of the Church.[7]

Leo was so much taken by this that in 1520 he commissioned a great cycle of decorations for the Vatican from Perino del Vaga and Giovanni da Udine, two pupils of Raphael. The largest room in the Borgia apartments, the Sala dei Pontefici, was redecorated in the new style derived from the Roman vaults of the Domus Aurea (see Chapter 7), to show by means of astrological creatures, pagan divinities, and *grotteschi* Leo's cosmic predestination and the return of the Golden Age under his papacy. As it happened, he died the following year. He was succeeded by his cousin Clement VII, on whose watch came the Sack of Rome (1527) as the ghastly consequence of papal politicking.

A more mysterious "cosmic" chamber was meanwhile being painted in one of the lesser palaces of Mantua.[8] We do not know who commissioned it around 1517, and the ascription to the Veronese painter Giovanni Maria Falconetto (1468–1535) is only provisional. The palace itself was destroyed, but the wing containing this room survived as a two-story garden house on the property of the Marquis Dalla Valle. In 1872 the garden was acquired by its neighbor, the neoclassical Palazzo d'Arco, and the Zodiac Room became part of the museum that the Marquesa d'Arco bequeathed to the city in 1973.

The Zodiac Room is the most Poliphilic chamber, every inch of

To show, by means of astrological creatures, pagan divinities, and grotteschi Leo's cosmic predestination and the return of the Golden Age. Sala dei Pontefici, Vatican.

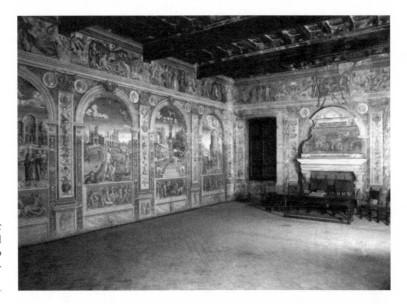

The Zodiac Room is the most Poliphilic chamber imaginable. Every inch of wall is painted in glowing colors. Sala dello Zodiaco, Palazzo d'Arco, Mantua. By permission of the Fondazione d'Arco.

it painted in glowing colors with scenes of classical inspiration. Whoever the painter was, he was knowingly following in the footsteps of Mantegna, who had filled the interstices of his Camera degli Sposi with Roman portraits, mythological scenes in grisaille, putti with garlands, gold mosaics and architectural members in *trompe l'oeil*. The Mantuan Zodiac Room has a frieze of the utmost decorative intensity, showing little episodes from Ovid against a black background, like Pompeian murals or cameos, separated by monsters of fearsome invention. The scenes are: Drunken Pan; the Rape of Europa; the Three Fates; the story of Meleager (five panels); Latona and her children; Niobe's children; Actaeon; Poliphemus and Galatea (?); Ceres; the Rape of Proserpina; Bacchus and Ariadne; Apollo and Marsyas.

Balancing these on the lowest level are exquisite panels in grisaille, simulating the relief sculptures of Roman sarcophagi, with battles, marine gods, sacrifices, etc. The large arched panels symbolizing the zodiac signs are set in a painted architectural framework, every Corinthian pilaster thick with grotesque ornament. The iconography partly comes from a Byzantine romance which contained an *ekphrasis* (literary description of pictures) of the twelve activities of the months.[9] But those are relegated to the background. More interesting, indeed unique, is the fact that the artist has put

A frieze of the utmost decorative intensity, showing little episodes from Ovid against a black background, like Pompeian murals or cameos. Meleager and Acteon, Sala dello Zodiaco. By permission of the Fondazione d'Arco.

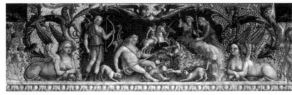
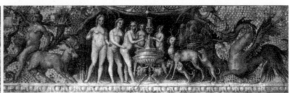

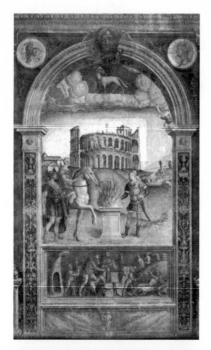

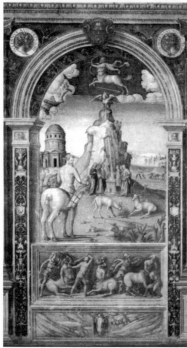

The artist has put into each scene an actual ancient building. Aries and Sagittarius, Sala dello Zodiaco. By permission of the Fondazione d'Arco.

into each scene an actual ancient building. In the foreground are one or two large figures, which iconographers have yet to explain or agree upon. In the sky is the appropriate sign of the zodiac and—another unusual feature—a god or a goddess raising it to the heavens. Here are the principal subjects, and the buildings:

Aries: Mucius Scaevola putting his hand in the fire
 The Amphitheatre, Verona
Taurus: Pan and his flocks
 The Arch of Augustus, Fano; the "Basilica of Constantine," Rome, and a round temple
Gemini: Castor and Pollux (with Jupiter?)
 The Church of San Vitale, Ravenna, sectioned and shown as a classical temple
Cancer: Hercules and the Hydra
 The Coliseum, Rome
Leo: Diana of Ephesus
 The four-sided "Arch of Janus," Rome
Virgo: an old man drinking (Midas?)
 The Mausoleum of Theodoric, Ravenna
Libra: badly damaged by insertion of a fireplace (Justice?)
Scorpio: partly damaged by insertion of a door (Jupiter?)
 Exterior of San Vitale, Ravenna
Sagittarius: Chiron (or Croton?), Mount Helicon, and the Muses
 Torre degli Schiavi (?)
Capricorn: two male figures (Jupiter and Pan?)
 Mole Adriana, Rome, obelisks
Aquarius: a hunter and Diana (or Mars?!)
 Porta dei Leoni, Verona
Pisces: partly damaged by insertion of a door. A man warming himself by a fire; a woman falling from a cliff (Sappho?)

The room is on a medium scale (15.4 x 9.7 x 6.3 m.), but its density and richness, not to mention its arcane qualities, make it more like a studiolo. The designer combined a taste for the byways of mythology with a love of the architectural remnants of antiquity, ruined and otherwise; but unlike Francesco Colonna and the artist of the *Florentine Picture Chronicle*, he could open his eyes to the real buildings around him. The decorative program is based on an astrological cycle, but it is also a paean to the Ovidian world of metamorphoses and monsters. There is nothing quite like it. Its comparative obscurity and difficulty of access prevent ignorant tourists from tramping through, leaving its atmosphere intact for the determined pilgrim.

The city of Mantua is also a shrine for admirers of that most

pagan of painters, Giulio Romano (1492–1546). Not that he himself was anything but a good Christian, but his employer preferred to live surrounded by pagan imagery. The patron in question was Duke Federigo II Gonzaga (reg. 1519–40), son of Marquis Francesco II Gonzaga (reg. 1484–1519) and the great art connoisseur Isabella d'Este (on whom more in Chapter 5). Giulio was employed as a universal factotum for keeping the city running. He was responsible for the drains, for enforcing building codes, and for designing anything artistic or architectural that Federigo had a whim for. In return for this, Giulio enjoyed the profits of the city saw-mill, and died leaving a rich inheritance for his son Rafaello to fritter away.

This is no place for a treatise on Giulio Romano,[10] or on his great work the Palazzo del Te (named for the island on which it stood), built and decorated to his designs between 1525–1528 and 1531–1534. Everything about the palace was Roman in inspiration, but far from being a servile or a scholarly imitation of antique models. Giulio, like all great classical architects (including those of ancient Rome), used the canonical forms as the theme for his own variations. Likewise in designing the frescoes, he drew on a technique and an experience forged in the atelier of Raphael, which enabled him, like his master and a very few others, not merely to copy and imitate existing motifs but to invent freely and convincingly in the classical idiom.[11]

Giulio, unfortunately, was so pressed by his duties for Federigo Gonzaga that he did not paint many of the frescoes himself. He would do detailed, shaded drawings (*modelli*) and have them executed by his assistants, with more accuracy than inspiration. It is Giulio's invention one admires in the Te, not the lifeless and even embarrassing execution. The work was rushed through to satisfy Federigo's desire for a pleasure-palace outside the castle where he could disport himself with his mistress, Isabella Boschetti. But it was also for display: nearly every room had beds, indicating use as a guesthouse,[12] and there was a ballcourt next to the Sala dei Giganti, in which Emperor Charles V (reg. 1519–56) played for four hours during his memorable visit in 1530.[13]

The iconography of the Te includes cosmic themes (notably a unique set of extra-zodiacal constellations in the Sala dei Venti[14]), Noble Romans, Loves of Jupiter, Stages of Life (ending with the Ascent of the Soul), Bacchanalia, Aesop's Fables, and the famous Sala dei Giganti, which shows Jupiter, surrounded by his huddled Olympians, crushing the rebellious Titans. More particularly, in the Sala di Psyche there is a proven influence from the *Hypnerotomachia*.[15] Nearly every scene in the room, and they are many, can be paralleled from the novel. The story of Cupid/Amor

Everything about the palace was Roman in inspiration. Courtyard, Palazzo del Te, Mantua.

King Seleucus, having decreed that adulterers should be blinded and finding his son arraigned for adultery, offers one of his own eyes. Sala d'Attilio Regolo, Palazzo del Te.

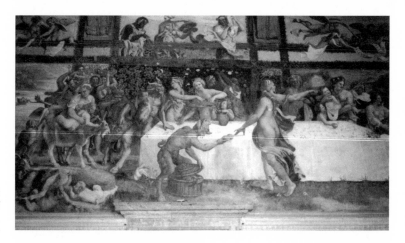

The preparations for the marriage-feast are set on an island like the Isle of Cytherea. Sala di Psyche, Palazzo del Te.

and Psyche was of course common property, but the circumstantial details were not. They include the preparations for the marriage-feast, set on an island like the Isle of Cytherea; the presence of Cupid and Psyche at the Bath of Venus, where Venus meets Mars, stripped of his armor; Mars chasing Venus's lover Adonis, whose tomb is the scene of the conclusion of Poliphilo's journey; the rotunda in which this takes place, which resembles the one in the center of Cytherea; the triumphal processions in the vault, the Three Graces, the Loves of the Gods, an ithyphallic monster, and even the putto who appears to be pissing down on the viewer, like the fountain which tricks Poliphilo.

At the end of his Neoplatonic reading of the Sala di Psyche, Frederick Hartt concludes that "a Neoplatonic interpretation of the Cupid and Psyche fable was not only possible at the court of Mantua, but so nearly automatic that the exact process could safely be left to the individual reader."[16] In case a hint is needed, it is that Psyche is the Soul, Cupid is Desire, and the fable tells of the gradual purification and expiation of lower desires, so that the soul may in the end be united with Desire in its highest form, Desire for the Good, which is the child of Divine Love or the Celestial Venus. Duke Federigo, like Poliphilo, was habitually on fire with love and not ashamed to admit it, as witness his ubiquitous emblem of the salamander with the motto *Quod huic deest me torquet* (What this lacks [i.e. the capacity to feel fire] torments me). This can be taken at various levels, but the liberating essence of Platonism was that all the levels were valid, whereas in Christianity the lower desires arose from, and led to, sin. Just as surely as the Vices were expelled from Isabella d'Este's studiolo in the Gonzaga Palace (see Chapter 5), so sin had no place in her son's Cytherean Isle. If we let our imaginations supply the wall-coverings of silk and gilded leather, the antique statues, the music, dancing, and feasting from sump-

tuous vessels (also designed by Giulio), the labyrinth and the grotto in the garden, the splendid and inviting beds, then we can be sure that Poliphilic pleasure reached a high point here, and one that was not deaf to the music of higher spheres.

Charles V was back in Mantua for a second state visit in 1532. When he was not fighting, the all but homeless Emperor spent much of his time on the road visiting his subject princes, who spared nothing to entertain him and impress his retinue. (Some of their efforts appear in Chapter 9.) In the following year, 1533, he made a triumphal entry to Genoa, home of the admiral Andrea Doria, whose palace had just been decorated by Perino del Vaga with themes of ancient history and mythology. In 1539 the Emperor visited the Château de Fontainebleau, the pride of his rival, King Francis I, where he saw what we cannot: the 150-meter-long Galérie d'Ulisse in the pristine glory of Primaticcio's decorations. As mentioned in Chapter 1, this artist had come to France in 1532 straight from working under Giulio Romano in Mantua, after Francis asked his friend Federigo Gonzaga for a young painter and stuccatore.[17] Through these and many lesser streams of influence, the style of the High Renaissance became the lingua franca of palatial decoration.

The imaginal vocabulary of classical paganism made it possible to work a discreet form of sympathetic magic without treading on the sensitive toes of the Church. The higher flights of Neoplatonism and Hermetism had broadened the spiritual horizon, while the carnal delights of classical mythology and art brought a new enchantment to earthly things. In Italy, after this time, the atmosphere of the Counter-Reformation stifled such expressions of ideas whose orthodoxy was, with good reason, suspect. The classical gods and heroes, the seasons and planets held their own, but in the work of the Carracci for the Palazzo Farnese in Rome, or of Pietro da Cortona in the planetary rooms of the Pitti Palace, the mystery had vanished and only the glory was left. In these as in countless other Baroque and Rococo decorative schemes, the gods were still seductive, and to that extent they fulfilled the psychological need for an alternative imaginal world. But the princes who commissioned them were less and less likely to be initiates.

If the tradition of Ficino and Poliziano, Pico della Mirandola and Lazzarelli survived anywhere, it was in Florence and in the Medici family that had been educated, so to speak, at their feet. The clan had been expelled from their native city in 1494, reinstated in 1512 as puppets of the Pope, supplanted in 1527 by a republic, and forced on the city again in 1530, after an eight-month siege. This time they bore a title of nobility, for the Emperor had created the Dukedom

of Tuscany in 1530, the same year as he promoted the Gonzagas of Mantua to ducal rank. The unappetizing first Duke, Alessandro de' Medici (reg. 1530–37), died by his cousin's dagger, and the prospects of the family, together with the peace of the city, rested on a knife-edge. The eighteen-year-old Cosimo (1519–74; reg. 1537–64) was imposed by imperial fiat. Unlike Alessandro, Cosimo was legitimate, being the child of a marriage that united the two major branches stemming from Cosimo the Elder and his brother. The young Duke had also inherited the warrior blood of his father, Giovanni delle Bande Nere (1498–1526), which served Cosimo well as he struggled against the prominent families who opposed Medici rule. With a show of will and determination beyond his years, he beat them on the battlefield on August 1, 1537 (the anniversary of Caesar Augustus's victory at Actium), then secured his position by hanging a goodly number of them.

In 1541, as part of his program of government, and also because his wife had just given him an heir, Prince Francesco, Cosimo decided to move his principal residence from the old Medici Palace on Via Larga to the headquarters of the former republican government, the Palazzo Vecchio or Signoria. This medieval stronghold had been built for battle and used for centuries by soldiers and stern administrators, not to mention prisoners. As a family home it left much to be desired. A major plan of renovation was set afoot, which included decorating the place in suitable style. Here we shall only consider some of the paintings commissioned by Cosimo: those of the Audience Hall, painted by Francesco Salviati (1510–63) from 1543–48,[18] and the twin suites of rooms in the extension to the palace, painted by Cristofano Gherardi (1508–56), Giorgio Vasari (1511–74), and their assistants in 1555–58.

The Audience Chamber (Sala d'Udienza) is also called the Painted Chamber (Sala Dipinta), for its four walls are covered with paintings rather than with tapestries, as was the norm. As its name conveys, it served for the Duke to give audiences, hence to remove him from common intercourse. Like the appropriation of the public palace itself, this was a necessary part of Cosimo's bold self-creation as an autocratic ruler.

It is not hard to see why episodes in the life of the semi-legendary Furius Camillus were chosen as the subject of the Audience Chamber. Camillus was a distinguished Roman general who, faced with trumped-up charges, had gone into voluntary exile. At the hour of greatest need in 390 B.C., when the Gauls had invaded Rome and taken all but the Capitol, Camillus was invited back and elected dictator. The Gauls were already weighing the gold with which the Romans had bought them off, when Camillus burst in with the words, "Romans buy their freedom not with gold, but

Each of the smaller panels represented a specific stage of the alchemical path, and a specific mental state associated with it. Francesco Salviati, paintings in the Sala Dipinta, Palazzo Vecchio, Florence.

with iron!" Backed by a large army, he slew every Gaul and was rewarded with a triumphal entry into the city. Florentines would have understood these Gauls to signify the French, who in 1538 had committed the unforgivable sin of allying themselves with the Turks in order to ravage the Italian coasts. In the scene representing the Schoolmaster of Falerii, who sold his own pupils to the enemy and was handed over by Camillus to be whipped by them, they would have seen an allegory of the traitorous anti-Medici faction. They would have seen themselves reflected in the grateful crowd at Camillus's triumph, and not without reason: Florence and Tuscany were to enjoy a long period of peace and stability under the rule of their Dukes and (after Cosimo's promotion in 1569), Grand Dukes.

But what of the other scenes in this room? On the window walls, hence more difficult to see, are seven smaller panels of single figures. A superficial glance reveals an obvious Mars and Diana-Luna, a sort of solar figure, and Hermes-Mercury, and one concludes that they must be the seven planets. But on closer inspection there is something wrong. Mercury is an old man, with wings on his back as well as his feet, weighing something in a scale. Another old, winged man is standing on a globe, pouring liquid from silver vessels in each hand into gold vessels below his feet. The seductive nude woman who passes as Venus stands on a triple-headed monster (ass, lion, and dog); she is framed by a vine, crowned with a crescent, and has a snake wrapped round one leg and her body. Most inexplicable is a young winged man running on a wheel, with four female figures in the background. Another nude, winged male is entwined with a serpent, holds a thunderbolt and a staff, and stands with fires at his head and feet, within an eliptical zodiac. He at least is recognizable as the Mithraic divinity Phanes Protogonus, copied from the antique stele in Modena. On the dado are monochrome paintings, now very faded, in which sphinxes figure prominently, emblematic of riddles and ancient mysteries.

Janet Cox-Rearick admits that these panels are difficult to accommodate to any astrological meaning, and refers her readers to the "unfortunately . . . not documented" study of Giulio Cesare Lensi Orlandi, an authority on Florentine architecture and art-history. Lensi Orlandi says that Cosimo I, following family tradition, was dedicated to Hermetic speculations, as other European princes were; in fact, he writes, "Cosimo was an alchemist."[19] The Italian scholar, who admits that he is neither one of the Wise, nor an Initiate, attempts to lift the veil that has concealed the meaning of these paintings for four hundred years. In brief, "The seven figures represent the successive realizations of the Work, following the Dry Way, the one chosen by Cosimo, the most difficult and

fulminating."[20]

Here are their titles, as given by Lensi Orlandi[21] and by Janet Cox-Rearick in her astrological study of the Medici iconography:[22]

Lensi Orlandi	Cox-Rearick
The Cave of Mercury	Time with the Scales
Mars and Iron	Mars Triumphant over a Gaul
Diana	Diana Huntress
Duality	Time with the Attributes of Prudence and Temperance
Unity	Hecate-Moon
The Child is Born	Favor
The Androgyne of Fire	Phanes-Sun

The whole ensemble of the Audience Chamber was a spiritual self-portrait of Cosimo. Giovanni da Bologna, *Cosimo I de' Medici.*

There is an old rumor of a secret tradition of esoteric wisdom handed down in the Medici and other noble families.[23] I call it a rumor because, like so much of the history of esoteric traditions, it is not verifiable in the way that scholars like to see things verified. But such is the nature of esotericism: if it were open, documented, and given to all to see, it would no longer be esoteric, but exoteric. It is worth mentioning, as a sign of Cosimo's times, that the *Corpus Hermeticum* was published for the first time in Italian in Florence in 1545, dedicated to Cosimo's major-domo and secretary, and re-printed several times before the end of the decade.[24]

Lensi Orlandi goes on to say that the mannerist artists followed scrupulously the directions they received from Cosimo, or from someone else through him, but that they themselves only understood these inventions in their exterior and apparent form. He mentions Vasari as a flagrant example of how the initiatic and esoteric significance of what the artists were painting was beyond them, but allows that Salviati did have an understanding of the esoteric meaning of what was commissioned from him.[25] What Lensi Orlandi's readers do not necessarily realize is that his interpretations, which are arresting and quite incongruous in their art-historical context, belong within an Italian tradition of esoteric paganism whose more recent spokesmen include Giuliano Kremmerz, Arturo Reghini, and Julius Evola,[26] and which, with whatever justification, regards itself as descending from Plethon, Ficino, and their school.

I draw attention here to the extraordinary situation of Cosimo's including such enigmatic figures in a public room, where the other decorations are so obviously meant to be admired and studied. Was the situation in the sixteenth century any different from that of the twenty-first, when not one in a thousand visitors, not one in a hundred art historians, shows any curiosity about them? My ten-

tative answer is not based on scholarship but on intuition. I am largely convinced by Lensi Orlandi's argument that Cosimo was an alchemist of some sort, and that he was taking a calculated risk in showing his hand here. The Camillus paintings displayed his public nature. As he sat in state receiving underlings and ambassadors, he drew energy from his identification, in his own mind and theirs, with the Roman hero. Meanwhile the seven smaller panels reminded him of his inner nature, and of the process that made him what he was. Each one represented a specific stage of the alchemical path, and a specific mental state associated with it. The whole ensemble of the Audience Chamber was a spiritual self-portrait of Cosimo, a mirror in which he could see his highest ideals and reinforce his will to realize them.

Ten years later, after the arrival in Florence of Giorgio Vasari, more ambitious schemes were set in motion. Beside the renovation of the Salone dei Cinquecento ("Room of the Five Hundred," though it holds many more), which would celebrate Florence's military victories and Cosimo's role as Hercules, a new wing was added to the palace containing two suites of rooms, one directly above the other. On the lower floor are the "Apartments of Leo X," painted with episodes from the lives of the most eminent Medici. On the upper floor are the "Apartments of the Elements," with scenes and figures taken exclusively from classical mythology. This is how they correspond, one above the other:

Apartments of the Elements	Apartments of Leo X
Room of the Elements	Room of Pope Leo X
Terrace of Saturn	Room of Pope Clement VII
Room of Hercules	Room of Giovanni delle Bande Nere
Terrace of Juno	Study
Room of Jupiter	Room of Cosimo I
Room of Ops / Rhea / Cybele	Room of Lorenzo the Magnificent
Room of Ceres	Room of Cosimo the Elder

It is not necessary to know the histories of these members of the Medici family in order to appreciate what was being attempted here. Nor was it necessary for the visitors in Cosimo's time to know all the arcane classical references and cross-references, for them to grasp the point. It was a none-too-subtle statement that the Medici were "terrestrial gods" (Vasari's own term[27]), and that Cosimo I was the Jupiter or king of them all.

It was part of Cosimo's lifelong strategy to get himself crowned King of Tuscany. Cosimo the Elder ("Pater Patriae," the patron of Ficino) had at least pretended to be a mere citizen of the Florentine

Allegories of the ruler's military might, his wealth, and their consequences in the birth of Venus, goddess of peace and delight. Sala degli Elementi, Palazzo Vecchio.

Republic. His grandson Lorenzo the Magnificent (1449–92) kept up the pretense, but acted more like a monarch and, as we shall note in the next chapter, engraved his most precious treasures with an inscription that aspires to royalty. Lorenzo's grandson Cosimo I entered Florence as Duke, and died as Grand Duke, just short of his royal ambitions, for which (also see the next chapter) he had prepared all the proper accoutrements. The overloaded decorations of Cosimo's apartments may satiate and bore the modern visitor, but in their time these and other flamboyant displays were a necessity, if his claim to a hereditary right to rule Tuscany was to be taken seriously.

The Room of the Elements[28] is the most complex of the suite, and probably has the most attractive paintings. On the walls are scenes symbolizing Fire (The Forge of Vulcan), Earth (The Reign of Saturn), and Water (The Birth of Venus). At the most obvious level, these are allegories of the ruler's military might (the forging of Jupiter's thunderbolts); his wealth (the Golden Age of plenty); and their consequence in the birth of Venus, goddess of peace and delight.

The ceiling, which serves as the representation of Air, has smaller panels of the Times of Day, and of Truth, Justice, Peace, and Fame. In the center is the very rare subject of *The Castration of Ouranos by Saturn*, derived from the *Theogony* of Hesiod via Boccaccio. Vasari explains it in his book of instructive conversations with Prince Francesco, giving a glimpse of deeper meanings such as probably underlie all the paintings in these apartments. He first interprets the castration in terms of Aristotelian cosmology: "Cutting off the

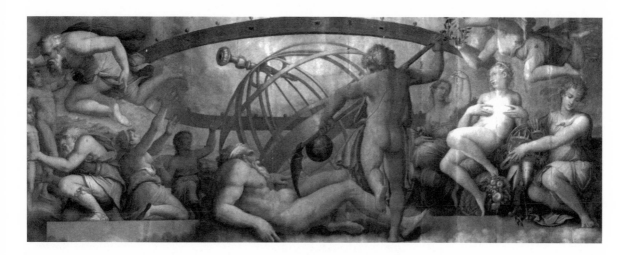

Vasari gives us a glimpse of deeper meanings such as probably underlie all the paintings in these apartments. Giorgio Vasari and Cristofano Gherardi, *Air*, Sala degli Elementi, Palazzo Vecchio. By permission of Casa Editrice Le Lettere, Florence.

heat as form, and its falling into the sea as matter, gave rise to the generation of earthly things that are fallen and corruptible and mortal, generating Venus from the sea foam." When the Prince asks about the choir of figures surrounding the protagonists, Vasari amazingly enough delivers an exegesis based (though he does not say so) on the ten Sephiroth of the Kabbalah:

> These are the ten powers or attributes that the Theologians ascribe to God, which actually collaborate in the creation of the universe. [The first, Kether, is] that crown, which the Theologians hold to be the first of the powers attributed to God, which is that bottomless spring, giving abundantly for all eternity; thus it is made great and abundant and rich in gems and pearls. [The second, Chokhmah, shown as a sculptor making a human body, is] the son of God, that is, the possibility of creating all things, which is Wisdom. [The third, Binah] is figured by God's providence in infusing the spirit into all created things, therefore he breathes into that statue . . . Mercy is the fourth [Chesed] . . . who appears larger, in that she extends to nourish all created thing; and thus I have painted her nude, and as beautiful as I can, pressing her own breasts and squirting milk for the nutriment of all animate beings . . . [29]

The next four figures described by Vasari do not correspond so closely to Sephiroth 5–8 (Gevurah, Tiphereth, Netzach, Hod), but at the end, sure enough, come the Firmament (Yesod) shown as a great stone slab supporting the whole scene, and the Kingdom (Malkuth), represented as an armillary sphere topped by a scepter.

Vasari's explanation is given in such terms that the uninformed reader or viewer can appreciate the painting as an allegory of God's powers and of the blessings of the Medici. Perhaps this is how the

painter himself understood it. Some prior knowledge is necessary in order to have any inkling of the underlying program, which is an audacious assimilation, worthy of Pico della Mirandola, of the earliest Greek cosmogony to Hebrew Kabbalah. Thus, in Lensi Orlandi's words, "Cosimo's and Francesco's knowledge impregnated with their secret the rooms in which they lived."[30] Later we will see how Cosimo's son and successor Francesco contributed to the mystery of this palace.

I turn now to the Habsburg lands, which, as mentioned in Chapter 1, were fertile grounds for the new style. Commerce across the Alps was frequent, as were dynastic unions. In a memorable ceremony of 1565 (see Chapter 9), Francesco de' Medici married the daughter of Emperor Ferdinand I, who had been responsible for the first Italian-style building in Bohemia. This was the Belvedere or Summer Palace, which stands at the far end of the gardens behind Prague Castle.[31] It was intended by Ferdinand (1503–64; acting Emperor from 1556) as a pleasant summer-house for his beloved wife, Anna Jagiellon, who had grown up in the late Gothic warren of the Hradčany Castle. (Her father's name and reign are commemorated in the great Vladislav Hall.) The Belvedere, which resembles the arcaded city halls of Padua and Vicenza, was designed in 1537 by Italian architects in Genoa. They brought a wooden model of the building to Prague, and began work the following year under the direction of Paolo Stella. The team included sculptors, who worked on the series of nearly a hundred sandstone reliefs of mythological and historical scenes that decorate the elegant arcade around the ground floor. Work was interrupted in 1541 by a disastrous fire that destroyed much of the Hradčany, and after that there were other priorities for rebuilding. Queen Anna died in 1547 after giving birth to her fifteenth child, and never saw her Belvedere completed.

It was Emperor Ferdinand's energetic son, Archduke Ferdinand II of the Tirol (1529–95), who ensured the completion of the Belvedere and of another monumental family legacy, the Tomb of Maximilian I (see Chapter 1). Ferdinand had grown up in Innsbruck, seen some mild action in the War of the Schmalkalden, and been appointed Statthalter of Bohemia in 1547, at the early age of eighteen. For sixteen years, he governed the kingdom on his father's behalf as well as anyone had a right to expect, given the perpetual sectarian bickering on all sides. His initiation into the world with which this book is concerned came in 1551–52, and like many Germans he came to it through an Italian journey. This expedition, organized by the two Ferdinands, father and son, had as its object the welcoming of their son/brother Maximilian (later Emperor

The whole ensemble is like a mirage of Italy. Belvedere and Singing Fountain, Prague Castle Gardens.

Maximilian II, reg. 1564–76) and his bride Maria. Maximilian had been governing Spain for two years on behalf of his uncle and father-in-law, Emperor Charles V, but now he was coming to stake his claim as King of Bohemia.[32] The cream of the Bohemian aristocracy—fifty-three nobles and innumerable attendants—made the long journey across the Alps and northern Italy to Genoa and back. It left an indelible impression on them and, through them, on Bohemian art and architecture.

It is not documented, but quite evident to the imagination that the younger Ferdinand now wanted to recreate what he had seen and admired in Italy. A secondary motive concerned his wife, Philippina Welser, whom he had met and fallen in love with at the Augsburg Reichstag in 1547. Philippina was the daughter of one of the richest bankers in Germany, but she was a commoner, hence unthinkable as the wife of the nephew, son, and brother of emperors. Ferdinand married her in secret in 1557, keeping the fact from his father until Philippina broke the news to the Emperor in 1561. Even then it was not until 1576 that a papal brief allowed the fact to be made public,[33] and it was firmly understood that the children of this union (passed off as adopted foundlings) could not inherit any titles or lands.

The court architect Bonifaz Wolmut (1522–72) took over the completion of the Belvedere in 1555, simultaneously with the new Star Castle (see below). Wolmut completed the upper story of the Belvedere and capped it with a mighty copper roof, shaped like the bottom of a boat, which must have been even more striking when painted in stripes of the Habsburg colors, red and white. One side of the building, true to its name, afforded a lofty view along the Moldau. The other gave onto an Italianate formal garden, graced in 1568 with a remarkable bronze fountain. It has statues of Pan, putti, and a shepherd playing bagpipes, and is known as the "Singing Fountain" from the sound the water makes when heard from beneath the bowl. Together with the formal plantings, the whole ensemble is like a mirage of Italy.

Ferdinand wanted the wooden ceiling of the Belvedere to be painted with stars, planets, and signs of the zodiac, while the wall paintings included portraits of the Kings of Bohemia.[34] So far the decoration followed the usual representation of heavenly and earthly powers. But the building seems to have had a peculiarly cosmic destiny. In 1599 it became a working museum for Tycho Brahe, the Danish astronomer who was brought to Prague by Emperor Rudolf II (reg. 1576–1611). A French visitor of 1603 saw in the Great Hall a sculpture of Boreas, the North Wind, abducting Oreitheia, and portraits of ancient and modern astronomers and the rulers who had patronized them, including Ptolemy,

The Star Castle, near Prague, as it was before and after the alteration of its roof and windows. From eighteenth- and nineteenth-century prints.

Copernicus, Al Batani, Brahe, Frederick II of Denmark, and Rudolf II. Outside, beneath the arcades, were "countless spheres, globes, astrolabes, quadrants, and a great many other mathematical instruments, chiefly of bronze and tin and of wondrous size."[35] Eliška Fučíková explains the rare subject of the sculpture:[36] Boreas is also the creative serpent of Egyptian and Hebrew mythology. Oreitheia or Eurynome is the goddess of all things. From their union came the sun, moon, planets, earth, mountains, water, herbs, trees, and all living beings. Thus the commonplace classical theme of a "rape" esoterically signifies a cosmogony. Finally, the Belvedere served as Emperor Rudolf's own residence for the few months left him after he had been deposed by his brother Mathias.[37]

The other monument to Ferdinand's Bohemian stewardship is the Star Castle, a hunting lodge and country retreat near the White Mountain (Bila Hora) on the western outskirts of Prague, built in 1555–56 by Giovanni Maria Aostalli and Giovanni Lucchese, under Wolmut's supervision.[38] In Chapter 2 we saw how fond the author of the *Hypnerotomachia Poliphili* was of buildings based on the regular divisions of a circle. Ferdinand and his Italian architects were among the few who succeeded in realizing this dream in stone. The Archduke himself designed the plan, which is in the shape of a six-pointed star.[39] It has four stories: the lowest contains kitchens and cellars, and the uppermost (now a concert hall) is a single large chamber beneath the roof. In between are two floors of oddly-shaped rooms, as necessitated by the groundplan.

The first question is why the building took this star shape. Was it intended as a hexagram, the union of two intersecting triangles that are the symbols of Fire and Water, representing the coincidence of opposites? So argues Martin Stejskal in his book dedicated to the building, but any alchemical illustrations of this symbol that I have found postdate the castle. In Prague, of all places, one's thoughts turn to magic and Kabbalah, and indeed Gershom Scholem writes that the six-pointed star was depicted on the flag granted to the Jews of Prague by Emperor Charles IV in 1354, and thenceforth became an official emblem. It was used especially as a printer's mark in books printed in Prague in the first half of the sixteenth century; but Scholem says that this and other usages "had as yet no general Jewish connotation."[40] If it connoted anything, it would have been the magic of talismans and amulets, drawn and worn for good luck. Then again, was the design in emulation of the fortified towns, with their protruding angles and, in a case like the town of Palmanova, perfect radial symmetry? This is the more practical view of Fučíková.[41] One chooses the interpretation with which one feels most comfortable. But one's choice while studying the Star Castle in an American library might well be different

Archduke Ferdinand himself designed the plan, which is in the shape of a six-pointed star. Plan of the ground floor, Star Castle, Prague.

from what one feels in the castle itself, where the genius loci is exceptionally strong.

The interior of the Star Castle once had frescoes painted on the walls, but these have utterly disappeared, and we do not even know what their subjects were. Something more remarkable has survived, though: 334 panels of stucco decorations that cover the vaults of the ground floor rooms. These white relief designs, made from 1556–60, derive ultimately from ancient Roman examples, via their revival by the Italian artists in the early sixteenth century. The pioneers were Raphael and Giovanni da Udine in the Villa Madama, Rome, then in the 1530s came Perino del Vaga in the Palazzo Doria (which Ferdinand must have seen); Falconetto's vault in the Chapel of Saint Anthony in the Santo, Padua; Giulio Romano's Sala degli Stucchi in the Palazzo del Te.[42] Before the end of the decade, the style and medium had reached Austria,[43] but in a tentative way compared to this first flowering in Prague.

The main stucco decorations in Ferdinand's castle show scenes of Stoic virtue taken from Livy, Plutarch, and Valerius Maximus. In the central room are represented:[44]

Aeneas and his family leaving Troy;
Mucius Scaevola holding his hand in the fire;
Horatius Cocles defending the bridge;
Cimon being nursed by Pera;
Seleucus giving his wife Stratonice to Antiochus;
Marcus Curtius leaping on horseback into the abyss;
Marcus Attilius Regulus being tortured in a barrel.

In the rooms filling the five rays of the star (the sixth is taken up by the stairs) is a mass of antique imagery. Dirk Jansen remarks that they "betray a rather accurate knowledge of such material from Giulio Romano's studio as could be consulted in Strada's *Musaeum*."[45] (We will meet Jacopo Strada, antiquarian entrepreneur, in Chapter 6.) Some of the rooms have the planetary gods in pride of place—Jupiter on an eagle, Mercury on a ram, Luna. The others have a centaur with a child on his back, and Minerva with her spear. Venus and Neptune appear in two of the corridors that separate the chambers. Other recognizable figures are Perseus, Leda, Europa, Flora, Pegasus, Ganymede. Then there are a host of putti, genii, Horae, sea-monsters, dolphins, birds, animals, herms, satyrs, griffins, sirens, river gods, pairs of lovers, and medallions with emperors in profile, apparently improvised by the artists without any overriding plan.

The outside of the Star Castle gives no hint of what is within. Unfortunately the original high, domed roof has been replaced by

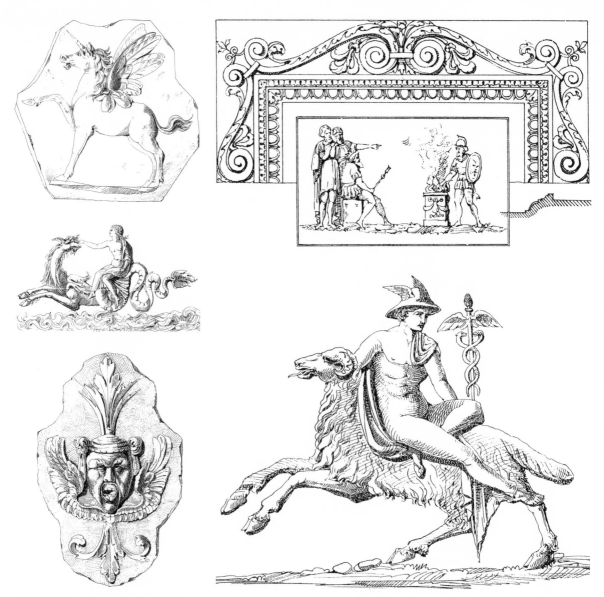

Ceiling decorations, Star Castle. ABOVE:
Pegacorn; Nymph riding a sea monster;
Mask. ABOVE RIGHT: Mucius Scaevola
holds his hand in the fire, to show the
Gauls that it would be useless to torture
him for information. BELOW RIGHT:
Hermes riding a ram.

a simple, low one. The windows, which should light the interior adequately, were reduced to slits when the building was used as a gunpowder magazine (c.1780–1866).[46] The marble flooring has mostly been stolen. One has to imagine the frescoes and tapestries on the walls, and the many niches filled with shining armor and statues, in order to appreciate the fairyland atmosphere of the Star Castle in its prime: half Italian villa, half antique grotto, hidden in the boar- and bear-haunted forest.

Bonifaz Wolmut's third Italianate legacy is the Large Ball Court (1567–69), which stands in the same garden as the Belvedere. This is a splendid building in the restrained style of Palladio, its arcades separated by giant Ionic pilasters. However, the decoration on the exterior is anything but restrained. It is like the Star Castle turned inside-out: every inch of wall is covered with grotesque motifs in sgraffito (scraped plaster) technique. The idea may have come from Ferdinand, but by the time building began, the Archduke had left Prague to become Landesherr of the Tirol, following the death of his father in 1564.

In 1563, Ferdinand had acquired as a summer palace Schloss Ambras outside the city of Innsbruck. We will treat this in more detail in Chapter 6, but mention here the decoration of the inner courtyard, also done in sgraffito. It shows male and female Roman figures between herms or Atlantes, classical scenes including Orpheus charming animals, the Triumph of Bacchus, and vintage scenes with putti and satyrs. These decorations are much cruder than the work in Prague, and were probably done by Tirolean craftsmen after Italian drawings or engravings. Nevertheless, they make of the courtyard an enchanted space, removed from Catholic Austria, from family quarrels, from the sixteenth-century world with its absurd religious squabbling. There was no esoteric program about it; as we shall see from his appearances in later chapters, Ferdinand was not deep like his brother-in-law Francesco de' Medici. But there was a nostalgia—for Italian style, for Roman virtues, for Bacchic freedom—which Ferdinand addressed with all the vigor of a man who lived his life to the fullest, and one might add, with a useful infusion of Welser money.

Private Microcosms

ONE OF THE most attractive inventions of the early Renaissance is the studiolo, a small, private, decorated study. Most of the examples—and there must have been dozens of them—have disappeared unchronicled. Those that are recorded are mostly destroyed; the few survivors are in a more or less mutilated condition. Yet they still exhale an atmosphere unique to the genre and are strongly flavored by the personalities of their owners.

The studiolo is a place of retreat from the public world into a private universe. As we understand it here, it is not a study for writing, nor a library, a treasury, or a monastic cell, though all of these contributed to its ancestry.

What most distinguishes the studiolo from the cell of a monk or nun is its decoration. A cell might contain a devotional picture as rare as the ones painted by Fra Angelico for his brothers at the monastery of San Marco; but the purpose behind a studiolo's decoration was quite different. It was not so much to take the owner out of this world, as to situate him within it. The decorations served as mirrors to qualities, aspirations, and knowledge already latent in the individual, but placed in a historical, moral, Hermetic, or cosmic context. The room was a model of its owner's mind and an exteriorization of his—or more rarely, her—imagination.

A scholar's study may have to serve also as his library, but that was not the role of the Renaissance studiolo. The owners whom we have in mind had plenty of room elsewhere for their collections of books and manuscripts. To fill the studiolo with bookshelves would have defeated its decorative purpose. Certainly one might retire there to read, but if anything were permanently housed in it, it would more likely be small, precious objects, shown to selected visitors or enjoyed in solitary contemplation. Yet a studiolo is not the same as a treasury, which is designed for security and with no more intention of creating atmosphere than a bank vault.

The earliest recorded studiolo, which set the fashion for many subsequent ones, was made at the beginning of the fifteenth century for Paolo Guinigi, an upstart condottiere (mercenary leader) who managed to lord it for thirty years over the city of Lucca. He had the walls of his chamber lined with intarsia—marquetry pan-

The virtuoso craftsman delighted in transcending the limitations of the medium. Intarsia stalls, Santa Maria in Organo, Verona.

els made from different colored woods—made at the considerable cost of 199 florins by the craftsman Arduino da Baese. These panels were sufficiently esteemed that after Guinigi's fall from power in 1430 they were taken to Ferrara, and in 1434 Arduino reinstalled them in the studiolo of Marquis Leonello d'Este (reg. 1441–50) at Belfiore, a magnificent palace just outside the city walls (see below). In 1479 the intarsia panels were reused a third time for the studiolo of Leonello's half-brother Duke Ercole I d'Este (reg. 1471–1505) in the Palazzo del Corte.[1] They were destroyed by fire four years later, when the Venetian and Papal troops attacked the city.

The art of intarsia originated in the Islamic lands, and when first imported to Europe it favored the geometric and floral designs that still delight tourists in the souks of Istanbul or Cairo.[2] By 1400 it had become a favorite form of decoration for choirstalls, sacristies, and chapterhouses, its natural woods lending comfort to places where churchmen spent much of their time. The same Arduino supplied panels in 1419–20 to the church of Santa Trinità in Florence.[3] These have vanished, but brilliant ensembles of intarsia work are still in place in the cathedrals of Florence, Perugia, and Modena, the Palazzo Pubblico and Cathedral of Siena, and the incomparable Sacristy of Santa Maria in Organo in Verona.

In the early fifteenth century a curious blending took place, as this medium became a favorite playground for experiments in perspective and illusionism. One reason is that the artists of the time were so excited by these discoveries, and it was they who designed the intarsias, not the specialized artisans who cut and fitted the wood. Another reason is the virtuoso craftsman's delight in transcending the limitations of a flat medium, just as he ingeniously exploited the narrow palette of colors offered by natural woods. A third reason, emphasized by Luciano Cheles in his study of the

CHAPTER 5

Urbino studiolo, is the rediscovery of antique painting and its illusionistic aims. Cupboards left ajar to half-reveal their contents, garden and landscape views, animals and fruits painted true to life: these were known from descriptions in classical literature, if not from examples that have since been lost.[4]

If the ceiling height allowed, the space above the panels was customarily given over to tapestries or paintings, either frescoed onto the walls or separately installed. It was Cicero who said that one should decorate one's study with images of the Muses, as well as of the morally inspiring divinities: Apollo, Mars, Mercury, Minerva, and Hercules, but not Bacchus and Venus.[5] Leonello d'Este appears to have been the first to follow this prescription, in the paintings of his studiolo at Belfiore. He was already the kind of person who "thought out his wardrobe in such a way as to choose the color of his garments according to the day of the month and the position of the stars and planets."[6] This accords with the style of decoration that uses themes with multiple meanings, linked by the doctrine of correspondences. The Muses were associated, as we saw in Chapters 1 and 3, with the arts and sciences, with the planetary spheres, and also with the Sirens. The figures and attributes of the Belfiore Muses followed a program drawn up in 1447 by the court humanist Guarino da Verona (1374–1460), who had fostered Leonello's self-identification with the rulers of Antiquity. The art historian Stephen Campbell distinguishes them as "the earliest pictorial cycle of the Renaissance to depend indisputably on the mythological and philological interests of the humanists."[7]

Five of the nine Belfiore Muses survive: Thalia in Budapest (Szépművešzeti Múzeum), Terpsichore in Milan (Museo Poldi-Pezzoli), Erato and Urania in Ferrara (Pinacoteca Nazionale), and Calliope in London (National Gallery). Disputes as to whether they belong together were settled when it was discovered that all the panels came from the same poplar tree.[8] But the Belfiore Muses in these oil paintings are not quite what Leonello saw. The experts are not agreed on exactly what happened, but it seems that the set of Muses was originally painted in tempera by Angelo da Siena[9] and (which goes without saying in this era) his assistants. Then after Leonello's death in 1450, some of them were repainted in oil by a much more eminent painter, Cosimo Tura (1430–95).[10] This repainting was commissioned by one of Leonello's successors and half-brothers: either Duke Borso d'Este (reg. 1450–1471), who commissioned the Schifanoia Room of the Months, or Ercole I.[11] Whatever the historical details, the evidence stares us in the face, especially if we encounter the most brilliant of the sisters, Thalia and Calliope. Thalia, her hair arranged in a glory of wheat-ears, looks disdainfully down from her fantastic throne, her dress hitched up,

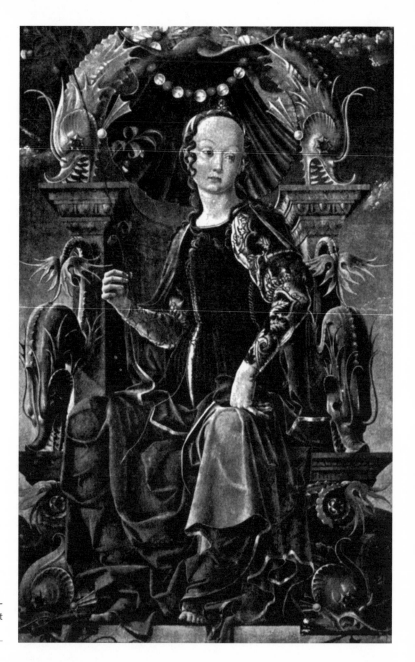

She combines haughtiness with a dissolute air; "decadence" is the word that comes to mind. Cosimo Tura, *Calliope*.

her bodice coming undone. Calliope's throne is in Tura's favorite combination of pink and green, ornamented by outsize gemstones and six golden dolphins covered with menacing spines. She, too, combines haughtiness with a dissolute air; "decadence" is the word that comes to mind. Erato is unlacing her bodice, while one of her crimson sandals is dangling off her left foot. Terpsichore is less concerned with the viewer, for she has three mischievous putti to

take care of, dancing around her feet. Urania alone seems to have escaped the repainting project: she lifts her gaze to the heavens, showing off her fashionably plucked brow.

The Tura scholar Stephen Campbell explains that the only women who dressed and looked like the Belfiore Muses were ladies of the prince's household, and high-class prostitutes.[12] He associates them with the complaint of their contemporary, Ugolino Pisano, that studioli were places of "dangerous and contaminating reading," such as the lascivious Roman authors Catullus, Juvenal, Propertius, Martial, and the Ovid of *Ars amatoria*; and with the most notorious book of the fifteenth century, *Hermaphroditus* (1425) by Antonio Beccadelli (1394–1471),[13] which was an imitation, in superb classical Latin, of this type of literature.[14] Beccadelli dedicated *Hermaphroditus* to Cosimo de' Medici the Elder—not a man one associates with such things, but who apparently enjoyed the book, as did other princes and distinguished humanists. Guarino da Verona, who provided the program for the Belfiore Muses, stated that the author of *Hermaphroditus* already wrote Latin prose as good as Cicero's, and that now he equalled Catullus and Ovid in verse.[15] The cultivation of erudite pornography (for the book is decidedly pornographic, rather than erotic) made no waves so long as it was kept within the club of consenting adults. But when Beccadelli's book fell into the hands of the friars, there was an outcry. Saint Bernardino of Siena preached against it; Pope Eugenius IV condemned it; Guarino, mortified, had to eat his words. *Hermaphroditus* was burned by public executioners, among fulminations against the dangers of pagan literature. Since most humanists worked as tutors, there was concern for the susceptible young. As for Beccadelli, he survived this trauma, finished his law degree, and enjoyed a stellar career as diplomat and counselor for the Kingdom of Naples.

Campbell concludes that the Belfiore Studiolo, as repainted under Borso d'Este, was deliberately conceived in counter-reaction to the censorship of *Hermaphroditus*, and to make the "dangerous curiosity" relating to Antiquity visible.[16] The courtesan Muses would then have been seen as a defiant affirmation of pagan sensuality. However, from a broader perspective there is more to the Belfiore cycle than naughtiness. Mythologically, the Muses are the inspirers of men, not only of artists but also of rulers. The psychological truth, that behind every masculine achievement is the creative energy of what C. G. Jung called the anima, expresses itself in Belfiore by giving the Nine Muses, for the first time in history, the lineaments of desire. Thus they occupy both the first and the later steps of Plato's erotic hierarchy.

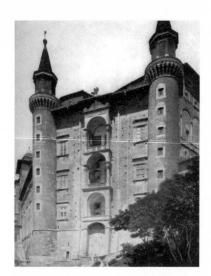

The home of everyone's favorite Renaissance prince. Ducal Palace, Urbino.

The first studiolo enthusiast in Florence was Piero di Cosimo de' Medici (1416–69), son of Cosimo the Elder and father of Lorenzo the Magnificent. A martyr to gout, Piero took solace in his Via Larga palace and in the collections he built up there. A poem written in 1459 to commemorate the visit of Galeazzo Maria Sforza describes a rich chapel, and on the other side a "triumphant and beautiful studio" with intarsias, perspective pictures, sublime intaglios, great architecture, many ornate books, and vases in alabaster mounted with gold and silver.[17] The windowless room was 4 x 5.5 m. in area, and like its companion chapel (still there, with Benozzo Gozzoli's *Journey of the Magi*), was an anomaly in an era of large public displays.

Piero's studiolo had intarsia panels installed by Arduino in 1451, which were admired for their illusionistic qualities. Above these were paintings (subjects unknown), enamelled terracotta reliefs of the *Four Seasons* by Luca della Robbia, and twelve roundels in the vault showing the Labors of the Months, the Signs of the Zodiac, and the divisions of night and day.[18] Although this studiolo is more celebrated for the richness of the collection kept in it (of which more below), its decorations followed the classic pattern of illusionistic paneling beneath a cycle of images on some mythical or humanistic theme.

Although no contemporary says as much, it is obvious that this type of studiolo is a microcosm whose two levels correspond to earth and heaven. The intarsias are monochromatic, worldly in subject-matter, and their nature is illusion: one reaches out to open a cupboard, or tries to sit on a bench, and finds only a flat wall. The painted zone, which often, as in Piero's studiolo, was vaulted like the heavens, carries cosmic imagery like planets or months, or else a set of figures representing the world of spirit, inspiration, and the higher intellect. These are brightly colored, like the "real world" reached by the fugitive philosopher who escapes from Plato's Cave.

The only fifteenth-century studiolo to survive almost complete in its original home is that of everyone's favorite Renaissance prince, Federigo da Montefeltro (1422–82), in the palace of Urbino. Federigo was an illegitimate but favored child who had been educated at Casa Gioiosa ("Happy House"), the coeducational school run by Vittorino da Feltre for the court of Mantua. Although he prospered by leading mercenary armies, the Lord of Urbino was devoted to the study of the Liberal Arts, and the patronage of all the others. His studiolo was not an isolated hideaway, but part of a suite of rooms designed for a life lived in deliberate emulation of the Ancients. Like his Roman exemplars, Federigo would begin the day with a visit to the *lararium* (shrine of the household gods), then

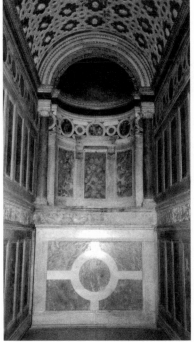

A pair of chapels, one dedicated to the Muses, the other to Christian worship. Tempietto and Chapel, Ducal Palace, Urbino.

attend to affairs of state. He would read some Greek literature, then take physical exercise, followed by a bath.[19] (His mania for tidiness and cleanliness was legendary.[20]) As Nancy Edwards has shown in her dissertation on Renaissance bathrooms, the Urbino palace housed these activities in a complex of rooms all joined by spiral stairs. There was a pair of chapels, one dedicated to Christian worship, the other to the Muses; the famous studiolo; a ballcourt; and rooms for hot and cold bathing. Apart from the chapel, none of these belonged to the typical setup of a medieval knight's castle.

The twin chapels, probably completed in 1476, are called "Cappella del Perdono" and "Tempietto delle Muse" (Chapel of Absolution and Temple of the Muses). In the vestibule that gives access to them is the inscription: BINA VIDES PARVO DISCRIMINE JUNCTA SACELLA ALTERA PARS MUSIS ALTERA SACRA DEO EST (You see two chapels joined by a slight divide; one is sacred to the Muses, the other to God).[21] Both rooms are narrow, barrel-vaulted chambers, almost claustrophobically small. The Christian chapel is imageless but lined with panels of colored marble, one end filled by the small altar. Around it is inscribed: ACCIPITE SPIRITUM SANCTUM ET QUORUM REMISERITIS PECCATA REMITTUNTUR EIS (Accept the Holy Spirit, and whose sins you forgive, they are forgiven them).

The Tempietto reputedly served Federigo's son Guidobaldo da Montefeltro (1472–1508) as his own studiolo,[22] and once contained intarsia paneling and eleven paintings of Minerva, Apollo, and the Nine Muses.[23] The latter are now in the Galleria Corsini, Florence; they are sometimes attributed to Giovanni Santi, father of Raphael.[24] These Muses are not seductive, enthroned Sirens like those of Ferrara, but sober musicians on the model of the Tarocchi. It may be significant, as Elisabeth Schröter suggests, that the only ones shown playing their instruments are the ones with the Apollonian viola da braccio and organetto; those holding the Dionysian wind instruments are not permitted to sound in this sanctuary.[25] Now it is empty of decoration except for its coffered ceiling and the couplet, running round the frieze: QUISQUIS ADES LAETUS MUSIS ET CANDIDUS ADSIS FACUNDUS CITHARAE NIL NISI CANDOR INEST (Whoever you are, be glad and pure for the Muses and skilled on the lyre, for purity alone is here.) After visiting these minute rooms and comparing them with the studiolo above, it occurred to me that they might have been used for some rite of incubation, in which one could sleep in absolute privacy and imbue one's dreams with sacred influences.

Upstairs from the chapels is the studiolo proper: an irregular room (3.60 x 3.35 m. excluding the niches), complete with its original intarsia paneling and the majority of its paintings. When

intarsias were used in church decoration, each scene—typically a townscape or a half-open cupboard—was an isolated creation, devoid of any systematic program.[26] The paneling of the Urbino studiolo, on the contrary, is conceived as a unit, and its illusionism is raised to a higher level as the visitor, encompassed on all sides, finds himself like Alice through the looking-glass, strayed into a world at once playful and profound in its symbols and implications. The perspectives of all the panels converge at a point in the center, from which the illusion is perfect. From here one sees a room surrounded by benches, some of them folded up against the wall to reveal their inlaid undersides, others strewn with musical instruments. Above the benches is a narrow dado with Federigo's heraldic emblems. Next is the most conspicuous element, a row of cupboards with half-open latticed doors. The objects depicted in this room comprise:

Books: about 30, some marked with authors' names, or open to show music;

Scientific instruments: astrolabe, armillary sphere, mechanical clock;

Musical instruments: organetto, two lutes, viola da braccio, clavichord, three recorders, jingle-ring, pipes and tabor;

Study equipment: writing desk, reading stand with lamp, candles, candlestick, jars, lamps, inkwells, dust-brush, boxes, hourglass;

Arms: sword, dagger, mace, suit of armor, spurs;

Miscellaneous: two caged parrots, rosary, Orders of the Ermine and of the Garter, and a *mazzocchio* (a chunky torus-shaped object used to secure a headdress and adopted by Renaissance artists as a tour-de-force of perspective drawing).

As Wolfgang Liebenwein points out, "The idea of a studiolo itself is shown in the room as an image."[27] It depicts all the things one would expect to find in a study, plus the accoutrements of a soldier. Although there are cupboards and shelves behind some of the panels, it is not a place for real study or writing—the equipment for these is also an illusion—but for contemplation of what all these things mean. Federigo had assembled his whole world in replica, not forgetting himself, for the decorations also include four standing figures. One represents a half-size statue of Federigo in a scholar's gown, holding a spear with its point down. The others personify Faith, Hope, and Charity, but these are illusions at second remove, for they seem to show perspective paintings of figures standing in shell-niches.[28] Lastly, there is the illusion of an open loggia, with a tame squirrel and a basket of fruit on the para-

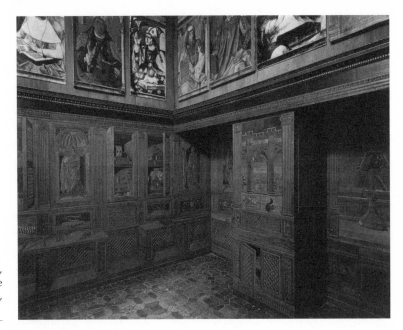

It is not a place for real study or writing, but for contemplation of what all these things mean. Studiolo, Ducal Palace, Urbino.

pet, and beyond them a view of the windy hills. If one turns one's back on this and opens the door in the opposite wall, the same scene (probably without the squirrel) is revealed in reality.

The Urbino studiolo is a small room but a very tall one, with a ceiling nearly 5 m. high. This allows space above the intarsia paneling for two complete rows of paintings. Federigo's choice does not refer to the Muses who govern the various arts and sciences; they are already symbolized by their instruments in the panelling. Instead, he called on an iconography with classical roots and a long history of medieval usage: that of Great Men. Pliny the Elder wrote that libraries should have portraits of the authors whose books they contain.[29] The medieval Nine Worthies, often shown in tapestries, comprised three Hebrew, three classical, and three Christian heroes (see Chapter 4). Federigo's learned imagination combined these precedents into an assembly of twenty-eight half-length portraits, executed by Joos van Wassenhove and reworked by Pedro Berruguete,[30] and arranged as follows:[31]

North Wall

Plato	Aristotle	Ptolemy	Boethius
St. Gregory	St. Jerome	St. Ambrose	St. Augustine

East Wall

Cicero	Seneca	Homer	Virgil
Moses	Solomon	Thomas Aquinas	Duns Scotus

South Wall

Euclid	Vitt. da Feltre	Solon	Bartolus
Pius II	Bessarion	Albert the Great	Sixtus IV

West Wall

Hippocrates	Peter of Abano	Dante	Petrarch

Like the twin chapels below, the studiolo portraits unite the pagan and Christian roots of Federigo's culture. The upper row comprises classical figures, plus Peter of Abano (thirteenth-century physician and magician) and Bartolo (fourteenth-century jurist); the lower row, Jews and Christians. The philosophers, authors, Fathers and Doctors of the Church need no comment. The Seven Liberal Arts are all represented by prominent exponents: Grammar (Vittorino), Rhetoric (Bartolus), Logic (Aristotle), Arithmetic and Music (Boethius), Geometry (Euclid), Astronomy (Ptolemy), as well as Medicine (Hippocrates). But Federigo exceeds the usual brief of "Great Men" in admitting four contemporaries: his patrons and employers Pius II (the humanist Aeneas Silvius Piccolomini) and Sixtus IV (founder of the Sistine Chapel, who promoted Federigo from Count to Duke in 1474), his friend Cardinal Bessarion, and even his schoolmaster Vittorino da Feltre (1374–1446). This was the pantheon whose presence he evoked, joining his world seamlessly to that of the recent and distant past and, by implication, enrolling himself therein.

Liebenwein points out that the placement of the studiolo was symbolic, being above the main portal of the palace, facing away from the city of Urbino over the Duke's rural domains.[32] The same is true of the twin chapels: that of the Muses is entered directly from the loggia, flanked by its perfect Corinthian columns. One is reminded of a more famous solar monarch, Louis XIV of France (see Chapter 11), whose bedroom at the exact center of the palace of Versailles overlooked the front entrance and the convergence of roads from every point of the compass.

When Federigo took ownership of a subsidiary castle in the town of Gubbio, he built another studiolo there. This room measured about 4 m. long, with unequal short sides of about 2 and 3 m. and a ceiling height of 5.3 m. According to Olga Raggio, the designer of the intarsias was most likely Francesco di Giorgio Martini (1439–1502), who from 1476 oversaw all the renovations and additions to the Urbino palace, and the execution by the Florentine workshop of the brothers Giuliano and Benedetto da Maiano.[33] These panels had a forlorn career until they found a home in the Metropolitan Museum of Art, New York, where they have been lovingly restored. This more restrained studiolo may disappoint by comparison with

This more restrained studiolo may disappoint by comparison with the one at Urbino, but there is something classically perfect about it. Studiolo from the Ducal Palace, Gubbio. New York, Metropolitan Museum of Art.

the one at Urbino, but there is something classically perfect about it, and to that extent more satisfying. Whereas in Urbino everything of any significance was crammed in, in Gubbio all inessentials were eliminated. There is no loggia protruding into the room, no cupboard of armor, no standing figures, and no real cupboards behind the paneling. The only object left out on the benches is the mazzocchio. As for the paintings, instead of Urbino's host of Great Men there were the Seven Liberal Arts, probably painted by the same artists.[34] Music and Rhetoric are now in London (National Gallery); Astronomy and Dialectic perished in Berlin during World War II.

The Arts are allegorized as elegant women of varying ages seated on thrones, each with a kneeling, male devotee. One of these is Federigo himself, who receives a heavy book from Dialectic: per-

Federigo receives a heavy book from Dialectic, perhaps an allusion to the contentious nature of his military life. Melozzo da Forli, *Dialectic with Federigo da Montefeltro.*

haps an allusion to the contentious nature of his military life. Music holds a slimmer volume, perhaps a part-book, and directs the attention of her handsome companion, Costanzo Sforza, to a portative organ. Ptolemy lays aside his crown (the Greek astronomer was often confused with Ptolemy, King of Egypt) and accepts an armillary sphere from Astronomy. Rhetoric's votary, who turns his back on us, is perhaps the young Guidobaldo da Montefeltro, for whom the unfinished studiolo was finished after his father's unexpected death.[35] Federigo died of malaria while on campaign to rescue the city of Ferrara. If he had not succumbed, Belfiore and its treasures might also have been saved from destruction.

Returning for a moment to Ferrara, the last of the three reigning brothers, Ercole I, was the father of two exceptional women, Beatrice and Isabella d'Este. It is the latter who commands our attention here, for she was the creator of the next important studiolo. Isabella d'Este (1474–1539) arrived at Mantua in 1490 as the wife of Marquis Francesco II Gonzaga (reg. 1484–1519), and immediately appropriated a pair of rooms, one above the other, in the Castello San Giorgio.[36] The upper room was called her studiolo, the lower one her grotto (*grotta*, an underground chamber—see Chapter 7). Two main precedents influenced her: her mother's suite in the Castle of Ferrara, which consisted of a largish oratory, three small chambers, and a secret garden;[37] and the rooms of the Urbino palace, which Isabella had often visited.[38] (Guidobaldo da Montefeltro grew up to marry her sister-in-law Elisabeth.)

At first Isabella planned rooms modestly decorated with portraits of her family and friends, and cupboards and shelves to hold her growing collection of bronzes, coins and medals, hard-stone carvings, etc. In 1494 the floor of the studiolo was taken up because rats had nested under it, and new tiles with the Gonzaga emblem were laid. (Isabella insisted that the rats not be killed, but turned out into the moat.) Two years later, she began to commission easel paintings, and in 1497 received the first and finest of these, Mantegna's *Mars and Venus,* often known as *Parnassus.*

The studioli described up to now have all shared the peculiarity that their walls were not painted directly in fresco or hung with tapestries, as most palace rooms were, but fitted with separate paintings. Isabella's decorative principles derived partly from this tradition, and partly from a growing regard for paintings as collectible objects and artists as interesting characters in their own right. She did not want a uniform cycle of decorations by a single hand or studio, but, like a modern curator, hoped to display examples of all the best artists. She actually saw her collection as a field for rivalry between the artists, where visitors were supposed

Mars and Venus's child Eros represents the higher, spiritual love, aiming a blow-pipe at Vulcan, father of his half-brother Anteros. Andrea Mantegna, *Parnassus*.

to judge the paintings against each other.[39] She eventually succeeded in acquiring two Mantegnas, two Lorenzo Costas, a Perugino, and two Correggios. Her efforts to obtain works by Giovanni Bellini, Botticelli, Filippino Lippi, and Leonardo were in vain.

Isabella's rooms were low-ceilinged in comparison to Federigo's, and did not have the marked contrast between two levels of imagery in the paneling and the paintings, nor the intellectual games of perspective and illusion. It was only after 1505 that intarsia panels were installed.[40] The paintings which, over many years of difficult negotiations, came to furnish the studiolo were all pagan in their themes and personages. All had to do in some way with Virtue triumphant over Vice. Isabella was sufficiently learned in her own right to prescribe the subject-matter, and so attentive to detail that she sent Perugino a piece of string, to show him exactly how tall the figures in his painting must be.

According to Egon Verheyen, a student of Erwin Panofsky, Mantegna's *Mars and Venus* celebrates the union of this adulterous couple and their parentage of Eros. Janet Cox-Rearick adds to this that the astrological implications point to Isabella's (entirely regular) marriage on February 12, 1490.[41] The traditional title of *Parnassus* derives from the presence of Apollo playing his lyre while the Muses dance, but this is secondary: they always provide the entertainment at Olympian weddings. In Neoplatonism and late antique mythology, Mars and Venus's child Eros represents the

higher, spiritual love. His half-brother, Anteros, who stands for the lower, bestial love, is the child of Venus and her husband Vulcan.[42] Mantegna shows Vulcan excluded from the celebration: he gesticulates angrily from his cavern, while Eros, standing beside his parents, aims not an arrow but a long blowpipe or pea-shooter at Vulcan's genitals. Mercury and Pegasus, otherwise unexplainable, are there for the sake of the astrology. It is a sensuous, joyful, and amusing painting.

Turning to its pendant, Mantegna's *Minerva,* or *Wisdom Expelling the Vices from the Garden of Virtue,* even the great iconologists are unable to satisfy one another as to the meaning of all the details. The same is true of Lorenzo da Costa's twin paintings, *Comus* and *The Coronation of a Lady.* Each has a token scene of violence off to one side, while the main cast goes through the motions of a courtly pageant with the blank expressions of sleepwalkers, to the accompaniment of fantastic musical instruments. Perugino's *Combat of Chastity and Eros* is more simplistic and moralizing, and no more bloody than a ballet. This completes the set of five paintings in the studiolo. Seeing them today in the Louvre, it is hard to imagine their effect in a room of only about 4 x 2.5 m., lit by a single window or by lamplight. In contrast to the single, large figures of Federigo da Montefeltro's studiolo paintings, Isabella's must have presented an almost indigestible richness of color and incident.

The same applies to Isabella's grotto below, which was reached by a little staircase. The low vaulted ceiling was decorated with two of Isabella's emblems: a musical staff with time-signature filled entirely by rests, and the number XXVII. The former denotes Time and Silence; the latter supposedly a pun on *ventisette* (twenty-seven) and *vinti siete* (you are conquered). I also suspect an allusion to Harmony in a cosmic sense, for 27 is the limiting number of the scale with which, in Plato's *Timaeus,* the Demiurge creates the World Soul. The grotto contained the following items: 79 vessels of jasper, rock-crystal, agate, and onyx; cameos; flasks and salt-cellars in goldsmith's work; 8 clocks, 6 hourglasses. In a cupboard there were a few sacred objects: a Pax, a reliquary, and four books of hours. There were 29 gold coins or medals, 866 silver ones, displayed in boxes and in a special cupboard; antique statuettes and bronze portrait heads, miscellaneous pieces of marble, a Dying Cleopatra, and, prize of the collection, three Sleeping Cupids, one antique and the others by Michelangelo and Sansovino. (Visitors were invited to compare them.) The natural objects included a unicorn's horn, a long fish tooth (sawfish jaw?) hung over the window, seashells, corals, and uncut stones.[43]

After her husband died, Isabella moved her private suite to the ground floor of the palace. This presented a new challenge to her

collecting and decorating talents, for the suite consisted of a large chamber, a flat-ceilinged studiolo, a vaulted grotto, three little rooms, and a secret garden, all on the same level. Unlike her mother's suite and the complex of small rooms in the Urbino palace, neither of Isabella's suites included a chapel. While her court was no less Christian than Federigo da Montefeltro's, Isabella, as one of the most educated, curious, and self-directed women of her era, could not have been satisfied with the pious observances that were supposed to fulfil the inner needs of aristocratic matrons and widows. Nonetheless, it is worth noting Patrizia Castelli's arguments in favor of some sacred or divine quality adhering to the grotto.[44] Castelli cites several letters from Isabella's friends which indicate something of the kind, perhaps pointing to a Marian devotion with associations to the *hortus conclusus*, the cave of the Nativity, and the virgin womb.

Isabella's existing set of paintings did not quite fit into her new studiolo. She chose to leave out Costa's *Coronation of a Lady* and to replace it with two new paintings in vertical format and up-to-date style: Correggio's *Allegory of the Virtues* and *Allegory of Vice*. The fact that the vices are pictured at all suggests to Wolfgang Liebenwein that *voluptas* or pleasure has a place in Isabella's universe, and that, in accord with the new humanism, a man or woman has the freedom to choose between elements that are both present in the psyche.[45]

Certainly there is a humor and a humanity in Isabella's paintings that is lacking in Federigo's Great Men and solemn allegories of the Liberal Arts. While one feels sure that the Urbino and Gubbio studioli were always kept scrupulously tidy and probably empty, Isabella's must have been more like Piero de' Medici's glorious muddle. Eugenio Battisti makes the point that whereas Federigo's studiolo was an opening to history, Isabella's (and also the Belfiore studiolo) was open to a garden and to nature. Instead of heroic decorations, there were gods and nymphs, rites, eroticism, and intellectual subtlety. Battisti calls it an "active Arcadia," where one goes for the cure of the passions; an "artificial Paradise" that is a place of music and the harmony of the sentiments.[46]

As a retreat for the contemplation of rare and beautiful objects, the studiolo had a place in the palaces and villas of many princes and wealthy commoners. Few of them, however, felt so temperamentally drawn to this way of being that they devoted as much thought and energy to it as Federigo da Montefeltro and Isabella d'Este. There is one studiolo of the sixteenth century that outdoes theirs in its originality and concentration of atmosphere: the famous one in the Palazzo Vecchio of Florence, designed for Grand Duke

Agostino Bronzino (attrib.), *Francesco I, Grand Duke of Tuscany.*

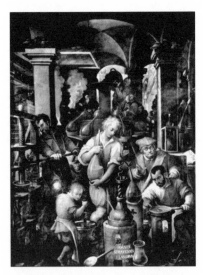

Francesco, seated, with rolled-up sleeves assists his court botanist in alchemical work. Giovanni Stradano, *Alchemist's Laboratory.*

Francesco I of Tuscany (1541–87).[47]

We shall return to Francesco more than once in the course of this work. He took over the reins of the Duchy in 1564 when his father Cosimo I retired, exhausted by failing health and by the recent death of his wife and two of his favorite children, and succeeded to the grand ducal title on Cosimo's death in 1574. By that time Francesco had taken a firm hand with his ailing but still lusty father, ensuring that none of the offspring of Cosimo's liaisons should threaten the succession or eat into the Medici inheritance. But the Florentines found the introverted and melancholic Francesco a disappointment after the brilliant and self-aggrandizing Cosimo, who brought the Medici back from exile, got them dubbed Grand Dukes, and firmly married them into some of the best families in Europe. Francesco returned the Florentines' compliment and tried neither to cause them any trouble, nor suffer any from them. For the whole of his reign there was no war, but also no economic progress. It was at least two centuries too early for research and development in technology, which was one of Francesco's favorite pursuits, to have any practical economic benefit.

Francesco loved to spend his time in laboratories and workshops, both in the Palazzo Vecchio, now appropriated as the Ducal Palace, and in the complex of foundries and workshops that Cosimo had established near the monastery of San Marco. In 1576 the Venetian ambassador wrote that the Grand Duke "spends practically all his time in a place they call the Casino, where in the guise of a little arsenal in several rooms he has various masters who work at various things, and there he keeps his alembics and all his apparatus. He goes there in the morning, and stays until lunchtime, and after lunch he goes back to stay until the evening, and when he comes out he walks around the city a little for recreation. He undresses there and stands working now at this artefact, now at that, always doing some experiment and making many things with his own hands."[48]

Several of the paintings in Francesco's studiolo show him in person, visiting the glassworks and foundry, working in the goldsmith's atelier on the grand-ducal crown, and with rolled-up sleeves assisting his court botanist Joseph Goedenhuyse in alchemical work. As already mentioned, Francesco's ancestors Piero the Gouty and Lorenzo the Magnificent had collected antique, Islamic, and modern vessels made from semi-precious stones and rock-crystal, as well as the blue and white porcelain of the Orient which was almost as highly prized. Francesco was a collector, certainly, but was not content just to admire other men's work. It is reported that he learned to melt rock-crystal and to recast it into vases,

It is reported that Francesco learned to melt rock-crystal and to recast it into vases. More certainly, he and his assistants invented the closest approximation to Chinese porcelain. Vases of rock-crystal and porcelain from the Medici workshops.

though I am not aware of any objects ascribed to this source. More certainly, he and his assistants invented the closest approximation to Chinese porcelain before the correct formula was discovered in Saxony in the 1710s. The modest-looking blue-and-white pieces from Francesco's workshop are among the rarest items in ceramic collections. He also founded the Florentine industry of *pietra dura* (marquetry in semi-precious stones) that still flourishes today. Less productively, he joined in the quest for perpetual motion, and conducted research into poisons that required the supply of thousands of scorpions. Perhaps he was testing the efficacy of his porcelain, for there was a traditional belief that a genuine porcelain vessel would shatter if poison were placed in it.

The studiolo or *stanzino* (little room) in the Palazzo Vecchio was begun in 1569, completed three years later, and dismantled in 1586 when Francesco moved his collections to the new Uffizi Gallery. Marco Bardeschi describes it as "a crypt, a hypogeum, grotto, humid matrix, moving in darkness at the heart of the gigantic palace, dedicated to the night hours when cares are dismissed. Here one enters the oneiric state, sleep as a state of grace, bringing visions and extrasensory perceptions, exploring the world of lost desires."[49]

Francesco's studiolo is a rare example of Renaissance artists collaborating not as subordinates in a master's workshop, but as equals, as though realizing Isabella d'Este's ambition to have paintings by all the best artists. A whole school of Florentine Mannerists—eight sculptors and over twenty painters—gave it some of their finest work. The room is large for a study (8.4 x 3.3 x 5.6 m.), but so crammed with imagery that it seems smaller. The barrel-vaulted ceiling is painted in fresco, and the walls below are completely filled with two rows of paintings on slate panels, of which the lower row forms the doors of cupboards. Circular portraits by Bronzino of Francesco's parents, Cosimo I and Eleonora of Toledo, preside from opposite ends of the room, recalling the custom of decorating studioli with family portraits or with the owner's genealogy. On a level with the upper row of paintings there are also eight bronze statues of gods and goddesses in niches. The artists were free to use their individual styles, which are very various, but beside the restrictions of shape and size, the subjects all conformed to an overall scheme devised by Francesco in consultation with his secretary, the Benedictine abbot Vincenzo Borghini (1515–80). As Eugenio Battisti points out,[50] the studiolo may seem minor or marginal in the history of art, but one should consider the quality of the work that went into it, in comparison with the suffocating conformity of other works (meaning religious ones) by the same artists. Unable anywhere else, either individually or as a group, to reach the same level, "second-rate" artists like Santi di Tito, Maso

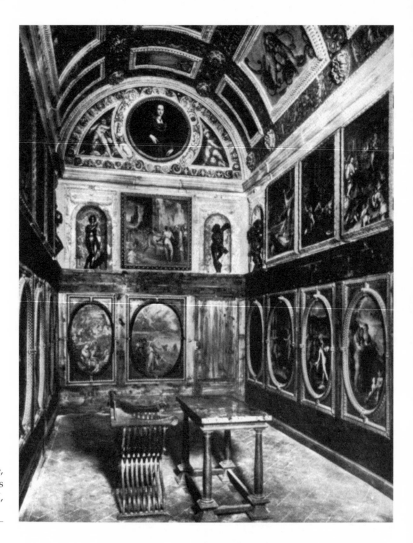

A crypt at the heart of the gigantic palace, dedicated to the night hours when cares are dismissed. Studiolo of Francesco I, Palazzo Vecchio, Florence.

di San Friano, Poppi, Allori, Zucchi, Cavalori, and Macchietti gave there of their very best.

The overall theme of the decoration is Nature, who is represented in the key position at the center of the vault. She is shown as an ample, nude figure suckling an infant and surrounded by many animals, handing a crystalline object (the Philosopher's Stone?) to the nude male figure of Prometheus. Wolfgang Liebenwein points out that Borghini's chief idea, unique to Renaissance humanism, was the equal worth of man's and nature's creations. Like Prometheus, man takes what nature or the gods give him, and makes from it a second creation.[51] The figure of Nature is surrounded by personifications of the four qualities of Aristotelian physics (Hot, Cold, Moist, Dry), the mixture of these (shown as pairs of wrestling putti), and the four elements that result from the mixtures. The vault also pictures the four seasons, which are the

Free from the suffocating conformity of religious art, "second-rate" artists gave of their best. Vittorio Machietti, *Medea rejuvenating Jason*.

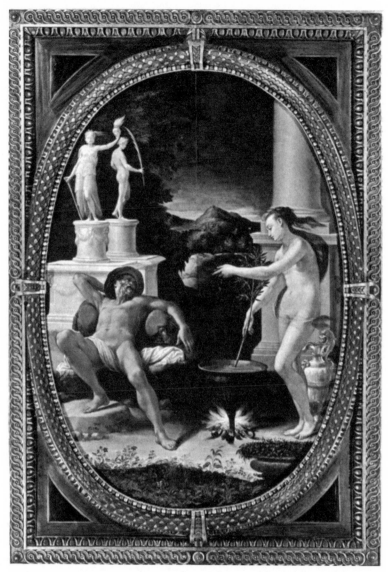

The melancholic humor, best suited to philosophers and alchemists. Francesco Poppi, *Melancholy*.

temporal reflections of the four qualities; the four humors (Choleric, Sanguine, Phlegmatic, Melancholic) and the corresponding temperaments, which represent the elements in the human microcosm. All of these are archetypal forms or energies that apply to macrocosm and microcosm alike.

Mediating between the "heaven" of the vault and the "world" of human activity shown in the paintings are the eight medium-sized bronzes that are masterpieces of the nude figure. For Fire there are Apollo and Vulcan; for Air, Juno and either Zephyr or Boreas; for Water, Venus and Amphitrite; for Earth, Pluto and Ops (god of wealth). Borghini intended the room to contain specimens classified according to these eight divinities.[52] He wrote to

Vulcan presides over iron and steel, clocks and automata, locks and snares. De Rossi, *Vulcan*.

Francesco: "The stanzino which is being renovated is intended to serve as a closet for objects that are rare and precious on account of their value or their art, as for example jewels, medals, intaglio stones, worked crystal and vases, devices, and the like—not too large, kept in their proper cupboards, each according to its kind."[53] The attributions were as follows:

> Pluto: gold, silver, medals, enamels set in goldsmith's work;
> Terra or Ops: porphyry, jasper, agate, marble, colored stones (the "bones of the earth"); also animal bones, ivory, horn, and rare woods such as ebony;
> Venus and Amphitrite: pearls, coral, amber;
> Juno: rings, jewels, diamonds, and other precious stones;
> Boreas: rock-crystal (thought to have been frozen by intense cold), porcelain, glass;
> Apollo: colors, light, lapis lazuli, and other coloring stuffs made, by art or nature; also healing things: horns, bones of special beasts, juices, plants, mixtures reserved for great princes;
> Vulcan: hard metals, steel and iron, clocks, automata, locks.

Underlying Borghini's plan is the traditional doctrine of correspondences, according to which celestial and terrestrial things are linked by kind, and the time-honored principle of astrology—that earthly things are formed and ruled by the planets—and that these are named for the similarity of their natures to those of the classical gods and goddesses. The studiolo organizes them into a memory-system, thus impressing them on the imagination, which receives its fullest stimulus in the thirty-four paintings.

The paintings on the two long walls are dedicated to Fire and Water, those on the shorter end walls, to Earth and Air. The subjects are of two kinds: episodes from ancient mythology or history, and depictions of manufacturing or discovering specific substances. The latter, reflecting Francesco's technical interests, are as follows:

<div align="center">

Collecting Amber
Processing Wool
Pearl Fishing
Diamond Mining
Mineral Baths
Gunpowder Factory
Glass Factory
Goldsmithing
Alchemical Laboratory
Bronze Foundry
Gold Mining

</div>

Venus gives her girdle to Juno, to help her seduce Jupiter; or else she takes it back from Juno to give to Paris. Francesco della Coscia, *Venus and Juno*.

The large paintings of diamond and gold mining occupy the places of honor at the two ends, because diamonds were believed to be a condensation of the element of Air, gold of Earth. The mythological and historical themes in the Studiolo mostly relate to the objects, the elements, or both:

Perseus and Andromeda (monster's blood turns to coral)
Alexander gives Campaspe to Apelles (paintings)
Crossing the Red Sea (water)
Triumph of Neptune and Thetis (water)
Lavinia at the altar (fire)
Phaeton's Sisters (weeping tears that turn into amber)
Mercury tells Ulysses how to restore his companions to human form (herbs)
Dreams (opiates?)
Cleopatra's Feast (pearls)
Venus lends Juno her girdle (aphrodisiacs?)
Aeneas lands in Italy (discovery of glass)
Fall of Icarus (machines)
Belshazzar's or Polycrates's Feast (gold and silver vessels; ring)
Medea rejuvenating Jason (potions)
Hercules and the Dragon of the Hesperides (golden apples)
Hercules and Iole (her dog discovers the murex shell that gives purple dye)
Sack of a City (carrying off golden treasures)
Apollo delivers Asclepius to Chiron (medicines)
Alexander and Darius's family (jewelry)
Vulcan's Furnace (iron and steel)
Danae and the Shower of Gold (coins)
Deucalion and Pyrrha (stones)
Atalanta's foot-race (golden apples)
[Lost: Francesco as Solomon, asleep][54]

Francesco de' Medici's studiolo, which is one of the most extraordinary rooms ever created, unites the themes and the purposes of all the preceding ones. Like Federigo da Montefeltro's portrait in the Urbino studiolo, or Isabella d'Este in Perugino's *Coronation of a Lady*, Francesco himself is shown in five of the paintings. His favorite pursuits are pictured, but these are not, as in Federigo's case, the liberal arts and the conduct of war, but the investigation of nature through practical experiment. The eight gods and goddesses of antiquity take the place of Apollo and the Muses, or of the Liberal Arts in the Gubbio studiolo. Instead of perspective intarsia that requires a person to stand at one point and admire the whole, there is a more subtle situation of the hu-

man being as the focus in which the four qualities, elements, seasons, humors, and temperaments meet. Instead of Great Men, or Isabella's moralizing allegories, there is a whole pageant of figures from Homer, Virgil, Ovid, and the classical historians. The two worlds that are held in equilibrium here are not those of paganism and Christianity, as in Federigo's twin chapels, but those of the mythic past and the scientific present. Moreover, in the cupboards behind the pictures were the prize pieces of the Medici collections, natural wonders, monstrosities, and strange compounds. Only books were absent; but the whole studiolo was an invitation to read the Book of Nature and to plumb her mysteries.

Marvels of Nature and Art

CHAPTER 6

WHAT Francesco de' Medici kept in the cupboards of his studiolo comes very close to the definition of a *Kunst-und Wunderkammer*, a "chamber of art and marvels," as such collections became known in the German-speaking lands. When Eugenio Battisti, in his monumental study of the Mannerist mentality, wrote that there were 250 Wunderkammer in Italy alone,[1] he was not referring to exquisitely decorated retreats, but to the phenomenon of collections that would ultimately evolve into museums. The boundaries between studiolo and Kunstkammer (as I shall call it) are vague, for examples of each vary widely. As I understand the two room-types and the intentions behind them, the studiolo is defined by its decoration, the Kunstkammer by its contents.

In the last chapter, mention was made of Piero de' Medici, called "il Gottoso" (the gouty). A less painful affliction was Piero's passion for collecting rare and beautiful objects. He began a family obsession that lasted up to Grand Duke Cosimo III (1642–1723), who after collecting 30,000 coins and medals, arranged them neatly in cupboards and sealed them shut, because they stole time from his religious devotions.[2] Piero's studiolo in the Medici Palace contained paintings by Botticelli and Piero di Cosimo, and bronzes by Donatello,[3] but those were not his prize possessions. Beside the indispensable unicorn's horn, his greatest treasures were antique gems and the hard-stone vases he had inherited from his illustrious father. The gems were valued at 400–1000 gold florins apiece, at a time when a master painting cost 50–100 fls., and 1000 fls. bought a city house, or paid for the whole cycle of frescoes of Saint John the Baptist at Santa Maria Novella.[4]

There were several reasons for the inflated value placed on these hard-stone collectors' items. First, they were antique, hence irreplaceable. Second, many of the gems and vases were in perfect condition, whereas the paintings, sculptures, and architecture surviving from the ancient world were all more or less damaged. Third, they were beautiful both in substance and in form. The engraved gems preserved the classic canons of beauty in miniature. The human figures, which for the Renaissance were the essence of Greco-Roman art, were exquisitely formed, sometimes within the compass of a thumbnail. This made them ideal models for artists. The courtyard of the Medici Pal-

ace, for instance, was decorated with roundels in relief based on gems in the family's collection. Fourth, they were portable: a prince's ransom could be hidden in one's pocket. When the Medici were exiled from Florence in 1494, they took these treasures with them, and brought them back again in 1512.

The vases of crystal and hard stone were not all as antique as they were believed to be: many of them were of Byzantine or Fatimid (Arab) work. But the nature of their material prevented a too obvious imposition of any regional or transitory style. They still showed a perfection of craftsmanship that had yet to be recaptured, along with the secrets of carving stones that were harder than tempered steel. In the *Hypnerotomachia* there are many passages redolent of the awe in which these lost techniques of the ancients were held. For example, describing the altar in the Temple of Venus, Poliphilo writes: "This wonderful sculpture was made entirely from a single piece of finest jasper, with many colors mixed and beautifully combined, and worked with incredible and exquisite lineaments on its every part. It was surely not worked with chisel or knife, but marvelously made through some unknown artifice."[5]

When Piero died in 1465, he left six vases of rock crystal, seven of jasper, and two of chalcedony.[6] His son Lorenzo the Magnificent was just as fond of this art form. The inventory of 1492 values his 33 vases at 21,318 florins, as compared to the entire contents of the Medici Palace at around 75,000 fls.[7] Alone among Renaissance collectors, Lorenzo had the temerity to have his own initials engraved on his vases and on many of his gems, invariably written thus: "LAV.R.MED." This has been interpreted as standing for "Laurentius Rex Medicorum" (King Lorenzo of the Medici), in a discreet presumption of royal status.

There was also an aura of sanctity attaching to chalices and drinking cups because of the associations with the Mass and with the Holy Grail, which in one legend is said to have been carved from the emerald eye of Lucifer: the ultimate hard-stone vessel. Lorenzo's son Giovanni (1475–1521), who became Pope Leo X in 1513, honored this connection in using many of the "LAV.R.MED" vases as receptacles for relics, which he presented to his family church, San Lorenzo in Florence. Along with this gift came conditions, and such fierce threats in case of the slightest infraction that the papal bull declaring them was known as the *bolla fulminante*.[8] The relics were to be kept in a cupboard above the high altar, secured by three keys entrusted to separate dignitaries, and shown to the public only once a year, on Holy Saturday. The faithful were to assemble in the church, men on one side and women on the other, and the clerics would lift up each vase, proclaiming the relic within in Latin

and Italian. Since the relics must on no account leave their vases, the public only saw the containers and had to take the contents on trust. For this act of faith, they received indulgence of their sins.

With the change of attitude in the eighteenth century the cult of relics was regarded with enlightened disdain. The relics were purged, the surviving ones put into rock-crystal vases so that they could at least be seen, and the ancient hard-stone vessels came home to the Uffizi. They are now in the Museo degli Argenti at the Pitti Palace, their magical aura much diminished.

Although in the mid-sixteenth century the craftsmen of Milan and Bohemia discovered ways to rival the antique and medieval masters, the mystique of hard-stone carving remained undimmed. Perhaps the irreplacable patina of antiquity had lost some of its prestige, since the achievements of Leonardo, Raphael, and Michelangelo had raised that of modern art so high. Perhaps, too, the taste of the new century was better pleased by the Mannerist style. However that may be, the work of the Miseroni family and others supplied an eager demand for these aristocratic table-ornaments and cabinet-pieces, including some that deserve no better name than kitsch.

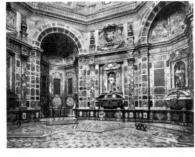

A frigid, octagonal space designed by the lordly amateur Don Giovanni de' Medici, entirely lined with hard-stone panels. Chapel of the Princes, San Lorenzo, Florence.

Some think that the nadir of taste was reached in the burial chapel of the Grand Dukes at San Lorenzo: a frigid, octagonal space designed by the lordly amateur Don Giovanni de' Medici (1566–1621), entirely lined with hard-stone panels in geometric patterns. But this is to mistake the Poliphilic nature of the enterprise, which occupied several generations of Medici and was completed only in the twentieth century. For one thing, it was meant to echo the Pantheon in Rome, which was the earliest surviving colored marble interior.[9] The conquest of hard stone, the perfection of surface and pattern; the extraordinary colors and textures that nature has concealed for aeons, waiting to be released by human effort and polish; the tradition of the medieval lapidaries, which classified the therapeutic and magical virtues of rare stones and gems: all this was present to the sixteenth-century mind in a way that has been forgotten today. In an essay of poetic scholarship, Alessandro Rinaldi writes of this chapel as resembling the matrix of minerals, where, under the saturnine lead of the roof, seven Medici princes rest in their sumptuous bronze and gold coffins, corresponding to the seven mythical Wise Men or Kings, or to the seven fundamental sidereal minerals, "perpetuating the granitic dynasty as if it were the primordial *lapis*."[10] But when everything can be made, after a fashion, from plastic, there is little empathy for the patient work of the *pietra dura* craftsman.

No more does the tourist care for Francesco del Tadda's porphyry statue of Justice (made 1569–81), which stands on a tall col-

umn in the Piazza della Trinità, but it commands respect, at least, in the light of Suzanne Butters' monumental study of the use and meaning of porphyry. This was a hard stone quarried in Egypt, imported to Europe and Byzantium by the Romans, carved by them into columns and statues, and left there to torment the sculptors of succeeding eras, who could not make a dent in it with their steel tools. No wonder that Poliphilo's dream-buildings are so full of porphyry and its green companion stone, serpentine. No wonder, too, that Isabella d'Este was so keen to have these stones in her studiolo, where they were set as roundels into the marble door-frames.[11]

The deep blood-red stone was associated, as its name suggests, with the purple dye of royal garments—another thing that the Renaissance could not reproduce. The heirs to the throne of the Eastern Empire were traditionally born in the porphyry-lined birth chamber of the Imperial Palace at Constantinople:[12] hence the surname Porphyrogenitus ("born to the purple"), given to the child of a reigning emperor. The idea of royal blood led to that of the blood of Christ, and, especially when the porphyry was carved into circles, to the consecrated Host that was really Christ's flesh. In old St. Peter's in Rome, there was a great porphyry roundel in the floor which figured prominently in papal, royal, and imperial ceremonies.[13] A copy of it was made for the coronation of Emperor Charles V in Bologna, 1530: a ceremony at which Cosimo I was present, and young Giorgio Vasari helped with the decorations. When in 1565 Duke Cosimo was presented with a roundel seven feet in diameter, he still nursed ambitions to be crowned King of Tuscany. The royal porphyry would then have been the ultimate transmutation of the *palla*, the red ball-like emblem of the Medici. When Cosimo was eventually crowned Grand Duke in 1570, this great slab was prominently displayed in the Pitti Palace, along with the new grand ducal crown, as if to say that now he was *almost* a king.[14] It is still there, in the Museo degli Argenti, bearing silent witness to the end of the Medici—as a table-top.

Even Michelangelo could not cut porphyry.[15] It could only be shaped by abrasion, which was suitable for grinding flat panels but quite hopeless for sculpting. In 1555 there was a breakthrough. Cosimo himself oversaw the distillation of an herbal liquor that tempered steel tools sufficiently that they could attack the stone.[16] It was never established whether Cosimo or his sculptor Tadda had invented this new tempering formula, which superseded the hitherto favored mixture of radishes and worms [sic],[17] and was of course kept secret. But at all events, Tadda now began to make small porphyry carvings, and over the years developed his technique, and his tools, to the point when a monumental statue was

The idea of royal blood led to that of the blood of Christ, and, especially when the porphyry was carved into circles, to the consecrated Host. Porphyry roundel set in the wall of the Baptistery of the Arians, Ravenna.

The tyrant-slayers of old Florence were no longer appropriate subjects for the autocratic Grand Duchy. Francesco del Tadda, *Justice*, on Roman column, Piazza della Trinità, Florence.

feasible. The tyrant-slayers of old Florence (David, Judith, Perseus) were no longer appropriate subjects for the autocratic Grand Duchy, and so Tadda and his sons were set to work on a giant figure of Justice. When they finished it eleven years later, no one was very excited any more,[18] and no one finds it beautiful.

Where natural and artistic marvels are concerned, taste is a secondary matter; far more important is the aura conferred by tradition or credulity. It is not what a thing is in itself, but what it is believed to be, that matters. The whole fuss about porphyry was because it was royal, sacred, scarce, and so hard to work. If it were not for the aura, a perfect replica or fake would not worry anybody; attributions to famous artists would be irrelevant, and the cult of relics would have died with the Enlightenment, whereas of course it flourishes to this day in various debased and secular forms.

As I have defined the difference between studiolo and Kunstkammer as stemming from decoration, as opposed to contents, it becomes plain that they answer different psychological needs. Nobody would spend time in a studiolo whose decorative cycle was still in progress, because the atmosphere and the microcosmic wholeness would be lacking. It would be like putting on a half-tailored garment. But the collector's preference is for an eternal work in progress. Unless he is merely an investor or a curator, he does not want a whole collection that someone else has assembled, but enjoys the pleasures of the chase, and, as it were, the kill, whether his object of desire is big-game trophies, antiques, seashells, or what not.

The man who brought the idea of the Kunstkammer from Italy into the German-speaking world was Jacopo Strada (1515–88).[19] He had begun his career in Mantua as a goldsmith under Giulio Romano, but soon moved to art-dealing, in which he was highly successful. He worked for the Fuggers, the Augsburg banking family, then entered the service of Emperor Ferdinand I (see Chapter 4) and moved to Vienna in 1558. Well aware of the value of publicity, Strada built a residence in Italianate style, and there kept open house to artists and patrons who came to view his "Musaeum": a huge collection of visual arts material. As its foundation, Strada had obtained all the papers of the architect Sebastiano Serlio (1475–1554), to which he and his assistants added a systematic program of copying famous painting-cycles in accurate drawings. For example, they copied all the bays of the Vatican Loggie, the frescoes in the Palazzo del Te, and those of the Sistine Chapel. Strada was also an authority on numismatics and antiques, on languages, and on mechanical devices. His presence and his museum had a decisive impact north of the Alps, inspiring artists and helping to form

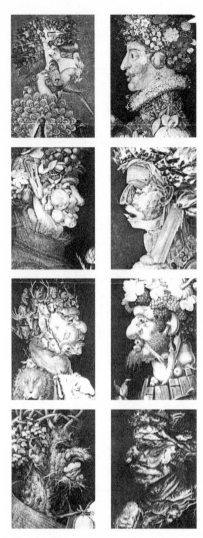

Both space and time were organized according to the principle of correspondences. LEFT COLUMN, from top down: Spring, Summer, Autumn, Winter. RIGHT: Air, Fire, Earth, Water. Giuseppe Arcimboldo, *Four Seasons* and *Four Elements*.

the taste of patrons, especially those who had not themselves been to Italy.

After the accession of Emperor Maximilian II, Strada became the official supervisor of the Imperial Kunstkammer.[20] Maximilian did not just collect oddities: he was systematic and scientific in his approach, and keen to study nature and its laws.[21] In 1569, construction began on the Neugebäude (new building), a summer palace outside Vienna that was destined to hold his collections. In the vestibule were six scenes from Roman and six from Greek history, painted in oils by Giulio Licinio (now in London, Turin, and St. Petersburg). The Great Hall contained over-life-sized figures in stucco and fresco, probably also of Famous Men,[22] and in the Westsaal were portraits of the Kaiser's ancestors. Thus the Neugebäude served the dual purpose of displaying the collection of antiquities, and of asserting the antiquity of the House of Habsburg.[23] Jacopo Strada had a hand in this, as also in furnishing the "Antiquarium" that the Dukes of Bavaria added to their Residenz in Munich.[24] These were the first purpose-built, freestanding galleries in the German realms.

Maximilian II was also a patron of Giuseppe Arcimboldo (1527–93), a Milanese who had joined the Imperial service in 1562. Arcimboldo was as versatile as any other artist of his time, ready to turn his hand to designing pageants, costumes, interior decorations, and even a "color harpsichord." The *Ringelrennen* (Procession and Tournament) which he organized in 1571 for the wedding of Maximilian's brother Charles of Styria to Maria of Bavaria is eloquent of the artist's and the Emperor's way of imaging the whole world.[25] There were representations of the Four Continents, the Four Seasons (with the Emperor as Winter, the "head of the year"), the Four Countries of Europe with their Four Rivers, the Four Winds, etc. Both space and time were organized according to the principle of correspondences, based ultimately on number. This pageant has an obvious connection with the works on which Arcimboldo's reputation rests today: the paintings that show a multitude of objects or creatures formed into a characteristic head. There is the portrait of *Rudolf II as Vertumnus* made from fruits and vegetables, that of *The Scholar* made from books, *The Cook* made from vegetables, and the cycles of *Four Elements* and *Four Seasons* presented to Maximilian in 1569, which the Emperor kept in his bedroom.

These comical paintings have deep implications. They breathe new life and plausibility into the Hermetic thesis, "that which is above is like that which is below," and vice versa. Everyone was familiar with personifications of the Elements and the Seasons, but Arcimboldo suggests something more. One can go close to the pic-

Ceres (summer) with a cornucopia, Vulcan (winter) with his forging tools. Wenzel Jamnitzer, Gilt bronze statues from the Kaiserbrunnen.

ture and scrutinize the components one by one, then as one moves away, at a certain point the head congeals out of the mass. Just so, archetypal ideas such as seasons and elements may have no other reality than that which we ourselves imagine on the basis of separate, known things. One cannot plumb Arcimboldo's intentions, or the Emperor's reactions, but this is one line of plausible speculation. Another is exactly the contrary: it occurs when one glimpses the head from afar, and only on approaching it, perceives that it is made from an assemblage of objects. Here we might draw the more Platonic conclusion, that it is the intellectual form that gives being to the physical. Philosophy apart, the Arcimboldo heads are among the most remarkable wonders of art, not least because they are so beautifully painted.

Another wonder made for Maximilian II, probably designed by the learned Jacopo Strada,[26] was the gold and silver *Kaiserbrunnen* (imperial fountain) commissioned in 1568 from the goldsmith Wentzel Jamnitzer of Nuremberg (1507/8–85) and the sculptor Johann Gregor van der Schardt.[27] By the time it was delivered in 1576,[28] Emperor Rudolf II was on the throne and already preferring Prague to Vienna, so the fountain was set up in the Hradčany. It was shaped like some Poliphilic temple. On the round base stood four, firegilt bronze figures: Flora (spring), with her attribute of flowers, Ceres (summer) with a cornucopia, Bacchus (autumn) with grapes, and Vulcan (winter) with his forging tools, around a lion with the shields of Burgundy and Austria. The four figures, now in the Kunsthistorisches Museum, Vienna, are all that survived after the fountain was melted down in 1749–50. Tuscan capitals on their heads supported an entablature that formed the base of the second level. This was shaped like an open dome or crown, arching over a symbolic landscape of land and sea, or Earth and Water. Cybele presided over Earth with mountains, mines, a forge, a stamping-mill, flowers, metals, and the four rivers of Europe (Danube, Rhine, Elbe, Tiber) driving four millwheels, each bearing a nymph. Neptune ruled Water and the sea, in constant mechanical motion with shells, seahorses, and other sea-creatures, some of them cast from life. Above them, for the element of Air, was Mercury hanging from a golden star, moving as if in flight and giving rain, with angels, eagles, and the four winds.

Somewhere above these (and we have no pictures, only descriptions to go by) were the figures of four Emperors: Ninus of Babylon, Cyrus of Persia, Alexander the Great for Greece, and Caesar/Maximilian II for Rome. Above the dome was the fountain bowl, then a celestial globe in which the sun and moon were visible. There were also four archangels alternating with four young nobles holding scepters; or, in another description, members of the human hi-

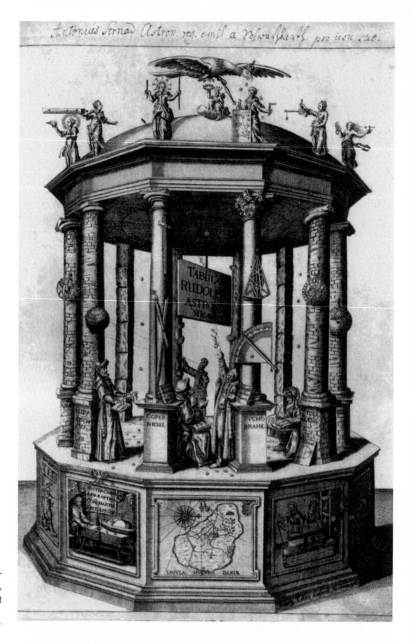

The symbolic temple pictured in the half-title of Johannes Kepler's *Rudolfine Tables*, 1627, seems like a simplified descendant of the *Kaiserbrunnen*.

erarchy from the seven Electors down to peasants.[29] At the summit was Jupiter with his thunderbolts (for the element of Fire), sitting on his eagle. This bird represented the Emperor, placed directly under God.[30] The entire fountain was a giant automaton, driven by clockwork: its parts whirred, clicked, spun, and chimed, and the water flowed. A mechanical organ, driven by water pressure, played two popular tunes: *Roland* and *Pickled Herring*.

At this stage of our study it is hardly necessary to emphasize the cosmic, cyclical nature of this fountain, in which everything

goes by fours, from the archangels Michael, Gabriel, Raphael, and Uriel, down to the seasons and their earthy produce; the parallel of human with cosmic hierarchy, familiar from the Tarocchi (Chapter 3); and the absence of any Christian imagery. The choice of music is a nice touch, for it shows that, notwithstanding the erudition and the breathtaking craftsmanship, the whole contraption was meant for entertainment.

As for the Strada family, Jacopo's son Ottavio (1550–1606) continued in the service of the Habsburgs and others.[31] He made the copies of the frescoes by Giuliano Romano and others in the Palazzo del Te, and also specialized in collecting *imprese*, the heraldic and enigmatic emblems used by princes. He compiled a manuscript of 200 emblems for the Bohemian magnate Wilhelm von Rosenberg, and a collection of 600 for Francesco I of Tuscany. In his dedication to Francesco, Ottavio Strada wrote that no explanations had been included, because princes like to keep their emblems secret. He also had secrets of his own to keep, for his natural daughter Anna Maria,[32] married to the complacent courtier Christoph Ranft von Wiesenthal, was the long-term mistress of Rudolf II and the mother of the Emperor's only offspring.

The Emperor's brother, Ferdinand of the Tirol, shared his love of curious and historical things. Archduke Ferdinand II of the Tirol, anonymous painting.

Emperor Maximilian II's younger brother Archduke Ferdinand II of the Tirol shared his love of curious and historic things, and, up to a point, his religious tolerance. Ferdinand was introduced in Chapter 4, with the Italianate buildings and the Star Castle that were the fruit of his Statthaltership in Prague. He left Bohemia in 1563 upon his appointment as Landhalter (regent) of the Tirol, and returned to Innsbruck where he had lived for his first fourteen years. He lost no time in improving his new domain. Just before he left Prague, he had commissioned the Singing Fountain, with its rustic and grotesque imagery, for the pleasure-garden beside the Belvedere; now he ordered a fountain with the theme of Actaeon for the garden that ran along the River Inn, adjacent to the Hofburg. Later he beautified it (if that is the right word) with 134 painted clay statues of gods and animals, made in 1574–78 by the court sculptor Alexander Colin.[33] He also built the Hofburg Church to house the tomb of Emperor Maximilian I, which was finally brought to completion under his pious care.

The ancestral Hofburg appealed to Ferdinand's sense of dynasty and history, but his preference was for the castle of Ambras outside the city, which he had bought upon leaving Bohemia.[34] As the years passed, Schloss Ambras acquired a free-standing "Spanish Hall" with a dynastic display of ancestors, a library, a Kunstkammer, a Rüstkammer (armory), and magnificent gardens. Exotic fruit trees bloomed there; ponds swarmed with fish, and there

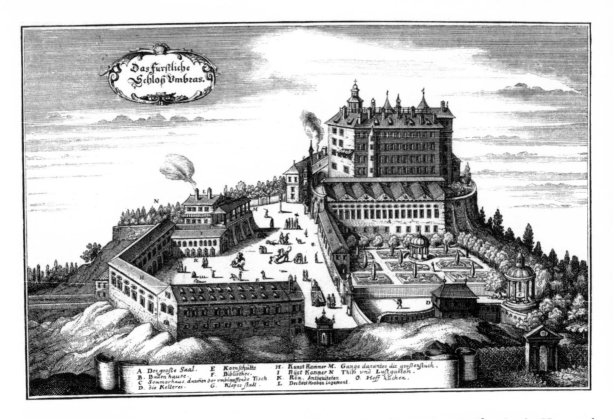

Exotic fruit trees bloomed there, ponds swarmed with fish, and there were fountains, summer houses, and half-hidden statuettes. Schloss Ambras, engraving.

were special enclosures for pheasants and other birds. Here and there were fountains, summer houses, half-hidden statuettes, and large terra cotta figures on columns. The sculptures were not classical, but fashionably humorous according to the taste of the time: there were swaggering Landsknechte (mercenaries), Hungarians, Jews, beggars, fools, and gypsies.

Then there was the Bacchus Grotto, which seems to parody the god-haunted grottoes of Italian gardens (see Chapter 8). It comprised a *Lusthaus* (pleasure house) with a revolving table and chairs that would spray the visitors with water. This gave access to a descending stair, leading to a dark cave full of barrels. Every visitor had to be initiated by being bound, fettered, and locked in this place; then the "Bacchic Priests" would enter, bearing a great cup of wine and a ritual book. The neophyte had to empty the cup, then write in the book. The guests who had undergone this initiation included other archdukes, bishops, and lords (but not Emperor Rudolf II). Unlike most drinking clubs, it was not exclusively masculine: many ladies were initiated, including Ferdinand's wife Philippina Welser, her aunts, and her sisters.[35] The ritual book was a comical piece of Ferdinand's "personalia," recording the stupidities that these patricians had written during their Bacchic hazing.

Ferdinand was a man of great physical strength and apparently

There was never a dull moment at his court. Actors, fools, dwarves, freaks, conjurors and card-sharps would come and entertain the courtiers. Glass figures of actors from Ferdinand's collection.

boundless energy. He was fascinated by artisanal work and enjoyed dabbling in it, especially in the forge, where he would make presents for his servants out of gold and silver.[36] He had his own chemical laboratory, and listened willingly to visiting alchemists,[37] but out of practical rather than philosophical interest. There was never a dull moment at his court. Traveling comedy and dance troupes would come and instruct the courtiers; fools, dwarves, freaks, conjurors and card-sharps would entertain them.[38] Other guests came on sufferance, like the Swiss peasant woman who had given birth to quadruplets: Ferdinand insisted that she be brought to Innsbruck to meet him.[39] All of this accorded with his collecting mania and his obsession with the wonderful and weird.

The interior of Schloss Ambras bristled with horns and hunting trophies, for Ferdinand's favorite occupation was the typical one of his class, hunting. (To avoid troubling his game, all housedogs within two hours' ride of the castle had to have a forepaw cut off.[40]) In the corridors were painted serious and humorous sayings. Joseph Hirn, Ferdinand's biographer, writes that the castle was intended to be a Valhalla, a memorial to military virtue. There were seventy-four cannon of light and heavy caliber, and a separate building to house the collection of arms and armor that Ferdinand had begun during his tenure in Prague. Because he was essentially a romantic, not an aesthete, he favored real, historical suits of armor that had been used in battle. He would write to other princes throughout Europe, asking if they would kindly give him one of their cast-offs. How could they say no to such a modest request, coming from the Emperor's brother? For example, in 1581 Francesco I de' Medici sent Ferdinand a sallet (helmet) that had belonged to his warrior grandfather Giovanni delle Bande Nere, and a suit of armor of Cosimo I.[41] In this way Ferdinand built up a unique collection, at minimal cost.

Ferdinand followed the example of Federigo da Montefeltro in paying homage to the great ones of the past and present. When he could not get their armor, as in the cases of those long dead or of women, he acquired their portraits. Eventually he accumulated over a thousand, which now fill room after room at Ambras, while several hundred in picture-postcard size are in the Coin Room of the Kunsthistorisches Museum. Among the subdivisions were portraits of beautiful women, of family members, and of Tirolean notables;[42] also colored wax portraits in high relief and great numbers of coins, the oldest type of historical portraiture. The whole enterprise of Ferdinand's collection of personalia reflected the humanist awareness of individuality and the uniqueness of every person, abetted by the realism of Renaissance artists who could evoke the subject's presence as never before. As for the suits of

Ferdinand's collections ranged from the sublime (Cellini's gold salt-cellar) to the ridiculous. Benevenuto Cellini, *Neptune and Amphitrite*.

armor displayed in the Rüstkammer, even though empty they gave the spooky feeling that the owner was there.

Ferdinand also collected prints, manuscripts, and books: the latter heavily biased, after the inevitable theology, toward history and the practical arts and sciences. He bought up whole libraries, making Ambras the intellectual focus of the land.[43] To modern, post-surrealist taste, the most alluring of Ferdinand's collections is his Kunstkammer. Although depleted, it can still be seen *in situ* at Ambras, and gives the best idea today of a late Renaissance collector's mentality.[44] This assemblage of objects ranged from the sublime (Benevenuto Cellini's gold salt-cellar, for example, now in Vienna) to the ridiculous (the actual rope with which Judas hanged himself). Ferdinand grouped his objects according to the substances out of which they were made, and displayed them in matching wooden cabinets, painted inside in colors complementary to the objects. The examples of goldsmiths' work were shown against a blue background; silver, against a green one; *Handsteine* (crystalline rocks) against red; musical instruments against white. There were also cases of Coral, Wood, Ivory, Automata, Iron, Porcelain, Glass, Bronze, and Feathers.

Outside the cabinets were the larger objects: a stuffed shark, a deer's horns grown into a tree-stump, a joke chair that imprisoned its sitter. On the walls were portraits of human oddities, including a man who lived for months with a spear through his head, a family with cat-like, hairy faces, dwarves, giants, a pathetically de-

formed cripple, and the original Count Dracula (Vlad the Impaler). In a separate annex, eighty-five niches held replicas of ancient sculptures, bronzes, and busts of Roman emperors. There is a weird quality to the Ambras Kunstkammer, but to enjoy it only on that level, as Sunday visitors do, is to miss its philosophical meaning.

Ferdinand's lust for the curious, the grotesque, and the gruesome was part and parcel with his acquisition of the beautiful and the magnificent. Both stemmed from the desire to possess the ultimate in any field, the supreme example that serves as Platonic Idea to all the rest. For example, he commissioned objects made from ivory and boxwood carved as fine as horsehairs, that take the breath away. They are not particularly beautiful, but one stands amazed at the transcendent skill of the artist. These, one is meant to feel, are the *ne plus ultra* of their species. In just the same way, one gasps at the ultimate horror, the man with a spear-shaft through his eye, who yet survived, for here was a triumph of Nature over certain death. The giants and dwarves, and even the cripple who lived to manhood without the use of limbs, show Nature as virtuoso, achieving what one never dreamed to be possible.

Horst Bredekamp, in his study of the Kunstkammer idea, narrowed the bewildering variety of objects to four categories: Naturalia (remarkable works of nature), Artificialia (remarkable human creations), Antiquities, and Machines.[45] A special place in Renaissance collections was reserved for objects that cross these boundaries and combine nature and art, such as the corals, lightly modified to resemble trees or monsters and set in miniature landscapes made from pearl or crystal. At their worst, these objects are kitsch, like beach souvenirs made out of shells. What is one to say of the glass-topped boxes of insects and small reptiles, cast from the life and painted, which wriggle when one shakes the box? The barrier between nature and art becomes hazy. Nature herself is an artist, as we see from those agates which, when sliced open and polished, display landscapes and figures. Princely collectors also loved natural rarities made up into cups with elaborate silver-gilt mountings. The favorites were coconuts, ostrich eggs, nautilus shells, conches, rhinoceros horns, pieces of "unicorn horn" (from the narwhal), and the bezoar-stones, which were believed to be the concretions of tears wept by a certain deer after eating poison. (Actually, they are hard nodules that grow in the stomachs of llamas and other herbivores.) All these were honored for their magical or curative properties, as some of them still are in China. Powdered bezoar, for example, or the use of a cup made from it, was especially prized as antidote against poison, the plague, and other diseases. The marvels of nature and art together make up a microcosm, alchemically distilled to extract the very finest, the strang-

They are not particularly beautiful, but one stands amazed at the cooperation of nature and art. Ivory table-piece, coconut goblet, and mounted crystalline rock from Ferdinand's collection.

est, the rarest examples by which the rest are judged and known.

Antiquities were essential to every serious collection, because the moderns had nothing to match them. We recall that in fifteenth-century Florence, an ancient hard-stone vase was valued at several times the price of a painting by Botticelli or Perugino. Archduke Ferdinand was not able to buy antiques on the scale of the Medici: like Isabella d'Este, he had to be content with modern Italian reproductions. Modern, too, were the bronze busts of Roman emperors that had been cast in 1520 for the tomb of Maximilian I. But these gave him a link with the past and its dynasties, from which the Habsburgs, as Holy Roman Emperors, claimed legitimate succession.

By the 1580s, when Ferdinand was assembling his Kunstkammer, it was possible to extend one's collection geographically as never before. From the Ottoman Empire came Turkish pottery, bows, quivers, and boots (all represented at Ambras). Porcelains and paintings filtered through from China and even from Japan; from the Habsburg dominions in the New World came jade, and the feathered cloak of the Emperor Montezuma.

As the last of the four ingredients of the ideal Kunstkammer, Horst Bredekamp lists Machines. Renaissance taste was attracted to them because it seemed wondrous and inexplicable when man-made objects moved as though they were alive. The phenomenon was on the borderline between art and nature. Leonardo da Vinci was adept at such inventions, having made, for example, a silver lion that walked and disgorged a bunch of lilies from its breast. The most memorable event of John Dee's Cambridge career was when in 1547 he made a flying beetle carrying a man for a performance of Aristophanes's comedy *Peace* in the hall of Trinity College, and was rewarded for his ingenuity by being suspected of black magic. In the later sixteenth century, the instrument-makers of Nuremberg and Augsburg specialized in clockwork centerpieces for dining tables; we have already mentioned the apogee of this craft in the Kaiserbrunnen. Their work was often more practical, for they also made clocks and mariners' compasses, sundials, astrolabes, surveying instruments, and firearms of the highest quality. In the sixteenth century they did not have a name for all this, but we do: it was technology. The infatuation with it has never diminished, and neither has the suspicion that there is something sinister about its power.

The machines completed the repertory of the Kunstkammer in a thoroughly Hermetic way. Of all the passages in the *Corpus Hermeticum*, the description in the Latin *Asclepius* of bringing gods into statues had caused most debate and curiosity.[46] Now it could actually be done, after a fashion. Perhaps the ancient Egyptian stat-

Perhaps this very act of setting lifeless matter in movement was something occult, an exercise of a creative power reclaimed. Musical automaton from Ferdinand's collection.

ues mentioned in the *Asclepius* were also nothing more than clever automata. But perhaps this very act of setting lifeless matter in movement was something occult, an exercise of a creative power that had been reclaimed after an aeon of human abasement. Frances Yates has written much about this borderland between technology and magic,[47] which saw its greatest flowering about this time in the grottoes of Italian gardens, and in the masques and intermedi of the late Renaissance courts (see Chapters 8 and 9).

To conclude Ferdinand's story: Philippina Welser died in 1580, and in 1582 he was married again to Eleanora Gonzaga, daughter of the Duke of Mantua. His second wife was much less fun-loving than Philippina had been, and she influenced the naturally tolerant Ferdinand into suppressing the Protestants.[48] Maximilian II had called himself neither Catholic nor Protestant, just a Christian, but his tolerance had backfired. The Protestants had taken over Vienna and proved worthy rivals in bigotry to the Catholics. Innsbruck, on the other hand, was under firm control of the Jesuits, and Ferdinand had a justifiable fear of civil war. Another sign of worsening times was the increase in trials for witchcraft, and a change in the severity with which witches were treated.[49] In 1568, Ferdinand had given express orders that a woman convicted of witchcraft in Innsbruck not be executed, and was furious, demanding an investigation of the case, when his orders were disobeyed. During the 1570s, convictions for "sorcery" were being punished merely by fines, and inquests into witchcraft were to be conducted only by learned authorities. But as time went on, the mania grew. The people became more credulous, believing in orgies (1590) and in the possibility of children of seven to ten years old being witches (1595). In 1593 the Synod of Trieste declared that magicians and their kind were "heretics," which unleashed the full power of the law on them. It is little comfort to read that in Ferdinand's territory those convicted were often sent to the galleys instead of being executed. Ferdinand delivered all such malefactors to the dreaded Count Spinola, who waited in Innsbruck for the purpose. No wonder that the Archduke's last years, until his death in 1595, were clouded by illness, political unrest, and by his failure to father a son who could inherit his title and domains. Also he was not on good terms with his nephew, Emperor Rudolf II, to whom we now turn.

Rudolf had long envied his uncle's collection. It galled him particularly that Ferdinand, as the oldest of the family, had inherited from Maximilian II two of the Hapsburgs' most magical treasures, now in the Hofburg of Vienna: a particularly fine "unicorn" horn known as the *Ainkhurn*, and the *Achatschale*, a giant agate bowl of Byzantine origin whose natural markings resembled the name of

As time went on, the witch mania grew. People became more credulous. Spirit in a bottle, from Ferdinand's collection; Mandrakes and bell for summoning spirits, from Rudolf II's collection.

His collections were a purposeful and philosophical enterprise, not the extravagances of a semi-demented monarch. Adrian de Vries, *Emperor Rudolf II*.

Christ, and which was revered as a kind of Holy Grail. Ferdinand offered them to Rudolf on loan, but this would not satisfy him: the Emperor wanted to own them.[50] The Archduke again offended Rudolf in 1584, when Philip II of Spain, as head of the Order of the Golden Fleece, asked Ferdinand (a member since 1557) to confer the Order on the Emperor. After setting out for Prague with his extensive train, Ferdinand felt ill and, fearing an epidemic, returned to Innsbruck. One can imagine what elaborate reception arrangements had to be cancelled, and what the prickly Emperor must have felt at being denied his due honor by one of lower rank. Ferdinand did make the journey the following year, installing Rudolf, the Archdukes Charles of Styria and Ernst, the Bohemian magnates Wilhelm von Rosenberg and Leonhard von Harrach, and the Duke of Bavaria;[51] but relations remained chilly.

After Ferdinand's death, Rudolf was able to buy the whole Ambras collection from Ferdinand and Philippina's son. But he was not able to unite it, as he had hoped, with the Imperial Kunstkammer in Prague before his deposition in 1611 and his death the following year. As a result it escaped the depredations of war, and survived, by a roundabout route, to this day — partly in Schloss Ambras, where it is displayed in the original cases, and partly in the Kunsthistorisches Museum of Vienna.

Historians of art and of ideas have gradually recognized Rudolf's Kunstkammer and other collections as a purposeful and philosophical enterprise, rather than (as was formerly the fashion) the extravagances of a semi-demented monarch.[52] This became abundantly clear in 1997, when the Kunstkammer was reconstituted in the Belvedere.[53] Even more than the extroverted and omnivorous Ferdinand, Rudolf made his collections the center of his imaginative, even his spiritual life. This explains why he was so reluctant to share them or show them to visitors: they were, in a sense, his inner self. In the outer world Rudolf was a prisoner of his own neurotic sensibility, of the stilted Spanish etiquette that he was never able to shake off, the leaden cape of his imperial office, and the ceaseless menace to his empire from Turks, Christian fanatics, scheming courtiers, and his own relatives. In his Kunstkammer he could close the door on all of these, and step into a world where he was truly an Emperor. In one sense it was a world that he could rule and order, while in another sense it was an unknown world waiting to be explored. In both senses it was a microcosm of the earth itself, and of the human experience of earth in that late Renaissance, when people still believed in an ordered cosmos, and there were still lands to be discovered.

The entrance to Rudolf's Kunstkammer was reached through a covered walkway, the Gangbau, between the old Palace on the

south edge of the Hradčany plateau and the stable block in the north. Eliška Fučiková has shown[54] that this was the location of a remarkable series of paintings, now lost, by Paul and Hans Vredeman de Vries: they depicted the Twelve Months and the Four Elements around Jupiter, all shown in the perspective for which these Flemish artists were famous. There was also a *trompe l'oeil* painting of a garden with a fountain: a mannerist play on the fact that there was a real one outside. Fučíková points out several parallels to this cycle of paintings, including Arcimboldo's cycles of *Elements* and *Seasons* painted for Maximilian II, and Vasari's frescoes of the Elements and Seasons in the Palazzo Vecchio, mentioned in Chapter 4. An obvious inference is the apotheosis of the ruler, as lord of time and of the sublunary world. From this antechamber, favored visitors proceeded to the Kunstkammer complex, which filled the first floor of the connecting wing with four long, narrow chambers.[55] The first three, called the "anterior Kunstkammer," were vaulted, and together stretched for sixty meters. The fourth room, with a flat ceiling, was the Kunstkammer proper, and was 33 meters long by 5.5 wide. The walls were lined with cabinets, chests, and display cases, and, at least in the fourth room, a long green table stood in the middle.

The wealth of exhibits was overwhelming. We do not know what, if any, was the overall system, but some objects of a kind were grouped together, as in a chest containing 105 knives and daggers, and a case of 178 pieces of faience pottery, while others were mixed, as on the long table, which was "covered with globes, clocks, mechanical devices, caskets, mirrors, musical instruments— for example, *'eine ganze silberne lauten'* [a lute all of silver]—silver vases with flowers of coloured silver or so-called *'handstein'* pieces, which are igneous rocks with figural decoration."[56] Bukovinská makes the significant point that, whereas the typical Kunstkammer was an object of display and exaltation of the owner's status, with everything shown off to its best advantage, Rudolf's collection existed for himself alone. Many of the crystal and hard-stone vases that were the *sine qua non* of princely collections were kept in chests or in their own fitted cases. In the admittedly scanty reports of visitors to Rudolf's Kunstkammer, there is no indication that anyone was invited to spend very long there, so much probably remained unseen. For example, the ambassador of the Duke of Savoy, Carlo Francesco Manfredi, had to wait nine months in 1604–05 just to be granted an audience with the Emperor. He did not come empty-handed but brought with him "'an Indian dagger,' a ruby-encrusted rhinoceros horn, three bezoar stones, 'a large silver ship that contained inside it half of an Indian nut, larger than a man's head,' and a crown."[57] When on the point of leaving, no

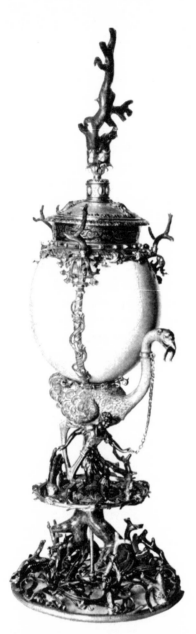

What is melancholy is the sense of exile, even captivity, as these objects sit in their glass cases like exotic creatures in a zoo. Ostrich egg set in silver-gilt.

doubt much disappointed, he was suddenly given a tour of the Kunstkammer by two attendants.

Manfredi's reports to his employer are the source of a most revealing anecdote. In 1604 he writes that the Emperor has spent "two and a half hours sitting motionless, looking at the paintings of fruit and fish markets sent by Your Highness."[58] Allowing for some exaggeration by the court artist who told this to Manfredi, it does show Rudolf's intense involvement in works of art. They evidently gave him access to mental states unknown to the average art lover.

Rudolf's power of concentration accords with his strongly scientific bent. The Emperor shared with Francesco I de' Medici not only a fascination but a deep knowledge of practical science. While his court might have seemed chilly and excluding to ambassadors and others who came to him on boring businesses of state, to a scientist like Tycho Brahe or Johannes Kepler it was more like an Institute of Advanced Studies, and the Rudolfine collections a working resource. One example is that of the court physician de Boodt, who studied the "unicorns' horns" in the Kunstkammer and came to the scientific conclusion—by no means a consensus opinion at the time—that unicorns do not exist, because the horns could all be attributed to the rhino or the narwhal.[59] As is often the case with rulers, the Emperor who seemed so unapproachable and stilted in formal situations had an easier relationship with people of humbler rank. Towards the end of his reign, and for all we know for long before, he liked the atmosphere of the workshop and the practice of arts and crafts. The Florentine ambassador wrote in 1609 that "he tries alchemical experiments himself, and is busily engaged in making clocks, which is against the decorum of a prince. He has transferred his seat from the imperial throne to the workshop stool!"[60] Well might he complain, for Florence had experience with a prince of this type, as we saw in Chapter 5.

The Kunstkammer of the Vienna Kunsthistorisches Museum gives the best sense of the Artificialia of the imperial collection, with its cabinet upon cabinet of useless objects made from gemstones, ivory, amber, boxwood, precious metals, etc. A melancholy atmosphere hangs about them now, because while their virtuoso workmanship beggars the imagination, their sheer quantity wearies the eye. Far be it from me to deplore the hours—or sometimes years—of craft that went into them, to satisfy the avidity and self-esteem of Habsburg princes. Both craftsman and prince were acting out their roles in a society that understood these things. What is melancholy is the sense of exile, even captivity, as these objects sit in their glass cases like exotic creatures in a zoo, too precious for visitors to fondle and turn over in their hands. Having fallen

Rudolf loved to study minutely realistic paintings of fruits and flowers. Georg Hoefnagel, Emblems of Rudolf II from Georg Bocskay's calligraphy book.

into the possession of the democratic state, they are half-accessible to everyone, but owned and loved by none.

Rudolf's other major field of collecting was paintings, both those of Old Masters—a concept already coming into vogue—and newly commissioned ones. Among the former, he acquired all he could of the works of Albrecht Dürer, which spoke to him of that happier time under another romantic emperor, Maximilian I, before the religious conflicts that plagued his own.[61] From his brother Ernst he inherited a magnificent collection of Jan Brueghel's landscapes and encyclopedic works. Like Philip II of Spain, at whose court he had received his early education, he treasured the Italians of the riper Renaissance. Titian, Correggio, and Veronese figured in Rudolf's collection, while his many sculptures included work by Giovanni da Bologna and by Giovanni's pupil Adrian de Vries. In commissioning works from his large stable of court painters, he seems to have sought two different things. First he loved pictures that represented nature, from the wild, imaginary landscapes of Roelant Savery and Peter Stevens to taxonomic studies of nature's individual works. Into this category fall the illuminated manuscripts of Joris Hoefnagel, a masterly painter of fruits, flowers, and the humbler sorts of animals like mice, reptiles, and beetles. So do Arcimboldo's paintings, such as the allegory of *Water*, with its several dozen distinct types of fish and crustacean. The report of Rudolf's studying paintings of fruit and fish markets shows how much he enjoyed realistic detail. The allegorical paintings of Brueghel, such as the *Netherlandish Proverbs* and the *Children's Games*, with their throngs of busy figures, must have delighted him.

The distinction between "fine" and "decorative" arts makes no sense in Rudolf's world. Paintings and sculptures were not superior, and certainly not more valuable in his eyes than the objects of the Kunstkammer. In the case of sculpture, where does "fine" end and "decorative" begin? Is a Riccio bronze fine art, unless it happens to serve as an inkwell? Any answer based on making the distinction will be forced. The effect of Savery's naturalistic canvases shades off into that of the Hoefnagels' illuminated catalogues, then into the preserved objects themselves—stuffed birds, shells, horns, minerals, etc.—hence into a category now kept miles apart and called "natural history." One of the lessons to be learned from Rudolf's collections is how much of the world's wholeness has been lost to us through artificial categories, isolated disciplines, over-specialization, and the defence of professional "turf."

Rudolf's second predilection was for erotica, and it does seem that this was something special to paintings and sculpture, not to be found in other genres of his Kunstkammer. Rudolf was certainly "seduced by the gods," and loved to watch them seducing other

The complicated involvement of the figures is both physical and psychological. Adriaen de Vries, *Mercury and Psyche*, engraving.

people. His chief artist in this field was Bartholomaeus Spranger, ably abetted by Hans von Aachen, Joachim Wtewael, Josef Heintz the Elder, and Dirk de Quade van Ravesteyn. They were all of German or Netherlandish origin, but trained in the common language of Italian mannerism, with perhaps a slight French accent picked up from the Fontainebleau School. The typical Rodolphine painting shows a nude female involved in some complicated way with a male. The characters are from classical mythology: we find Venus and Adonis, Jupiter and Antiope, Bacchus and Ceres, Hermaphroditus and Salmacis, Vulcan and Maia, Hercules and Omphale, Odysseus and Circe, Venus and Vulcan, Eros and Psyche. Sometimes Cupid or an animal joins the company. The paintings are never obscene: sexual intercourse is only implied, e.g. through the convention of the "slung leg" of one character over another. (If Rudolf did collect pornography, it was surely eliminated by his pious successors.) The "complicated involvement" in these pictures is both formal and psychological, each couple demanding a different treatment based on their mythological relationship. Spranger's *Hercules and Omphale*, for example, are cross-dressed: he wears a shift and reluctantly wields a spindle, while she shows off a splendid rear view as she flaunts his club over her shoulder. Jupiter seduces Antiope (or vice versa, in Spranger's version) in the form of a furry-legged satyr. Sometimes the woman takes the initiative, sometimes the man. As in the case of Francesco's studiolo, these commissions enabled a group of otherwise undistinguished artists to give of their most imaginative work, and to know that although it would not be displayed in public, like their altarpieces, it would be appreciated by a connoisseur.

Grotesqueries

IT WAS AROUND 1480 that people started to dig down and explore the dank chambers of Nero's Golden House (Domus Aurea) on the Palatine Hill in Rome. They did not find the legendary audience hall with its rotating vault, for that, along with most of the palace, had been abandoned and destroyed not long after it was built. The splendid rooms were flattened or packed with rubble, and used as the foundation for the Emperor Trajan's baths. This is how they came to be underground, and to be known as *grotte* or caves.

The chambers that remained, although surely among the more modest ones of Nero's palace, still offered a wealth of inventive decoration on their walls and especially in their painted vaults. Time, decay, and visitors had taken their toll (and have taken much more since the fifteenth century), but the artists who set to copying the ancient paintings by lamplight were well able to make good the loss from their imaginations. Even the most eminent of them could not resist leaving their graffiti behind.

Nicole Dacos, author of the standard book on grotesque decoration in the Renaissance, remarks on how until this discovery, antiquity had been monochrome, seen through its sculpture and architecture, its numismatics and gems. Then suddenly, a colored vision of antiquity was revealed.[1] The painted rooms of the Domus Aurea included a notable apse, frescoed with ribs of candelabrum pattern. This was a decorative device already known from Roman architecture in which an elaborate, symmetrical candelabrum sprouts leaves, masks, animals, pendants, etc., in a potentially endless sequence that can include almost anything but a candle on top. The ones in the Domus Aurea apse featured lyres, and were painted in an impressionistic style that contrasted strongly with the detailed manner of early Renaissance painting. Another room had a Golden Vault, whose pattern of geometric panels was highly influential. Renaissance ceilings had hitherto been filled with regular, repetitive coffering. There was a Yellow Vault, whose motif of a pair of satyrs chained to the foot of a trophy was widely copied; a vault of Screech-owls, with the equally fertile motifs of medallions like large coins, bearing the draped busts of emperors; also isolated landscapes in little frames. There was a Black Vault, whose

Time, decay, and casual visitors have taken their toll of the Emperor Nero's legendary Golden House. Cryptoporticus, Domus Aurea, Rome.

The motif of a pair of satyrs chained to the foot of a trophy was widely copied. Palazzo dei Diamanti, Ferrara.

use of a black background to the sparse decorations was less to the taste of the fifteenth century; and a long Cryptoportico or gallery that was an education to artists in the economy of filling large wall spaces.

Most surprisingly, these ancient paintings seemed devoid of any meaning or iconographic program. The mixture of *trompe l'oeil* still-lives, aediculi (little temples or pavilions), pastoral landscapes, busts, flora, fauna, and abstract motifs had no apparent thematic or illustrative intention. This and the skilful calligraphic execution were liberating influences that led to a revolution in the decorative arts. Dacos describes them as a non-problematic solution to the search, at the end of the fifteenth century, for decorations that could be done almost automatically, as a sort of erudite game. They were part of the taste for the fantastic that, as she says, was to rule the sixteenth century.[2] Eventually the term "grotesque," originating from the underground caves, became a catchword for anything monstrous or misshapen.

Each painter developed his own style of grotesques.[3] Among the earlier ones, Pinturicchio (1454–1513) painted the loggia of the Villa Belvedere in the Vatican (1484) in a delicate style resembling the Roman models. By the time he painted the Zodiac Room in Palazzo Colonna (1490), he had blended this influence with that of the contemporary style of manuscript illumination, which aimed at the greatest possible richness within the small space of a page. Pinturicchio's murals are like outsize illuminations, bursting with gems, monsters, miniature landscapes, and grisailles imitating reliefs from Roman sarcophagi. He was one of the first to introduce grotesques into church, with Cardinal Domenico della Rovere's

Pinturicchio was one of the first to introduce grotesques into church. Bernardino Pinturicchio, *Delphic Sibyl*, Santa Maria del Popolo, Rome.

CHAPTER 7

As light relief, Signorelli painted little monsters around the poets and philosophers. Signorelli, *Empedocles*, Orvieto Cathedral.

The Planetary Gods are all but swamped by the grotesques that fill every space between them. Perugino, *The Planet Venus*, Collegio del Cambio, Perugia.

funerary chapel in Santa Maria del Popolo (1501).[4] Filippino Lippi (1457–1504) used grotesque candelabra, sphinxes, sirens, trophies, and herms in the Chapel of Filippo Strozzi (Santa Maria Novella, Florence, 1497–1502) to give a sense of pagan mystery and a whiff of sulfur to his spine-chilling recreation of a Mars temple. In his Orvieto Cathedral frescoes (1499–1504), Signorelli (1441–1524) painted little monsters around the poets and philosophers, as light relief from the *Last Judgment*. Perugino (1446–1523) and his assistants painted the vault of the Collegio del Cambio in Perugia (1499–1507) with cycles of Liberal Arts and Planetary Gods, all but swamped by the grotesques that fill every space between them.

Grotesques are the nearest that painting has ever come to the condition of music. They are even closer to it than abstract art, because they follow strict forms, as music does, and blend familiarity with surprise. (Abstract art, on the other hand, parallels the perpetual unfamiliarity of atonal music.) Being essentially meaningless, grotesques were adaptable to every decorative need. They were well suited to execution by minor artists, for they did not demand careful portraiture or accurate perspective. From cathedrals down to fireplaces, armor, musical instruments, and Majolica pottery, no empty space was safe from the grotesque invasion. Only one thing kept them in order: they were nearly always symmetrical.

The most significant agent in the dispersion of the style was the print, of which the sixteenth century was a golden age. Woodblock prints and engravings spread first from North Italy (especially those of the Mantuan artist Zoan Andrea), then were developed by a host of French, German, and Netherlandish printmakers. Thus the style of Nero's Golden House reached England and eventually even Scotland, where a seventy-year old French print served as the model for a zodiacal vault in the church of Largs, Ayrshire (1638).[5]

The first flush of enthusiasm for the antique motifs had fast developed into a *horror vacui*,[6] resulting in a style far removed from the cool and understated decorations of the Golden House. Early in the sixteenth century there came a reform movement in grotesque decoration, if one can imagine such a thing. The painters of Raphael's studio in Rome, highly conscious of their role as revivers—and rivals—of the Antique, made a concerted effort to return to the classical models. The prime mover was Raphael's assistant Giovanni d'Udine (1494–1561), who made a careful study of the Domus Aurea paintings and designed a series of frescoes intended to recreate authentically the atmosphere of the ancient chambers.

The first room thus decorated was a *stufetta* or bathroom made in 1519 for the apartment of Cardinal Bernardo Dovizi da Bibbiena (1470–1521) in the Vatican Palace. The very idea was a recreation

The first flush of enthusiasm for the antique motifs had developed into a *horror vacui*. Zoan Andrea, *Grotesques*, engraving.

of antique customs described by Vitruvius and taken up by Alberti in his manual of architecture. Bathrooms become so fashionable that by the end of the fifteenth century, they were a standard fixture for Italian castles.[7] That of Federigo da Montefeltro's Urbino palace was mentioned in Chapter 5. The Vatican already contained a tub-room annexed to the bedroom of Pope Julius II (reg. 1503–13), decorated in 1507 by Peruzzi and assistants with grotesques and a scene of the Judgment of Paris.

Cardinal Bibbiena's bathroom measures only 3.45 x 1.48 m. As in the studioli, its smallness is part of its charm. There are six niches with shell caps in stucco, or with fan-like awnings set with real cockleshells. The water comes from hot and cold faucets that form the horns of a satyr's mask. The walls are painted by Giovanni d'Udine, with a red background against which appear little landscapes, amoretti, and scenes of Cupid and Psyche from Apuleius's *Metamorphoses*. They show Psyche's descent to Hades; Cupid shooting at Diana; Venus and Cupid; Venus seated on her bed, with a mirror; Vulcan, and Mars. Nancy Edwards observes that the paintings do not make a coherent cycle, but that they seem to be dedicated to the power of love.[8] My remarks on the Cupid symbolism of the *Hypnerotomachia* (see Chapter 2) and its Christian connotations are relevant here, for surely the Cardinal did not intend his bathroom to be a celebration of carnal love. These churchmen must have made the excuse even to themselves, and certainly to others, that to surround themselves while bathing with pictures of female nudes was not soft pornography but erudite allegory reserved for a humanist-educated elite. In Neoplatonic terms, the earthly eros is there to arouse the soul's energies for the flight to a higher, sublimated form. The ignorant could only jeer, like the German visitor in 1536 who evidently thought that the bathroom belonged to the Pope, for he wrote with Protestant glee:

> And then I arrived in a narrow bathroom, small but extremely elegantly decorated with sea shells and gilded paintings. Here, seated in a tub, His Holiness washes with hot water which is supplied by a bronze female nude. There are also other nudes, and I have no doubt that these are touched with great devotion.[9]

This visitor's honest cynicism goes to the heart of the matter of this book: that whatever the philosophical and theological evasions, the pagan and erotic imagery was there for all to see. Pope and cardinal alike were in thrall to fashion, and to a fascination with an alien and ancient world. Nancy Edwards writes that "this conflation of past and present in a timeless golden age is, perhaps, nowhere so perfectly realized as in the stufette decorated by the circle of

Raphael's studio made a concerted effort to return to the classical models. Raphael and assistants, *Loggie*, Vatican.

In Villa Madama every trace of religious iconography has disappeared, at the behest of the future Pope. Villa Madama, Rome.

Raphael."[10] And she mentions, too, "the leitmotif of water as a life-giving substance being in concert with the fecundity represented by the goddess Venus and the salubrious nature of the baths."[11] Looking back at Julius II's tub-room, one recalls that it was Venus who won the Judgment of Paris.

Larger-scale projects of grotesque decoration followed from Raphael (1483–1520) and his workshop: the Vatican Loggetta, which most closely resembles the rooms of the Domus Aurea; then the Loggie (1517–19) that include "Raphael's Bible" of 52 scenes amid the grotesque decoration of the vault, and for the first time recreate the white stucco decorations of the ancients; and lastly the Villa Madama (1515–23), designed by Raphael and finished after his untimely death.[12] In Villa Madama every trace of religious iconography had disappeared, to give place to uniquely pagan scenes. This was at the behest of Cardinal Giulio de' Medici, the future Pope Clement VII, who asked the artist in charge (Mario Maffei) to paint "choice and varied things," not obscure ones. Scenes from Ovid would suit him admirably, he added, while Old Testament scenes were all very well for the Pope's Loggie, but not here.[13]

In the course of the sixteenth century, grotesques began to raise some eyebrows, as well they might with their frivolity, impudence, and even indecency. In favor of them was the evidence that the Ancients had used them to decorate their palaces; but no less an authority than Vitruvius had censured them. Was it right to cultivate an irrational form of art? Was it an artist's job to exercise his fantasy and caprice? Leonardo da Vinci could be cited for the defense, with his advice to artists to inspire the imagination by gazing at a stained wall. As Dacos points out,[14] this is exactly what artists would have done in the Domus Aurea as they tried to pierce through the moldy growths and imagine the paintings in their pristine state. Michelangelo, too, had always stood up for the artist's license to paint as his knowledge and inspiration dictated. But by the latter part of the century, the tide of the Counter-Reformation had turned against free fantasy. The pundits of the day were men like Pirro Ligorio (c.1510–83), the antiquarian who planned the Villa d'Este (see Chapter 8) and wrote an encyclopedia article on "grotteschi." He mistrusted them as being chthonic and infernal by nature, yet acceptable as carriers of symbolic meaning, as he mistakenly believed all Roman painting to have been. Ligorio saw no point in any non-representational art, except to teach moral lessons. He wrote that the representation of the good Muses, of Mnemosyne, Apollo, Athena, Hercules, "all signify the works and days of those devoted to better things, which lead man to the immortal pleasures of goodly knowledge and lofty cognition. Thus

The cycle of frescoes illustrates Homer's mysterious "Cave of the Nymphs." Sala di Baglione, Rocca di Soragna. By permission of Prince Diofebo Meli Lupi.

he sees with the eyes of intellect how wondrous is the Great Artificer who has made heaven, earth, and all in it."[15]

This allegorizing of grotesques and other pagan-derived decorations continues to the present day, though not in the narrow and pedantic sense of Ligorio. Emanuela Kretzulesco-Quaranta, the interpreter of Renaissance gardens in the light of the *Hypnerotomachia* (see Chapter 8) took a Neoplatonic approach to grotesques in her second book *Giardini Misterici*.[16] Her subject was a cycle of frescoes in her family's castle, the Rocca di Soragna near Parma. These were painted shortly before 1589 by Cesare Baglione[17] in a palette of cool, washed-out colors: greens, mauves, blue-gray and dull gold. The entire room is painted, vault and walls, with large panels descending to the floor. They are peopled by attenuated figures, nude and draped; by crouching children supporting the bowls of complicated fountains; by satyrs, sphinxes, and sirens; dolphins, birds, shells, lamps, vases, and shrieking masks; in short, by the typical denizens and furniture of the grotesque realm. With the touch of a finger, or upon their heads, the tall figures support pierced and broken vaults, massive entablatures, strapworks and trellised domes. Water sprays from every orifice and drips down into bowls of porphyry and serpentine, or into reedy ponds haunted by frogs

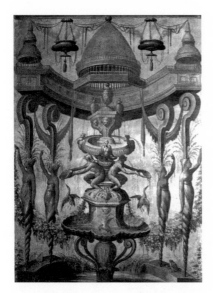

The baldachin floats on volutes of green and red stone, lightly resting on the heads of four siren-nymphs. Sala di Baglione. By permission of Prince Diofebo Meli Lupi.

and marsh-birds. Without a doubt, these are grotesques of a very high order of imagination.

If Pirro Ligorio could hold that grotesques were only justified by carrying allegorical meanings, then it is reasonable to assume that there were artists of the same opinion, who did not use the style merely for decorative fantasies but rather to convey a message, at least to the cognoscenti. Kretzulesco received the key to Baglione's decorations when a visitor (Professor Nicolai Rubenstein, of the Warburg Institute) asked her if the lords of Soragna had read Porphyry. He was referring to the essay *On the Cave of the Nymphs in the Odyssey*, which we have treated in Chapter 3 in connection with the Tempio Malatestiano. The clearest hint of this was the purple-red drapery that hangs from so many of the gray stone structures. In one case, a pair of nymphs seem to be winding it on, while another group has red strings looped from the stone vault to their mouths.[18] Once the clue is given, the correspondences leap to the eye. Baglione has built up a world of his own from the scanty images given in the poem, and glossed it with many other symbols and allusions from initiatic lore, both pagan and Christian, such as the Three Graces, the Cosmic Egg, the Dionysiac Vase, and the Fount of Living Water.

Kretzulesco shows that the Soragna paintings form a cogent cycle, beginning at the "north gate" or door of the room, going along the west side to the south, where—since Porphyry calls this the Gate of the Gods—there is appropriately a cupboard containing an altar, and returning along the windowed east wall. The end of the pilgrimage is marked by a magnificent image of a fountain beneath a baldachin, whose railings suggest that it is of stupendous size. It floats on great volutes of green and red stone (serpentine and porphyry again), lightly resting on the heads of four nymphs whose lower parts turn into attenuated spirals; they are a type of siren whom we often meet at fountains. Two female nudes lean forward with scallop shells to catch the falling water, and water-birds fly up to drink from them. Smoke wafts from two censers at the top of the painting, hanging from we know not where. Kretzulesco comments:

We are witnessing the triumph of the "Fons Vitae": the "living, eternal water" flows from one vase to another, following a tradition that comes from Asia Minor. Leonardo recalls it when he writes of the "place of Venus": the water runs from one vase into the other. This in fact occurs naturally at Pamukkalé, at the site of Hierapolis. The legends speak of throwing salted fish into these waters, which tumble from enormous stone conches down a series of cascades:

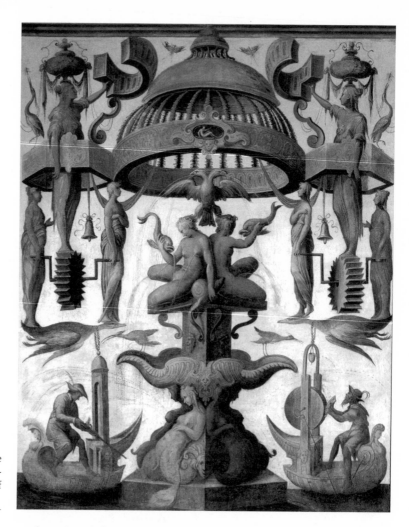

The great toothed wheels represent the metaphysical origins of cosmic movement. Sala di Baglione. By permission of Prince Diofebo Meli Lupi.

the salted fish come to life, and happily dart away! The "living" water revivifies the realms of nature. We are in the Paradise Garden.[19]

In a free improvisation around her chosen themes, Kretzulesco weaves a fantasy as beguiling and mysterious as Baglione's paintings themselves. Though it is unlikely that these precise associations were in the mind of the artist or designer, one can well imagine a learned Christian Neoplatonist giving such an explanation to a visitor. As is always the case with interpretation, this then becomes the meaning of the work for those who give their assent to it. Those elements of the paintings that do not have a source in Homer and Porphyry, such as a pair of great toothed wheels, serve to stimulate further glosses and commentaries. For Kretzulesco, those wheels represent the metaphysical origin of cosmic motion:[20] an interpretation in accord with both classical and Christian cos-

mology, which require something to set the primum mobile turning.

We touch here on the central problem of Renaissance iconography: how to interpret works of art, when our knowledge and world-views are utterly different from those that brought them into being. To judge from the new pundits of art criticism, world-views have even changed in the past few years. David Carrier, in his handbook *Principles of Art History Writing*, dismisses Kenneth Clark's thirty-year-old book on Piero della Francesca, for reasons such as this: "Clark's claim that '[Piero's] Madonna is the great mother, his risen Christ the slain god, his altar is set up on the threshing floor, his saints have trodden in the wine press' today seems indefensible."[21] Against whom, one might ask? Carrier is even more nervous when faced with a truly esoteric interpreter: ". . . when Maurizio Calvesi sees Christ [in Piero's *Flagellation*] centered in the magical space later described by Giordano Bruno and relates the light on the golden statue to alchemy and early capitalism, his account is too eccentric to be worth debating."[22] If eccentricity is a flaw, then Piero's picture itself had better be put away for good!

It is not that I believe that Clark, Calvesi, or Kretzulesco have hit on the correct interpretation of the works in question, even if they thought so. Perhaps it is because my own training is in music that I care so little for the rightness or wrongness of their interpretations, for in music anything worth saying cannot be put into words. One talks about it largely to satisfy one's own needs (including the need to sound authoritative) and to concretize a fleeting experience. Anyone's interpretation of a piece of music, or a work of art, is the result of their state of education, sensitivity, and spirituality. It was the latter that inspired Kretzulesco's reading of the Baglione grotesques, as it did Clark's interpretation of Piero, for all the differences in personality and erudition between the two. So long as the fashion in criticism is a secularist ideology with Marxist roots, of course such views as theirs are "indefensible" and "not worth debating."

As a trespasser on this mined territory, I take comfort from the Professor of Art History at the University of Oxford, Martin Kemp. Writing on a topic quite close to our own (the natural objects in the Renaissance Kunst- und Wunderkammer), he throws down the gauntlet to the current trend in his discipline:

> I will be arguing that a complex fluidity, ambiguity, and diversity of meaning characterizes the viewing of such items even in a number of apparently similar contexts in Renaissance societies, and that such viewing undermines any propensity to characterize them neatly in terms of the kind of historical 'meta-realities'—such as

power, colonialism, possession, oppression, patriarchy, Eurocentrism, and otherness—which now tend to be taken as having a privileged explanatory power.[23]

I presume that the viewer of grotesques, whether in Soragna or anywhere else, would have seen in them exactly what he or she was capable of seeing, and inclined to see. The servants of the house were probably indifferent to them, as matters beyond their ken. At a higher social level, they would register almost unconsciously as fashionable decorations. The children would tell their own stories about them. The visiting humanist or cardinal would look at them with a keener eye to their meaning, especially if the name of Porphyry came up. Like music, the "complex fluidity, ambiguity, and diversity" of grotesque art would, and still does, speak to each person in a different way.

The discovery of an antique time capsule in the Domus Aurea, although slight in comparison to the eighteenth-century surprise of Pompeii and Herculaneum, yielded material for the favorite occupation of the Renaissance humanist: pretending to be an ancient Roman. But this nostalgia went deeper than Rome, whose civilization was not so very different from that of the Renaissance. It went back to the ancestral memory of the Golden Age, for which the Romans themselves felt nostalgic. Before civilization, with its glories and its woes, mankind lived contentedly under the benevolent rule of Saturn, eating wild honey and fruits that fell from the trees, and enjoying a perpetual spring. So goes the myth, according to Hesiod and Ovid. A feature of this imagined infant state of humanity is its closeness to the animal world, which men had not yet learned to kill for food. This is probably why human-animal hybrids are conspicuous in it, and why they also populate the world of pastoral fantasy which is a child of Golden Age mythology. The three main species are satyrs, who are goats from the waist down, fauns, who have human bodies but pointed ears, horns, and tails, and the reputedly wise race of centaurs. The captive satyrs in the Yellow Vault of the Domus Aurea gave Renaissance grotesque painters the idea for a whole menagerie of twinned, hybrid beings. In one respect, these were descendants of the *babewyns*, the little monsters and demons with which medieval illuminators liked to spice their margins. But the artists of the Renaissance, inspired by the models on Roman sarcophagi and gems, had already begun to treat these mythological creatures as having a life of their own.

The first major artist to do so was Donatello, whose bronze statue known as *Atys-Amorino*, appearing out of nowhere around 1440, continues to puzzle the iconographers. Why, for example, does he

He continues to puzzle the iconographers. Why, for example, does he have wings *and* a tail? Donatello, *Atys-Amorino*.

Girolamo's satyrs and centaurs are noble creatures, and at the same time they have the pathos of all extinct species. Girolamo da Cremona and assistants (attrib.), frontispiece to the *Physics,* from Aristotle, *Opera,* Venice, 1483. The Pierpont Morgan Library, New York. PML 21194, f.2. By permission.

have wings *and* a tail? Michael Levey writes eloquently of this figure: "It captures a very real force, sexual, wild, and almost dangerously exuberant; even though it is most unlikely that the boy originally held a bow and arrow, there is a certain aptness in the suggestion that he could do damage."[24] That is the perilous attraction of fauns and satyrs! Mantegna emphasized the danger more than the attraction in his four great pagan engravings of bacchanals and fighting sea monsters, and in the *Minerva* painted for Isabella d'Este's studiolo. There the the hybrid beings mingle with humans, but stand for the "subhuman" vices of drunkenness and anger.

A gentler vision of these creatures appeared in the margins of a

series of magnificent illuminated books from the 1470s and 1480s. These were the *éditions de luxe* of printed books, made for collectors who otherwise might have despised the new, mass-produced product. (Federigo da Montefeltro, for example, would only allow manuscripts in his library.) They were printed on parchment, with ample margins that left room for the illuminator to make each copy unique. One of the most exquisite groups of such books was decorated with satyr scenes by Girolamo da Cremona (fl. 1451–83) and others. Girolamo was trained in Ferrara, where he worked on Borso d'Este's illuminated Bible, before coming to Venice around 1475 and working for Nicholas Jenson's printing house. His satyrs and centaurs are noble creatures, and at the same time they have the pathos of all extinct species. Girolamo plays on this sentiment by showing them wounded, or being teased by mischievous putti. These little dramas bear not the slightest connection to the texts by Pliny, Aristotle, etc. But irrelevance had always been the prerogative of the illuminator, who in earlier times could not necessarily read the book he was decorating.

The redemption of the satyr is a minor, but a telling episode in the pagan dream. In medieval iconography, beings with goat's legs, horns, and tails were read as demons, as they still are in the language of strip-cartoons. One sees them extracted by saints from the mouths of demoniacs, or tempting Christ or Saint Anthony. They may have originated in paintings and sculptures of Pan and the satyrs left over from the Greco-Roman world, whose gods and goddesses were believed by some theologians to have been actual demons. In quite another category was the medieval tradition of the Wild Men or Woodwoses, who were looked on with tentative affection as relics of a primitive humanity. They appear frequently in heraldry. Girolamo's satyrs seem to blend the two types, the semi-human and the primitive. There is nothing devilish about them: they have reverted to their classical status, as belonging to the Golden Age.

The supreme painter of the lost ages of mankind is Piero di Cosimo (1461–1521), who executed in the early years of the sixteenth century a series of *spalliere* (horizontal panels) on pastoral and satyric themes. These include *The Forest Fire*, which shows placid, man-faced sheep and goats among other animals; *The Hunt* and *The Return from the Hunt*, populated by satyrs, humans, and a centaur; *The Discovery of Honey* and *The Misfortunes of Silenus*, whose characters are the motley train of Bacchus. In Piero's Bacchic pictures, apart from Silenus and Bacchus most of the males are goat-footed, and most of the females are human. The same is true of his most moving work, usually called *The Death of Procris*, in which a satyr kneels before the body of a young woman who has been ac-

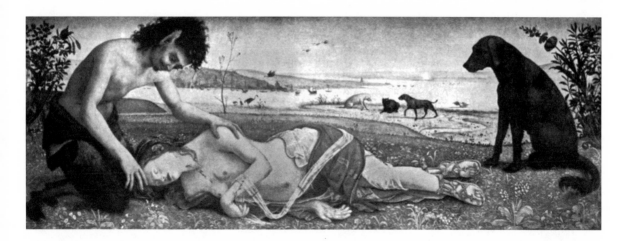

A satyr kneels before the body of a young woman who has been accidentally slain by her husband's javelin-cast. Piero di Cosimo, *Death of Procris*.

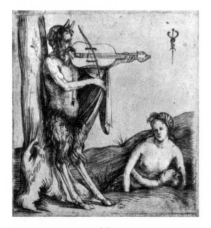

A strong current of Renaissance iconography depicts male satyrs and human females living as a family. Jacopo de' Barbari, *A Musical Satyr and His Family*.

cidentally slain by her husband's javelin-cast. The expression of puzzled compassion is all the more touching for appearing on the face of a hairy-eared, semi-human being.

When I first knew this painting, whose iconography was not explained by the caption-writers of London's National Gallery, I took it for granted that the satyr and the nymph were a couple; that the satyr had discovered that his loved one was dead, and that the dog had been a mute witness to the tragedy. In my innocence I knew nothing about the propensities of satyrs to rape nymphs, goats, and anything else within reach. English children of the time tended to meet them first in C. S. Lewis's *The Lion, the Witch and the Wardrobe*. Much less did I know about the findings of future art-historical authorities on the "gendered gaze." But I find my instincts reinforced by a strong current of Renaissance iconography that depicts male satyrs and human females living as a family, together with their children (who may favor either parent). It seems to me that the bad reputation of the goat-footed ones is left over from the Christian view of them as demons and seducers of mankind, especially of the weaker sex: a view humorlessly parodied by the art historians in question. Piero and his contemporaries, on the contrary, took pains to domesticate the satyric male.[25] The *Hypnerotomachia* is exemplary in this regard. Early in that story, Poliphilo comes upon a sculptured fountain that shows a nymph sleeping under a tree, her breasts flowing with hot and cold water, while looming over her is a satyr. Yet while he responds naturally enough to the sight of "her lovely body [which] was enough to provoke even one made of stone," Colonna's satyr, like Piero's, is a perfect gentleman. Far from assaulting her, "This satyr had violently seized the arbutus tree by its branches in his left hand and was gallantly bending it over the sleeping nymph to make her a pleasant shade."[26] (See illustration, p. 24.)

Satyric subject were favored as hand-sized objects for connoisseurs to keep in their studies. Andrea Riccio, small bronze sculptures.

The fact that in these miscegenations, the satyrs or fauns are male and their partners female might be illuminated by imagining the reverse: a pairing of men with women who were goats from the waist down. Somehow this would carry an unpleasing suggestion of bestiality. The conventions of art, if not of life, require women to obey the norms of human beauty, whereas men can get away with being "characters," even quite beastly ones (consider the loves of Zeus!), and still be found attractive.

These satyric fantasies were not, at first, for public consumption. Piero's *spalliere*, like the painted *cassoni* (marriage chests) were regarded as part of the furnishings of a house rather than as independent works of art. In sculpture, satyric subjects belonged to the genre of small bronzes: hand-sized objects for connoisseurs to keep in their studies. The sculptor and goldsmith Andrea Riccio (1470/75–1532) made a speciality of such things. He had the ingenious idea of fitting his little bronze monsters with a screw-joint, to which could be attached an inkwell or a candlestick as the customer preferred. Wendy Sheard writes sympathetically of them that:

With Riccio's rustic, deeply pagan creatures, we feel we have entered into an antique world quite different from the Roman history and civilization celebrated by Mantegna. By the beginning of the sixteenth century, artists turned for inspiration to the works of ancient poets, in addition to and sometimes instead of visual sources. Ovid's world of centaurs, Pans, satyrs and satyresses sprang to life in the inventions of Riccio. Their corollary was eroticism, implicit or explicit, a part of the antique heritage that was ignored in large-scale public works in the all'antica style. And the erotic, in the pastoral mode, often brings with it that sense of melancholy expressed by Riccio's Pan.[27]

The pathos of a monster with a human face is exceeded by that of a human with an animal head, like the Minotaur or Bottom the Weaver, but more especially, for our period, like Actaeon (see Chapter 1). Unlike most viewers today, the owners of the countless Actaeon paintings were likely to be familiar with deer hunting, and well able to supply the gory details from their own experience. If they were allegorically-minded, they could also have supplied the moral of a "wild, sexual force" that "can do damage" when the sanctuary of the virgin goddess is violated. When Polia and Poliphilo embraced in the Temple of Diana (see Chapter 2), they were lucky to get away with a mild thrashing by a bevy of angry nuns, and to find a welcome in the rival Temple of Venus.

Venus presides over grottoes, whether in the forest depths or by the shores of the sea. We know the latter type already as the Cave of the Nymphs (see Chapter 3) through which souls enter the world, thanks to the goddess of desire and the honey of generation. Mythological resonances are not hard to come by in the land of the Catacombs, the Mithraea, and the Etruscan tombs; of the Cave of the Cumaean Sybil and the Blue Grotto of Capri—to say nothing of the Cloaca Maxima. There is also a practical side to grottoes, for in sunny Italy the greatest need of outdoor life is for shade, coolness, and water, and every garden must have a place for them. Garden historians have written much about the different genres which cross-fertilized one another during the golden age of garden design: the grotto, the fountain, the Nymphaeum (temple or shrine of the Nymphs), and the Musaeum (likewise, of the Muses).[28] The defining feature of a grotto is that it includes some reference to nature, using unshaped rock or imitating volcanic magma and stalactites. Often the décor incorporates seashells, mosaics made from colored pebbles, corals, and semi-precious stones. Cristina Luchinat makes the acute observation that Renaissance grottoes are the one instance in which architecture acts as an imitative art, like painting and sculpture.[29] In so doing, she says, architecture deliberately breaks its own rules, discarding rational and regular geometry in favor of chaotic, primordial forms.[30] There is a range of motifs that run from extreme rustication and vermiculation that suggest raw stone, through deliberate faults like the dropped keystones of the grotto in Heidelberg Castle gardens, to end with the artificial ruins and hermitages of the eighteenth century.

Grottoes are not necessarily underground. The Grotte des Pins at Fontainebleau (1530), one of the very first of the type, is more of a garden house, but marked as an archaic, chthonic place by giant Telamons who are only half distinguishable from the heavily rusticated stones. At the other end of Europe, in the elegant garden of the Wallenstein Palace in Prague (1630), it is surprising, and a little

In an Apollonian garden, the grotto represents the complementary power of Dionysus. Salomon de Caus, design for a grotto fountain.

sad, to see the single garden wall bulging with blackened, magmatic forms. It takes a moment to realize that this, too, is an attempt at a grotto, because by definition every Italianate garden has to have one, even in a city backyard.

In an Apollonian garden of geometrical parterres and straight paths aligned on classical fountains and façades, the grotto represents the complementary power of Dionysus. Eugenio Battisti saw this as contrary to the early Renaissance of the humanists; therefore he called his monumental study of the Mannerist period *L'Antirinascimento*. Yet this complementarity had existed in Antiquity too, which bequeathed ample material to feed both the Apollonian and the Dionysian stream. Battisti points to those who, while studying Roman monuments and reading Cicero, passion-

At certain hours of the day, the sunlight penetrates to the depths of the grotto, as happens in some neolithic caves and ancient sanctuaries. Grotto of the Animals, Villa Medici, Castello.

ately collected gems with bizarre images and loved Apuleius, Ovid, and the Hermetica.[31] The *Hypnerotomachia* is once again prophetic of the Mannerist period, for Colonna's recreation of antiquity burst all "classical" boundaries in its verbal, imaginal, and emotional hyperbole, only palely reflected in its Apollonian woodcuts.

The grottoes constructed in or near Florence during the sixteenth century are, in this sense, typically "antirinascimental." The one at the Medici villa of Castello, probably designed by Giorgio Vasari and constructed between 1565–72, is the most modest, consisting of a single chamber with three wall-fountains. Around the walls are thirty-six large sculptures of animals, including elephant, rhinoceros, camel, and giraffe. They are made from hard stone, but wherever possible, their horns and tusks are real ones.

Interpretations of the Castello grotto differ. Claudia Lazzaro sees the animals, gathered from all quarters of the globe, as bearing witness to Medici magnificence and power, and tells many stories of how animals at this time were regarded, used, abused, or given as princely gifts. She identifies several of the sculptures as particular exotic creatures, sometimes the only example known in Europe.[32] Emanuela Kretzulesco-Quaranta, on the other hand, believes that the Castello grotto illustrates the appearance of animal life on earth. She associates it with the Roman mosaic of the Animals of the Nile, formerly in a sea-cavelike apse of the Temple of Fortuna at Palestrina.[33] Kretzulesco explains that at certain hours of the day, the sunlight penetrates to the depths of the grotto, as happens in some neolithic caves and ancient sanctuaries. Here is the meaning, as she interprets it:

> The primordial mystery, at the origin of the most extraordinary event ever produced in the solar system, is the appearance of the vital fluid in a cell, in a cleft of the rock warmed by a ray of sunlight passing through the transparent sea water, in a place sheltered by the vault of a cave. The Pilgrim contemplates an illustration of this mystery when great showers of water, spurting from the mosaic floor of the cave-sanctuary of Castello, are shot through by a ray of sunlight.[34]

The contrast between these two readings is a perfect example of the principles of interpretation discussed above. What neither of them mentions is the humour and delight felt by the visitor at the sight of this petrified menagerie, turning to shrieks as the hidden vents in the floor started to squirt water. The experience would probably not lead to deep thoughts, but it would be memorable and in a way otherworldly, in complete contrast to what went on in the normal world outside the grotto. Another author, Jacqueline

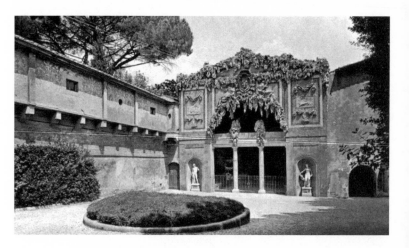

The grandiose façade was built under Cosimo I, and the grotto developed under his sons and successors Francesco and Ferdinando. Grotta Grande, Boboli Gardens, Florence.

Dauxois, has some words on Emperor Rudolf II's fascination with animals that are applicable to the Castello grotto, and to the "anti-Renaissance" in general:

> The point is that animals are a superb introduction to Greco-Roman mythology, the Emperor's true universe; he is not an atheist, as the stupid Nuncio believed: Rudolf is a pagan, in osmosis with the gods of antiquity. He penetrates boldly this fabulous universe where one meets centaurs (half men, half horses), where Jupiter changes himself into golden rain or a swan, depending on the woman he wants to seduce, where humans and gods communicate freely, where the animate world is in symbiosis with the inanimate, where plants have a soul, where springs and woods are sacred.[35]

In the Boboli Gardens, laid out after Eleanor of Toledo's acquisition of the adjoining Pitti Palace, there is a large grotto, called the Grotta Grande or the Grotta di Buontalenti. The façade (1556–60) was designed by Vasari, the chief architect of Cosimo I, but the interior was a much later work (1583–93), mainly constructed by Bernardo Buontalenti (c.1531–1608) under Grand Dukes Francesco I and Ferdinand I.[36] Buontalenti was an orphan who had been brought to the Medici court at the age of fifteen as an older companion to Prince Francesco. The two boys grew up together, spending their leisure in the foundries, workshops, and laboratories on the ground floor of the Palazzo Vecchio, and sharing a passion for the strange and the marvelous.[37] The well-named Buontalenti accompanied Francesco on his journey to Spain (1562–63), designed the "Triumph of Dreams" for the prince's wedding (see Chapter 9), realized his adult fantasies, such as the gardens and grottoes of Pratolino (see Chapter 8), and survived his master to design the

intermedi for the wedding of Ferdinand I de' Medici and Christine of Lorraine (see Chapter 10).

Litta Maria Medri writes of the Large Grotto of the Boboli Gardens:

> Its presence, discretely announced by the sculpture of *The Dwarf Morgante Riding a Turtle*. . . alluded to the favorite theme of Neoplatonism: of the regeneration of man through his journey in the dark, subterranean world, the ancient cavern of magic, legend, and allegory. The fantastic climate evoked at Pratolino [see Chapter 8], emblem of an era characterized by intellectual disquiet, of the passion for plumbing the secrets of stones and metals, of the cult of refined decoration marked by restless emotional tension—the particular characteristics of Francesco I de' Medici—was prodigiously recreated in Boboli by Bernardo Buontalenti, from the moment he became the sole executor of the Large Grotto project . . .[38]

The Large Grotto as it stands—currently undergoing thorough restoration—is a patchwork reflecting the three Grand Dukes under whom it was constructed. First there is the grandiose façade built under Cosimo I. Then there are three rooms, entered one after the other, of which two were probably completed in the second building phase (1582/83–87) under Francesco I. The third room was finished, and the final touches given to the whole project, under Ferdinand I (1587–92).

The statues of the grotto were all made for different places and purposes. Baccio Bandinelli's *Ceres* on the façade had begun as an *Eve* for Florence Cathedral. In the first room were Michelangelo's four unfinished *Captives* (also called "Slaves" or "Giants"). Originally intended for the tomb of Julius II, these roughed-out torsos, together with the finished *Victory,* had been given to the Medici in settlement of debts by Michelangelo's nephew and heir Leonardo Buonarotti. They were installed in 1585, but later elevated to the Accademia and replaced in the grotto by casts.[39] The second room contains a sculpture by Vicenzo de' Rossi da Fiesole (1525–87) of *Paris and Helen*[40] in a favorite mannerist posture with one of her legs slung over his. The identity of the man and woman is shown by the pig beneath their feet, a symbol of Troy. Rossi had presented this work of 1558–60 to Cosimo I during the latter's visit to Rome, and thereby secured the commission to make the *Labors of Hercules* for the Palazzo Vecchio. In the third and inmost room is a marble Venus by Giovanni da Bologna (1529–1608), which Francesco had acquired in his teens[41] and kept in his bedchamber. It was only removed to the grotto after his death, and then supplied with its supporting fountain, with four leering satyrs (by Michelangelo

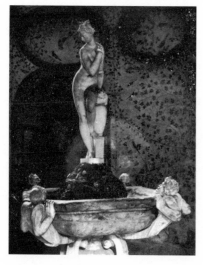

The satyrs are there in mockery of anyone who lusts after the beautiful figure. Giovanni da Bologna, *Venus*.

Ferrucci) clinging to the basin. Their lower parts mutate into architectural members, like herms, and their mouths spurt water.

The first, domed chamber which seems to rest on, or to crush, Michelangelo's Captives is decorated with formations of *spugna* (a chalky limestone) from which emerge faces and human figures. Looking upwards, the pitted stone blends into pastoral landscapes and wild creatures, glimpsed through the ribs of a collapsed dome. At the crown of the dome, instead of the sky there is a circle of glass which was originally the bottom of a fish tank, from which the light filtered into the grotto. The whole room was piped behind the scenes to supply sprinklers, fountains, and the watering of the real mosses that grew among the painted vegetation on the walls. In the second chamber, the walls carry architectural motifs of pedimented portals and windows, all grown over by barnacles or stalactites, like a seashore ruin. The third room has niches of colored stone around the walls, framing miniature mountains of spugna, and higher up there are oval oculi, through which one glimpses real or painted sky. The walls and oculi are decorated by Bernardino Poccettti with trellises and cheerful plant and bird motifs.

The meaning of the Large Grotto, never spelled out by its creators, is an open invitation to scholars of an imaginative bent. Maurizio Fagiolo d'Arco sets out the standard interpretation, according to which the first room refers to the myth of Deucalion and Pyrrha, who recreated the human race after the Deluge by throwing behind them "the bones of their mother," i.e. stones, which forthwith became men and women. The unfinished *Captives* and the forms emerging from the spugna then represent the emergence of the human race, within a subtle game of ambiguities and sculptural puns on the themes of nature and art, creation and destruction, love and death. The vault perhaps contains the "waters above the heavens" which poured down in the Deluge, though Fagiolo inteprets the hermetically-sealed aquarium as referring to the Grotto of Nereus under the sea.[42] At all events, there is deliberate confusion of what is natural or artificial, finished or unfinished, above or below.

Whereas the first chamber shows the destruction wrought by the gods, the second chamber invites reflections on the Trojan War and all the other consequences that Helen's irresistible beauty set in motion. As for the third chamber, Fagiolo calls it the symbol of the generative principle of the world and the cosmogonic womb.[43] When Ferdinand I was living in Rome as a cardinal, in the gardens of the Villa Medici he had a private hideaway built into the actual city walls. It has one chamber painted very similarly to the Boboli Grotto, resembling a pergola with climbing plants and birds, and

a smaller one crammed with *grotteschi* (perhaps the smallest decorated stanzino in existence).[44] If the rumors are true that the Cardinal used this garden suite for discreet meetings with his mistress, then the erotic and Venereal connotations of the Boboli grotto are complete. The satyrs, added under Ferdinand's rule, are there in mockery of anyone who lusts after the beautiful figure (a version of the "Actaeon problem" mentioned in Chapter 1).

There is nonetheless something unsatisfactory about the "story" as it was told by the first official exegete, F. Bocchi.[45] According to Medri, Ferdinand's completion of the Large Grotto deliberately eliminated everything suggestive of his brother's sinister, irreligious interests; she even speaks of a *damnatio memoriae* (condemnation of the memory) of Francesco's legacy.[46] In the first room, the emergence of animals and man from the matrix of minerals probably had a precise connection with Francesco's alchemical work and his theories of the four elements, amply documented if not explained in the Studiolo. Under Ferdinand it became a simpler allegory of the powers of nature, and the pastoral scenes emblematic of the *pax medicea*, while the classical myth of Deucalion and Pyrrha provided a respectable cover-story.[47] Medri writes:

> The vitality of dumb, primordial matter is also expressed in the following sequence of rooms; the large vegetal festoon made from spugna, coral, and shells which surrounds the opening into the little grotto of Venus reveals, to the attentive eye, the visible presence of male and female sexual symbols, cleverly masked so as to appear as fruits and vegetables. In the "*grotticella*" the shapes in terra cotta, formerly colored azure and glazed, allude to the world of Eros with the celebration of the loves of Zeus with Danaë and Leda, alternating with figures of nude river demigods and groups of little erotes, busy with their games or sunk in a knowing sleep. The iconography of the Ferdinandean epoch halted the spread of sculptural and pictorial representations that alluded to the primordial world and to Eros's generative force of life.[48]

In the following chapters we will meet further examples of the dangerously pagan growths that were permitted to flourish by Francesco I, and stifled after his premature death. At this point we can compare the Large Grotto as he planned it with the Studiolo. The function of the latter seems plain: it was a private retreat, possibly for incubation (as I have suggested in Chapter 5 in connection with Federigo da Montefeltro's chapels) and certainly for some kind of disciplined contemplative and imaginal work. Few people even knew of the Studiolo's existence (the present entrance from the Salone dei Cinquecento was added later). The Large Grotto

was not nearly so private. Its magnificent façade compelled curiosity about what was inside, and there is no evidence that the interior was a guarded secret. The triple-bayed façade is not at all like a cavern entrance, but more like the west front of a church.

Pursuing this analogy, I would suggest that the Large Grotto functioned like a pilgrimage church, built to house a sacred relic. Just as a church is open to people of all qualities and degrees of understanding, so was the Grotto. The route to it leads past Morgante, who to most visitors is just a joke, and not always a nice one. But the turtle had a distinct meaning that would not have been lost on the more educated: when equipped with a sail and the motto *Festina lente* (make haste slowly), it was a favorite device of Cosimo I. The literate might trace this maxim further back to the *Hypnerotomachia,* in which it is a recurrent theme, and in which it also leads to an epiphany of Venus. Morgante's warning, which we will see repeated in the gardens of Versailles (see pp. 237–38), means that one will reach one's goal faster if one does not rush towards it; which implies that the goal in question is not the obvious one which any fool can see.

For the religious "fool," the goal is to see or touch the sacred relic, say a quick prayer, and hope that it will bring money, love, health, etc. But the more philosophical pilgrim knows that the only value of a relic or a holy place is the change that it operates in one's own being; and that this is mostly due to one's own effort. He "hastens slowly" by letting the atmosphere of the place slow his thoughts and concentrate his mind. Moving at tortoise-pace, he opens himself to the influences flowing from the symbols that have been wisely placed for his edification. In the present case, the imagery of the first room leads to profound thoughts about the origin of life on earth, of humanity, and of the rebirth of the true man that is the esoteric goal. Even art critics have sensed that Michelangelo's Captives, left unfinished as they are, speak of the struggle of the soul to free itself from the density of matter.

In a church, one enters the nave, proceeds to the chancel, then to the reliquary which is typically found behind the high altar. The second room of the Large Grotto is like the chancel reserved for the clergy and choir, hence for a higher degree of philosophic understanding. Here is the mystery of sexuality, as blatant as can be. Only the inhibitions of Western culture prevent it from being shown as sexual intercourse, as it is in Hindu temples. The reader, like the visitor, will take this at whatever level is appropriate to him or her. For present purposes, let us assume the Platonic approach that has been mentioned several times in this book. Musings on the consequences of erotic love in antiquity are not out of place; nor is the suggestion that there is something swinish, especially about male

desire. But the Platonist knows more, and after due meditation proceeds to the inner sanctum.

Giambologna intended his statue of Venus as the cynosure of feminine beauty, and evidently Francesco responded to it as such. He acquired the statue at an age when one's first loves imprint one's erotic nature for life, and it had been his talisman ever since. An envoy from Urbino wrote in 1583: "I seem to see the Grand Duke more melancholic and retired than usual, but ever more in love with the Grand Duchess, if that were possible."[49] Bianca Cappello, to judge from her later portraits,[50] no longer looked like the goddess she once was; yet the higher beauty to which the Platonist aspires is a thing of the soul, not the body. Prepared by the meditations occasioned by the first two chambers, the pilgrim who does not simply rush into the inner sanctum is granted an apparition of the Celestial Venus who is the Platonic Idea of Beauty. In the niches around the chamber, the spugna rocks exude water, the life-sustaining gift of the earth; and as he sips the sacramental liquid he may realize that the earthly and the heavenly gifts are one.

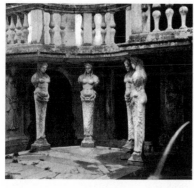

One cannot avoid suspicions of an alternative cult surviving "underground" in the guise of antiquarianism. Bartolomeo Ammannati, Nymphaeum in the Villa Giulia, Rome.

I conclude this chapter with three examples of that transitional type between grotto and nymphaeum, which seem to have been constructed with particular attention to the spirit of place and to the sacred qualities of the elements. The first is in the Villa Giulia in northwestern Rome, now the Etruscan Museum. Beyond the main accommodation block is a courtyard, interrupted by a loggia by the ingenious Bartolomeo Ammannati (1553). Its nobility is only exceeded by its playfulness, for it mixes curves and straight lines, inside and outside, and various levels above and below ground in a way impossible to comprehend. It seems to be designed to create a state of confused wonder and expectation, which culminates in the discovery of the *raison d'être* of the whole affair. One looks over the balustrade and sees, at a hitherto unexpected depth, a nymphaeum dank with mosses and lichens. Standing in a semicircle are the guardian spirits of the spring, growing out of the rock which forms their lower parts. Behind them it is cool and deeply shaded, and one can make out the ghostly doubles of the herm-like figures, only half emerging from the wall. There seem to be grottoes beyond, to which entry is forbidden. *Terribilis est locus iste!*[51] This being Rome, and the villa that of the future Pope Julius III, one cannot avoid suspicions of an alternative cult surviving "underground" in the guise of antiquarianism, as a place of escape from institutionalized Christianity. Not, of course, as an organized secret society, but as something called forth by the needs of the collective soul.

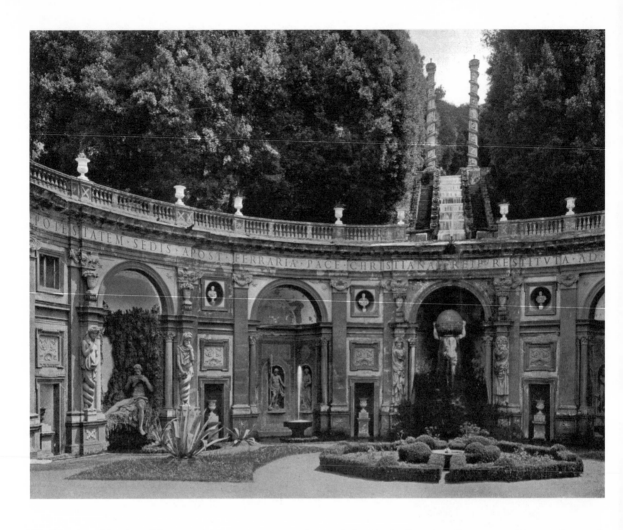

The form resembles that of the apse of a cathedral, with chapels dedicated to various saints. Water theater at Villa Aldobrandini, Frascati.

On a grander scale by far is the nymphaeum or "water theater" of the Villa Aldobrandini in the resort town of Frascati. It is not left for visitors to come upon unawares, but is thrust upon them as soon as they pass behind the villa. The water comes tumbling down the hill between two columns which evoke the motto of the Columns of Hercules, *Ne plus ultra*, and the arrogant reply of Emperor Charles V's device, *Plus ultra*. The water feeds a hemicycle of fountains, niches, and semi-grottoes, centered on the figure of Atlas bearing the globe. The rest of it is thickly inhabited by nymphs, satyrs, Roman emperors, anguiped (snake-legged) herms, and a host of other characters. The form resembles the apse of a cathedral, with chapels dedicated to various saints. The iconography, too, is a "bible in stone," but of classical mythology. As in a cathedral, the impact is immediate and may satisfy the senses and the spirit, but there is also material for hours of study.

Flanking the hemicycle are two large chambers, to which ad-

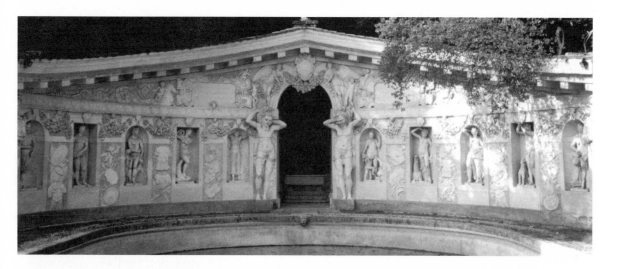

It is said that there has always been a sacred spring here. ABOVE: Nymphaeum. BELOW: Statue of Diana the Huntress. Villa Barbaro, Maser.

mission is not so freely given. The one on the left hand is a Christian chapel, which is not surprising in the country villa of a cardinal. On the right is a freestanding grotto or fountain room with a model of Parnassus in place of an altar. It has painted wooden statues of Apollo with Pegasus and the Nine Muses, each of them with a musical instrument. They seem to have been carved by a local maker of Christmas crêches, rather than by a classically-trained sculptor: a kind of artisanal work common in garden decoration, which has a charm of its own. On another artistic level, stories of Apollo painted by Domenichino once adorned the walls. Unseen music issued from this magical mountain, provided by a hydraulic organ. As at the Ducal Palace of Urbino (see Chapter 5), there is symmetry between the Christian and the pagan chapels. Christ and the Saints are in equilibrium with Apollo and the Muses, and those disturbed by the symmetry could console themselves by seeing the one as merely emblematic of the other.

At the Villa Aldobrandini theater, as in an equally theatrical baroque church, the spirits of place are overwhelmed by the grandeur of the human construction, and nature is thrust back behind those bastion-like walls. Not so at my third example, the Villa Barbaro at Maser. Christ and the Saints receive their due here, in an exquisite chapel aligned with the approaching road. Like the villa itself, it is the work of Andrea Palladio (1557–58). Behind the villa, as at Frascati and many other Italian gardens, the wooded hillside rises impenetrably, and the water that springs from it is channeled into a nymphaeum. But here everything is on a relatively domestic scale.

The interior of the villa prepares one for surprises with *trompe l'oeil* frescoes by Veronese, in which mythic and contemporary fig-

ures are mingled, and artificial vistas giving glimpses of people (and dogs) who are not really there. Fireplaces shaped like gaping mouths bear inscriptions from the *Golden Verses of Pythagoras.* The nymphaeum is as odd a vision as one can find anywhere in Italy. It consists of a wide, pedimented façade that serves both as the backdrop to a pond with fountains, and as a proscenium to a small grotto that can be seen through its central archway. Its niches, alternately flat- and round-headed, house statues of a satyr, an old satyress, nymphs, Diana, Actaeon, Hercules, and Venus with Cupid. Part of the strangeness comes from the amateurishness of these figures and of the oversized telamons that support the pediment. They are carved not in stone, but in the easier medium of stucco, and some of them are the work of Marcantonio Barbaro, who owned the villa together with his brother Daniele. It is not that Marcantonio's sculptures are incompetent, but there is something subtly wrong about their proportions, just as in the best classical and Renaissance sculptures there is something that seems, to our accustomed eyes, just right. At the same time they are likeable, like the carousel figures of Aldobrandini's Parnassus. One comes upon them after admiring the artistry of Palladio and Veronese, names known to every student of the Mannerist period. Some visitors, conditioned to see only what they have already heard of, are oblivious to them. But to others there is something most beautiful and numinous about this place, and about the thought of its owner working earnestly with his own hands. It is said that there has always been a sacred spring here, and that the temple-like villa is a tribute to the pagan temple that once existed by it. At Maser one feels with particular intensity that desire for antiquity and its gods, for making images of them and living familiarly in their company, as the ancients did. Coupled with this are the rich associations with caverns and sacred springs, with the grottoes where "grotesqueness" also has a place, with the seductions and also the dangers of meddling with chthonic and nocturnal powers.

Garden Magic

The statues in a garden stand for an active awareness, returning our glance and speaking to us. Giusti Gardens, Verona.

T HE GARDEN MAGIC is a mood that descends especially on the solitary visitor, a trancelike atmosphere of suspended excitement beyond words or the rational mind. In earlier times, when consciousness was less rigidified, it must have been stronger, leaving no doubt of the presence of Pan and his retinue. The Italian gardens of the sixteenth century seem to have been designed to induce and amplify this mood, preserving those whom the votaries of Yahweh and of Christ would have banished from their sacred groves. How strange that they were typically created by cardinals of the church: Cardinal Ippolito d'Este at Tivoli, Cardinal Gambara at the Villa Lante in Bagnaia, Cardinal Aldobrandini at Frascati, Cardinal Alessandro Farnese at Caprarola, Cardinal (later Grand Duke) Ferdinando de' Medici at the Villa Medici, and Pope Julius III (formerly Cardinal del Monte) at the Villa Giulia in Rome! Far be it from me to impugn their piety or their Catholic orthodoxy, but these clerics certainly cultivated another myth with all the intensity of an alternative religion. Pan and the nymphs should be grateful to them for giving them a home.

Whereas any garden in the temperate zone brings an awareness of the natural cycle of growth, flowering, decline, and dormancy, the Renaissance garden aspires beyond this to the supernatural condition: the eternal spring of the Golden Age. It favors those plants that defy the seasons: evergreen trees, especially the cypress and umbrella pine which give a vertical profile to the flattest landscape, the ilex, and the ubiquitous box and yew—slow-growing shrubs that respond well to the human taste for geometry. Their tidiness lifts them above the natural tendency of the plant world to rank growth and ruthless competition. Flowers, being creatures of a season, are welcome but not essential to the ensemble. They are like the jewelry that a beautiful woman may or may not choose to wear.

After evergreens, a second essential ingredient of the Renaissance garden is stone, the mineral skeleton that gives it its unique form. Stone provides gravel walks, pavements, walls, balustrades, vases, and basins, adapted to the landscape. Ingeniously articulated, these support the vegetable life, which is, as it were, the flesh of the garden, and the flowing water, the third element, which is

its lymph and lifeblood.

The fourth requisite is statues, which are like the intelligence and consciousness of the garden. While the mineral and vegetable elements are offered passively to our contemplation, the statues stand for an active awareness, returning our glance and speaking to us. Ideally, they should be authentically ancient sculptures, envoys from an epoch when statues were worshipped and brought to life (if we believe the *Asclepius*), because they incarnated the daemonic influences that the pagans called gods. As we saw in Chapter 1, a frisson of danger adhered to ancient statues, left over from Judaism and early Christianity and preserved in superstition. The sophisticated garden-building cardinals of the sixteenth century had grown out of that, but the memory of pagan idols was still there, together with the ambiguous allure of the nude. It was enough to charge garden statuary with several layers of significance.

An overview of tall-grown trees, and almost no clue as to what lies below. Villa d'Este, Tivoli.

The Villa d'Este in Tivoli, five leagues east of Rome, offers to hundreds of visitors each day the archetypal garden experience. Most of it was constructed between 1563 and 1572 under the governor of Tivoli, Cardinal Ippolito II d'Este (1509–72), with the learned Pirro Ligorio as architect and archaeological advisor.[1] Today one enters at the upper end, as the Cardinal's guests must have done, emerging from the villa into a belvedere that gives an overview of tall-grown trees, the tops of towers and monastery buildings, and almost no clue as to what lies below. Descending the stairs, we take the right-hand path, which seems to offer the gentlest downward slope—though still a slippery one—passing between well-trimmed hedges of box and yew. Already the sound of water can be heard, and following it, we emerge quite suddenly into a walled and paved enclosure, with the astonishing illusion of a shimmering mound of water rising out of a pond. In fact, the water is falling over the rim of a large oval basin, its sheer quantity giving the impression of a solid, circular mass. The sound is thunderous. In the basin there is an odd-looking sculpture of a head and shoulders between two clamshells. Behind the fountain curves an arcaded loggia with ten statues in niches, each holding an amphora which discharges more water into the oval basin. Above it rises the natural hillside. Looking up, one sees what is evidently the presiding goddess: a seated female figure with a little boy at her knee. On either side, half hidden in the foliage and overgrown with moss, is a recumbent river god, with the solemn, elderly features appropriate to his kind. Crowning the ensemble is the figure of the winged horse Pegasus, indicating that this hillock stands for the mountain of Helicon or Parnassus, and the fountain for the spring of inspiration. The ten statues, then, must be Muses. Like

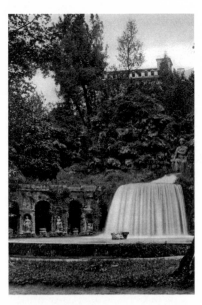

The astonishing illusion of a shimmering mound of water rising out of a pond. Oval Fountain, Villa d'Este.

the invocation to them that begins an epic poem, it is a fitting start to the itinerary.

Turning around, we contemplate the walled enclosure with its benches and niches. Here everything is crumbling. The broken limbs of statues show their iron armatures, guiltily revealing that they were only plaster, and that this whole place is merely a theater. One feels already the melancholy side of the garden magic, which reminds us that for all man's efforts to tame and improve Nature, she will have the last word. She is already taking over the rusticated loggia of the Muses. One would like to enter its green shade to see and hear the tremendous fountain from behind, even at the risk of being sprayed. But it is roped off, being too decrepit and dangerous for the public to be admitted.

Leaving the Oval Fountain and continuing on the same raised path, other features of the garden come into view. Looking over the balustrade, we can see ponds below, and avenues. But first,

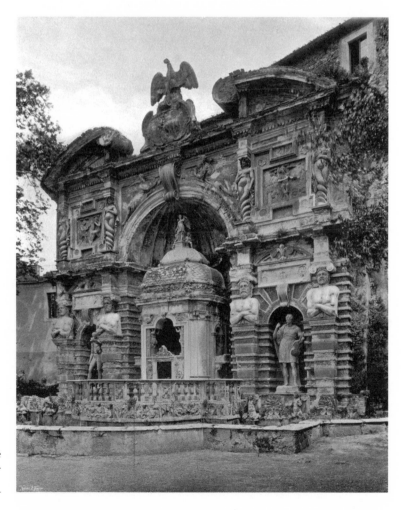

Is it a temple, a triumphal arch, the façade of a grotto, or just a stage set? Organ Fountain, Villa d'Este.

another wonder, and surely the most bizarre structure in the whole garden. Is it a temple, a triumphal arch, the façade of a grotto, or just a stage set? Twin pairs of herms pretend to support it, their muscular arms folded on their chests, their lower parts merged into solid masonry. Between each pair is a niche with a human figure, one naked with a lyre, the other clothed and holding a viola da braccio. They are evidently Apollo and Orpheus, respectively the god and the demigod of music. Relief carvings in the upper story show episodes from their myths: Apollo in contest with the aulos-playing Marsyas, and Orpheus charming the animals. Here the supporters are four anguiped Sirens, well-formed women whose legs turn into serpent-tails entwined around each other. These are not friendly beings, and neither are their legends very cheerful, for we know what happened to Marsyas (skinned alive) and to Orpheus (torn to pieces by Maenads), while the Sirens' song lures sailors to a watery grave.

A peculiar empty tabernacle occupies the central space of this fountain which is too big to be called a niche, more like the apse of a church—in which case the tabernacle is like a parody of the altar. It is a mystery, unless we know that this is called the Organ Fountain, and that it once housed a hydraulus or water organ, so that the music of the cascade was blended with real music. Only an organ, one imagines, could make itself heard above the din.

Retracing our steps and taking another downward path, we reach the fish ponds, oblongs of still water bordered by flowering urns. Like the deep pool that forms at the bottom of a waterfall, they are curiously undisturbed by the thunder of the Organ Fountain. Following them brings us to the central axis of the garden, which on the left runs up to the villa through a series of fountains and grottoes. We resolve to explore these later by way of the two stairways that sweep upwards in symmetrical curves. On their banisters are urns that fling great arcs of water into a pool that is home to three bristling, spouting dragons.

Turning right toward the lower end of the garden, one enters a quiet area of parterres, hedges, bosquets, and clearings, which seems to have lost its defining form but is none the less pleasant for that. There is a pair of undramatic fountains that are nothing but dripping, moss-grown humps. They recall the Meta Sudans, the "sweating cone" that stood before the Coliseum in ancient Rome. The garden comes to an end with a wall, marking the central alley with a locked gate. At that point we must turn back, and have the experience of entering the garden from this end and moving upwards to the villa. As we turn, a minor fountain catches the eye: it is attached to the garden wall and contains an over-life-sized statue of Diana of Ephesus. This Diana is very different from

The pool is home to three bristling, spouting dragons. Dragon Fountain, Villa d'Este.

CHAPTER 8

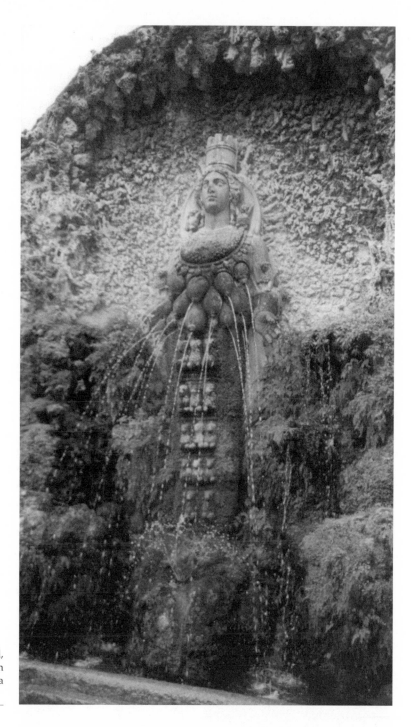

The Great Mother who gives birth to all, sustains all, and receives all things upon their dissolution. Diana of Ephesus, Villa d'Este.

Apollo's sister, the virgin goddess of the moon and the nocturnal hunt. She is a mature lady with an astonishing array of multiple breasts, and a close-fitting garment divided into panels, each one bearing an animal. This is the Great Mother, who gives birth to all,

sustains all, and receives all things upon their dissolution. But her placement lacks any drama, and one wonders whether she is stuck away here out of embarrassment over her excessively pagan appearance.[2]

Having entered from the villa in the southeast, we are now drawn to explore the southwestern side. This brings us to a balustrade that offers a spectacular view over miles of countryside, beyond which we may even glimpse Rome. We realize with awe how miraculously the garden is suspended above a steeply-plunging hillside, touching off associations with the Hanging Gardens of Babylon and other wonders of the world. If we have already visited the Temples of Vesta and the Sybil at the other end of the town, we have admired the waterfalls of the River Anio—a favorite "picture-postcard" view since the sixteenth century—and understand how fortunate Cardinal Ippolito was to have a natural source of falling water to supply his fountains. How fortunate we are, too, when so many Italian gardens are all but dry.

The next exhibit is barred to visitors, and workmen and machines are busy behind the fences. I am describing a temporary situation that does not correspond to everyone's experience, but it is important to notice it. A garden of this kind is in a perpetual state of attrition, and demands constant repair. It was already being repaired twenty years after it was begun, and unless maintenance continues, it will become a ruin, like the Temple of Vesta. Ruins of classical temples are romantic and picturesque, but ruins of gardens, once they lose their hedges, their stucco decorations, and their fountains, are rather dull. What it has taken to keep all the fountains going at the Villa d'Este, one can only guess: it must be a plumber's nightmare, and never more so than at the Fountain of Rome, which is our next discovery.

This fountain complex is unique to the Villa d'Este. Sitting in a small pond is a stone ship the size of an average rowboat, improbably carrying an obelisk. Behind it are statues of a goddess, and of the wolf that suckled Romulus and Remus. Everything here is very busy, with water pouring from the boat and striking up in arcs from dozens of outlets. To the left we can see the decayed remains of the "Rometta," a cluster of famous Roman monuments in miniature. Once they must have been crisply carved, and probably painted as well. A small fountain, recently rebuilt, sends its water down staircases that imitate the Temple of Fortune in Palestrina. Now that the allusions are so obscure and the carriers of meaning so ruined, the main theme of these fountains is the mobile sculpture of the water itself.

Turning our back on the Fountain of Rome, we are greeted by the most celebrated feature of all, the Alley of the Hundred Foun-

A stone ship the size of an average rowboat, improbably carrying an obelisk. Boat Fountain, Villa d'Este.

Musical visitors may hear reminiscences of Liszt and Ravel. Alley of the Hundred Fountains, Villa d'Este.

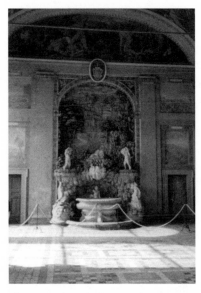

These rooms are half grotto, half painted salon, on the borderline between the garden and the town. Room of the Fountains, Villa d'Este.

tains. (In fact there are ninety-two, but each has two or three separate jets.) It is shaped like a long buffet, with running water at three levels and a high back crowned with heraldic sculptures: boats, eagles, and fleurs-de-lis, every one of them spurting water in thin streams, fans, or arcs. In the garden's heyday one could examine a hundred bas-reliefs of Ovid's Metamorphoses that have moldered away or vanished among the luxuriant mosses and maidenhair ferns. The only carved details one can still see are the row of drooling heads on the lower level, each trying to out-grimace the next. Musical visitors may hear reminiscences of Franz Liszt's *Les jeux d'eaux à la Villa d'Este* or Maurice Ravel's *Jeux d'eau*. But the soul and the senses are already too full to need the stimulus of such virtuosity. Those piano pieces were meant to evoke the sounds of the fountains, but when one is actually present, the waters make music enough. One walks along this alley as slowly as possible, entering ever deeper into its enchantment; and then perhaps one walks back again. At the far end, its music is drowned in the thunder of the Oval Fountain, where we began.

Most visitors to the Villa d'Este hurry to the garden, exploring the villa afterwards, or not at all. Those who do, appreciate the way in which certain rooms have been invaded by the dominant theme of water issuing out of the earth. There are a number of indoor fountains, framed in the same spugna or pumice stone that is used in garden grottoes. Just as this stone is ambiguous, being an artificial imitation of natural, unhewn rock, so these rooms are half grotto, half painted salon, on the borderline between the garden and the town. Then there is the numbing richness of the painted decorations, room after room of them, whose imagery needs much leisure and a learned expositor.

There is more to the garden of the Villa d'Este than I have described here, but one does not discover it all on a single visit. Nor does one understand it, or even grasp the degree to which it can be understood. Is it necessary to go any further than this? Probably not. Erudition and scholarship play no role in the mildly trance-like state of openness to its wonders, aided by one's own casual associations. A parallel could be drawn with Christian churches and cathedrals, and with the way they give access to that other magical and mythical world. There, too, is an environment formed with great artistry and care, in order to enchant the five senses with imagery, music, incense, and even the tangible and edible presence of the Deity. It is not only theologians and scholars who are susceptible to the mystery of the Mass, or spiritually nourished by private prayer in such a sacred space. On the contrary, theologians and scholars may deliberately set their learning aside in favor of a more unmediated experience of the holy.

Be that as it may, it is only fair to honor those who have sought to reveal the secrets of the Villa d'Este, and by extension those of other Italian gardens. An early work by David Coffin, one of the pioneers of garden history, published the documents that illuminate the authorship, chronology, and intended meaning of both garden and villa. One learns there, for instance, that the many-breasted Diana originally stood at the center of the Organ Fountain, being removed from there in 1611.[3] At the opposite end of the axis that begins at the Organ Fountain, there was intended to be a great semicircular Fountain of Neptune. This and some other features of the original plan were never carried out, due to Cardinal Ippolito's death in 1572 and the centuries of disputed ownership that followed. A widely-distributed engraving of the gardens from a bird's-eye view, made in 1573 by Etienne Dupérac, shows several of the projected features in place,[4] and some literary descriptions have been based on this print, rather than on first-hand knowledge. Therefore the interpretation of the Villa d'Este garden, or of any garden of its type, has to consider the possibility of an incomplete program, piecemeal construction, and partial destruction. That is why I have first described it from the point of view of an unprepared visitor, representative of the majority, who is more open to mood and atmosphere than eager for erudition.

Perhaps his enjoyment is increased (and perhaps not) if he is aware that the garden has definite themes, one of which is a microcosm of the Tivoli-Rome region expressed in the major northwest-southeast axis.[5] The great female figure who presides over the Oval Fountain is almost certainly intended as the Tiburtine Sibyl, who legend says prophesied to Emperor Augustus the birth of Christ and who, as the patron of Tivoli, personifies its river, the Anio or Aniene. Like many ancient divinities, she was subject to multiple syncretisms, and was identified early on with Ino, daughter of Cadmus and Harmonia. Ino's husband Athamas became insane and drove her into the sea, together with her son Melicertes. Perhaps the odd sculpture in the basin of the Oval Fountain is meant to show her drowning. But the story had a happy ending. Neptune, seeing Ino's plight, called on Venus, who came on her shell-boat and saved mother and child, transforming them into the water deities Leucothea and Palamon. Like Christian saints they became known as helpers of mariners: Ino-Leucothea helps Odysseus in *Odyssey* 5.333. The Romans knew her also as Mater Matuta and as Albunea.[6]

It is thus the Tiburtine Sibyl who sits with her son above the Oval Fountain, and the fountain itself stands for the nearby waterfalls of the Anio, already mentioned as flowing below her temple. The Anio is one of three rivers in the region, the others being the

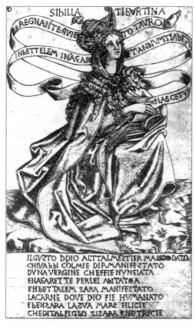

The Tiburtine Sibyl, who legend says prophesied to Emperor Augustus the birth of Christ. Baccio Baldini, *Sibylla Tiburtina*.

The nearby waters of the Anio fall beside the Sibyl's Temple. The waterfalls of Tivoli.

Albuneo and the Erculanea, personified in the river gods flanking the statue of the goddess. Their triple stream is formalized in the three channels that flow along the Alley of the Hundred Fountains. At the far end of the alley is the Fountain of Rome, for all the rivers end up in the Tiber, as do the waters of this place, both in allegory and in fact. If the Fountain of Neptune had ever been built as planned, it would have received the flow from the Fountain of Rome, to symbolize the Tiber flowing into the sea at Ostia. Thus the garden is a microcosm of the landscape.

Another theme, as Coffin explains, is that of Hercules, who was the mythical ancestor and patron of Cardinal Ippolito and his family. The decorations of the villa show Herculean themes, especially his Twelve Labors, while the gardens, with their invitation to freely choose one's itinerary, play on the particular theme of the Choice of Hercules. This is an apocryphal episode in which the young hero was offered the choice between two paths (often figured as the capital upsilon: Y), one of which leads to ease, pleasure, and vice, and the other to hard labor and virtue. Hercules rules the axis of the garden running from the villa in the southeast to the northwest portal, at right angles to the Tiburtine axis. His statue dominates the Fountain of the Dragons, from which paths lead one way to a Grotto of Venus, the goddess of pleasure, the other way to a Grotto of Diana, goddess of chastity. On the same axis, in the steeply rising ground towards the villa, were also a Grotto or Fountain of Pandora, and a Fountain of Leda. Coffin reminds us that it was Pandora who first let the vices out of their box and into the world; and that the lustful union of Leda with Jupiter (in swan form) had as its consequence all the tragedies that befell the Greeks and the Trojans.[7] A thoughtful and informed perambulation of the gardens thus invites moral reflections.

A third theme, more present in the villa decorations than in the garden, is that of Hippolytus son of Theseus, who was a particular interest of Pirro Ligorio and of the Cardinal who bore his name. The antiquarian produced a series of drawings (reproduced in Coffin) for tapestries based on the Hippolytus legend, which go beyond the better-known episodes of the story. They tell that after Hippolytus's death, he was resurrected by Asclepius, and under the name of Virbius sailed to Italy, founding temples to Diana as he went. Once on Italian soil, he founded the city of Ariccia and its sanctuary on Lake Nemi. The Cardinal evidently identified with Virbius's creative achievements, as well as with his exemplary chastity.

These are some themes that are documented in the Villa d'Este. But thus stated, they have little of the garden magic about them. For that I turn to the interpretations of Emanuela Kretzulesco-

Quaranta, whose views on grotesques we met in Chapter 7, and of Maria Luisa Madonna.

Kretzulesco finds the key to understanding the garden in the character and family history of Cardinal Ippolito, whose parents were Alfonso I d'Este, Duke of Ferrara (reg. 1505–34) and his second wife Lucrezia Borgia. Lucrezia's father, Pope Alexander VI (reg. 1492–1503), had been responsible (in Kretzulesco's view) for trying to turn Christendom into a theocracy after the model of the ancient religions of Hermes, Solomon, and Ramses II, which he commemorated in his Vatican apartments. Lucrezia, on the contrary, was a gentle devotee of Christian humanism, of which her friend Cardinal Bembo was the wisest representative at the Ferrara court. Bembo dedicated to her his dialogues on Platonic love, *Gli Asolani* (1505), and Ippolito followed in the footsteps of his mother and the humanist cardinal. This background suffices to explain Kretzulesco's opening thesis:

> The garden of the Villa d'Este, loud with living water, is a garden of resurrection. After the devastating storm which had been unleashed on Christendom in the time of the Borgia, the son of a Borgia, no less, wished by its creation to affirm here—by means of allegories as transparent as the spring water itself—a new faith in the perennity of the Church's mission.[8]

Kretzulesco's garden interpretations all hinge on the mystery of creation, persuaded as she is that this was part of the secret knowledge of the Renaissance humanists. The first stage is the formation of the physical earth through aeons of volcanic turmoil, figured in the battle of Gods and Titans or in Apollo's conquest of Python. Next comes the appearance of vegetable and animal life on earth. Writing of the shell-shaped basin in the Fountain of the Dragons, she writes: "The symbolism of the shell never varies. The animal world began in the crevice of a sea grotto, in an anfractuosity close enough to the surface that the germ there could be warmed by the sun, and could develop and secrete the substance of a protective shell."[9] The life-principle only reaches its goal, however, with the coming of man, who is able to participate in both the physical and the spiritual worlds. This she sees in the egg-shaped Oval Fountain, with its representation of the Spirit in a shell, moving over the waters.

The Organ Fountain, in Kretzulesco's words, "derives from a conception aiming to exalt the harmony existing in the 'cosmos organized by Number' and, in particular, the laws regulating the emergence of life,"[10] notably the Golden Section. She alludes to the way in which this proportion (also known as the Fibonacci Series)

governs the process of exponential growth, especially in plants and mollusc shells, but the connection to musical harmony (where it plays no role) remains unclear.

Kretzulesco's considerations are on the borderline between theological and scientific cosmogony. They speak to us of a time when the two were still held in potential balance. By the mid-sixteenth century, discoveries in science and the reading of the cosmogonic myths of Hesiod, Lucretius, and Ovid had forced a rethinking of the exclusively Bible-based, Hebrew cosmogony of the Middle Ages. But no one was yet ready to exclude every consideration of a spiritual or theological nature, as would happen later in the Scientific Revolution. The idea of concealing such hybrid and eventually heretical doctrines in garden design, which is Kretzulesco's primary and brilliant insight, could only have occurred during this brief window of time.

The fountain that was under repair during the itinerary described above was the Fountain of the Owl. When functioning properly, it contained many bronze birds perched on artificial trees, and each bird moved and sang its appropriate song as the water played from many jets. Then the Owl came out of its hole and hooted, whereupon all the other birds fell silent. Coffin points out that the apparatus realized one of the hydraulic devices described by Heron of Alexandria (first century B.C.). Kretzulesco suggests that it was an amusing allegory of the quarrelsome churchmen with whom the Cardinal had to deal at the Council of Trent, and that the Owl, being the bird of Minerva, stood for Divine Wisdom, which alone can settle controversies. She interprets the Fountain of Rome in a complementary way. The classical monuments, here shown in miniature, stand for the return to classical sources that is essential to a philosopher's development. The stone boat is the unsinkable boat of Saint Peter, the "rock" on whom Christ said he would build his church, and the obelisk which it carries is the solar emblem of resurrection.[11]

Kretzulesco's story of evolution finds its fulfillment in the Incarnation, and thus the chapel of the villa is the essential conclusion to the symbolism of the gardens. This chapel, too, takes the form of a grotto, for Christ who is the Life was born, like the first living molecule, in a cave. Lastly, she points out the fountain attached to the wall of the monastery cloister, now the courtyard of the villa by which one enters and leaves. It is a sleeping Venus, beside the tomb of Adonis. "She awaits the resurrection of spring, just as Christians waited for an Angel to announce the Resurrection to them on Easter morning."[12]

Maria Luisa Madonna's essay on the Villa d'Este occupies a region between Kretzulesco's intuition and Coffin's erudition. Her

The whole apparatus was a realization of one of the hydraulic devices described by Heron of Alexandria (first century B.C.). Salomon de Caus, mechanical birds powered by water.

"I sleep, whilst I hear the murmur of the soft water. Whether you drink or wash, be silent." Ariadne Fountain, Villa d'Este.

essay opens in poetic vein, speaking of the magnitude of the project, with its structures on a scale comparable to those of Hadrian and Semiramis, and the sense that one has there of something lost for millennia: of vast natural movements, deep gorges, the cosmic breath, the bellow of Typhon and his primordial transforming force — all this in stark contrast to the geometrical order of the garden. We enter today, she says, through the privileged entrance from the palace—lesser visitors would have used the lower gateway—and so have the benefit of the esoteric itinerary reserved for the Cardinal's intimates. This plunges us into "the middle of a Hesiodic cosmogony, re-seeded by Neoplatonic Orphism and historicized in honor of the genius loci."[13] Its key is given us by the Fountain of Venus, right after the entrance to the great court. She is the classic image of the *nympha loci,* as shown by her recumbent position, her gesture, and her vase. One can apply to her the saying of the similar nymph (otherwise "Ariadne" or "Cleopatra") of the Belvedere in Rome: "I sleep, whilst I hear the murmur of the soft water. Whoever should touch this marble basin, do not interrupt my sleep. Whether you drink or wash, be silent." Sleep for Ficino (says Madonna) is the portal to higher states in which the soul recovers its original condition, culminating in the mystic marriage. But this is possible only to initiates who, spurning desire and ambition, follow truth alone.

Madonna continues by speaking of the Sibyl who is the protagonist of the Oval Fountain and the *nympha loci.* Her history as

Ino-Leucothea is one of voyaging across the unknown, disburdening oneself of the mortal coil in order to gain peace. In this garden, the voyage takes the form of an initiatic path to profound mysteries of nature and history, proceeding from the known to the unknown in a sort of descent into the underworld.

Hermetic silence (Madonna goes on) was part of Cardinal Ippolito's early education, for his tutor was Celio Calcagnini, author of a *Descriptio silentii* (description of silence). He knew that the divine reason only reaches us under the veils of poetry, architecture, art, and especially music. Here the murmuring of water leads us to Parnassus and its Muses: they who suggested the riddles to the Sphinx. Muses and nymphs were assimilated to one another in antiquity, both sharing in Venus's attribute of fecundation and nutriment through water. Venus Genetrix, as worshiped by the Romans, rules the energies by which all things are born from Nature and return to it, in a cosmic round resembling the circulation of waters. For example, the garden illustrates in miniature how the water coming from the springs of Venus (the Oval Fountain) eventually arrives at Neptune's ocean (the Fountain of Neptune, projected but never built).

Moreover, in the genealogy of the gods explained by Pirro Ligorio, it was the love of Venus and Mars in Vulcan's furnace that generated Harmonia, who in turn is the mother of Ino/Leucothea/the Tiburtine Sibyl. For Ligorio, "harmony" is all that moves. It is the universal harmony infused in all things of heaven and earth by the Creator, which we know especially as human activity and as the arts ruled by the Muses. And the conditions for hearing this great consonance of the cosmos are sleep, and silence.[14]

Another pervasive myth of the garden, according to Madonna, is that of Dionysus, who fits into the family as the son of Harmonia's other daughter, Semele. The Tiburtine Sibyl was thus his aunt, and she and her water nymphs cared for the infant god after his mother's death. There were originally two statues of him in the Oval Fountain enclosure, which Coffin interprets as referring to Dionysus's double birth—once from Semele's ashes, and once from the thigh of Jupiter.[15] For this reason, Dionysus or Bacchus is a god of the mysteries of spiritual rebirth. Moreover, the Grotto of Venus, close by, was changed early in the seventeenth century by the substitution of a statue of Bacchus for that of Venus, thus becoming known as the Grotto of Bacchus. Ligorio, following late Roman authors, assimilates Bacchus to the Sun, to harmony, passion, and to Neoplatonic love.[16] Given what we have already learned about Venus, we no longer associate these divinities merely with luxury and drunkenness. Regarded esoterically, they have risen to another level altogether.

Turning to the Fountain of Rome, Madonna recalls the Tiburtine Sibyl's prophecy of the fall and mutation of the Roman Empire, and her invective against Rome as the mother of adultery and other sins. The Rometta, then, appears as the loved and hated city, here seen in its state of sin and corruption, but still holding the promise of rebirth. At the center of the Rometta is the Temple of Jupiter on the Campidoglio, which held the Sibylline Books and to which the statue of the Tiburtine Sibyl, last of her prophetic kind, was taken in triumph.

Madonna's rich and evocative essay concludes with some observations on Cardinal Ippolito, who apparently saw himself as assimilated to the Tiburtine Sibyl through shared priesthood and virginity, the necessary conditions for contact with the divine and for receiving oracles. Perhaps this was some compensation for his failed efforts to get himself elected Pope.

Even these short summaries show that the garden of the Villa d'Este is pregnant with meaning, both that which was put into it by Pirro Ligorio, and that which has been projected onto it subsequently. It would be both arrogant and shallow to say that there was only one meaning to Ligorio's scheme, though it is possible to class some interpretations as more exoteric, others as esoteric. Each interpreter is limited by his or her powers of response—a response that may include months of work in chilly archives, but which would never have been undertaken without the initiatory touch of the garden magic.

The Villa d'Este stands here for all the gardens that could have been treated in similar fashion, regarding the search for their meaning, or the indifference to it in the quest for a supra-rational experience.[17] Each of the great Italian gardens is like a Beethoven symphony, obedient to certain rules of form and content but distinct from all the others. And just as modern technology enables one to hear those symphonies at will, one after another, so we can spend the morning at the Villa d'Este and be at Caprarola by afternoon to visit the Villa Farnese, and maybe take in Bomarzo or Villa Lante before the day is over. How unthinkable this would have been for their creators! We may rejoice that the masterpieces of the past have become so accessible to us, but something has been lost in the way of leisured response to them.

The garden of the Villa Lante in Bagnaia, near Viterbo (constructed 1568–78), is unique in not having a dominating villa, but a pair of moderate-sized pavilions. The visitor passes first by a fountain of Pegasus and the Muses, which announces the theme of control and artistry that is played out to perfection in the lower garden. One notices the extreme neatness and intricacy of the par-

One notices the extreme neatness of the parterre, dead level with its geometrical hedges, ponds, boat-fountains, and the central sculpture. Villa Lante, Bagnaia.

terre, dead level with its geometrical hedges, ponds, boat-fountains, and the central sculpture of four dark stone figures holding aloft the mound and star of the Montalto, a subsequent owner. There is the same intricacy in the original loggia (its pair was added later), which is painted top to bottom with gods and heroes, grotesques, and portraits of the neighbors' villas and gardens.

Nothing in garden art is more musical than the ascent up the central axis, which introduces one captivating theme after another. One pauses to consider the long table with water flowing down the middle, at which the Cardinal's guests dined and cooled their wine. Then comes a pair of imperturbable river gods, like the ones at Villa d'Este, Caprarola, Bomarzo, and their ancestors in the Vatican Museum. A water-chain with curly edges begins and ends with Cardinal Gambara's heraldic beast, an oversized *gambaro* (crayfish). Then comes a region of giant urns, columns, and grottoes that is halfway to becoming a *boschetto*, as the trees have infiltrated it from the forests on either side. At the top of the walk are two small, inviting loggias again dedicated to the Muses, which Bruno Adorni interprets as "the twin peaks of Parnassus, where Deucalion and Pyrrha were saved from drowning, and thus secured the future of humanity."[18] The end of the garden journey is the beginning of our race. In between the loggias is the Fountain of the Deluge, where the waters spill from a marble mask amidst a riot of vivid green growth. The image is captured by Rilke's sonnet to the self-contained wisdom of Nature:

O Brunnen-Mund, du gebender, du Mund,
der unerschöplich Eines, Reines, spricht,—
du, vor des Wassers fliessendem Gesicht
marmorne Maske . . .

O fountain-mouth, you giver, you mouth
that speaks inexhaustibly the One, the Pure,—
you marble mask, before the water's flowing face . . .[19]

Then back down the hill, to horticulture and civilization, thankful that all Renaissance churchmen were not as Christian as Saint Carlo Borromeo, who after being entertained a little too well at the Villa Lante grumbled that all this money might have been better spent helping Catholic refugees.[20]

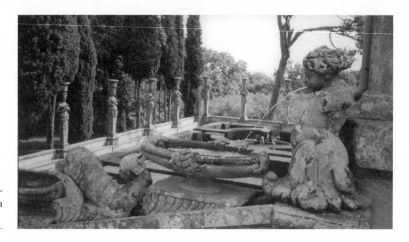

No garden is more alive with the presences that come to haunt old statues. Villa Farnese, Caprarola.

The garden of Villa Farnese at Caprarola, begun in 1584, is indebted to Gambara's model, but its situation is very different, beginning with the vast pentagonal fortress of the villa that sits topheavily on the cowering town. One feels that the people of Bagnaia liked having Villa Lante in their town, but that the Caprarolans feared this monument to ecclesiastical arrogance. Under its walls are a pair of ordinary parterres, and one has to follow an uphill path through a chestnut wood before the real garden appears—a *giardino segreto* on a grand scale. It once served for Theseus's palace in a film of *A Midsummer Night's Dream,* and now its Casino is used to entertain visitors of state. One cannot feel intimate and comfortable there: it is too imposing for that. But no garden is more alive with the presences that come to haunt old statues. There are river-gods, a water-chain of dolphins, brooding, leering, and spewing heads, and a whole assembly of giant herms. The architect has stood some of them face to face, and it is easy to believe that when

The architect has stood some of them face to face, and it is easy to believe that when we are not there, they talk to one another. Villa Farnese.

we are not there, they talk to one another. There is humor in this place, but mingled with awe. Many of the faces look unclassical. They speak of the Etruscans perhaps, or of the earth-sprung peoples of Latium's prehistoric past, when the human stock was not yet separated from the goat-footed ones.

The end of the Caprarola garden is an anticlimax. After the magnificence of the Casino, a large parterre of low hedges and dry fountains stretches further than one cares to walk. There seems to be no beginning to the design, just as it has no definite end. But one should imagine it lit by torchlight, with all the fountains playing amidst music, dancing, and revelry. Then it would truly resemble Theseus's palace, or Oberon's: a world apart in the enchanted wood.

The third mythic garden of the Viterbo region is the Sacro Bosco, which lies near the foot of the plateau that supports the little town of Bomarzo and the large palace of the Orsinis. This "sacred wood," the brain-child of Duke Vicino Orsini (1523–85), is like the black sheep of the family of Italian gardens, sharing enough of their features to betray its likeness, but not observing their norms of behavior. It lacks geometry, hedges, parterres, a recognized itinerary, and any villa or casino in which to sit, sleep, or hold a party. Mariella Perucca[21] helps to put it in perspective by explaining that in the sixteenth century there was probably a formal garden at the foot of the Palace, which led to it. This would have made of the Sacro Bosco the secret *boschetto*, the wilder woodland beyond the formal area, as found in Bagnaia, Caprarola, etc.

One should imagine it lit by torchlight, with all the fountains playing, amidst music, dancing, and revelry. Villa Farnese.

The natural outcrops of stone were carved into figures to make a whole menagerie of oversized statues and objects. Dragon, Sacro Bosco, Bomarzo.

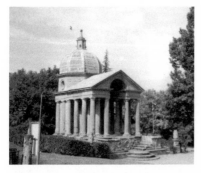

The journey through the Sacred Wood ends at an exquisite temple by Vignola. Sacro Bosco, Bomarzo.

Pier Francesco Orsini, called Vicino, was a virtual vassal of the Farnese family. He was obliged to accompany them on military campaigns, including the war of 1546–47 against the Protestant League of the Schmalkalden and the Flanders campaign of 1553. There his commander Orazio Farnese was killed, and Vicino was taken prisoner. It took two years to ransom him. On his return to Bomarzo, he resumed the work on the Sacro Bosco that he had begun in 1552, and continued it, with interruptions, almost until his death. The natural outcrops of stone were carved into figures, and enhanced with masonry and free-standing sculptures to make a whole menagerie of oversized statues and objects. There is a twenty-foot giant tearing apart a naked, screaming Amazon; an elephant just as large, with a castle on its back and a victim in its trunk; a gigantic turtle with a statue of Fame riding on its shell; a fountain of Pegasus that used to have Muses, too; a dragon fighting with lions, a gaping mouth-cave with a stone picnic table, a sea-monster, a siren, huge inscribed vases, heraldic emblems, a leaning house with rooms inside, a river god, a nymphaeum, a grotto, an amphitheatre, Pans, putti, Janus-heads, serene-faced goddesses, and an exquisite temple by Vignola that is out of character, no doubt deliberately, with everything else.

Part of the attraction of the Bomarzo sculptures today is their mossy decrepitude, as they seem to emerge from the forest floor or to sink back into it. In another century they may be gone, like the other Orsini garden of Pitigliano of which only a few stumps remain.[22] But this sentimental ruinolatry falsifies the maker's intent. Like the Parthenon, the Bomarzo statues were once smoothly carved and brightly painted. They also abounded in inscriptions,

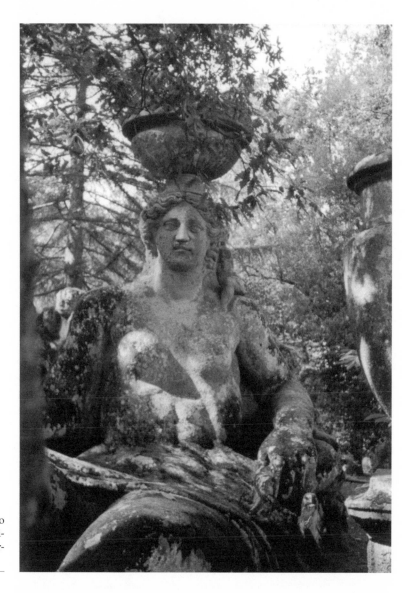

Part of the attraction of the Bomarzo scuptures today is their mossy decrepitude, as they seem to emerge from the forest floor. Ceres, Sacro Bosco, Bomarzo.

like that around the mouth-cavern which parodies a famous line from Dante: "Abandon all care, you who enter!" It is as though Duke Vicino were giving a running commentary on a work of whose unique nature he was justly proud.

Bomarzo is a torment to the exegetes. Mariella Perucca lists the many attempts to explain its meaning, none of them definitive. There have been comparisons with Oriental art. Its execution has been called raw and dilettantish, but also a work of refined sculpture. It has been read as the perilous wood of the chivalric romances; a place of the triumphal entry of sovereigns; a biography in images of Vicino's military career; a pilgrimage through the pagan sacred mountain. It has been explained as a Neoplatonic sanctu-

ary, a creation of Epicurean philosophy, the itinerary of the soul from human to divine love, and a hieroglyph of the alchemical work. What can be said without fear of contradiction is that the Sacro Bosco is Hermetic, in the sense that it has not yet yielded up its secrets.

Eugenio Battisti writes that the genius loci of the Sacro Bosco is Cybele, the goddess of the ecstatic Near Eastern cult which invaded imperial Rome; and also that the place feels Etruscan. Certainly the region is filled with Etruscan remains and with memories of that pre-Roman people. As a possible inspiration, Battisti points to the nearby necropolis of Polimartium, with its tombs decorated with serpents, sea-horses, and demons.[23] The apparent crudity of some of the Bomarzo figures, like the Caprarola heads, must have been a deliberate attempt at archaism, because other heads there are perfectly classical in style.

The contrast between the two worlds provides the theme of the Fontana Papacqua (1561), a remarkable fountain in the nearby town of Soriano nel Cimino. It consists of troughs at right angles to each other, backed by sculptures that emerge from the rock in high relief. One of these is a moot of the most pagan folk imaginable: a large, recumbent satyress with her babies, smiling like an Etruscan tomb-figure, a virile satyr, goats, owls, reptiles, snails. There is also a giant Pan, visible from the chest up and seemingly supporting the rock, though the latter is carved as a crudely-fashioned curtain as though in allusion to the Fountain of the Nymph in the *Hypnerotomachia* (see p. 24). The other wall, in contrast, shows Moses striking water from the rock, surrounded by Hebrew men and women carved in the normal style of the time. I suspect that the satyr-scene is an evocation of the natural spring where the earth has proffered its gift from time immemorial, while the Moses scene redounds to the greater glory of Cardinal Cristoforo Madruzzi, a new Moses who has brought this water by acqueduct to the town.[24]

Cardinals Madruzzi, Farnese, Gambara, and Duke Vicino Orsini were all friends. Perucca writes that they were frequent visitors to each other's villas, and that Vicino's Sacro Bosco was probably an inspiration to the others' projects. She adds that these patrons probably exchanged architects and sculptors, as their creations share so much stylistically and thematically. (Vignola seems to have had a hand in most of them.) Peter Lamborn Wilson has written memorably about his "esoteric mystery pilgrimage" to these places and to the Villa d'Este, following an itinerary recommended to him by an Italian student of alchemy and history.[25] His guide had a theory that these gardens and their a-Christian imagery were the evidence of "a secret society of Hermeticists and neopagans who were not merely in love with Antiquity, but also in revolt against Christian-

ity,"[26] and Wilson admits that on a poetic level, at least, he was convinced.

This "poetic level" satisfies me, too, if it is understood as something like the "imaginal paganism" discussed in Chapter 1, i.e. as a subconscious revolt manifesting as a passion for pagan imagery. Still, I warned that all the Renaissance enthusiasts for the pagan past had Christianity so deeply in their bones that they could not have been unbelievers in the modern sense. Even Vicino died *"confessato e communicato."*[27] The suggestion that there was a secret society of neopagans that included such luminaries as Cardinal Madruzzi, a major figure in the Council of Trent, and Cardinal Gambara, a chief of the Inquisition, presupposes an astounding acting talent on their part. Emanuela Kretzulesco-Quaranta's theory seems mild by comparison: that these gardens encoded the doctrines of a secret society of esoteric Christians that went underground after the persecution of the Roman Academy (see Chapter 1). Like all grand historical and conspiracy theories, these are poetic over-simplifications. People are complex beings; they change over time, and one hand may not know what the other is doing. It is sanguine to assume that their beliefs are consistent and rational. Impatience with the Church does not preclude working for it, and for Christian principles as one chooses to see them. Nor does religious skepticism exclude esoteric activities, such as the alchemy and astrology in which Vicino Orsini was engaged.[28]

Vicino has left a testament of sorts for the edification of those who think they understand him and his philosophy. On the southwest terrace of his palace in Bomarzo are two sets of inscriptions. Those on the south façade read, from the top, BENE VIVERE ET LETARI (live well and rejoice), and below this, in the center, MEDIUM TENERE BEATI (blessed are they who keep to the mean). Then, on the left: E.[DE] B.[EVE] E LVDE POST MOR[TEM] NVLLA V[O]L[UPUTAS (eat, drink, and be merry; after death, no pleasure). On the right: SPERNE TER[RAM] POST MOR[TEM] VERA VOL[UPTAS] (spurn the earth; after death, true pleasure).

On the west face is a similar ensemble: at the top, DIRIGE GRESSVS MEOS D[OMI]NE (direct my steps, Lord); in the center, QUID ERGO (what, therefore?); on the left, SAPIENS DOMINABITVR ASTRIS (the wise man dominates the stars), and on the right, FATO PRVDENTIA MINOR (wisdom is less than fate). Could one wish for a clearer expression of philosophical ambiguity?

I turn now to another aspect of the garden magic, already encountered at the Organ Fountain and the Fountain of the Owl at the Villa d'Este. This is the hydraulic automata, which commanded such admiration in their heyday from about 1550–1620, and which

seem so puerile today. Models of humans and animals that move by themselves, and music that plays without human agency, occupy the far end of a scale that begins with the abstract, elemental beauty of a fountain. The next step is to give it a program, usually by means of a statue, starting as basically as the *Brunnenmund* or mask that personifies the spring. Two early examples by Niccolò Tribolo, made for the Medici Villa at Castello in 1543–45, use the image of Venus wringing out her hair (the water runs out of it), and that of Hercules squeezing the life (symbolized by a jet of water) out of Antaeus's mouth. Water emerging from breasts, etc., belongs here, as do the little men with arquebuses who used to shoot water from their boats at the Villa Lante. Such devices divert attention from the water to the statue, which becomes an actor, enlivened for as long as the water flows, after which it is just a statue again.

Going one stage further, the statue is made to move by water power, like the birds at the Villa d'Este, and this is where the "magic" begins. I have mentioned in Chapter 6 the passage in the *Asclepius* about how the Egyptians put gods into statues, and Horst Bredekamp's ideas about the place of machines in the Kunstkammer. Those considerations apply here, too. Hervé Brunon, in an essay on the aesthetic of automata, shows that the thinking behind automata was more Aristotelian than Hermetic or Neoplatonic, and even less an anticipation of Cartesian notions of nature as a machine. He cites the continuing concern in the Mannerist era with Aristotle's analysis of what makes living beings, namely that they contain their own principle of growth and / or movement, thus differing from works of art or technology which have their principle outside themselves. The automaton violates or overcomes this distinction, for it is an artefact that has, or seems to have, the power of self-motion. Brunon connects this with the notion of art as imitation of nature.[29] By general consent, the static imitation of nature had reached perfection in the masters of the High Renaissance, especially in Raphael's paintings and Michelangelo's sculpture. Mannerism in the arts was partly a search for new challenges, one of which was the imitation of living and moving nature. This brings us to the last degree on the hypothetical scale: automata that do not just move, but act, in the sense of playing out a drama.

It is no surprise that Francesco I of Tuscany was a pioneer in the field of automata, and his faithful factotum, Buontalenti, their designer and executor. The site of their creations was the new Medici villa at Pratolino, which was begun in 1569, the same year as the Studiolo in Palazzo Vecchio. Of the two complementary projects, the Studiolo was Francesco's solitary microcosm (see Chapter 5), while Pratolino was for his life with Bianca Cappello, the woman

he loved and eventually married. Built on a desolate hillside to which everything, notably the water supply, had to be imported at great expense, it housed no ghosts of former Medici. In this respect it was ultra-modern, and all the more so since it was a testing ground for the latest in technology. Eugenio Battisti likens it to the New Atlantis, Francis Bacon's scientific utopia, which was also inside a hill.[30] But Pratolino was also a magical kingdom, built for escapism of the most determined kind. Francesco and Bianca would go there, always accompanied by a heavily-armed guard, and stay for months free from the malevolence of the Florentines, while the Grand Duchy presumably ran on the well-oiled wheels forged by Cosimo I.

The villa of Pratolino was flattened in 1822, together with nearly all the marvels of the grottoes and gardens, in order to make an "English" park, but the stable-block alone was sufficient to provide a respectable villa for the Demidoff family, whose name the site now bears. One unique monument was spared: the personification of the Appennines by Giovanni da Bologna, which is the largest statue of the century. It contains rooms in its head and body, and windows in its eyes through which Francesco could fish in the pool below. Also surviving is the grotto dedicated to the River Mugnone, personified by a masculine figure whose awkward, crossed-legged pose mimics the windings of the local stream. The Mugnone grotto once had automata of Fame sounding a trumpet, Pan playing the syrinx, and a peasant with a serpent who drank water. These have vanished, along with the living collections of rare birds and fish, the flower garden where Francesco could indulge his passion for botany, the Parnassus with its nine Muses whose music was made by a water organ, and a tree house in an old oak.[31] A modern touch was a swimming pool with heatable water, 18 x 12 meters, whose depth increased from end to end from a handsbreadth to the height of a man.

The main automata of Pratolino were located in a series of grottoes underneath the villa. On the ground floor beneath the *piano nobile* was a suite of nine rooms, all decorated with *spugna*, fake stalactites, real seashells, coral, mother-of-pearl, marble, and mosaic.[32] The largest of the rooms was the Grotto of the Deluge, which could be filled instantly with water, and in which the water powered numerous automata: a knife grinder with his assistant, an olive press with laborers and oxen, a paper mill, ducks which dived and drank, a putto with a revolving world map, a tree with water-spouting animals, a harpy, etc. It seems that these were of the penultimate type in my classification, performing repetitive motions. In the circular Grotto of Galatea was one of the miniature dramas to which I referred. It began with a triton who sounded his

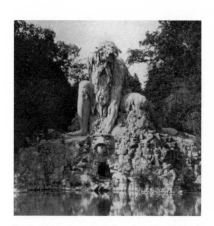

It contains rooms in its head and body, and windows in its eyes, through which Francesco could fish in the pond below. Giovanni da Bologna, *Personification of the Appennines*, Pratolino.

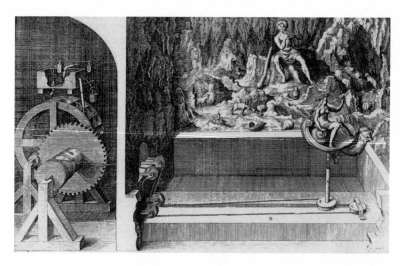

A door opened and Galatea floated out on a golden shell, drawn by two dolphins. Illustration from Salomon de Caus.

shell-trumpet, whereupon a door opened and Galatea floated out on a golden shell, drawn by two dolphins. These sprayed water at the onlookers, turned around, and went back inside. The Grotto of the Samaritan Woman had a whole array of automata, beginning with the lifelike figure of the woman herself who came out, filled her bucket at the well, and returned, watched by a shepherd playing the bagpipe. Set into the walls, like a puppet theater, were moving models of Vulcan's Forge, a mill with laborers, a hunt, a squirming serpent, and more singing birds. When the grottoes were used for dining, warm water and hand towels were presented by life-sized automatic servants, and the food came in and out on a revolving buffet. Thus Francesco and his guests, like Marie Antoinette in the Petit Trianon or Ludwig II at Schloss Linderhof, could dine without the intrusion of human servants.

John Dixon Hunt remarks that "it is difficult for us now to accept the numinous in gardens, since we have lost certain habits of mind and imagination in face of them."[33] One such habit is the admiration for early industrial technology. Buontalenti was in the vanguard, being also the inventor of practical water- and windmills, and a water pump,[34] to say nothing of a grenade and a perpetual motion machine. So was the *dux mechanicus* Francesco, with his experiments in the Casino San Marco (see Chapter 6). Both prince and architect were part of the contemporary movement to liberate industry and irrigation from reliance on the muscle power of men or animals, perfecting devices of wheels and levers that used water power, and would eventually be adapted to steam. If Buontalenti's perpetual motion machine had succeeded—and there was no reason, in the late sixteenth century, to doubt that it could— then all work would soon have been done by automata.

Something of the pride and wonder of this period comes through

When Ramelli drew his machines, it was quite natural for him to decorate them with classical motifs. Agnostin Ramelli, *Le Diverse e Artificione Machine*.

in splendidly illustrated volumes such as Georg Agricola's treatise on mining, *Ars metallica* (The Metallic Art, 1550) and Agostino Ramelli's *Le diverse e artificiose machine* (The Various and Artificial Machines, 1588). It explains why the Pratolino automata included such things as mills and waterwheels. To those not initiated into the mechanics of air and water power, their workings were as incomprensible as computer hardware is to the majority of users; but they were not so blasé about it. The sentiment of *stupor*—being struck dumb with amazement—was the proper tribute to the prince as adept in *magia naturalis*.

Another lost habit of mind is familiarity with the classics, and instant recognition of their myths and legends. As we saw in Francesco's Studiolo (Chapter 5), no discord was perceived between the classical world and its mythology and the latest thing in science. Natural science was still "natural philosophy"; the occult properties of things were not relegated to occultism. Wisdom was to be sought from the ancients, who in so many ways were deemed superior to the moderns. The garden automata are all realizations of designs from Heron of Alexandria's *Pneumatica* and *Automata*, just as the architecture of the villas was out of Pliny and Vitruvius. When Ramelli drew his machines, it was quite natural for him to decorate them with classical motifs, such as the sphinx who hints at the mysteries of the new-old technology.

Another Mannerist fashion was the use of deliberately ignoble subjects, such as the peasants and laboring folk who are honored with life-size statues in the Boboli Gardens, and who had a prominent role in the Pratolino automata. While it would be mistaken to read into these any dawning of a modern social conscience,[35] they were treated with amused condescension rather than with mockery. One of them even parodies the classics: the Fountain of the Laundress in the garden of Pratolino, which represented a laundry woman squeezing out her washing with the same gesture and effect as Venus wringing out her hair,[36] while her little boy raises his shirt and pisses.[37]

Absent in Pratolino is any sense of a spiritual or even a moral or mythological theme, such as existed at the Villa d'Este. The Samaritan woman at the well, for example, is presented with absolutely no thought of her source in John's Gospel 4:7–30. One senses in Francesco, as one does in Bacon, the shadow of a technocrat obsessed by experiment for its own sake, and detached from any ethical or ecological considerations.

For all its apparent absence of meaning, Pratolino did not lack for a hermeneutist, in the person of F. de Vieri, who in 1586 and 1587 dedicated to Franceso his *Discorsi delle maravigliose opere di Pratolino, e d'Amore* (Discourses on the Marvelous Works of

Pratolino, and of Love). This savant had spent only one day at the villa, and been given a brief tour by Buontalenti and his son. He had no official program to hand, or he would undoubtedly have mentioned it.[38] Instead, he spun a theory about Pratolino as a Paradise Garden that is totally fantastic, yet must not have displeased Francesco so as to make him refuse the dedication.

De Vieri understands a *pratolino* (little meadow) as meaning "every place full and adorned with good and beautiful things," and he gives twelve examples:[39] 1. the Divine Essence, with the [Platonic] Ideas; 2. the Empyrean Heaven of angels and saints; 3. the visible heavens; 4. the natural world; 5. the earthly Paradise; 6. the royal garden, such as that of the Pitti [Palace]; 7. the park rich in multiple attractions, like Pratolino itself; 8. the person endowed with beauty and nobility, like "the beloved lady to her lover"; 9. the assembly of artists and their works, such as that in the Uffizi or in the Cardinal [Ferdinando] de' Medici's palace in Rome; 10. those rare men who are valorous in peace and in war, like Giovanni delle Bande Nere [. . .]; 11. the assembly of the wise, like the "famous Studio of Pisa"; 12. an essay of varied erudition and philosophy [like de Vieri's own].

It is a curious way of looking at things, but not without precedents, e.g. the *Tarocchi* (see Chapter 3) with their scale from the First Cause down to the ten ranks of humanity. As an example of imaginatively "re-ordering the world," it shows the kind of philosophical musings to which a garden like Pratolino could give rise, in a mind formed by Neoplatonism and the Hermetic doctrine of correspondences. Somewhat in the same spirit, when Ficino in 1475 witnessed a performance by a German theater group that used automata, he saw in it a demonstration of God's omnipresent moving force.[40]

To install automata, especially a hydraulic organ, in one's villa or garden was a rare extravagance. The only places that had organ fountains, besides the Villa d'Este, were the papal garden on the Quirinal Hill in Rome (organ constructed 1595, recently restored to playing condition[41]), Schloss Hellbrunn, near Salzburg (1612–19, still in working order), Saint-Germain-en-Laye, near Paris (before 1614),[42] Villa Aldobrandini at Frascati (1615–21), possibly the Hortus Palatinus at Heidelberg,[43] and the Grotto of Tethys at Versailles (see Chapter 11). By 1650, when Athanasius Kircher published a blueprint of the Quirinal instrument, the fashion for such things was already passing, and the main interest of aristocratic garden enthusiasts had turned to flowers and exotic imports.

The automata, the hidden music, and the grottoes which one is a little hesitant to enter, help to make the garden a portal to a parallel reality. Untidy nature is corrected by geometrical art, while

RIGHT: Hydraulic organ with automata, from Athanasius Kircher, *Musurgia Universalis*, 1650.

CHAPTER 8

Πᾶν, θεὸϛ Ἁρμωϛὴϛ, ἠχῶ ὦ πάντα διδᵒ́ϊ

the artist's creations move like natural beings. There is a bit of a Feast of Fools atmosphere, in which the norms of behavior are turned upside-down. Water defies gravity, sprays from mouths, breasts, and penises, then outrages decorum and rank by spurting in the faces (or, at Hellbrunn, the bottoms) of bishops and ambassadors. Everywhere there are reminders of fertility and sexuality, rapes and abductions, and the semi-human creatures born of illicit couplings. "It is as if our Savior had never breathed!" exclaimed Queen Christina of Sweden after seeing the glories of Caprarola.[44] Like another convert, Madame de Maintenon (see Chapter 11), she sensed something in the Renaissance spirit by which she was not amused.

Water outrages decorum and rank by spurting in the faces (or the bottoms) of bishops and ambassadors. Schloss Hellbrunn, near Salzburg.

CHAPTER 8

Joyous Festivals

OF ALL the art forms of the Renaissance, that of the courtly festival and the "joyous entry" is the most inaccessible to us, and perhaps also the most alien. It is still in the state of Renaissance painting and architecture before color photography and universal tourism, or Renaissance music before high-fidelity recording and the early music revival. Indeed it is worse off than these, for there is no prospect of re-enactment or of technological re-creation. One must make the most of what evidence exists (aided by a few masterly interpreters), then use one's imagination. This situation ill reflects the importance of such festivals in their own time, both to those who gave them and to the onlookers, for whom they must have been among the more memorable spectacles of their lives.

The main occasions for festivals and triumphal entries were the coming of a ruler into his or her own domains, visits of foreign dignitaries, and weddings. Since marriage was a tool of international politics, the last two often coincided. The birth or baptism of an heir was another pretext, as was the inauguration of a new ruler after the death of the previous one. During the period 1450–1550, these festivals underwent two main changes. In the Middle Ages they had always had a civic and popular dimension, serving as a ritual to strengthen the bond of mutual obligations between ruler and people. Their symbolic language drew on the tradition of religious pageantry and mystery plays. Just as those had brought the divine within reach of the people, with a judicious mixture of earthy humor and superstitious awe, so the entry of a monarch would make him rub shoulders with his subjects, admire their folkloric efforts to entertain him, and consent to have his horse and trappings seized by the rabble. He would hear the complaints of the city fathers and the pleas of prisoners (whom he might pardon[1]), and be reminded that he was but a privileged mortal with the same prospect of Heaven or Hell as any of his subjects. For this system to work without danger of *lèse-majesté*, the monarch or lord had to possess a legitimacy in the eyes of the people, which came not from below—certainly not from them—but from above. Even in the case of an elected monarch like the kings of Poland or Bohemia, or the Holy Roman Emperor himself, a spiritual chrism

The "chariots" were flat-bedded farm carts adorned with fanciful *all'antica* ornaments. Pluto's Abduction of Persephone, from the Florentine Picture Chronicle.

was bestowed at his coronation and brought with it a divine right.

All this changed with the upsets of the Italian Wars, in which the lordships of cities and territories vacillated with the power-struggles between France, the Papacy, and the Empire, and thereafter with the Wars of Religion in France, the Netherlands, and Central Europe. Hereditary lords were supplanted, as the Visconti by the Sforza in Milan, or, like the Medici, imposed on formerly free republics. Rulers who lacked a traditional warrant for their rule, or who were fighting for their survival, were not interested in mutual obligations or civic approval: they needed to assert their power, and the symbolic machinery of festivals was a primary instrument in this. It played the same role—though in a far more aesthetic and noble mode—as the media of today in broadcasting slogans, promises, and lies.

The other change that occurred over these hundred years was the adoption of antique imagery and style. In one sense, this was merely a side effect of the general trend in all the arts. In another sense, it went along with the political change just mentioned and emerged in the revival of the Roman triumph. The entries of the Middle Ages had been scripted by the hosts in the form of decorated arches, adulatory poems and songs, *tableaux vivants*, etc., while the prince, riding on horseback surrounded by his courtiers, played his role in a traditional drama. The imagery was more redolent of Christ's Nativity, Epiphany, or Entry into Jerusalem,[2] than of Roman triumphs. The revival of the latter began, after some sporadic medieval attempts,[3] with Alfonso the Great's entry into Naples in 1443, commemorated in a neoclassical triumphal arch at the Castel Nuovo. Significantly, it was organized by Florentines.[4] Ten years

CHAPTER 9

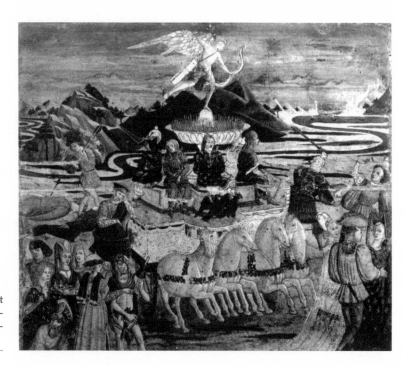

"Love conquers all," even the mightiest of gods and the most magnificent of mortals. Anonymous Sienese master, *The Triumph of Love*.

later the megalomaniac Borso d'Este (as Bonner Mitchell calls him)[5] entered his cities of Reggio nell'Emilia and Modena in Roman style, with triumphal chariots and allegorical floats. Alfonso's and Borso's entries were no longer dialogue between prince and people but pure theater, instigated by themselves, scripted by court humanists, and staged to exalt the ruler in the eyes of a passive and admiring crowd. One medieval residue was that they both involved "marvels": in 1443, there was a triumphal chariot that showed Alexander the Great standing on a revolving terrestrial globe, and in 1453, flying angels, rotating circles of cherubim, a chariot drawn by "unicorns," and a car that apparently moved by itself. The paintings in the Hall of the Months in Borso's Schifanoia Palace give an impression of such paraphenalia, as do the contemporary drawings from the *Florentine Picture Chronicle* (see Chapter 3).

These early efforts were quite modest. The "chariots" were flat-bedded farm carts, such as had served as outdoor stages for the medieval mystery plays. In the Schifanoia frescoes they are draped with scalloped cloth; in the Chronicle's "Triumph of Joseph" and "Pluto and Persephone" they have fanciful *all'antica* ornaments. The triumphal cars of Federigo da Montefeltro and his wife, Battista Sforza, shown on the reverse of their twin portraits by Piero della Francesca, are humbler still. The carts are cleaned up and painted for the occasion, but are still quite rattly and precarious for the Victories standing behind the Duke and Duchess. The allegorical

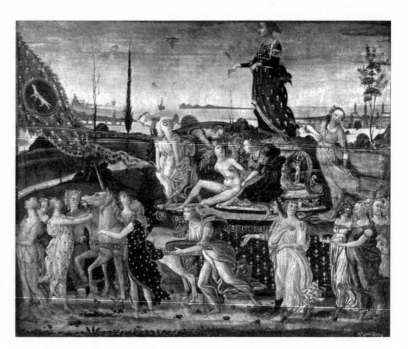

The Carnival seizes the moment for pleasure and excess, because the next forty days are ones of abstinence and penance. Jacopo del Sellaio, *The Triumph of Chastity*.

figures of the Seven Virtues are played by plain, solid girls from the Marches, dangling their feet off the carts.

In Florence, Lorenzo de' Medici used the existing festivals, especially Carnival and the midsummer Feast of Saint John the Baptist, to endear himself to the people while indulging the refined interests of his circle. A landmark in festive decoration was the tournament held in 1475 to honor Lorenzo's brother Giuliano de' Medici, commemorated in Angelo Poliziano's poem *Giostra* (Joust).[6] The theme of it was a typical courtly conceit: the conversion of Giuliano from a rough hunter into a votary of Love, brought about not by medieval allegorical figures but by the goddess Venus. The principal decorations were two series of reliefs ("by Vulcan") on the portal of Venus's palace. The first series had the theme of cosmogony: 1. Castration of Saturn; 2. Battle of Nymphs and Giants; 3. Birth of Venus; 4. Venus welcomed to earth; 5. Venus welcomed to Olympus; 6. Vulcan. In the Christian-Neoplatonic atmosphere of the early Medici court, these could be read as pagan symbols for biblical truths: the primordial dividing of the heavens and of the waters, the eternal begetting of God the Son through Love, the incarnation of that principle, and its return to Heaven. The second series depicted Venus's power, especially as it obtains over the gods: 1. Rape of Europa; 2. Jupiter as swan, shower of gold, eagle, serpent; 3. Neptune as ram and bull; 4. Saturn as horse; 5. Apollo pursuing Daphne; 6. Ariadne forsaken; 7. Arrival of Bacchus on Naxos; 8. Bacchus's train; 9. Rape of Proserpine; 10. Hercules

Just as Lorenzo's vision of love was tainted with melancholy, so was his Roman grandeur. *The Triumph of Fame*, anonymous illustration to Petrarch, 1488.

dressed as a woman; 11. Polyphemus; 12. Galatea. The theme is the familiar *Amor vincit omnia* (Love conquers all), even the mightiest of the gods and, by implication, the most magnificent of mortals. A Christian Neoplatonic gloss might be forced here, too, but this looks more like a proclamation of the chief pagan themes for the next hundred years.

The entertainments that Lorenzo devised for Florence's annual Carnival were somewhat different. He did not participate himself, but planned them and wrote the songs that were sung from the carts. Nicole Carew-Reid writes of how the Magnifico and his social set would celebrate Carnival in the comfortable house of one of them, where Lorenzo would read the script he had prepared for public consumption and invite improvements.[7] This would be the time when the obscene double meanings that are present in the majority of the songs[8] would cause helpless laughter among the sophisticates. The simple citizens would presumably hear only the surface meaning, if they could catch the singers' words at all, and miss the multiple allusions to sexual organs, their uses and abuses. (One recalls the delight that Lorenzo's grandfather Cosimo took in the *Hermaphroditus*—see Chapter 5.)

For the Carnival of 1490, Lorenzo presented a "Triumph of the Seven Planets," based on their traditional astrological qualities but again centering on Venus as the planet of love. The loves of the gods are all very well, but these Renaissance hedonists never tire of reminding us that to humans, love brings pain as well as pleasure. Lorenzo's poetry exhales an Epicurean pessimism, arising from contemplation of the human reality of love and death, with no notice whatever of the Christian solution. Hence the most famous motif of his Carnival songs, sung at the "Triumph of Bacchus": "How beautiful is youth, which flies so soon away! If you want happiness, take it, for tomorrow is uncertain." Carew-Reid writes of how the Carnival itself plays out this theme, seizing the moment for pleasure and excess because, in the cycle of the Church's year, the next forty days are ones of abstinence and penance.[9]

Saint John's Day was more a festival of civic pride, in which the Florentines would thank their patron saint and congratulate themselves. In the following year, on June 23, 1491, Lorenzo offered a Roman triumph based on the same precedent as those already mentioned, that of Paulus Emilius (third century B.C.), as described by Plutarch. This time there were fifteen chariots drawn by oxen and accompanied by five squadrons of horsemen. Although Lorenzo himself did not ride in triumph as Alfonso and Borso had, the object of the entertainment was to prop up his waning prestige. For just as Lorenzo's vision of love was tainted with melan-

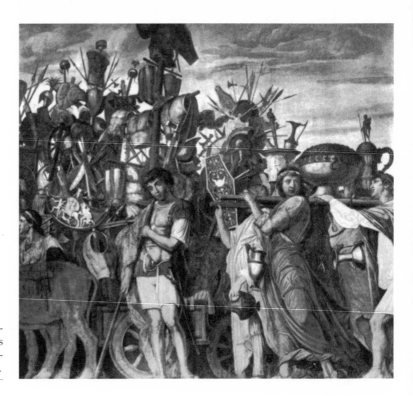

Mantegna poured into these extraordinary canvases the full cornucopia of his antiquarian researches. Andrea Mantegna, panel from *The Triumphs of Caesar*.

choly, so was his Roman grandeur. He was fast losing his popular support; the Florentine coinage, after centuries of stability, had just been devalued; the incendiary friar Savonarola was ranting against the Medici and their culture of "vanities"; and within a year Lorenzo would be dead at forty-three.

The anonymous woodcuts of the *Hypnerotomachia* give a realistic impression of the pseudo-Roman triumphs of the later fifteenth century, with unpretentious cars surrounded by picturesquely dressed (or undressed) attendants waving banners, trophies, standards, etc. But this was not what they aimed at. The descriptions in Colonna's text are full of hyperboles: the cars are made from precious stones, the harnesses are gold and pearls, and every surface is encrusted with bas-reliefs of mythological imagery. The illustrations that are admired today for their purity of line could not begin to match the hothouse atmosphere and the crowded imagery of the text. For a closer visual parallel we should turn to the epic work of Mantegna: the eight large paintings comprising the *Triumphs of Caesar.* These were begun in the 1470s for Lodovico II Gonzaga, but not finished until shortly before 1494, when Isabella d'Este showed them to Giovanni de' Medici.[10] Mantegna poured into these extraordinary canvases the full cornucopia of his antiquarian researches. Every object has its source in some literary or pictorial record of ancient Roman triumphs—no matter that some

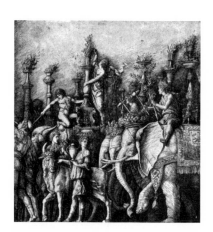

Mantegna's *Triumphs* were widely imitated and publicized through prints. Engraving after Mantegna.

of them are misunderstood. The result is as rich in detail as an epic poem. Each canvas is like a canto, with a central theme and a moral or aesthetic point to make. Andrew Martindale writes: "The total effect is such as instantly to make one feel that one is in the presence of the Age of the Caesars. This was an experience which was entirely new in the years around 1480–90 . . ."[11] After the decay of the Gonzagas, the series was acquired by Charles I of England and now hangs in the Orangery of Hampton Court Palace, marvelously resurrected after centuries of misguided restoration.

Mantegna's paintings were soon copied and imitated. A set of woodcuts loosely based on them by a Strasburg artist was published in Venice in 1503. A comparison of these with the Petrarch illustrations of only fifteen years earlier shows what a difference Mantegna's imagination had made, and explains why these prints, pale reflections of the paintings as they are, were so well received and widely circulated. Suddenly the Roman triumphs had come off the written page and taken visible form. One result of their influence was the *Triumphs of Maximilian*; another, the paintings in the Galérie François I at Fontainebleau (see Chapter 1).

Rome saw its first triumph *all'antica* on January 1, 1501/02, at the marriage of Lucrezia Borgia to Alfonso I d'Este, heir apparent to the Duchy of Ferrara. The details are known from letters sent to Duke Ercole I in Ferrara and to Isabella d'Este in Mantua. Lucrezia was the daughter of Pope Alexander VI, for whose apartments Pinturicchio had painted Osiris, Hermes Trismegistus, and the Bull of Apis, and who has been accused of trying to turn the papacy into a theocracy on Egyptian lines (see Chapters 1, 8). For Lucrezia's wedding, Roman imagery sufficed. The Piazza San Pietro was flooded to create a naumachia (mock sea-battle) —perhaps the first since ancient times—and there were dramatic skits in Latin. A procession of thirteen triumphal chariots wound its way through the city, each one representing a Roman hero such as Julius Caesar, Paulus Emilius, and Scipio Africanus Major. When they reached Saint Peter's, verses were recited explaining their significance. For light relief, Plautus's comedy *Menaechmi* was given, presumably in Latin rather than in the Italian translations that were preferred in Ferrara, and the Pope's son Cesare Borgia showed his prowess in a bull fight.

The Roman Academy's members must have had a hand in planning this classicizing extravagance. As mentioned in Chapter 1, the Academy survived the trauma of 1468, and its head, Pomponio Leto, lived until the end of the century to educate an international college of humanists. Compared to the philosophical Accademia Platonica of Florence, which celebrated Plato's birthday with an

annual symposium, the Roman Academy was more antiquarian, leaning to drama and "creative anachronism." Their annual celebration was held on April 21, the date of Rome's foundation, and passed as a revival of the Palila, an ancient feast in honor of Pales, the Dea Roma.[12]

The Academy collaborated with another humanist pope in 1513, when Giuliano and Lorenzo de' Medici were given Roman citizenship at the instigation of their brother/uncle Leo X. Bonner Mitchell writes: "The republican city fathers, delighted at having been asked for such citizenship, and still full of good will toward the new, humanistically inclined pope, commissioned the construction on the Capitolium of an enormous temporary theater of neoclassical architecture, with paintings and sculpture that evoked the ancient grandeur of Rome and did the Florentines the supreme honor of portraying their ancestors the Etruscans as virtual equals of the ancient Romans."[13] The director was Tommaso Inghirami, a former student of Pomponio Leto. He planned the decorations of the theater, while another Academician, Camillo Porzio, organized a troupe of patrician boys in a series of skits on Roman and Etruscan themes. Finally they presented Plautus's comedy *Poenulus* under Inghirami's direction. Raphael's portrait of Inghirami shows him as a likable man, alert and certainly not underfed. He must have been a pleasure to work with, and what fun the boys must have had, dressing up and acting a whole range of pieces from solemn allegory to slapstick comedy.

Earlier in the year, the same Medici had been welcomed at the Florentine Carnival with a parade that included seven chariots depicting "Seven Triumphs of the Golden Age": 1. The Golden Age of Saturn; 2. The Age of Numa Pompilius; 3. The Age of Titus Manlius Torquatus; 4. The Age of Julius Caesar; 5. The Age of Caesar Augustus; 6. The Age of Trajan; 7. The Return of the Golden Age.[14] The parade was organized by a group called *Il Broncone* (the Branch), after the Medici device of a branch putting forth new leaves. The tradition of the Four Ages of the World goes back to archaic Greece (its earliest recorder is Hesiod), and stands in stark contradiction to the Christian theory of history as a series of divine revelations and covenants, with the next expected event being that of the Apocalypse and the Second Coming of Christ. It would have been blasphemy to associate even the Medici with that, so—in a perfect illustration of my main theme—they slipped into the alternative language of pagan imagery, pretending with heart and soul that things were otherwise than the dominant dogma; that the history of the world had been one of glorious restorations of the primal state, all due to the Romans; and that the Medici were the instigators of the first restoration in 1400 years!

As already mentioned, the two Medici popes Leo X and Clement VII had been acclaimed with hopes that they, too, would usher in a Golden Age for the Eternal City. Much had changed by 1536, when the triumphal chariots of the Borgia wedding were recreated for the solemn entry of Emperor Charles V.[15] The emperor was making his way up the Italian peninsula after his naval victory over Barbarossa, the pirate-lord of Tunis, and the parallel with Rome's victory over Carthage was not missed. Every city was at pains to demonstrate its loyalty to the man who had crushed French ambitions in Italy, and accidentally let his mercenaries sack Rome in 1527 to teach the papacy a lesson about who was in charge on earth. The new Pope, Paul III Farnese (reg. 1534–49), was himself an alumnus of Pomponio Leto's school, and the Roman entry was planned by his secretary-diplomat Latino Giovenale Manetti. The Emperor was expected in time for the Carnival in February, when Manetti staged a parade of thirteen chariots, again reproducing the triumph of Paulus Emilius. These had come and gone by the time Charles arrived in April, but Rome had other resources to impress him. It had real triumphal arches, not just the canvas and stucco ones with which other cities had to make do. On the Pope's orders, three or four churches were destroyed, and more than two-hundred houses (with no compensation to the owners[16]), so that a smooth, unobstructed road could lead the Emperor right through the Arches of Constantine, Titus, and Septimius Severus, opening up splendid vistas as he went. The Senators put on togas for the occasion, young men in ancient costume escorted the Emperor, and scholars were on hand to expatiate on the sights to their visitor, who was both patient and curious. As if this were not enough, two artificial arches were raised, covered with statues and painted stories glorifying the Habsburgs; then, as the road neared the Vatican, Christian imagery prevailed.

When Charles V returned to his native Netherlands in 1549, bringing his son Philip as their ruler-to-be, another series of cities decked themselves out to impress him. The grandest display of all was the arch erected by the city of Genoa for the Antwerp entry. To use a favorite expression of Francesco Colonna's, the great portal of the *Hypnerotomachia* was as nothing to it. This monstrosity was seventy-feet wide, one-hundred high, and ninety in depth, with double colonnaded porticoes at either end. It was of the Corinthian order, with blue-veined marble columns and gilded bases and capitals. On the first façade, Charles and Philip were pictured twice as large as life, receiving homage from the Olympian gods and goddesses. Jupiter offered them his thunderbolt; Apollo his bow and arrows; Mercury his caduceus; Athena her spear and shield; Mars his sword; and Neptune his trident. Other panels showed Atlas

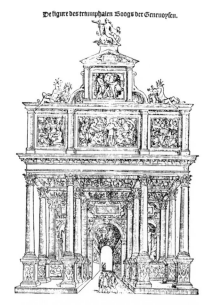

De figure des triumphalen Boogs der Geneuopsen.

This monstrosity was seventy-feet wide, one-hundred high, and ninety in depth, with blue-veined marble columns and gilded bases and capitals. Frans Floris and others, Arch of the Genoans, Antwerp Entry of Charles V.

resigning the world to Hercules; an old man, chained and naked, surrounded by the Three Fates; and a young man resembling Philip battling monsters. Marine and river gods perched atop the edifice, symbolizing the maritime city of Genoa.

The ceiling of the portico was painted with scenes of the Revolt of the Titans. While the Olympians looked on in terror (exactly as in the Palazzo del Te), Jupiter cast his thunderbolts, making flames spurt from the Titans' bodies, while his eagle bloodied them with its talons. Another scene showed Susanna and the Elders; she represented Faith, and was rescued from her molestors by the Emperor. In the second portico, Philip played Jason overcoming the dragon of the Hesperides and seizing the Golden Fleece, a reference to the knightly Order of which he would become the Grand Master. There was a curious scene of an old man holding a squared stone, standing with one foot on the terrestrial globe. Apparently he was Terminus, who alone among the gods refused to give way to Jupiter; but now, so went the fiction, he was departing the earth so that Philip might possess it. (Charles hoped that Philip would be the next Emperor, and rule America as well as Austria, Spain, and the Netherlands.) Other paintings on the ceilings showed allegories of the arts and crafts: "Venus and Cupid in Vulcan's Forge," with the Cyclopes at work (as at Schifanoia) and Cupid doing his best to help (as in the Palazzo Vecchio); and Apollo and the Muses. The pedestals of the columns depicted the inevitable Labors of Hercules.

The porticoes also had over-life-sized statues in niches. On the first, Janus carried a message of peace, with the closing of his Temple of War, and Saturn announced the return of the Golden Age, perennial promise of sovereigns. Neptune and his train figured in the decorations, as did the River Tiber and the Wolf of Romulus and Remus, evoking Rome and the fulfilment of Sibylline prophecy in the Augustan Age. The second portico had statues of hundred-eyed Argus, also seen as a master of war and peace, and of Pan. This was not the lusty Pan of Ovid but the "All-God" of Macrobius, with a ruddy face and his chest spangled with stars. In the tunnel or gallery that led through the arch were allegories of Earth and Sea, with their customary satyrs and nymphs, tritons and sea monsters. On the vault was Juno with the Winds—indispensable players in linking the continents of Charles's empire.

Contemporaries tell us that this Arch of the Genoans took seventeen days to build, employed 280 artists, and cost 9,000 gold florins. The chief painter Frans Floris (1520–70) astonished the Italians by his speed and facility: Jean Jacquot estimates that he painted 200 over-life-sized figures in five weeks.[17] The scholar adds:

It was not by chance that Floris was put in charge of this Italian arch. Had he not spent several years (c.1542–47) in the peninsula, where he was passionate about antiquities and the Sistine ceiling? To judge from the minute descriptions of Grapheus, Floris drew his inspiration for this arch from a mythology that was both sensual and cruel, appreciated for its own sake but also as a means of adulating power and exalting the Counter-Reformation.[18]

Perhaps my comparison with the portal of the *Hypnerotomachia* was unjust to the latter, for that was made from porphyry and serpentine, jasper and lapis lazuli, and the capitals were of solid gold. The Arch of the Genoans was lumber and canvas, tinsel and stucco—no more than a stage-set, to be swept away after the show. There is something shabby about it, like a huge advertisement hoarding, which is exactly what its function was. Jacquot has put his finger on the crucial distinction between its use of mythology and that of the Roman events described earlier. Admittedly those were fawning, but there was a sense that Rome, with its history and its arches of real marble, was something bigger even than the Emperor; that his glory was increased by emulating the ancients, and that he would get pleasure from admiring their legacy in architecture and drama. In Antwerp, on the other hand, who was being taken in by this adulation? Not Charles, who had seen so much. Perhaps the fanatically Catholic Philip, who would have approved of the underlying message. For the whole point of the Arch of the Genoans was to flatter the imperial pair as enemies of heresy, and to welcome the subjection of the Netherlands to Spain.

In his Roman triumph, Charles had been celebrated as the victor over infidels, having driven the Turks back from Vienna, and over the pirates of Tunis, from whom he had freed hundreds of Christian slaves. But by 1549 he had been maneuvered into warring on his fellow Christians, beating the Protestant Schmalkaldic League at Mühlberg in 1547. The Titans whose fate was gleefully depicted were to be read as evil Germans, like the Elector of Saxony and the late Martin Luther. No longer was classical mythology being used as an escape from the religious insanities of the present: it was being prostituted to inflame them.

In Enea Vico da Parma's engraved portrait of Charles V (1550), the Doric portal with its allegorical figures and mottoes gives a good impression of the festival structures of his reign. At the bottom, Germany and Africa lounge in elegant *déshabillé*. Germany, with fruits, musical instruments, and moneybags, rejoices in the bounty Charles has brought her, while Africa says resignedly that it's not so shameful to be conquered by him who has conquered all others. Against the columns are Clemency and Pallas Athena, the

The Doric portal with its allegorical figures and mottoes gives a good impression of the festival structures of his reign. Enea Vico da Parma, *Charles V*.

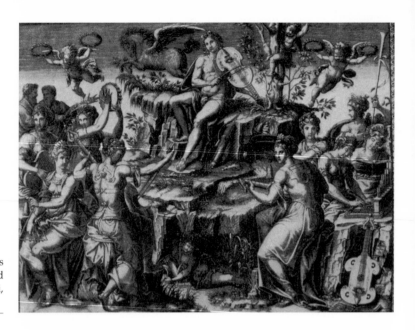

The Nine Muses, all dressed in gorgeous costumes with musical instruments and symbols of their attributes. Luca Penni, *Parnassus*.

latter, in Jacquot's words, "both nude and armed, whose sinuous forms are thought to incarnate the truth of dogma and the offensive spirit of Catholicism."[19] Jacquot, in his exhaustive analysis of the print, comments on how Counter-Reformation imagery issued out of a Platonism that "justified physical beauty, too, insofar as it allowed the contemplation of the beauty of souls, or of ideas, of which it is the reflection"[20]—but that this implied a profound change of attitude toward the sensual aspect of art. In other words, the seduction by the gods and goddesses of antiquity had been successful, and there was no aborting their progeny.

A very different use of mythology for the reinforcement of power policy appeared ten years earlier, when Cosimo I de' Medici married Eleanor of Toledo. In Chapter 4, I mentioned Cosimo's strategic move into the public palace of Florence, and the decorations that followed. The wedding celebrations of 1539 preceded these, and were held in the Medici family palace on Via Larga, where the second courtyard was the setting for the "Pageant of the Muses," an after-dinner entertainment for the city's nobility.[21] Around the court were large paintings showing parallels between Cosimo's career (so far—he was only twenty) and that of his Medici forbears: a theme that would be developed in the Palazzo Vecchio apartments. The pageant was only one of many events surrounding this wedding (another will be described in Chapter 10), but it carried a significance that gives insight into the whole. The show began with the entrance of Apollo, followed by the Nine Muses, all dressed in gorgeous costumes with musical instruments and

symbols of their attributes. These were based on Martianus Capella's equation of the Muses with the spheres of the seven planets, plus the Fixed Stars and the "Sphere beyond the stars." The research was done by the court humanist Pierfrancesco Giambullari, who drew on Marsilio Ficino's treatise on cosmic correspondences (*De vita coelitus comparanda*) as well as on books of magic and Kabbalah, in which we know Cosimo was also interested (see Chapter 4). Claudia Rousseau, in her study of this pageant, describes one of the less elaborate Muses:

> The fourth to enter was Melpomene, traditionally the Muse of tragedy, but in this program representing the fourth sphere, the Sun. Wearing the Sun's gold and crimson colors, her gown was belted with fresh heliotrope. The little skin of a lion cub was on her breast— a miniature of the Sun's domicile in Leo—and among the solar jewels adorning her were chrysolite, Sun's eye, and heliotropia. Her hat was composed of five layers of *organetti* (little rows of organ pipes) while other musical instruments sacred to Apollo were depicted on a flounce of gold at the hem of her dress. To each foot was attached a scarab beetle, a creature conceived by the Egyptians as the symbolic counterpart of the Sun. Her *taninera* [inscribed plaque] was decorated with peonies, solar not only by their "power," according to Ficino, "but even by their name," and with vervain, a solar herb said to promote "prophecy and joy."[22]

When the Muses were all assembled, Apollo sang a poem to the accompaniment of his lira da braccio in the ecstatic, improvisatory style that Ficino had developed for his Orphic Hymns:

> From the Fourth Heaven, where, going around with my gilded chariot I give light to the world, I come among you, drawn by that love which I always bore, valiant Duke, toward the noble race from which you were born . . . And this is the sacred rank of the Muses, who always fire generous hearts to glorious enterprises and who are the guides of anyone who wishes, through fame, to conquer death.[23]

Then the Muses sang a nine-part madrigal representing the Harmony of the Spheres, wishing joy and fertility to the newly-wed couple. The rest of the pageant presented allegorical figures of Flora/Florence and other cities of the new Duchy of Tuscany, for each of which there was a madrigal with appropriate sentiments. Rousseau expounds the elaborate astrological symbolism of the pageant and its relation to the eventual decoration of the Hall of the Five Hundred in Palazzo Vecchio. Echoing a constant

theme of the present book, she puts the question:

> Why, it may be asked, did the authors of this program go to so much trouble? Their precision was motivated, it would appear, by the intention to invoke or replicate the celestial spheres through sympathetic magic. In this way, once the Muses were gathered together the group would visually and, in a magical sense, literally have represented a sort of microcosm of the entire cosmos. The arrival of Flora in their midst, as the personification of the place on Earth where the "birth" of the new Medici dynasty was taking place, would have given form to a schema that in concept resembled a kind of "horoscope" of the event.[24]

All the "joyous entries" and festivals described so far were carefully organized symbolic events, intended to impress the audience with the might and majesty of the prince, and hopefully to initiate an era favorable to all concerned. Moreover, given the metaphysical assumptions of the time, there was hope that the event, just like the Masses and prayers that followed it, would help to bring about the desired result. But the difference in the Pageant of the Muses, as in the Palazzo Vecchio decorations, is that the Medici were actually practicing magic, both of the celestial, Ficinian kind, and the subtler Cabalistic variety. There are tell-tale signs of it in the magic circle that the Muses formed around the ducal couple, and in the costumes of the higher Muses: Urania, who wears the zodiac band over her shoulders, complete with its "secret images" that Rousseau thinks were either the decan rulers or symbols of the 360 degrees; and Calliope, whose gown was sewn all over with "Celestial characters and divine writing, of a smoldering blackish color, as the Cabalists say, that were the first letters."[25] I think that this claim can only be made for the events in Florence, and for the festivals of the French court organized by Queen Catherine de' Medici (Cosimo's second cousin), whose magical intentions were revealed by Frances Yates and later confirmed by Roy Strong.[26] This magic was done not in the spirit of piety and petition—that was the business of religion—but in a scientific spirit; or to be more precise, in a spirit somewhere between "science" and "art," given that art in the sixteenth century functioned as a cause with calculable effects.

The next ducal wedding in Florence, in 1565, was that of Francesco I de' Medici, who had taken over the regency from his father in the previous year. By now the spell of the 1539 wedding had come to fruition. Cosimo had remained faithful to his wife Eleanor, and their marriage had brought them ten children (though sadly, two of them had died along with Eleanor in the malaria epidemic of

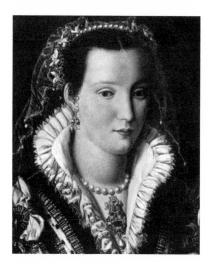

Francesco was becoming fascinated by the Venetian refugee Bianca Cappello, to whom he gallantly offered protection. Agostino Bronzino, *Bianca Cappello*.

1562). Florence had enjoyed harmony in the form of prosperity and civic order. One sign of this was that during Cosimo's and Francesco's reigns, the annual total of executions in the city averaged in the single figures—an unprecedented condition compared to the reigns of Lorenzo the Magnificent or of Duke Alessandro.[27]

Francesco had meanwhile had his ups and downs. In 1561 he went to Rome, where he was solemnly received by the Pope and visited by Michelangelo. (Attendants were amazed when the courteous prince gave up his chair to the aged painter.) Among his many gifts were a sixty-foot monolithic granite column, which he had to leave behind. In May 1562 he left for Spain and stayed there for "finishing school" at the court of Philip II until September 1563. There he had to rescue his attendants from various scrapes, keep up Medici prestige vis-à-vis the Farnese and other rivals, and spend ruinously to entertain his hosts.[28] Cosimo had meanwhile decided to use his son's marriage to forge a link between the Medici and the other branch of the Habsburgs. As a sign of his good faith, in December 1563 Francesco accompanied the Archdukes Rudolf and Ernst to Milan and Nice, as they departed for a rather longer indoctrination at Philip's court.[29] One wonders if on this winter journey there was any rapport between the twenty-two-year-old Francesco and the future Emperor Rudolf II, aged eleven. They would come to share many traits, but at this point probably language and age were barriers to any intimacy.

Back in Florence, Francesco worried his father by wandering around the city streets alone at night: a dangerous sport in an era of assassins.[30] The prince was becoming fascinated by the Venetian refugee Bianca Cappello, to whom he gallantly offered protection. By 1564, Cosimo passed the test that all fathers face, and allowed that his son was fit to govern the Duchy, while he himself led a more relaxed existence in various Medici villas with his own young mistress.

The match that Cosimo had obtained for Francesco was stellar: he was to marry the seventeen-year-old Joanna of Austria, daughter of the late Holy Roman Emperor Ferdinand I (d.1564) and sister of the present one, Maximilian II. Francesco's *wanderjahre* now concluded with a journey to his fiancée's country. In October 1565 he saw Joanna for the first time in Innsbruck, where her brother Ferdinand of the Tirol had recently settled into Schloss Ambras. According to Luigi Zangheri, the two men contracted a deep friendship, and it was Ferdinand's example that inspired Francesco to become a collector and an art patron.[31] Francesco also visited Vienna, where Maximilian, who was practically a Protestant, lived uneasily with his cousin and wife, Maria of Spain. (It was she who had packed off her sons Rudolf and Ernst for a safe Catholic edu-

The courtyard of the Palazzo Vecchio was redecorated with encrusted columns, grotesques, and scenes of Austrian cities in honor of the bride. Palazzo Vecchio, Florence.

cation.) Duke Alfonso II d'Este had just made a similar journey, for he was to marry Joanna's sister Barbara, and it was important that Francesco's presents to his hosts should outshine those of the Ferrarese.[32] Francesco then struck north into Bohemia, west through Bavaria, and returned to Florence in late November.

The approaching wedding had thrown the city's artists into a flurry of activity. The courtyard of Palazzo Vecchio, now to be Francesco's residence, was painted with scenes of Austrian cities in honor of the bride. Vasari designed an ingenious link between the old palace and the Medici's property on the other side of the Arno, the Pitti Palace, to which the family had moved in 1553. He ran a corridor at third-floor height leading out of the Palazzo Vecchio past the Uffizi, above the goldsmiths' shops on the Ponte Vecchio, and almost undetectably along the streets that led to the Pitti, debouching near the Grotta Grande in the Boboli Gardens. Thus the ducal family could come and go without all the annoyances, and the need for armed escorts, that attended travel at street level. In the Salone dei Cinquecento the painted ceiling was finished, and Rossi's statues of Hercules's Labors that were not ready were replicated in plaster, as was Ammanati's pompous Fountain of Neptune in the Piazza della Signoria. The granite column that Pius IV had given Francesco was at last floated and hauled to Florence and erected in Piazza Santa Trinità, with a painted clay statue of Justice on top, eventually to be replaced by Tadda's porphyry (see Chapter 6).[33] Francesco's sixteen-year-old brother Ferdinand had been made a cardinal, to keep the family's foothold in Rome. Little did anyone suspect that he would one day renounce his cloth, become Grand Duke, and marry a French princess.

Joanna of Austria entered Florence on December 16. In deference to Habsburg piety, she was greeted by a gaudy "Arch of Religion," covered in trophies made from ecclesiastical objects, with gilded terra-cotta statues of the Life of the Virgin and paintings to match.[34] She and Francesco were married on the 18th, and the wedding celebrations lasted until the end of Carnival on February 26, 1566. They included plays with spectacular intermedi by Buontalenti, football matches, an assault on an artificial castle, hunts and animal combats, and two events of a more sophisticated nature, and of particular interest to us.

On February 2 there was a nocturnal procession through the city streets, designed by Francesco himself, called the *Trionfo dei Sogni* (Triumph of Dreams).[35] First came trumpeting Sirens, then the Four Humors (who would in due course become the cornerstones of the Studiolo). Five squadrons of elegant masked figures impersonated the five principal human desires: Amor, Narcissus (standing for beauty), Fame, Pluto (for riches), and Bellona (for

CHAPTER 9

war). They wore large silver bats on their shoulders, to indicate that all these ambitions are nought but flitting dreams and phantasms. A sixth group presented Madness, as the consequence of too much immersion in the preceding passions. Somewhere in the procession there were thirty-six witches. Lastly came the Chariot of Sleep, drawn by somnolent bears. It was shaped like an elephant's head, hollowed into a cavern which contained the figures of Sleep, Silence, Morpheus, Dawn, and Night. Bacchus and Ceres also appeared as the father and mother, Pasithea as the wife, and Mercury as the president of Sleep. The chariot had six bas-reliefs by Giambologna: 1. The Altar of Aesculapius; 2. The King of Latium sacrificing a cow in a grotto, with Mercury whispering in the sleeper's ear; 3. Orestes pursued by the Furies and finding rest in poppies; 4. Hecuba's vision of a wolf strangling a kid; 5. Nestor appearing in sleep to Agamemnon; 6. The Altar of Sleep surrounded by the Nine Muses. The epigraph read "Make sacrifice to Sleep, and to the Muses." As the triumphal car passed, a song was sung that repeated the theme of the first six squadrons, and then urged the auditors to spurn the deceptions of Art and to devote their time to Nature's demands.

This simplistic moral recalls the carnival songs of Lorenzo the Magnificent, and served as a popular excuse for events of deeper meaning. Among Luciano Berti's many wise comments is the following:

> For Francesco, the Night is not only the time of dreams, or of retirement for meditation—which surely were his motives—but also that of the transfiguration of the real under the veils of mystery, through unquiet phantasms and hidden perils; where things slough off the chains of custom, novel and unexplored paths of sensation open up, and voluptuous desire is plumbed to its deepest roots.[36]

Berti, in his discreet way, and Bardeschi more openly, hint at practices taught in the initiatic schools of Italy at least since the time of Dante, which lead to a conscious use of sleep. Whereas for us it is a time of oblivion, bodily recuperation, and the playground of the subconscious mind, for the initiate into this heroic path it is the gateway to other states of being, in which may occur encounters with what paganism called the gods.[37]

The concept of the Triumph of Dreams was Francesco's, and its execution Buontalenti's. No one had much to say about it: perhaps it puzzled or disturbed them, as well it might. Vasari made no mention of it, but he was a rival, being responsible for the other great parade, planned together with Vincenzo Borghini and Cosimo, the "Genealogy of the Gods." This was held on February

Demogorgon was a spurious god with no classical pedigree, but as the *fons et origo* of all the gods he was too good to leave out of this parade. Vasari, design for float of Demogorgon.

21, and a long and learned description was immediately published.[38] The theme of the twenty-one triumphal cars came from Boccaccio, who had done his best to explain all the interrelations and attributes that the heathens had given to their gods and goddesses. Borghini had taken advantage of further sources, which gave him a plethora of imagery that the artists then had to incorporate, resulting in the typically overloaded god figures of the learned Cinquecento. The divinities were as follows: 1. Demogorgon; 2. Heaven; 3. Saturn; 4. Sun; 5. Jupiter; 6. Mars; 7. Venus; 8. Mercury; 9. Moon; 10. Minerva; 11. Vulcan; 12. Juno; 13. Neptune; 14. Oceanus and Tethys; 15. Pan; 16. Pluto and Proserpina; 17. Cybele; 18. Diana; 19. Ceres; 20. Bacchus; 21. Janus.

Demogorgon, the interloper in this assembly, was a spurious god with no classical pedigree, based on medieval misunderstandings. He had already been exploded by Lilio Giraldi (*De Deis Gentium*, Basel, 1548) and Vincenzo Cartari (*Le imagini dei dei degli antichi*, Venice, 1556),[39] but as the *fons et origo* of all the gods he was too good to leave out of this parade. Drawn by dragons, he appeared aged, pallid, covered with mold, and surrounded by dark clouds. Beside him rode Eternity, as a young woman clad in green with a golden basilisk on her head (a nice detail from Horapollo). Flanking her were Demogorgon's large family, including Chaos and Erebus, Earth, Night and Ether, Discord and the Three Fates, Polo and Phyton, Fear and Pertinacity, Poverty and Famine, Momus and Antaeus, Work and Day, and other nameless figures, all with elaborate attributes. That was only the first triumph. The event was a living encyclopedia of pagan theology. But to what end? Baldini says:

> The object of the author was to represent the genealogy of the principal Gods of the Gentiles, and to show them in their chariots, as the ancients did for their greater majesty; and thus also to show the rapid course of the heavenly bodies, and the variations of the elements of which those are the cause . . . All these Gods of the ancients were either the four elements variously considered, or else men who were made into gods because of benefits they had conferred on mankind. Consequently they all had a beginning, and it was not proper to mix into these fables God the Greatest and Best, first, true, and sole principle of all things, from whom depends Heaven, and nature.[40]

At the end of his account Baldini promises soon to publish illustrations of all the gods, "so that everyone can see them and consider well the vanity and frivolity of these fables and falsehoods in which the ancient Gentiles believed, and compare them to the sa-

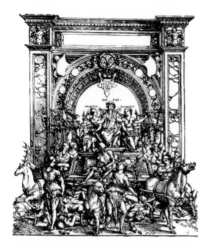

Greco-Latin humanist culture makes itself felt north of the Alps. Pieter Coeck van Aelst, *The Triumph of Dr. Jacobus Castricus,* c.1530.

cred ordinances and holy commandments of Christian piety."[41] But if that was really the point, why devote so much time, effort, and enthusiasm to them? Why picture these heathen divinities with such loving detail and grotesque realism that their images would be forever imprinted on the imagination?

Nowhere else in Europe was there such a lavish display of pagan imagery as at the Medici court. Even Ferrara, where the previous century had seen the extravagances of Leonello and Borso d'Este, had become a world apart. For Alfonso II's marriage to Barbara of Austria in 1565, the Este idea of entertainment was a theatrical tournament-styled *Il Tempio d'Amore* (The Temple of Love), planned by Torquato Tasso in the chivalric spirit of his *Rinaldo.* It had sorceresses, magic castles, knights imprisoned in rocks or lost in labyrinths, stage machinery, moralizing allegories; in short, as Roy Strong says, "the marriage of the ingredients of a Greco-Latin humanist culture to the mythology of romance civilizations from north of the Alps."[42]

This would have been thoroughly appealing to Barbara's brother, Ferdinand II of the Tirol. In his part of Europe tournaments, rather than passively-witnessed parades, were still the norm, though classical themes were breaking in, as they were into architecture. When Ferdinand's father (Emperor Ferdinand I) visited him in Prague in 1558, the visit concluded with a clash of Titans. Five huge giants attacked Jupiter, mounted on a great rock, and were repelled with thunder and flames—the Palazzo del Te theme again. There were accidents, of course, but no one important was hurt, and they had a lot of chaotic fun.[43] Ferdinand's brother Charles's wedding in Vienna, 1571 (already mentioned in Chapter 5) featured an allegorical tournament on the theme of Juno's strife with Europa. Juno's champions were the three "kings" of America, Asia, and Africa, the last role being taken by Ferdinand dressed in a lion skin.[44] I suppose that this was a geopolitical allegory of some kind. Ferdinand's own wedding, celebrated in Innsbruck, 1581, had to outdo them all. The chief guests were dressed as heroes from the Trojan Wars, in addition to Mercury, Polyphemus, and other actors in Homer's story. The biggest event was a foot tournament between Greeks and Trojans, which of course included a wooden horse. With no apparent connection there was also a presentation of the myth of Actaeon, and the usual fireworks, hunting, feasts, and picnics.[45]

Ferdinand's second wife, Anna Caterina Gonzaga, was a dull and pious girl (she was only fifteen when they married), preferring to live a retiring, religious life in the company of her Italian courtiers. This put a damper on court life in Innsbruck. However, promises and plans must already have been made, for in the fol-

lowing year, 1582, there was one final fling in the series of Tirolean entertainments: the wedding of the chamberlain Johann von Kolowrat to Katharine von Payrsberg.[46] This was like the Florentine processions in its encyclopedism, but it followed the tournament style in that aristocrats, not paid actors, took the principal roles. It also recalled Maximilian II's commissions, like the Kaiserbrunnen and Arcimboldo's paintings mentioned in Chapter 6, in its structure around the Four Elements, Seasons, and Zodiac. Here follow the names of the principals and their roles.

Ottoheinrich von Braunschweig led the procession as Apollo riding on a leopard (was it a real leopard? and if not, what?), followed by Spring, represented by a maiden in a chariot drawn by two unicorns with the signs of Aries, Taurus, and Gemini. Jaroslaw von Kolowrat took the role of the corn goddess Ceres riding on a crocodile, followed by Summer, represented as a farmer in a chariot made from wheat sheaves, drawn by oxen and bearing the signs of Cancer, Leo, and Virgo. The bridegroom Johann von Kolowrat played the part of Mars mounted on a wolf, followed by Autumn, in which Turkish coachmen drove a chariot laden with fruit, and the signs of Libra, Scorpio, and Sagittarius. Georg von Sternberg rode an elephant as Saturn, followed by Winter's chariot pulled by pigs, and the signs of Aquarius, Capricorn, and Pisces. Air was led by Ludwig Bordona von Taxis as Aeolus crowned, winged, and mounted on a white horse; the Air chariot was made from clouds, carried the four winds, and was drawn by two griffins. Christoph Truhress von Waldburg played the part of Cybele, Earth goddess, riding a rhinoceros; the realm of Earth was represented by a castle on a chariot whose wheels had earthen vases for spokes, driven by a naked man and pulled by two lions. Neptune's role was taken by Balthasar von Schrattenbach riding on a seahorse, while Water's shell-shaped chariot was drawn by two mermen and carried a naked man blowing a conch. Hipolit von Zuliol was Vulcan, mounted on the three-headed hellhound Cerberus, followed by Pluto on his flaming chariot.

A series of miscellaneous figures brought up the rear. Karl von Burgau played Hercules fighting with the Hydra; Graf Wilhelm von Zimmern was Aeneas. Hans Albrecht von Sprizenstein was "very successful" in the role of the Amazon queen Penthesilea. Lastly came Archduke Ferdinand himself, inevitably cast as Jupiter brandishing a thunderbolt, seated under a baldachin on four columns, on a float drawn by eagles; and as such he made the proclamation to announce the wedding.[47]

To end this chapter, we return to Ferrara, the scene in 1598 of a spectacular double wedding celebrated by Pope Clement VIII Aldobrandini (reg. 1592–1605).[48] After three marriages, Alfonso II

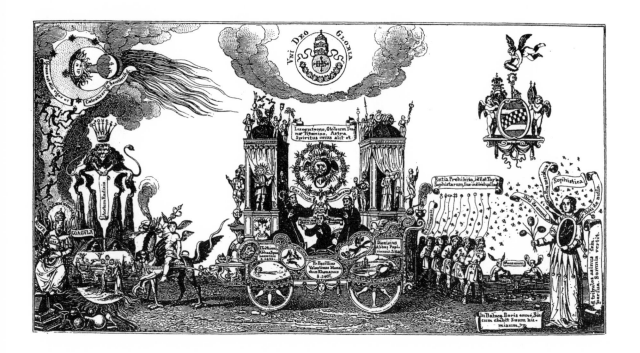

The parade style of the northern Counter-Reformation in an alchemical allegory. *Triumphal Chariot of Basil Valentine*, anonymous German print, seventeenth century.

d'Este had died in 1597 without a legitimate heir, causing the Duchy of Ferrara to revert to the Church. The Pope had come on a six-month visit to reorganize it as a papal domain under the rule of his nephew, Cardinal Pietro Aldobrandini. The couples to be married were Philip III of Spain (by proxy) to Margaret, daughter of Archduke Charles of Styria, and Archduke Albert to Philip's sister Isabel (also represented by proxy).

The celebration of 1598 obeyed the political correctness of the Counter-Reformation. Bonner Mitchell writes:

> The inscriptions at the *porta* hailing at least the papal nephew for a "war felicitously waged" [against the heir-presumptive Cesare d'Este] was in company with an affected pleasantry about the city's opening its gates to him who opens those of heaven. The inscription on the second arch alluded to the "most glorious, almost divine" victory that Clement had obtained "without blood, without fraud." The imitation of Trajan's column had statues of Saint Peter and Saint Paul at its base, but constituted only a mild, inoffensive combination of the classical and Christian traditions . . . Another indication of the change of spirit since the High Renaissance can be seen in the numerous personifications and other portrayals of abstract qualities, such as the Glory, Immortality, and Felicity to which the cardinal's three arches had been dedicated.[49]

For the entry of Margaret and Albert of Austria, the themes were

Religion, Holy Marriage, and the Glory of the House of Austria. The main entertainment after the wedding was a Latin play: not a Plautian comedy, but a new concoction of *Judith and Holofernes*. This was put on by the pupils of the Jesuits, with no sex or violence (quite an achievement, considering the plot) but with long speeches in hexameters.[50] Virtually every residue of paganism was purged from the occasion, leaving only a faint echo of the "noble Romans" theme and a lavish helping of Latin pedantry. While the Pope's presence made this a particularly delicate occasion, it was symptomatic of a sea change in public shows and princely spectacles. Yet if the gods were excluded from these, they had already found a back door through which they could continue to work their insidious and delightful magic. This will be the subject of the next chapter.

The Roots of Opera

MOST OF THE entertainments treated in the previous chapter were held outdoors and in the public eye. This chapter covers the same time period, but concentrates on events held indoors before an invited audience. As we continue tracking the footprints of the pagan gods and goddesses, we will pass in review the after-dinner entertainments of the fifteenth century, the re-creation of Orphic singing, the musical interludes of comedies, the cultivation of a secret, virtuoso style, and the launching around the year 1600 of the *dramma per musica* soon to be known as opera. This will serve two purposes. First, it will fill some more gaps in this disjointed narrative, rather as one might revisit Florence, Rome, Mantua or Ferrara, each time discovering new things of interest and understanding their history a little better. Second, it will introduce the new genre that kept the classical presences alive for a century and more after others had abandoned them.

One could liken the triumphs and parades of the previous chapter to the exterior architecture of a Renaissance palace, made to be seen by all and to impress with its strength as well as its beauty. Now we turn to the equivalent of the interior decoration, the delicately arcaded courtyards and the painted halls. After the joyous entry through the throng came the banquet for selected guests followed by songs and dancing, in a pattern that goes back at least to Homeric times.

Most such occasions have passed into happy oblivion, and of those that are recorded, we can only notice a handful. One of these was a banquet in Bologna in 1475, for the wedding of Count Guido Pepoli and a young countess of the Rangoni family of Modena. Before the feast, the guests were informed that Jupiter was to grace the occasion and give his oracles, as he was wont to do in the ancient Forest of Dodona. While the poet Tomaso Beccadelli recited, or perhaps sang, the story of the oracle, Jupiter's dove descended, mysteriously speaking to the assembly (by means of a hollow cane, we are told). That was the first episode. After dinner, Beccadelli told the tale of Cephalus and Procris, which was also acted out so that Cephalus himself declaimed—or sang—the touching lament for his wife. Thirdly, Apollo entered with the Nine Muses and the Three Fates, to sing and bless the newlyweds.[1] This is an early ex-

The Queen of Sheba on an elephant, carrying offerings from the Jews. Festival at Pesaro, 1475. Manuscript illumination.

The Helicon Spring, Apollo with his lyre and laurel tree, and the Nine Muses, all made from sugar. Festival at Pesaro.

ample of an entertainment consisting of several classical themes unrelated to each other, presented with narration, solo and choral song, almost certainly dance, and spectacle. In the next century, this recipe would become the norm.

In the same year, 1475, there were festivities in the Adriatic town of Pesaro for the wedding of Constanzo Sforza and Camilla of Aragon. Federigo da Montefeltro from nearby Urbino was one of many visiting princes. The hall was given a cosmic theme by a dark blue ceiling marked with the constellations and their guardian divinities. Between the courses were what the French called *entremets* and the Italians *intermedi*, in which allegorical floats rumbled into the hall. They included "The Hill of the Wild Man, on which the courtiers' gifts were shown, the Queen of Sheba on an elephant carrying offerings from the Jews, the Hill of the Israelites, and the Company of the Seven Planets on seven small square classical chariots." Men and animals emerged from the hills, fought, danced, and sang.[2] Further allegorical figures were the Muse Erato, Orpheus, Sacred Poetry, Truth, and a float of Parnassus made entirely from sugar. On it were the Helicon Spring, a laurel tree, the Nine Muses, and Apollo with his lyre. Lastly came ten Greek and ten Latin poets with sugar books, from which they recited before breaking them up and distributing them to the company.[3] Despite its classical themes, there is a carnival atmosphere about this banquet, closer in spirit to the feasts of the court of Burgundy with their *morescas* ("moorish" or any type of grotesque dance), Wild Men, live animals, and people jumping out of pies.[4]

Several of the events described in Nino Pirrotta's study of the pre-operatic period were banquets given by cardinals of the church. Cardinal Francesco Gonzaga (1444–83), younger brother of the Marquis of Mantua, had achieved the purple at sixteen and taken it for all it was worth. His taste was refined and classical, as one might imagine for one pictured in Mantegna's *Camera degli sposi*. In 1472 he gave a banquet for the French ambassadors in his Bologna palace at which the story of Jason was acted out: the slaying of the dragon, the capture of the golden fleece, the sowing of the dragon's teeth, etc. And in 1480 he presented his guests with a landmark in the history of drama.

Cardinal Gonzaga's banquet at the Carnival of 1480 (as far as the date can be established[5]) was given for his brothers in Mantua. Among the guests were Isabella d'Este, daughter of the neighboring Duke Ercole I of Ferrara and probably quite capable, at the age of six, of appreciating the show; and the Florentine poet Angelo Poliziano, currently in self-imposed exile at the Gonzaga court after offending the wife of his patron Lorenzo the Magnificent. Poliziano brought with him the flavor of the Platonic Academy.

Ficino's circle regarded the philosopher as a new Orpheus who had brought back from Hades the true Eurydice, that is wisdom and control. Giovanni Bellini, *Orpheus*.

His offering, written in two days, was a short Italian verse-play, *La fabula d'Orfeo* (The Story of Orpheus), which was modestly staged in the fashion of the carnival floats and church plays of his home. As Elena Povoledo puts it, all that was required was "a hill with hell inside it,"[6] so that the story could begin in a pastoral setting, then proceed, as the set opened up, to Hades. Orpheus sang a Latin song in honor of the assembly, a lament for Eurydice, and at the end, after he had been torn to pieces (offstage) by the Bacchantes, these women sang a finale. It is possible that Poliziano himself took the title role, for he regularly performed before friends, to his own accompaniment.

Scholars are divided in their minds as to whether Poliziano's *Orfeo* was Neoplatonic or not. Nino Pirrotta thinks that "it contains no trace of the reflections of Ficino's Orphic mysticism which some have claimed to see in it."[7] Edgar Wind allows that "Politian's *Orfeo* too would deserve to be reexamined in the light of the 'Orphic' revival."[8] Robert Donington is more positive: "Its connection with the Florentine cult of Orpheus . . . seems evident. Least of all on the subject of Orpheus could Poliziano forget his Neoplatonic inclinations: Orpheus, whom the Florentine academy took to have been a kind of proto-Platonist by anticipation."[9] Frederick Sternfeld is most explicit, saying that "the concealed meaning of the plot would have been obvious to the circle around Ficino of which Poliziano was a member. This circle regarded the philosopher as a new Orpheus who had brought back from Hades the true Eurydice, that is wisdom and control in terms of Plato's philosophy."[10] But nowhere have I seen a satisfactory Neoplatonic explanation for Orpheus's tragic end, which later dramatizations ducked by inventing a *lieto fine* (happy ending) for him, if not for Eurydice.

Poliziano's *Orfeo* became a classic. It was published and reprinted many times, and many too were its imitators up to Striggio and

Monteverdi's *Orfeo* of 1607 and beyond.[11] At a stroke, Poliziano had invented the genre of pastoral drama, which was free from the rules both of comedy and tragedy. It evoked a Golden Age when gods and goddesses appeared to men and when speaking in song seemed natural. Opera itself was far in the future, but with the benefit of hindsight we can see how advantageous was the choice of the Orpheus myth, in which the power of music was an indispensable factor, demanding that drama and music somehow work together. The story also required that Orpheus sing alone, rather than in an ensemble, and this raised the question of how to re-create his antique song.

Unlike the history of art, which is open to all those with eyes to see, the study of music history requires a knowledge of music theory, which appears to the outsider as something between a foreign language and a branch of mathematics. Without it, it is difficult to grasp some of the concepts and developments that follow, though I have kept technical terms to the minimum. For example, it is a remarkable fact that the most important musical development of the fifteenth century, namely imitative polyphony, was of no interest to Poliziano and his philosophical companions. Polyphonic music dominates the history books because it had to be written down, leaving a far more substantial record than the other seven-eighths of the musical iceberg that consisted of monophonic and extemporized music. The arcane art or science of polyphony was a speciality of the Low Countries and adjacent Burgundy, and its greatest masters such as Dufay, Ockeghem, Obrecht, Busnois, and Josquin Desprez came from those regions. They were mostly church singers by profession, and in holy orders; their musical universe was centered on the Mass, with the satellite genres of motet and chanson.

The Italian humanists may have had a pedantic streak when it came to Greek and Latin, but for the pedantry of canons (in both senses) they had no time. As Pirrotta says in the context of Poliziano's work, they saw it as part of the convoluted, scholastic thought against which they were reacting.[12] The Florentine Academy was Platonic, but not Pythagorean. For them, the locus of inspiration from Apollo and the Muses was not number made audible, but poetry, to which music was handmaid. Their impassioned declamation of poetry, especially in Latin and Greek, went over the brink from speech into song, but its music was spontaneous, the poetry itself being already of the nature of music.

As Greek poets had accompanied themselves on the lyre or cithara, so these emulators would declaim or sing to their own accompaniment on some modern equivalent. The best instrument for the purpose was one that was portable and able to play chords,

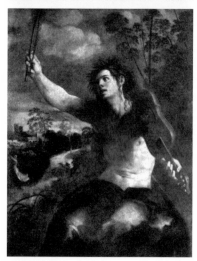

One see the viola (or lira) da braccio anachronistically pictured in the hands of Orpheus, Apollo, and other classical poet-musicians. Raphael, Apollo, from *Parnassus*; Dosso Dossi, *Apollo*.

which meant the lute, the guitar, and especially the lira or viola da braccio, a bowed stringed instrument the size of a modern viola. One sees these instruments anachronistically pictured in the hands of Orpheus, Apollo, and other classical poet-musicians, but not a single written example of the style exists. It was extemporized, and came not out of the polyphonic tradition but out of a broad popular stratum of declamation. A few decades before Poliziano, "Antonio di Guido, a surprisingly cultured and poetically talented Florentine strolling player (*cantimpanca*), had amazed learned audiences; his singing was able to render remarkably vivid tales which, merely read, appeared totally insignificant."[13] Just so may we imagine Marsilio Ficino to have accompanied his ritual performances of the Orphic Hymns to Apollo, Jupiter, Venus, and Mercury, as he sought to draw down by correspondence the influences of the benefic planets.[14] And for the ultimate expression of *furor poeticus*, we have the Orphic end of Poliziano himself, thus related by his biographer: "Smitten by the insane love of a charming youth, he soon fell into a deadly sickness. While burning with fever, he seized his cithara and sang songs with supreme fury, so that the delirious man was gradually deserted by his own voice, then by the nerves of his fingers, and finally by his vital spirit, driven out by merciless death."[15]

Strange old-fashioned instruments that make one think of Filippino Lippi's implausible inventions. Filippino Lippi, *Music*, Santa Maria Novella, Florence.

At neighboring Ferrara, during the Carnival of 1487, the reigning Duke Ercole I was offered a dramatic "fable" on the theme of Cephalus and Procris[16] in which the acts were separated by interludes or *intermedi* (the first use of the term with this meaning) consisting of songs and dances. After Act III a satyr and his companion danced, with "strange old-fashioned instruments" that make one think of Piero di Cosimo's or Filippino Lippi's implausible inventions. By the century's end, the convention of inserting musical intermedi between the acts of comedies was well established, as was the custom of using classical topoi unconnected to the plot. In February 1491, at Alfonso I d'Este's wedding with Anna Sforza, Plautus's *Menaechmi* was given with intermedi, among which Apollo appeared with the Nine Muses, and they all sang to Apollo's lyre in praise of the pair.[17] At Carnival, 1499, Antonio Cammelli's *Filostrato e Panfila* was performed in Ferrara with four intermedi composed by Bartolomeo Tromboncino, sung respectively by Love; by four of the planetary Sirens of Plato's *Republic*; by the Three Fates; and by Atropos.[18]

In these themes we can already see emerging the three favorite settings of the sixteenth-century intermedi: celestial, pastoral, and infernal. They correspond to the three worlds found in every traditional cosmology:[19] an upper world, including the planetary

spheres and classical Olympus; the middle world of earth, usually seen in its primordial state of a pastoral Golden Age; and a lower world, divided between Pluto's Hades and the realm of Neptune under the sea. Thus the whole event took place within a hierarchical framework, with human life (the comedy framing the intermedi) balanced in the middle.

These were great days for theater in Ferrara, and especially for the revival of Roman comedy, now being translated into Italian. A series of letters to Isabella d'Este in Mantua shows how well she was kept informed about events in her home town. Her agent recounts details of four plays of Plautus and Terence that were done during the same Carnival season of 1499, with their sixteen intermedi minutely described. They were less erudite than Tromboncino's, featuring much dancing, ludicrously complaining lovers, peasants, fools, mock combats, and a bear.[20]

In Mantua two years later (1501), four comedies were presented on consecutive days, with sumptuous decorations.[21] The hall was practically rebuilt to resemble an ancient theater, whose arches incorporated six of Mantegna's *Triumphs of Caesar* (see Chapter 9) and whose stage his (lost) *Triumphs of Petrarch*. Silvered and gilded statues loomed above the frieze, and a mobile apparatus represented the courses of the sun and moon through the Zodiac. Other themes were the Four Winds and a grotto containing the Wheel of Fortune. What music was played, we do not know, but I mention this as yet another "cosmic" decorative program, here seen as an appropriate setting for comedies and intermedi. Perhaps the appropriateness should be spelled out. The cosmic meaning of comedy, which never lacks some cruelty, is that men and women are bound inexorably to their own horoscopes and subject to the transiting planets, so that fools, knaves, and the rest cannot be other than they are. Moreover, as sublunary beings they are the playthings of the "winds" which blow them hither and thither, while the goddess Fortuna, her reasons and workings obscure even to the wise, spins them round on her wheel. The comfort of a good comedy is that it ends with the most likeable people sitting on top.

The triumph of the intermedi came in the sixteenth century and in Florence, when their importance and elaboration far outweighed that of the comedies. Instead of four intermedi separating the five acts of the play, there were now six, framing it with a prelude and a postlude. From this point I shall tabulate the themes of the principal intermedi, to give a bird's-eye view and facilitate comparison:

I. Florence, 1539. Medici Palace, for the wedding of Cosimo I de' Medici and Eleonora of Toledo. *Il commodo* by Antonio Landi. Intermedi composed by Francesco Corteccia and Constanzo Festa.

1. Dawn (soprano) sings, accompanied by claviorganum with birdsongs;
2. Twelve shepherds dressed in pairs as goats, trees, plants, etc., with instruments disguised as their staffs and other attributes, play and sing a pastoral canzonetta;
3. From a canal between the audience and the stage emerge three mermaids, three sea nymphs, and three sea monsters. Their instruments are disguised as shells, etc. They sing a canzonetta in praise of the Duchess;
4. Silenus sings a song about the return of the Golden Age, to the accompaniment of a violone disguised as a tortoise, with an asp as the bow;
5. Eight huntress nymphs sing a canzonetta addressed to the nymphs of Tuscany;
6. Night sings to the accompaniment of four trombones. Suddenly a crowd of Bacchantes rushes in: ten women and ten naked satyrs. On each side of the stage, eight sing and dance, while two act drunk. Their instruments are concealed in wine bottles, roots, hunks of raw meat, etc. All have small burning torches. After this the audience partakes of wine and sweetmeats, then goes home to bed.[22]

This was a most influential set of intermedi, marking as it did a new era for Florence and Tuscany. Not since Lorenzo the Magnificent had the city known such a patron of the arts as Cosimo I. The framing by Dawn and Night alludes to the Aristotelian principle of the Unity of Time (the action of the play to take place within a single day). Florentines would also think of Michelangelo's long-awaited statues of these subjects in the Medici Chapel of San Lorenzo, completed in 1534 but not yet placed on the tombs. Dawn's and Night's songs, note well, were madrigals in which the lower parts were taken by instruments rather than by other voices. The central intermedi were pastoral in nature, except for the related one of sea-beings. Given the restricted space and resources of the Via Larga Palace, the scenographic aspect was limited; the "water" was almost certainly not wet. Like Poliziano's *Orfeo*, and like the satyr-plays that followed Greek tragedies, this event ended in Bacchic revelry. It was the Dionysian counterpart to the masque of Apollo and the Muses that was given at the same wedding festival, and described in Chapter 9.

II. Lyon, September 27, 1548. Sponsored by Cardinal Ippolito d'Este for the entry of Henry II of France and his queen Catherine de' Medici. *La calandria* by Cardinal Bibbiena. Intermedi composed by Pietro Mannucci.

1. Dawn; then Apollo, singing to the lyre, introduces the theme of the intermedi: the Four Ages;
2. The Age of Iron recites a madrigal, repeated by four unseen voices, while Cruelty, Avarice, and Envy parade;
3. The Age of Bronze, with Fortitude, Fame, and Revenge;
4. The Age of Silver, with Ceres, Pales, and Agriculture;
5. The Age of Gold, with Peace, Justice, and Religion;
6. Apollo again; then the Golden Age sings and presents the Queen with the golden lily of Florence; Night.[23]

The sponsor of this spectacle, Cardinal Ippolito d'Este, would later create the gardens of the Villa d'Este in Tivoli (see Chapter 8). The framing by Dawn and Night is borrowed from the preceding event. The Four Ages are presented in reverse chronological order, for the present age is obviously that of Iron, the worst of the four. Their sequence turns back the cosmic clock, gradually bringing back the Golden Age.

III. Florence, December 26, 1565. Wedding of Francesco I de' Medici and Joanna of Austria. *La cofanaria* by Francesco d'Ambra. Intermedi designed by Giovanbattista Cini, composed by Alessandro Striggio the Elder and Francesco Corteccia.

A heavenly vision of Venus, Cupid, the Hours, and the Graces. Annibale Carracci, *Venus and the Graces.*

1. Heavenly vision and descent of Venus, Cupid, the Hours, and the Graces. Chorus of the other Olympians;
2. Numerous amorini with disguised instruments sing of Cupid's love for Psyche;
3. A chorus of Deceptions, with crumhorns disguised as hooks, snares, grapples;
4. Discord, Anger, Cruelty rise out of holes; Furies join them. A madrigal and a mock-battle moresca;
5. Psyche appears, dispatched by Venus to the Underworld, which opens up to reveal Proserpine, Cerberus, Charon, etc. She sings a lament;
6. Mount Helicon rises from the stage; joyful dances of the good characters, together with Pan and satyr-music.[24]

These are all scenes from the myth of Cupid and Psyche, which was the great theme of the Palazzo del Te (see Chapter 4). Again there are the three topoi: celestial, infernal, and pastoral, but with

an unwonted emphasis on the infernal. This set of intermedi was supposed also to reflect the events unfolding in the comedy—a rare case of coupling the two elements of the entertainment. It must have been thoroughly confusing to the young Austrian princess, though perhaps not quite so much as the "Triumph of Sleep," which her husband was now planning (see Chapter 9).

IV. Florence, early 1566. Presented by the Accademia Fiorentina to celebrate the wedding of Francesco I de' Medici and Joanna of Austria. *Il granchio* by Leonardo Salviati. Intermedi by Bernardo de Nerli.

1. Apollo has advised the Muses to leave Mount Parnassus, since Greece is now occupied by the Turks, and to come to the Accademia of Florence and then to Fiesole. The Muses arrive on a cloud and sing a madrigal;
2, 3, 4, 5. In some unrecorded way, these presented the Four Ages of Man: Childhood, Youth, Virility, and Senility;
6. The Muses sing another madrigal as they move to Fiesole, their new Parnassus.[25]

The Accademia Fiorentina had been founded by Cosimo I in 1541, the year of Francesco's birth, with Michelangelo and Bronzino among the founding members. Not much information about this event survives, and nothing of its music. It is interesting as evidence of the same kind of cyclical plan as the Four Ages of the World, shown in the Lyon intermedi, and framed by the Muses, as that one was by Apollo.

V. Florence, 1568. Salone dei Cinquecento of the Palazzo Vecchio. Baptism of Eleonora, daughter of Prince Francesco and Joanna of Austria. *I Fabii* by Lotto del Mazzo. Intermedi composed by Alessandro Striggio the Elder.

1. The mouth of Hell opens and the Furies come out, singing to the accompaniment of trombones;
2. Hercules sings a duet with the Lady Pleasure. The monsters of his Twelve Labors sing a canzona;
3. A meadow appears, with nymphs and shepherds. Satyrs come and abduct the nymphs. The meadow vanishes;
4. Calumny appears. A royal throne rises out of the floor, and allegorical figures address the king;
5. Cupid and his attendants watch a cloud descend containing the Three Graces and Nine Muses. They sing;
6. The heavens above Florence open to show the banquet of the

gods, celebrating the birth of Venus. The twenty-nine deities on the stage sing a finale.[26]

Some of these intermedi hardly seem suitable for the baptism of a female infant. Their deeper reasons probably lie in the ambitions of Cosimo I, whose deeds and magnificence were depicted in the great hall, along with the Labors of Hercules. By 1568 he had stepped down from government, but still hoped to have Tuscany promoted from a duchy to a kingdom. This would require consent of both Pope and Emperor, and naturally it roused the "calumniators" in jealous rival states. The epiphany of gods recalls the parade at Francesco's wedding, making use again of the scenographic skills of Buontalenti.

VI. Florence, 1569. Visit of the Archduke Charles of Austria. *La vedova* by Giovanbattista Cini. Intermedi directed by Alessandro Striggio the Elder.

1. Vision of Florence, with its neighboring villas. Fame;
2. A Sorceress evokes spirits to obtain from them prophecy of the future;
3. Choral intermedio with Winds and Clouds.
4. Latona, mother of Apollo and Diana, is mocked by peasants whom she turns into frogs;
5. Diana and thirty-six nymphs dance;
6. The heavens open; the gods sing in harmony and in antiphony with Jupiter.[27]

The appearance of an image of Florence, including all its major monuments, is reminiscent of the "Rometta" of the Villa d'Este. The Sorceress and her evocation is a new topos that would have a long and successful run in opera. The last episode, with its antiphony between soloist and chorus, anticipates the finale of the 1589 intermedi.

After this cluster of events, years passed before another series of intermedi were presented in Florence. Among the significant happenings were the promotion of Cosimo I to Grand Duke of Tuscany in 1569 and his journey to Rome in 1570 for coronation by the Pope. Cosimo died in 1574, and the regent Francesco succeeded to the Grand Duchy. In 1578 Joanna of Austria died in childbirth, and Francesco secretly married his long-time lover Bianca Cappello. Their wedding was celebrated publicly the following year—not with a comedy and intermedi, but characteristically with a pageant that included a Chariot of Night. Musicologists have noted that the famous singer-composer Giulio Caccini (c.1545–1618) rode

on this vehicle and sang to a consort of viols, playing one of them himself: another early example of the solo madrigal or proto-aria.[28] Bianca's father and other Venetian dignitaries came to the wedding, stopping on the way in Ferrara, where they heard a *concerto grande* by Striggio played by twelve harpsichords, an organ, four trombones, two cornetts, thirty viols, a violin, a piffaro (shawm), a double bass, and twelve lutes.[29] (The Florentines present turned up their noses, saying that *they* often heard performances with more than a hundred players.) The mass of plucked-string instruments shows that the music depended on broad chordal effects, rather than on polyphony. We might almost call it Baroque.

The revival of Florentine intermedi began more modestly than this, with the following homage offered to the two young princesses of the house of Medici: Eleonora (born 1567—see above), and Virginia (born 1568), daughter of the late Cosimo I and Camilla Martelli.

VII. Florence, February 16, 1583. Presented by the Order of San Secondo to the Princesses of Tuscany. *Le due Persilie* by Giovanni Fedini. Intermedi composed by Jacopo Peri, Stefano (Rossetti?), Giovanni Legati, Costantino Arrighi, Cristofano Malvezzi, Alessandro Striggio the Elder.

1. Demogorgon in dialogue with Eternity;
2. The House of Sleep, with True and False Dreams;
3. The Elysian Fields, with Aeneas, Anchises, the Sybil, Mercury, and Souls;
4. Pleasure, Youth, Sardanapalus, Wealth, Ignorance, and Pride;
5. Dialogue of the Muses and Pleasure; the same cast as in 4. Sorrow disguises himself as Pleasure and leads the others;
6. Love, Hymen, the Three Graces, Juno, and Venus.[30]

The Knights of San Secondo were a naval military order, founded by Cosimo I to keep the seas clear of pirates. Spectacle was less important here, where the vast resources of the court were lacking. Instead, there seems to be a reference to the parades of the time of Francesco's marriage: to the "Genealogy of the Gods," which likewise began with Demogorgon, and to the cynical message of the "Triumph of Sleep," in which all human desires were said to end in madness (see Chapter 9). The House of Sleep was one of the themes of Francesco's Studiolo (see Chapter 5), recently completed. The sixth intermedio was a natural subject for two nubile princesses, who would soon provide links with the Este of Ferrara (see the next event) and the Gonzaga of Mantua (Eleanora married Duke Vincenzo I).

VIII. Florence, 1586, in the Uffizi. Wedding of Don Cesare d'Este and Virginia de' Medici. *L'amico fido* by Count Giovanni Bardi. Intermedi composed by Alessandro Striggio the Elder and Cristofano Malvezzi, with the last intermedio by Bardi.

1. Heaven opens. Scene of the Marriage of Mercury with Philology. Prophecy of the Golden Age;
2. Flegias and the Evils; the city of Dis, demons;
3. Flora, Zephyrus, Spring, with dancing chorus of nymphs and satyrs;
4. Thetis, Neptune, sea-nymphs and tritons;
5. Juno on a cloud with nymphs; a storm is dispelled; a rainbow appears;
6. Chorus of Florentine shepherds and shepherdesses. The Sorceress of Fiesole in dialogue with them.[31]

Here is the full repertory of infernal, pastoral, marine, and celestial scenes, which now reveal themselves as the Four Elements: the infernal city of Dis for Fire, Flora for Earth, Thetis for Water, and Juno for Air. The local element is also present with the Great Sorceress of Fiesole: a good witch who tells the pastoral folk the news of the wedding.

In October of the following year, 1587, Francesco and Grand Duchess Bianca were entertaining Francesco's brother, Cardinal Ferdinando, at the Medici villa of Poggio a Caiano. Ferdinando had always loathed Bianca, and virtually shunned his brother's court since the death of Cosimo I in 1574. He preferred a life of ease and elegance in the Villa Medici, Rome, which he filled with antique and modern treasures. This attempt at reconciliation was in a context of concern over the future succession of the Grand Duchy. Francesco had no surviving male child from his first wife, Joanna of Austria. Bianca, desperate to give him an heir, had faked a pregnancy and birth in 1576, and Francesco—knowingly or otherwise—had recognized the resulting infant, Antonio, as his own natural offspring and endowed him generously. By 1587 the Florentines had turned sour toward the ever more reclusive Francesco, and viciously hostile toward Bianca. There was no chance of the illegitimate Don Antonio being recognized as the legal heir in case of Francesco's premature death. But equally, no one expected events at Poggio to turn out as they did.

On October 8, Francesco fell ill, shortly followed by Bianca. As their condition worsened, the two brothers spent hours in earnest conversation. On October 19 Francesco confessed, received Communion, and died. On the following day, Bianca died, too. It all looked highly suspicious, though historical opinion blames ma-

laria rather than poison for the *Tristan and Isolde*-like scenario.

The succession was settled at once. Ferdinando agreed to renounce his holy orders—like many cardinals, he had probably never been ordained a priest—and to become the next Grand Duke of Tuscany. Florence welcomed its new ruler with open arms, treating Francesco's splendid funeral (with no honors whatever rendered to his Grand Duchess) as an occasion for rejoicing. Ferdinando I was extroverted, healthy, and as autocratic as any of his family; he was just what the Tuscans wanted, and all he lacked was a wife. Now that the Medici had risen so high, the choices were limited. Cosimo I had married almost into Spanish royalty; Francesco I, into the Imperial Habsburgs. Ferdinando I chose France, in the person of Christine of Lorraine (1565–1636), granddaughter of Henri II and favorite grandchild of Catherine de' Medici. The old queen contributed half of Christine's enormous dowry, thereby returning to Florence some of the family treasures that had formed part of her own. After a long progress by land and sea, Christine entered Florence on April 30, 1589.

IX. Florence, May 2–June 8, 1589, Uffizi Theater. Wedding of Grand Duke Ferdinando I and Princess Christine of Lorraine. *La pellegrina*, by Girolamo Bargagli. Intermedi composed by Giovanni de' Bardi, Cristoforo Malvezzi, Luca Marenzio, Giulio Caccini, Jacopo Peri, Emilio Cavalieri.

1. Necessity, the Three Fates, the Sirens, Seven Planets, Astraea, Heroes and representatives of the Virtues;
2. Rivalry of the Pierides with the Muses; the Pierides turned into magpies;
3. Apollo kills Python; rejoicing of the Delphic inhabitants;

Third Intermedio: Apollo kills Python; rejoicing of the Delphic inhabitants. Bernardo Buontalenti, design for the Florentine Intermedi of 1589.

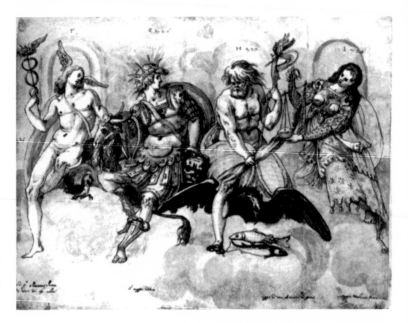

Mercury, Apollo, Jupiter, and Astraea announce a new Golden Age. Buontalenti, design for the Florentine Intermedi of 1589.

4. A vision of Hell; spirits sing that the coming Golden Age will deprive it of further souls to torment;

5. Arion, cast into the sea by pirates, is rescued by the dolphin which he has charmed by his singing;

6. All the gods appear, and Rhythm and Harmony are sent down to earth; a grand concluding dance with antiphonal singing.

Enough has been written about the Florentine intermedi of 1589, including James Saslow's fascinating chronicle of the preparations and machinations that went on behind the scenes. It was one of the grandest musical and theatrical events of the century, and also one of the best documented, for beside the accounts and minutes, the music[32] and even the orchestration[33] is known. The intermedi were repeated several times, with three different comedies.[34] The principal one, *La pellegrina* (The [female] Pilgrim), had been commissioned by Ferdinando in 1564,[35] the year in which he was created cardinal, but never yet performed.

A vision of the Fates around the Spindle of Necessity, measuring off the threads of human destiny. Buontalenti, design for the Florentine Intermedi of 1589.

The subjects of the intermedi, planned like those of 1586 by Bardi, all referred to that hardy perennial of Medici ideology, the Golden Age. Some of the episodes interpreted this in Neoplatonic vein as the advent of "Harmony," identified in the first intermedio as the Doric Mode (which Plato had recommended for exclusive use of the guardians of his ideal republic). The myths of the Pierides, Apollo, and Arion displayed the power of music, while the enclosing numbers referred to the cosmic harmony of Plato's "Myth of Er" in Book 10 of the *Republic*. This supplied the opening scene of the Fates around the great Spindle of Necessity, spinning, measur-

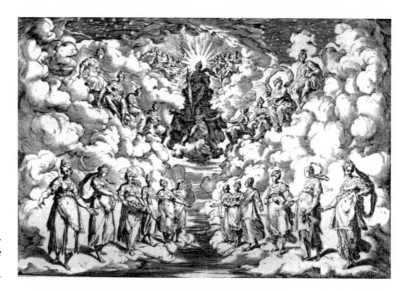

The Sirens stand singing upon the planetary spheres. Buontalenti, design for the Florentine Intermedi of 1589.

ing, and cutting off the threads of human destiny, and also the Sirens who stood singing upon the spheres of the seven planets. The final tableau of Harmony and Rhythm (or Music and Dance) descending to earth was in the spirit of sympathetic magic, enacting in allegorical form what was hoped to transpire in political reality.

Of the three traditional topoi, the pastoral was absent, perhaps because it did not offer sufficient scope to Buontalenti's machinery. This was the culmination of his career, and at the same time the beginning of a new era for European theater, for the hall of the Uffizi was the first to be equipped with a raked floor and a proscenium arch, enabling all manner of things to go on behind the scenes, out of sight of the audience. By all accounts, the illusion of reality had never been so strong—or should one say surreality, in view of the weightless gods, the fire-breathing dragon, and the metamorphoses of landscape.

As if in reproach for the exultant paganism of these intermedi, Ferdinando's accession was also celebrated by a sacred drama, *L'esaltazione della croce* (The Exaltation of the Cross) by Giovanni Maria Cecchi. It was performed outdoors by the young members of the Confraternity of Saint John the Evangelist. No music for it survives, only a description of its intermedi: they presented angels on a cloud machine, God as a bass soloist, and the biblical myths of Jacob's Ladder, the Exodus from Egypt, Aaron's Rod, the Brazen Serpent, and David bringing the Ark to Jerusalem. The finale showed the Exaltation of the Cross, whereupon as custom demanded the heavens opened to reveal not Olympus but—"Religion."

Despite this demonstration from the theatrical wing of the Counter-Reformation, Bardi's show was by no means the end of

Florentine intermedi and festivals on classical themes. However, it was the last event in which the Neoplatonic and Ficinian magic, deeply rooted in the consciousness of the city's ruling family, was taken seriously. How peculiarly Florentine it was appears from the comments of various ambassadors who attended the 1589 show and were baffled by the mass of allegories and allusions. One of them thought that the Doric Harmonia whose glorious song opened the event was supposed to be the Hydra; others, more reasonably, that she was an angel.[36] Just as in the pageants of 1566, it would take a book to explain all the allegories.[37] In later marriage celebrations, it is fair to say that spectacle—costumes, fireworks, horse ballets, monstrous floats, naumachia[38]—took the ascendance over meaning.

The Florentine intermedi were far from being operas, but they did give an increasingly important place to music in courtly drama. The spoken comedy, formerly the container, came to be contained by them, until it seemed more like a series of low-key interludes separating the real courses of the entertainment. The music of the intermedi favored two styles: the chorus of voices and colorful instruments, often combined with dance, and the solo song with instrumental accompaniment. Imitative polyphony, the central style of the sixteenth century, had no part in either. This, too, would be the case with opera.

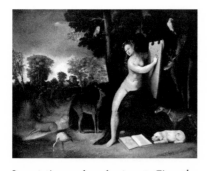

Incantation and enchantment: Circe the Sorceress with her magic tablet, and the men she has turned into animals. Dosso Dossi, *Circe*.

Two other dramatic productions enter briefly as a coda to this section. The first is *Circe,* or the *Ballet comique de la Royne,* performed in Paris on October 15, 1581. It started a long tradition of French court ballets that included song, dance, and spectacle. Robert Donington has garnered contemporary interpretations of it and added his own Jungian gloss, to show that *Circe* is as Neoplatonic as anything that came out of Florence.[39] Its philosophical roots lay in the deliberations of the Pléiade, an unofficial academy of seven poets who, in Donington's words, "addressed themselves systematically to the problem uppermost in the humanist discussions of art throughout the sixteenth century: the recovery of that intimate union of all the arts to which was attributed their celebrated mastery in classical times over strong and specific emotions."[40] Under the leadership of Jean-Antoine de Baïf and the poetic dominance of Pierre Ronsard, the Pléiade sought especially the union of poetry with music and dancing, as they believed it to have existed in Orphic times. They assumed that all the arts, like the cosmos itself, were governed by correspondences, and that by uniting them it should be possible to draw down cosmic influences. Needless to say, they were Ficinians through and through, following the Italian lead in Hermetic and Neoplatonic philosophy, just as the French

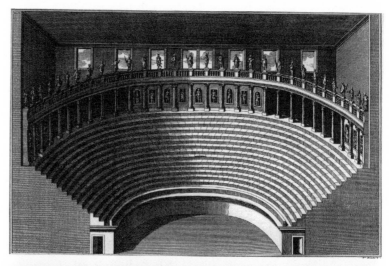

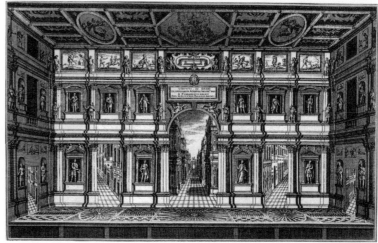

Sophocles's *Oedipus tyrannus* was given in Vicenza in 1585 in a purpose-built classical theater by Andrea Palladio. Auditorium and stage of the Olympic Theater. Engraving by G. Montenari, 1749.

artists and architects were learning Italian fashions and Jean Martin was editing the *Hypnerotomachia*.[41] Ficino's Orphic songs had been based on similar principles, but he was more concerned with the healing and growth of the individual, whereas the French group, living beneath the storm clouds of religious war, were looking for the healing of the nation.[42]

The second event is the performance of Sophocles's *Oedipus tyrannus* that was given in Vicenza in 1585, in a purpose-built classical theater by Andrea Palladio (1510–80), with choruses by Andrea Gabrieli (c.1510–86). While intermedi were well established as the way to serve up classical and neoclassical comedy, it was believed that tragedy required choruses as its musical component. The play was the result of a several-years' project by the Accademica Olimpica, a learned group in a city which already boasted several buildings by Palladio. The architect's design was executed after

his death, and the wooden building has miraculously survived with all its (immovable) scenery in place. Around the semicircular auditorium, the academicians set gilt wooden statues of themselves.

Circe and the architectural-dramatic project of the Olimpica reflect the two currents that have concerned us throughout this book. The French ballet belongs to the esoteric stream inspired by the Neoplatonists, which wanted to revive ancient theurgy, albeit in some way that would not jar with Christianity. It exploited the numinosity of the pagan myths for aesthetic adventures of a very high order—performances that viewers of every degree would find "bewitching"—but without an antiquarian's interest in getting the classical details right. The Vicenza academicians were more pedantic, humanistic, and, spiritually speaking, exoteric. By re-creating a classical theater and producing a Greek tragedy (in Latin translation), they were playing at being ancient Romans. This phrase carries no deprecation whatever. (Musicians and actors "play" all the time!) It was an imaginative game that they played, a self-transposition into an alternate reality, deeply serious and also joyful, as all the arts should be.

Another tributary of the gathering stream that would become opera arose in Ferrara, in the following way.[43] In 1579 Duke Alfonso II d'Este married his third wife, the fifteen-year-old Mantuan princess Margherita Gonzaga, described by everyone as "vivacious" but also highly cultivated and a lover of music. Among the Ferrarese courtiers was a minor aristocrat, Giulio Cesare Brancaccio, who was a bass singer of remarkable talent. He had developed a technique of virtuoso ornamentation, dividing the notes of a melody into a cascade of scales and leaps, but he disliked being made to display his skill to all and sundry. Like Castiglione's ideal courtier, Brancaccio wore his talent with *sprezzatura*, the disdain of a nobleman for those who show off and get paid for doing so. He preferred to sing in private for the mutual pleasure of his peers. Alfonso now hired two or three young women singers to join Brancaccio. They were the daughters of upper middle-class families, courtly in their manners but not ashamed to earn a living by their skills. These became the famous *concerto delle donne*, the Singing Ladies of Ferrara, who cultivated a *musica secreta* quite separate from the public music of the court. Soon the bass voice was redundant, for the Ladies sang not *a cappella* madrigals for voices alone, but duets and trios for sopranos accompanied by chord-playing instruments—harpsichord or lute. They sang in a small room in the apartments of the Duchess, where the Duke would listen to them every day for an hour or so, following the words of their songs in a book. They are said to have had a repertory of over 330 madrigals by

The singing ladies of Ferrara performed in the Duchess's apartments, accompanied by Luzzasco Luzzaschi at the harpsichord. Italian harpsichord with grotesque decorations, Venice, 1574.

heart.

There is a record of some of the events of a typical day in July, during a visit to Ferrara by the Duc de Joyeuse. First there was Mass, then dinner to the usual accompaniment of cornets and trombones. People returned to their chambers until three o'clock, whereupon the Dukes went to the Duchess's rooms to listen to the Ladies, singing in twos and threes to the accompaniment of Luzzasco Luzzaschi at the harpsichord. After this the dwarf couple was asked to dance, and the onlookers were utterly charmed by the elegance of the female dwarf's performance. Even the partial glimpse of this day is a microcosm of our themes. The daily Mass, never questioned, is the obligatory rendering of his rights to the Christian god. The public meal is for display, probably attended in the great hall by servants and dependents of all ranks, and its music is of the "loud" variety, in an era when music was classified as either loud (*haut/alto*) or soft (*bas/basso*). Around the room, this being Ferrara, there are tapestries or frescoes with classical or hunting scenes. After the siesta, a select few are taken to the musical Kunstkammer: the equivalent in sound of the collections of small, exquisite works of art and wonders of nature. The works of art here are the madrigals, available in lavish quantity like so many hard-stone vases, of which a few are taken out and admired. The wonders of nature are human ones: first the Singing Ladies whose skill is unique in all the world, and then the dwarves, no less valued as living treasures.

Vincenzo I Gonzaga (1562–1612), the heir to the dukedom of Mantua, was the first to emulate the *concerto delle donne* of Ferrara.[44] He regarded the Este city as a second home and a refuge from his disagreable father Duke Guglielmo (reg. 1550–87). Alfonso II d'Este was his brother-in-law, but played more the role of a surrogate father, teaching Vincenzo to swim and forming his tastes. As early as 1581 the young man founded a similar group of lady singers in Mantua, thereby beginning his distinguished career as patron of musicians. Duke Guglielmo's death in 1587 was the occasion for a second Mantuan renaissance, and soon Vincenzo's *concerto delle donne* was under the direction of no less than Claudio Monteverdi (1567–1643).

At the Carnival of 1583 a group of Florentines visited Ferrara, including Giovanni Bardi, his secretary Giulio Caccini, and Don Pietro de' Medici, younger brother of Grand Duke Francesco. They were so impressed by Alfonso's *concerto delle donne* that they decided that Francesco should form one of his own, which was duly done. To complete the circle, Vincenzo Gonzaga now married Francesco's daughter Eleanora, as noted above. Both Mantuans and Florentines enjoyed the services of the soprano Vittoria Archilei

(1550/60–after 1620), probably the greatest singer of her time. She was constantly at Pratolino during the summer of 1584, which adds considerably to our image of what life in that enchanted villa was like.[45] And it was her voice that opened the intermedi of 1589, singing the coloratura role of Harmonia.

There was nothing classical or humanistic about the *musica secreta*. It figures here because it was one more place where the sixteenth-century madrigal broke free of polyphony and made the transition to solo song accompanied by an instrumental bass and chords—what in opera would become the aria and duet. Also it was a vehicle for virtuosity, opening the portal to the dubious phenomenon of operatic stardom.

Giovanni de' Bardi, Count of Vernio (1534–1612) who has been mentioned several times in this chapter, was a man of wide interests and talents.[46] As a composer, he was a match for the average professional. As a soldier, he fought the Turks in the Hungarian campaign. He wrote the comedy *L'amico fido*, and a book on *calcio* (Florentine soccer). He could converse learnedly on Roman antiquities, astronomy, Platonic philosophy, Dante, and the Italian language. Bardi was the brains behind the Florentine intermedi of the 1580s, as Buontalenti was the engineer. But as a defender of Francesco's marriage to Bianca Cappello, he was uncomfortable with the new regime and Ferdinand's new men.

A solo singer, discreetly accompanied by a consort of lutes. Scene from *Ballet de la délivrance de Renaud*, 1617.

At his Florentine residence Bardi held a kind of salon, beginning before 1570, that only much later would be called the "Camerata." It was a place for the discussion of the ever-burning topic of the Ancients: their music, their theater, their astronomy, and the connections between these. In a memorable passage from his essay on tragedy, Bardi surmises that the movements of the Greek chorus were intended to replicate those of the planets and spheres.[47] This was part of a correspondence with Vincenzo Galilei, a man of similarly wide interests and a profound knowledge of ancient musical theory. It reminds us that Vincenzo was the father of Galileo Galilei (1564–1642), and that the astronomer's *Letter to the Grand Duchess* (1615) with its earth-shaking implications, would be addressed to none other than Ferdinand I's widow Christine of Lorraine. Returning to music: Vincenzo had come to the conclusion that the ancient Greeks used a kind of *stile rappresentativo* (dramatic style) that had little resemblance to sixteenth-century musical practice. In 1582 he put his theory to the test by singing himself the lament of Ugolino from Dante's *Inferno*, accompanied discreetly by a consort of viols. This struck Bardi's circle as epoch-making, although Bardi's protégé Caccini had done something very similar three years before on the Chariot of Night (see above) and al-

though solo song was quite an established practice in the intermedi. There must have been something else to Vincenzo's performance, perhaps a quality of dramatic energy, verging more to declamation than to melody. At all events, Caccini now concentrated on developing the monodic madrigal (i.e., with only one melody line), with the convenience of a single chord-playing instrument, not a consort, as accompaniment. Before the end of the century he had composed a whole repertory of such songs, entitled *Le nuove musiche* (The New Musics).

It is a curiosity of musical history that this group, feeling itself to be so revolutionary and new, was "re-inventing the wheel." What else had Ficino and Poliziano been doing, over a hundred years before, than singing monodies to the accompaniment of a chord-playing instrument? But they had done so in a separate bubble from the mainstream of court and church composers. These would be kept busy for most of the sixteenth century finding ways to make polyphonic music more expressive through word painting, dissonance, chromaticism, and the orchestration of a group of disparate voices. Moreover, there was a distinct difference in the way music was used. The mass production of madrigals and chansons, especially after the invention of music printing around 1500, suggests that secular singing was mainly a social activity. The model is the group of friends or family handing round the part-books, rather than the audience sitting passively to be entertained by a soloist. Our survey of court entertainments has shown how the latter model grew in importance until it became the dominant feature of the new music. It did not replace communal music making, which composers would continue to supply in obedience to various fashions until the modern era, but it added a new expressive resource to those in the business of public entertainment, propaganda, and "enchantment."[48]

Towards the end of the sixteenth century a younger Florentine aristocrat, Jacopo Corsi (c.1560–1602), held an erudite salon in rivalry with Bardi's, though membership in the two groups overlapped. Among Corsi's protégés were the poet Ottavio Rinuccini and the tenor singer Jacopo Peri (1561–1633). With Corsi's encouragement, Peri developed a different version of the new style of solo singing that was freer than Caccini's, and in so doing virtually invented recitative. Robert Donington writes: "Actual recitative differs from [strophic] songs in recitative style primarily in having not a rounded-off structure, but an open-ended structure. In this respect, recitative almost certainly originated not with Caccini, but with Peri; and recitative was quite certainly the innovation in and through which opera arose."[49] At an evening party during the Carnival of 1598, a pastoral drama called *Dafne* was performed under

Corsi's patronage, with text by Rinuccini and music in the new style by Corsi and Peri. It included the battle of Apollo and Python, for which Saslow suggests that the dragon and stage sets of the 1589 intermedi may have been reused.[50] Among the auditors who heard it "with astonishment" was Don Giovanni de' Medici, the son of Cosimo I by Eleonora d'Albizi.[51]

Dafne, repeated in 1599 and 1600, was the first opera, but as its music has vanished, our attention is drawn to its more famous successor, *Eurydice*. Rinuccini and Peri created this work for Corsi to offer as his contribution to the wedding celebrations of October 1600: the marriage by proxy of Maria de' Medici (Francesco I's younger daughter) to Henry IV of France. *Eurydice* was staged in modest fashion before a small audience in the Pitti Palace apartments of Don Antonio de' Medici (see p. 214), who was to escort the bride to France.[52] Corsi played the harpsichord, and other nobles contributed to the small orchestra. Caccini managed to insert some of his own music into the opera, on the grounds that his pupils could only sing his songs, and then rushed ahead to publish his own setting of the entire libretto. Hence there are two operas on Rinuccini's *Eurydice,* both printed and dated 1600, but Caccini's was only heard once (in 1602), whereas Peri's was several times revived, and stands as the earliest preserved and performable opera.

Caccini managed to insert some of his own music into Peri's opera, and then rushed ahead to print his own setting of the entire libretto. Title page of Giulio Caccini, *Eurydice*, 1600.

Caccini had a greater success three days later with one of the largest-scale events of the wedding, an opera to his music on *Il rapimento di Cefalo* (The Apotheosis of Cephalo), performed, if we can believe it, by one-hundred people before an audience of 4,000. Peri was one of the singers. Since all but a fragment of the music is lost, we cannot judge it, especially not the essentially operatic part of it, which is the *stile rappresentativo*. With its Buontalentesque machines, choruses, and dancing, it much resembled the intermedi. However, the epoch-making fact remains that the great event of Maria de' Medici's wedding was now a through-composed opera, rather than a comedy with musical interludes.

The tabulations of the intermedi, above, have shown how much they resembled the decorative and pictorial schemes treated in previous chapters. They either presented separate tableaux on classical themes, or else linked them together through a cyclic plan such as the Four Ages or Elements. In any case, they had a static quality, like a picture or a fresco cycle. The parades and triumphs described in Chapter 9 were also comparatively static, like a series of images with little or no sense of working up to a climax. This parallels the non-climactic nature of most fifteenth- and sixteenth-century music, which when it was not based on imitative polyphony was often in strophic or variation form. The open-

endedness of operatic recitative was as different as possible: it could end in a completely altered mood and key from those of its beginning. For the first time, a dramatic psychological event such as Orpheus learning of the death of Eurydice found adequate musical expression.

The stories of these early operas, coming as they did out of the world of the Florentine academies, were Neoplatonic; that is to say, the characters were allegories of the parts and destiny of the human being. This is the reason for their forced happy endings, because the Platonic philosophy is basically an optimistic one, at least for virtuous souls. In this light, Orpheus represents the higher part of the soul. His musical genius is the innate harmony infused in the soul by its correspondence with the World Soul, which can find an echo right down to the lowest level of creation (Orpheus's charming of animals and trees). Eurydice is the lower part of the soul, originally at one with the higher. But she is lost to the "underworld" of earthly concerns and desires. (Note that as in Eden, it is the serpent who is responsible for her fall.) In a gesture not unconnected with the incarnating savior-gods of the Roman period, Orpheus defies the chthonic powers that hold Eurydice in thrall, and begins to lead her back to union with himself.

What happens next depends on the version of the story that is followed, which varies widely in the classical authors. In Rinuccini and Peri's *Eurydice* the rescue operation is successful and the couple is reunited. In Poliziano's *Orfeo*, and in the version that Alessandro Striggio the Younger prepared for Monteverdi in 1607, Orpheus is forbidden to look at Eurydice or to speak to her until he reaches the upper world. Under pressure of her pleas he fails, and she returns irrevocably to Hades. Bereft for the second time, Orpheus renounces women for ever, and is murdered by the Bacchantes. The story has mutated from Neoplatonic fable to classical tragedy, in which a fatal weakness brings about the hero's downfall. In the revised version of Striggio's libretto, which Monteverdi eventually set and published, the second loss does not lead to Orpheus's death, but to his apotheosis as Apollo sweeps him up to heaven, where he is assured that he can contemplate Eurydice's image among the stars. However, the chorus reminds us of his fault: "Orfeo, who conquered hell itself, was conquered by his own feeling; whereas only the man who can conquer himself is really worthy of fame."[53]

The English musicologist Robert Donington, in the most stimulating treatment of early opera in general and Monteverdi's *Orfeo* in particular, offers a variety of interpretations from the point of view of depth psychology and comparative mythology. However, these all take modern man as their starting point, and assume that

Orpheus is forbidden to look at Eurydice or to speak to her until he reaches the upper world. Marcantonio Raimondi, *Orpheus and Eurydice*.

his problems are the same as those of the ancients and of the Renaissance; that previous eras, unable to articulate these problems as Carl Jung or Joseph Campbell could, put them into their myths and dramas. Readers will have their own opinions on whether men, and women, are psychologically different now from what they were 400 or 10,000 years ago. It is the kind of opinion that is unlikely to be shaken by argument, because for the historically-minded, much of one's world-view hinges on it. The present book is intended as a modest contribution to the question, not so much in the hope of resolving it as of stirring up the waters and foiling any attempt at an easy answer.

Returning to Monteverdi's *Orfeo,* the opera is known to have been performed only twice, on February 24 and March 2, 1607, before the Accademia degli Invaghiti (the "desirous ones") at Mantua.[54] Since March 3, 1607 was Ash Wednesday, it was evidently part of the Carnival season. The libretto with the tragic ending was published then and there, but for the publication of his score (and for all we know, for one or both of the performances) Monteverdi set a different, happy ending. Orpheus is moping on the plains of Thrace when suddenly his father Apollo descends on a cloud-chariot, and the two of them ascend to heaven singing a duet. In Neoplatonic terms, allowing that the ground rules have now shifted, we could say that Orpheus as the higher part of the soul, purged by suffering from attachment to its lower nature (Eurydice), is ready to ascend to union with its divine origin (Apollo). Then the opera ends not with a Bacchic chorus, but with the equally time-honored comic *moresca.*

The greatest works of art are so much richer than any possible interpretation—even Neoplatonic ones—that to dwell overmuch on the latter does them, and oneself, a disservice. In the rare and fortunate event of a live performance of one of these early operas, I pay no attention to any of this, but try to listen and watch with the uncritical wonder of a child.

After its beginnings in Florence and Mantua, opera spread to Rome, Naples, and eventually to all the major cities of Italy; then outside Italy, as musicians from the peninsular exported their style and skill throughout Europe. For a while, opera kept the pagan dream alive in a way that no other art could do, as one can see from the titles of some of the first operas performed in Rome between 1614 and 1628: *L'Amor pudico* (Bashful Cupid), *La morte d'Orfeo* (The Death of Orpheus), *Arethusa, La trasformazione di Dafne* (The Transformation of Daphne), *Bacco trionfante dell'Indie* (Bacchus's Indian Triumph), *La catena d'Adone* (The Chain of Adonis), and *Il giudizio di Venere* (The Judgment of Venus).[55] In Venice opera began later but rose to greater glory, with such mythic works

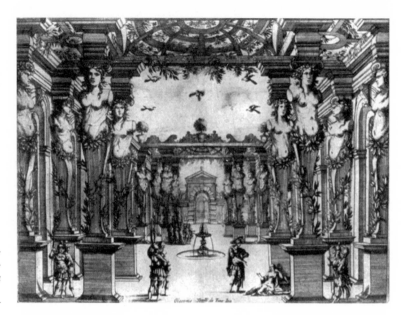

With their celestial and infernal happenings, the operas lent themelves to spectacular stage effects. Scene from *La finta pazza*, Paris, 1645.

as Monteverdi's (lost) *Proserpina rapita* (TheAbduction of Proserpina) and *Il ritorno d'Ulisse in patria* (The Return of Ulysses to His Homeland), and Cavalli's *Le nozze di Teti e di Peleo* (The Marriage of Thetis and Peleus), *Gli amori d'Apollo e di Dafne* (The Loves of Apollo and Daphne), *Amore inamorato* (Love Fallen in Love), and *Calisto*. In all of these the gods and goddesses appeared, interacting with mortals as they had always done in classical mythology, and as no one believed that they really did. One fiction supported another, the other being that all the words were sung. But this became more absurd as the conception of recitative changed to something far different from its roots.

Recitative or the *stile rappresentativo* had been the soul of the first operas, invented as a way to deliver a poetic text with the utmost emotional force. Songs and choruses were of secondary interest, for they were familiar from other genres. In the paradigmatic *Orfeo* of Monteverdi, the non-recitative music is always precipitated either by the story or by theatrical convention. Of Orpheus's two strophic songs, "Vi ricorda o boschi ombrosi" is part of a pastoral celebration to which he makes his contribution after the shepherds have made theirs; and "Possente spirto" is sung to charm Charon. The chorus acts both as Orpheus's pastoral companions and as an impersonal group of commentators, as in Greek tragedy. The instrumental pieces belong to the world of the intermedi, as do Musica's prologue and the duet with Apollo, who as the god of music is always expected to sing when he appears.

Within a very few decades, the balance had reversed. Opera went public, then with Venice leading the way it went commercial. The

THE ROOTS OF OPERA 227

Perhaps the grandest operatic event of the century. *Il pomo d'oro*, Vienna, 1667.

new opera lovers were not connoisseurs of Neoplatonic allegories or devotees of the *furor poeticus*. They paid to hear songs, to get emotionally involved with the character and more especially with the singer. Recitative, formerly the center of gravity of the drama, was demoted to the job of advancing the plot for the next aria. In comic operas it was discarded and replaced by spoken dialogue.

Along with this came a change in the subject matter of the libretti. The titles listed above were based on Greek myths, mostly via Ovid. The stories had an archetypal, lapidary quality, simple in outline and depending on the poet's power of imagery to spin them out. With their celestial and infernal happenings, they lent themselves to spectacular stage effects. The new, aria-based opera needed an entirely different type of libretto: one which would cause the characters to experience many varied moments of emotion. These would become the pretext for the several dozen arias that were the *raison d'être* of the work. It was soon found preferable to leave the gods out, except as presences in the background, and to use historical rather than mythical characters. Roman history and the epics of Ariosto and Tasso proved inexhaustible mines of raw material, which the librettists would twist into plots and sub-plots full of invented characters and absurd situations. These would generate the requisite number of love affairs, deceptions, cruelties, magnanimities, etc., to produce aria material of every emotional shade.

While the general trend of Italian opera in the seventeenth century was toward human and pseudo-historical subjects, the mythic type was still appropriate for state occasions, and for export. Cesti's *Il pomo d'oro* (The Golden Apple) was composed for the Imperial court of Vienna, and its performance in 1667 was perhaps the grandest operatic event of the century. Cavalli's *Ercole amante* (Hercules

in Love) was commissioned for the wedding of Louis XIV of France to the Infanta of Spain in 1660. With that, the young Italian expatriate Jean-Baptiste Lully saw and seized the opportunity to create a new opera tailored to French taste, and more especially to the taste of the king. It would form part of Louis XIV's great program for the re-ordering of his realm, whose pagan roots and perhaps intentions are the subject of the next chapter.

Versailles and After

I N Emanuela Kretzulesco-Quaranta's study of "Poliphilo and the Mystique of the Renaissance," Cardinal Giulio Mazarin (1602–61) appears as the last of the line of Italian initiates who caused their secret doctrines to be encoded in the language of gardens, and Louis XIV's gardens at Versailles as the last witness to their tradition. Despite his cloth, there was nothing churchly about Mazarin. He spent his life up to the neck in politics, first in Italy as a soldier and agent of the powerful Colonna family, then in France as apprentice to Cardinal Richelieu. After Richelieu's death, Mazarin became the first minister of Louis XIII (reg. 1610–43) and ably steered France through the aristocratic revolution of the Fronde and the end of the Thirty Years War. Upon the king's death, the Cardinal and the Queen Widow (Ann of Austria) acted as regents for Louis XIV (b.1638, reg. 1643–1715) and prepared the child king for his predestined glory.

Mazarin was also a highly cultured man and a patron of philosophers and writers. His splendid library survives as the Bibliothèque Mazarine, beside the Institut in Paris. His connection with the Colonnas of Rome is not fortuitous, in Kretzulesco's perspective, for she believes that the *Hypnerotomachia* was "protected" after the death of its author Alberti by Prince Francesco Colonna (rather than simply having been written by Friar Francesco Colonna of Venice, as current scholarship maintains). Moreover, she reports that the bibliophile cardinal owned copies of all the editions of the book that had appeared in Italy and France.

Louis XIV was the long hoped-for child of what had seemed the sterile marriage of his parents. His future was predicted in 1638 by the Hermetic friar Tommaso Campanella, on the basis of the prince's natal horoscope and an examination of the baby. Campanella, author of the utopian *City of the Sun*, prophesied that the child would reign over a solar empire, ushering in an Age of Gold that would precede the world's end. After a second examination he added: "This boy will be as pleasure-loving as Henry IV, and very proud. He will reign for a long time, sternly but happily. He lacks mercy, and in the end there will be great confusion in religion, and in the realm."[1] This prophecy seems to have been the foundation stone of the mythology that Louis would set to realiz-

This boy will be as pleasure-loving as Henry IV, and very proud. He will reign for a long time, sternly but happily. Louis XIV costumed for the *Plaisirs de l'Isle enchantée* (Bibliothèque Nationale).

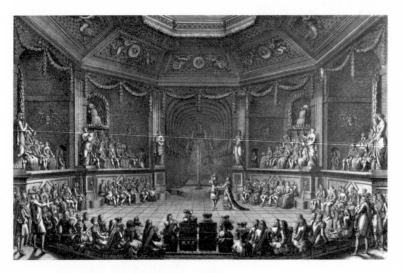

The highly-disciplined court ballet, in which the dancers formed and reformed into geometrical patterns. Ballet in the Bassin de Ceres, Versailles, engraving by Le Potre, 1678.

ing, as soon as he began to rule for himself.

When Louis came to manhood, Mazarin planned a Spanish marriage for him, to heal the breach caused by many years of war, and also in the hope that such a match might bring France possession of the Spanish Netherlands. It was a catastrophic choice, as would appear when Louis dragged his country into a series of futile wars to defend his claim and win glory for the House of Bourbon. But that was part of the future "confusion of the realm." To the Cardinal's dismay, Louis fell passionately in love with Marie Mancini, Mazarin's own niece. The young pair spent a chaste but blissful summer at Fontainebleau, "which at least gave the monarch a civilizing passion for Renaissance romance epics and Baroque novels,"[2] as another scholar remarks tartly. That was one side of Marie's influence. Another is described as follows:

> Louis XIV was twenty, and still seemed to be as submissive as a child to his mother and Mazarin. Nothing in him led one to expect mastery: he showed his boredom during council-meetings and seemed to want to leave the burden of business to others. Marie awoke in Louis XIV the pride that was slumbering within him; she often let the word "glory" reach his ears; she praised the joy that comes from commanding. Whether from a lover's pride or from calculation, she wanted her hero to be worthy of the crown.[3]

Royal marriage being a matter of politics rather than of the heart, Louis was obliged to jilt his beloved preceptor and marry Maria-Theresa, the Infanta of Spain. But two things remained from the affair with Marie Mancini: first, an awakened sense of himself and his regal destiny, and second, a passion for remaking the world in the image of a higher order of beauty.

As mentioned in Chapter 10, there was a tradition in the French court of symbolic entertainments used for a kind of magical politics, based on the Hermetic theory of correspondences. Thus it was, too, with the first great entertainments of Louis XIV's reign. As a young man, Louis' favorite creative outlet was dancing: not social dance, but the highly disciplined, choreographed court ballet, in which the dancers formed and re-formed into geometrical patterns on the stage. His epithet of the "Sun King" dates to his appearance in Isaac de Benserade's *Le Ballet des Noces de Pelée et de Thetis* (The Ballet of the Marriage of Peleus and Thetis, 1654), in which he danced six roles, including that of Apollo. Subsequent ballets were devised for the king's pleasure by Jean-Baptiste Lully (1632–87), the Italian composer, violinist, and dancer, who from 1661 was the undisputed master of the royal entertainments. The composer played a role similar to that of Bernardo Buontalenti toward Francesco I of Tuscany: that of an older mentor with surpassing artistic gifts, who knew how to realize the young prince's fantasies.

Mazarin's plans for his adopted country included giving it a taste for Italian opera, and this was the medium chosen in 1659 for a celebration of Louis' coming-of-age.[4] A new theater was built adjacent to the Tuileries Palace, especially adapted for the machines that were to produce breathtaking stage effects. The libretto was written by Mazarin's secretary, Francesco Buti, and the vocal music was commissioned from Italy's most eminent composer, Francesco Cavalli. Lully provided the ballets, an indispensable part of French court entertainments. The subject was *Ercole amante*, Hercules in Love. This was not Hercules the emblem of Fortitude, the chooser of the stony path of Virtue, the hero of the Twelve Labors that had decorated innumerable Italian palaces, but a man whose adulterous love for Iole leads to tragedy. The opera culminates in his death by fire, when his wife Dejanira misguidedly gives him the shirt of Nessus the centaur. As in Monteverdi's *Orfeo* there is a forcedly happy ending, as Hercules is translated to the heavens, now to be the spouse of no mortal woman but of Beauty herself: a crude and obvious statement of the Platonic doctrine of erotic ascent.

The alternation of operatic episodes with ballets resembled the older scheme of a comedy with intermedi between the acts. The stage effects, and the relations between the earthly and heavenly beings, were also in the tradition of the Florentine productions of a hundred years earlier. In the Prologue, the virgin goddess Diana descends from the heavens, promising Hercules the reward of Beauty (corresponding to his coming marriage). In the first act comes the opposing force of Venus, who promises him the woman

The seriously playful art of the splendid performance did not only record but could potentially provoke historical developments. Firework display at Versailles, engraving by Le Potre, 1678.

he lusts after. Juno overhears this and vows to foil the affair. Thus three *deae ex machina* frame the erotic conflict of the story. Other Florentine reminiscences are a Cave of Sleep, followed by a Ballet of Dreams; an apparition of Neptune in his shell chariot, followed by a storm; and a garden in Italian style whose statues are mortals, petrified through enchantment; they are brought to life, and dance a ballet.

Probably many of the audience smiled at the latter episode, because they would have known an anecdote told of Lully. It is said that one day, when the composer was still an unknown pageboy and fiddler, he overheard a group of courtiers walking in the palace garden. A lady, seeing an empty plinth, remarked that it would look much better with a statue on it. As the courtiers walked on, Lully took off all his clothes and climbed onto the plinth. When they returned, there was the statue. Lully's rise to fame and fortune began from that moment.

Kristiaan Aercke explains that *Ercole amante* was easily read as a family allegory. Hercules was young Louis, bold but untamed; Iole, Maria Mancini; Venus, the danger for the country of Louis' following his own pleasure; Juno, his mother, who opposed the Mancini affair. Hercules's death by fire was Louis' heroic purging from illicit desire, which earned him a place among the immortals. Aercke does not use the term magic, but she does recognize that "as part of political history in the making, art—which includes the seriously playful art of the splendid performances—did not only record but could potentially provoke historical developments."[5]

As it turned out, the interminable delays in getting *Ercole amante* onto the stage meant that by the time it was performed in 1662, its allegorical message was obsolete. Louis had duly and dutifully married Maria Theresa in 1660. The next year, Mazarin died and

Louis took over the first ministership for himself, assuming personal rule of the country. There would be no more Italian operas at court. Until the end of the decade, Louis would dance in Lully's ballets, then encourage the composer in developing a French national opera on mythical and Neoplatonic themes.[6]

Far from following the moral lesson of *Ercole amante*, Louis lost no time in taking a mistress, Louise de La Vallière, and began to plan a palace and garden that would reflect his chosen classical persona: not Hercules, but Apollo. Kristiaan Aercke paints in broad strokes the mythological dimension of the king's works:

> The cult of Louis XIV as Sun King started from the idea that Louis was the bright sun bursting through the clouds of civil war (the Frondes) and restoring the peace of the realm with his sunshine triumphant. The construction of Versailles continued the allegory: it was built to the West of Paris—like the Garden of the Hesperides, which is located in the remote West into which the sun-Helios-Apollo descends to rest; architectural rays emanate from the palace; the palace and the grounds are replete with light symbolism and with the motif of reflection (water surfaces, fountains, Hall of Mirrors); exuberant use is made of gold (especially in the heart of the palace, the royal bedroom, which is oriented towards the East); the *lever* and *coucher* of the Sun King are transformed into quasi-mythic ceremonies.[7]

The central importance of Versailles to the royal mythology was symbolically inaugurated from May, 7–14, 1664, years before the château and gardens were completed, with a week-long entertainment called *Les plaisirs de l'Ile enchantée* (The Pleasures of the Enchanted Isle).[8] It was nominally offered to the Queen and the Queen Mother, but it was common knowledge that the true dedicatee was Madame de La Vallière. The themes came mostly from Ariosto's *Orlando furioso* and Tasso's *Gerusalemme liberata*. Several comedies by Molière were given, including the first version of *Tartuffe*, which pokes fun at Christian hypocrisy. In one skit Molière and his wife impersonated Pan and Diana, an ill-matched and no doubt comical pair.

Some of the events of the "Enchanted Isle" could have come straight from *cinquecento* Florence. Molière's plays had intermedi in the Italian fashion. One mounted parade presented the Chariot of Apollo accompanied by the Four Ages, the Seasons, the Hours, and the Signs of the Zodiac, with their attributes based on Cesare Ripa's *Iconologia* of 1593. The Seasons rode on animals borrowed from the royal zoo: horse, elephant, dromedary, and bear. There was jousting, dancing, gaming, fireworks, costume parties,

The Four Seasons rode on animals borrowed from the royal zoo. Costume designs for *Les plaisirs de l'Isle enchantée* (Bibliothèque Nationale; Stockholm, Tessin Collection).

mounted parades, and more than enough food and drink. However, since the château was still little more than Louis XIII's modest hunting lodge, most guests had to find their own lodging, staggering off to hired beds in the villages of Versailles or Trianon, or inconveniently commuting to their *hôtels particuliers* in the capital.

Those historians of the court of Louis XIV who consider its esoteric aspects[9] agree that, behind the multiform project of Versailles, there must have been a group of men familiar with natural and sympathetic magic, astrology, and alchemy, and that they ensured that the project was marked by appropriate symbolism. Kretzulesco credits Louis himself with some of the seed-ideas: "Let us admit that the king had benefited indirectly from the lessons of Campanella and directly from those of Mazarin, and that, armed with a certain Ariadne's Thread of whose 'skein' he held one end (as François I had done), he required his collaborators to give new and original expression to ancient ideas."[10] She even supposes that Louis was an adept of some Pythagorean school that had survived in Italy and come to him through Mazarin. Her evidence for this, besides the symbolism of his palace and garden, is the uncovered

The freestanding Grotto of Tethys, during its brief existence, was reckoned one of the wonders of Versailles. Grotto of Tethys, engraving by Le Potre, 1672.

left knee that he shows in the official portrait by Hyacinthe Rigaud.[11] It is true that once one starts looking for this reputed sign of recognition of the Pythagorean Brotherhood, one finds adepts in the most unexpected places.

The exoteric view attributes the ideas behind the Versailles project to a "Petite Académie" of Abbés (not abbots of monasteries, but leisured men in minor orders) and literary men, including the brothers Charles and Claude Perrault (best known for the *Mother Goose Tales*).[12] At all events, it is agreed that the cyclical and cosmological themes of the Renaissance were integral to the plan of the palace and gardens alike. Their roots went back to the original château of Louis XIII, for the main SE–NW axis on which it was aligned points to the place where the sun set on August 25, feast of Saint Louis.[13]

The first of over 300 statues to be commissioned for the gardens were two marble sphinxes with gilt bronze amorini perched on their backs. They now greet the visitor at the entrance to the southern parterres, with gestures that Stéphane Pincas, the specialist on the sculpture of Versailles, interprets in Kretzulesque terms:

> The groups represent religious revelation and philosophical enquiry, indicating that knowledge of the divine is achieved through knowledge of nature. The cupid on the eastern pier points to the ground, signifying *hic et nunc* (here and now); only the present moment is real. The cupid on the western pier holds his hand open, palm downward, in a gesture signifying *festina lente* (make haste slowly); only a combination of impulse and reflection will lead to knowledge.[14]

The sphinxes were originally intended for the first major adornment of the gardens, the freestanding Grotte de Téthys (Grotto of

At evening the sun would penetrate the grotto and illuminate its recesses, lined with shells, corals, mirrors, and minerals. Grotto of Tethys, engraving by Le Potre, 1676.

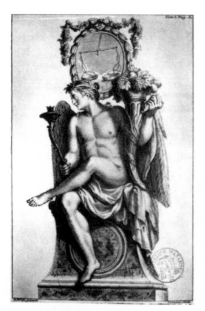

The bathing suite included statues of the Twelve Months in gilded metal, each holding a cornucopia and a torch. ABOVE: Libra. NEXT PAGE: Gemini. Figures from the Appartement des Bains, from Monicart, *Versailles immortalisé*.

Tethys[15]), reckoned one of the wonders of Versailles during its brief existence.[16] The amorini would then have played a welcoming and warning function similar to that of the dwarf Morgante at the approach to the Large Grotto of the Boboli Gardens (see p. 148). The Grotto of Tethys resembled the Large Grotto in the grandeur of its façade and in the way the interior was focused on three sculptural groups. The triple entrance was closed by tremendous gates of iron wrought in a pattern of gilded sun-rays, with six golden disks depicting the directions of space: North, South, East, West, and the two Poles. The grotto itself was a single chamber supported by mighty columns, with three niches resembling chapels in the apse of a church. At evening the sun would penetrate the grotto and illuminate its recesses,[17] which were lined with shells, corals, mirrors, and minerals arranged in geometrical patterns. The central apse framed a sculpture of Apollo being washed and attended by nymphs, and each of the flanking divisions contained two of the four horses of the Chariot of the Sun in the care of tritons and nereids. A waterfall descended behind the central group, a hydraulic organ played, and the visitors might be sprayed from hidden jets.

The Grotto of Tethys was a project as much desired by Louis as the procession of the Chariot of Dreams had been by Francesco I of Tuscany, a century before. It is generally interpreted within a program of solar symbolism that begins with the Latona Fountain (showing Apollo's mother about to give birth), rises to the heavens from the Apollo Fountain, and descends at night to the Grotto.[18] The latter is the "Palace of Tethys" described by Ovid in *Metamorphoses* 2.67–9. René Alleau, the authority on "Mysterious Versailles" and esoteric topography, glosses it thus: the Grotto is consecrated to Apollo as a chthonic deity, a "black god" as Osiris was also said to be, as he animates the world of minerals and subterranean waters.[19] This would certainly be a fertile idea for alchemical philosophers and others with theories about the Midnight Sun. For example, one interpretation of the latter is as the state of conscious or lucid sleep taught by some esoteric schools, along with the idea that things willed in that state are realized in the waking world. With a man as extraordinary as Louis, surrounded by advisors steeped in the Hermeticism never absent from French culture, nothing is impossible.

As the building program at Versailles proceeded, the front of Louis XIII's old château was preserved, with its beautiful blend of brick and stone, while the other three sides were wrapped with stone buildings of another scale altogether, and the approach was enlarged accordingly. Alleau interprets the two sculptural groups flanking the grand entrance as symbolizing the two principles of

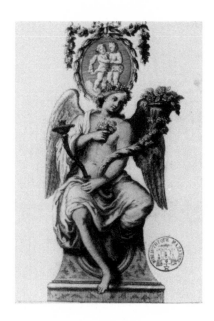

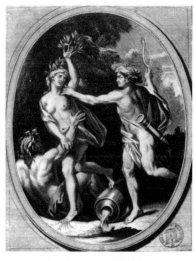

A symbol of the sublimation of carnal into spiritual desire, for after Daphne turned into a laurel tree, Apollo took her foliage as a crown for poets. Apollo and Daphne, from Monicart, *Versailles immortalisé.*

alchemy: volatile Mercury (the group with an eagle) and fixed Sulphur (the group with a lion). Against the common interpretation of these sculptures as France victorious over Spain and Austria, Alleau writes that the "scribes" were simply left in ignorance of the secret meaning of these allegories, because it did not concern them.[20] To the adept, on the other hand, they would be heralds of mysteries to follow. The decorations of the courtyard also have potentially alchemical connotations, though to the ordinary educated viewer they are the classical personifications of the Four Elements: Iris, Juno, and Zephyr for Air; Vulcan and two Cyclopes for Fire; Ceres, Pomona, and Flora for Earth; Neptune, Thetis, and Galatea for Water.

On the same (north) side as the Grotto of Tethys, Louis's architects turned the ground floor of the château into the Appartement des Bains (Apartment of the Baths), on the model of the bathing suite at Fontainebleau. They included a Cabinet des Mois with statues of the Twelve Months in gilded metal (witnesses to the Sun's passage), each holding a cornucopia and a torch. There was a painting of *Apollo Pursuing Daphne,* which, Hermetic meanings aside, was a symbol of the sublimation of carnal into spiritual desire: for after Daphne turned into a laurel tree, Apollo took her foliage for his crown, and for the reward of worthy "laureates." Another painting was *Vulcan Presenting Venus with the Arms for Aeneas*, and there were statues of Venus, Apollo, Bacchus, and Mercury. There is an evident connection with the imagery of the bathing of Apollo and his horses in the Grotto of Thetis, especially if we can accept the idea that Louis XIV did not think of himself merely as a man imitating the sun, but that he *was* the sun, or the solar power, as it manifests among men. The king immersing himself in the ritual bath was not different in kind, only in degree, from Apollo sinking into the ocean at the close of day, or from the alchemist's gold dissolving in *aqua regia.* Later, when Louis fell under the charm of Madame de Maintenon, the Baths were stripped of their suggestive ornaments. The monolithic bathtub, eight-sided like the font of baptism, was floored over, and is now exiled to the Orangery.

On the main floor above the Baths are the Apartments of the Planets, which became the king's own residence as soon as they were completed in 1673.[21] They were inspired by Italian precedents such as the Apartments of the Elements in the Palazzo Vecchio (see p. 75) and the Rooms of the Planets decorated by Pietro da Cortona in the Pitti Palace. The planetary rooms now begin with the Salon of Venus, then the Salon of Diana. These are lined with geometrical patterns of white, green, and red marble that would have done credit to the Tempio Malatestiano, alternating either with painted *trompe l'oeil* niches containing statues, or with real ones.

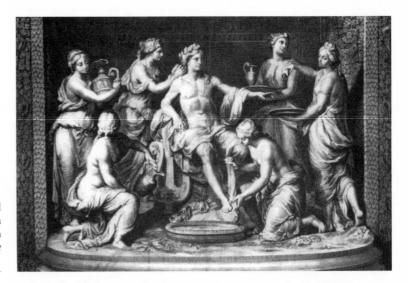

The king immersing himself in the ritual bath was not different in kind, only in degree, from Apollo sinking into the ocean at the close of day. *Apollo tended by the Graces*, engraving by Edelynck.

Busts of Roman emperors line the walls, and in the Salon of Diana is Bernini's 1665 bust of Louis XIV. The Salon of Mars is next, with a predictable iconography of battles and victories. It served as a guard room, controlling access to the king's original state bedroom, the Salon of Mercury. After the king moved his bedroom to the center of the building, this was the antechamber where ambassadors waited, contemplating the paintings of the god of communication and industry. The Salon of Apollo was the throne room, whose symbolism is obvious enough. Then[22] was supposed to come a council chamber dedicated to Jupiter where the king presided in Olympian fashion over his ministers, and a Salon of Saturn, the planet of melancholy and introversion, which was the king's small study. The Salon of Venus was meant to come last, giving access to a parallel suite of planetary rooms projected for the Queen's side of the building. That was the plan. In fact, the space intended for the last three rooms was taken over by the Salon of War and the Hall of Mirrors. By the time construction reached that point, Louis had lost interest in following the program of his early mentors. As the decades passed, the iconography veered away from classical myth and towards the celebration of military glory and the grandeur of France.

The gardens of Versailles prolong the Renaissance tradition, not in their unprecedented layout and scale, but in their suffusion with meaning. Louis XIV wrote several versions of a brief visitors' guide, called *Manner of Showing the Gardens of Versailles*.[23] He avoids any suggestion of symbolism or mystery, but the repeated enjoinders to stop and "consider" this or that feature leave a void in the mind of the visitor that cries out to be filled from one's own imagination. Here are the opening lines:

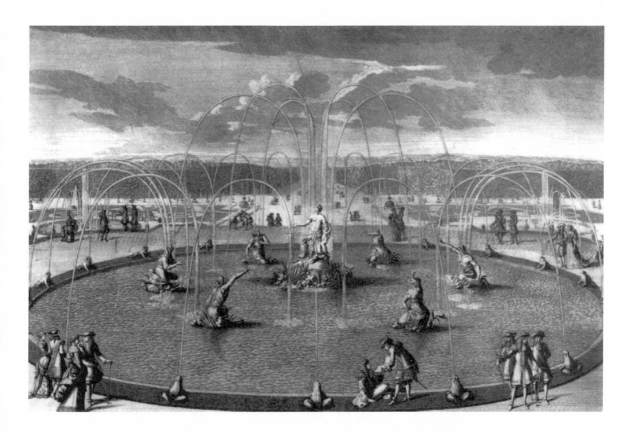

Latona, about to give birth to Apollo and Diana, is mocked by peasants whom she transforms into frogs. Fountain of Latona, engraving by Le Potre, 1678.

On leaving the château by the vestibule of the Marble Courtyard, one goes on to the terrace: one should pause at the top of the stairs to consider the situation of the parterres, ponds, and the Fountains of the Cabinets. One should then go to the right above Latona and make a pause to consider Latona, the [Fountains of the] Lizards, the ramps, the statues, the Royal Alley, the Apollo, the Canal, and then turn to see the parterre and the château.[24]

Simone Hoog, chief curator at Versailles, suggests that "Louis XIV has a photographer's view of his park, not a cinematographers. The promenade is a succession of pauses, of points of view."[25] This is very revealing, and gives an insight into the original conception of the gardens that is likely to be lost on today's visitor. We admire the grandeur and the immense vistas, and perhaps regret the long distances to be covered on foot. It is easy to forget that many of the features have been eliminated, as the gardens of Versailles have been stripped down over the centuries. A lack of maintenance has led to their decay and to replacement by plainer and less troublesome features. The preponderance of grass and gravel is a modernistic elimination of the original color and variety. For instance, the uniform pyramidal yews that we see from

The delights of the Versailles gardens lay hidden in the bosquets or clearings, where people would actually spend their time. Collation at the bosquet of the Montagne d'eau, engraving by Perelle.

The Labyrinth, made to edify the royal children, had thirty-nine fountains with figures representing the Fables of Aesop. Fountain of the Owl and the Birds, painting in the Grand Trianon.

the first viewpoint were once playfully cut in different shapes, like chess pieces, and beyond the parterres there were many more diversions to be discovered.

Admiring the views was one thing, but the delights of the Versailles gardens lay hidden in the bosquets or clearings, where people would actually spend their time. By the 1670s there were fourteen of these enclosures, each of them different. They were reached by paths hemmed in by tall, smoothly tailored hedges of hornbeam, and they were meant to be surprising. A series of paintings in the Grand Trianon shows them as colorful outdoor chambers, full of people and mythical beings, each with its own geometry, its own use of stone and water, and its own program. The Salle de Bal, for example, which still exists, has a wall of water cascading down over exotic seashells, flanked by candelabra.[26] There are turfed benches for spectators, and the dance floor is isolated by a circular canal. It begs to be brought alive by music, wine, and merriment. The Labyrinth, made to edify the royal children, had thirty-nine fountains placed at the intersections, with painted lead figures representing the Fables of Aesop (a theme only found previously at the Palazzo del Te[27]). According to Charles Perrault, the designer, it was the one place in the gardens that belonged to Cupid, not Apollo, for Love is the labyrinth in which one loses one's way.[28] At the grandiose bosquet of the Arc de Triomphe, Louis XIV enjoins the visitor to "notice the diversity of the fountains, the jets, the sheets, and the vessels; of the figures, and the different effects of the water."[29] Water spilled from buffets and pedestals of polychrome marbles, and from obelisks and the triumphal arch made from gilded ironwork.[30] The richness and the variety of the bosquets made them resemble floats in a parade, or the intermedi of a play—the play itself being the journey from one to another.

CHAPTER 11

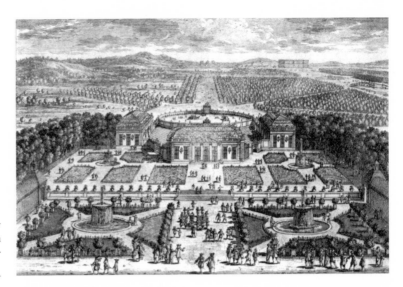

On the Grand Canal, one could travel by gondola to the Cytherea of the Porcelain Trianon. The Trianon de Porcelaine, contemporary print.

They called on the same skills of artists and engineers, and they invited the same response of delighted amazement, while serving as settings for small-scale concerts, amateur dramatics, dancing, and picnicking.

Poliphilic resonances are everywhere in the gardens. Hardouin-Mansart's Colonnade of colored marble is generally recognized as inspired by the *Hypnerotomachia*.[31] The Labyrinth, epecially considering Perrault's comments on its meaning, has its counterpart in the water labyrinth of Colonna's story. There was formerly a Menagerie containing all sorts of animals and birds, as a kind of living Kunstkammer. The Fountains of the Four Seasons carry the statues of Saturn (Winter) and Flora (Spring), then Ceres (Summer) and Bacchus (Autumn), which inevitably recall the old saw "Without Ceres and Bacchus, Venus would freeze." There were domed pavilions like the one that Poliphilo found in the seashore cemetery; a Water Theater; a Bosquet of Springs, little rivulets winding through a rocky landscape like the one at the beginning of Colonna's book.[32] The Triumphal Arch and Obelisk have already been mentioned. There was a "Sleeping Ariadne"—the Roman figure that inspired Colonna's fountain of the nymph and satyr; a giant sculpture of a Horse and Rider (made by Bernini as an image of Louis but rejected by him); a Fountain of Neptune; a Dragon; a fountain in the shape of a Pyramid, which is ornamented by Satyrs; a series of Herms; and the Grand Canal, on which one could travel by gondola to the Cytherea of the Porcelain Trianon (predecessor of today's Grand Trianon). Anyone familiar with Poliphilo's dream would be struck, time after time, by the coincidence of symbols, and by the implied invitation to "consider" everything he saw in a Poliphilic spirit. It was no chance that Jean de la Fontaine's

Les amours de Psyché et Cupidon (The Loves of Psyche and Cupid, 1667) is narrated by one "Polyphile," who takes his friends on a tour of Vaux-le-Vicomte, then to Versailles where they see the main features then in place: the Menagerie, the Orangery, the Grotto of Tethys, the Latona Fountain, the Basin of Apollo, and the Grand Canal.[33]

Today's pilgrim to the Sun King's Cytherean domain will miss many of the features mentioned so far. The Baths and the Grotto of Thetis are gone, the latter destroyed at Louis's own command in 1684 so that the north wing could be built. The King's Apartments have lost their symbolic plan through rearrangement and absorption into other rooms. Versailles only lasted for a few years in its "enchanted" state, with a carefully-planned program of decorations and entertainments, entirely pagan in theme. Even so, the wealth of classical imagery that meets one at every turn in sculpture, relief, fountain and vase is beyond compare. The formidable garden fronts of the 1680s, on close examination, continue the cosmic and cyclical themes in their personifications of the Twelve Months with the zodiac signs, and a series of keystones showing the course of human physiognomy from infancy to old age.

The hedonistic aspects of life at Versailles began to fade after Louis moved the government there in 1682, trapping his courtiers permanently in the rituals he had devised to keep them subservient. The death of the Queen in 1683, followed the next year by Louis's private marriage to Madame de Maintenon, marked a point of crisis in Louis's own soul. Always a punctilious observer of Catholic rituals and obligations, he now set to persecuting the Protestants and, in 1685, revoking the Edict of Nantes—the legacy of Henry IV that had ended the Wars of Religion by guaranteeing religious freedom. Those who could, left the country and became the Huguenot refugees, to the great benefit of the Netherlands, England, the Protestant states of Germany, and the Thirteen Colonies of America. The poorer ones were converted by main force, or suffered varying degrees of martyrdom. Much as Campanella had promised, Louis was rewarded for his "lack of mercy" by twenty years of military defeats, economic decline, and pious boredom.

Versailles was the last grandiose environment of the sort that has been chronicled throughout this book, namely one that used the imagery of Greco-Roman paganism to enrich the surface of things, to nourish the imagination, and to convey an esoteric message. Being the pagan imperial palace of a Christian king, its intellectual foundations were divided, and as a consequence its legacy was flawed. France did not become a whit more Christian as a result, nor its *philosophes* more aware of the eternal verities. The legacy was an aesthetic one alone, celebrating personal and na-

tional glory; and while we may enjoy the end result, we cannot easily forget the consequences of such celebrations. The tremendous historical events that have since taken place have laden the psychic atmosphere with unquiet ghosts. How can one forget the march of the Paris mob to the château in 1789 and the tragic fate of Louis XVI and his family; the capitulation in 1870 after the Franco-Prussian War and the proclamation of the German Empire in the Hall of Mirrors in 1871; the dire revenge taken by the French in the Treaty of Versailles of 1919? To the sensitive visitor, it is no longer a place of *divertissements* alone.

There would be material for another book if one were to investigate "Poliphilism" in the post-Renaissance era. All of the aspects I have treated have their own subsequent history, and their own heroic figures; but they no longer carried even a shadow of belief in the old pagan gods. The classical education to which the upper classes were now subjected stifled their magic in the cradle. The need still existed for escape into an alternative world of the imagination, but it was no longer from the tyranny of a religion in which fewer and fewer people believed, and which had worn out its claws and teeth upon itself. By the nineteenth century the cycle had come round again, and it was the rituals of the Roman Church that offered escape from industrial ugliness, materialism, and dour Protestant sermonizing: hence the attraction of Catholicism for the Nazarenes, the Pre-Raphaelites, the Oxford Movement, and the *fin-de-siècle* decadents.

Ludwig made a Knight's Hall decorated with Wagnerian themes, and a Throne Room with the iconography of sacred kingship. Throne Room, Schloss Neuschwanstein.

Catholicism and its doctrine of the Divine Right of Kings were the metaphysical basis for the strange life and conduct of King Ludwig II of Bavaria (reg. 1864–86), who of all post-Renaissance rulers came closest to the Poliphilic ideal. His passionate aestheticism drove him to excesses for which he was shamefully treated by his own government, but for which the Bavarian Tourist Board is eternally grateful. Ludwig was not drawn to the images of classical mythology, but to those of German legend and medieval chivalry, imbibed in his father's Gothick castle of Hohenschwangau and celebrated across the valley in the most enchanted castle of them all, the neo-Romanesque Schloss Neuschwanstein. There Ludwig made a Knights' Hall decorated with Wagnerian themes, and a Throne Room with the iconography of sacred kingship. The whole castle was adorned with the ultimate in the stonecutter's, metal forger's, and woodcarver's craft.

At Ludwig's second castle, Schloss Linderhof, the court artists turned their skills to reviving the Rococo style, and the Alpine surroundings became the setting for a series of thematic follies.[34] One was a Moorish Kiosk that had been exibited at the Paris Exhibi-

tion, to which a Peacock Throne was added. Two small buildings replicated theatrical props from the Wagner operas: Hunding's Hut, complete with the World Ash Tree growing up through the center, and the hilt of Nothung the Sword sticking out (as in the first act of Wagner's *Walküre*), and Gurnemanz's Hermitage (from *Parsifal*). There was an Italianate garden with a 100-foot fountain and a domed Temple of Love, like that at Trianon. The star attraction of Linderhof was the Blue Grotto, made in good Renaissance fashion from artificial stone but lit by electric light, which made possible effects that Bernardo Buontalenti would have given anything for. The Grotto contained a lakelet with a shell boat (straight out of the Florentine intermedi), and a stage on which it was hoped that Wagnerian performances would take place. All that was missing was a sound system, for which, alas, Ludwig had arrived too early. Ludwig's last work was Schloss Herrenchiemsee, where he abandoned fantasy in favor of a disciplined copy of the Château of Versailles' garden block. Much of the inside was left empty, but the finished rooms include replicas of the hall of Mirrors, the State Apartments of Louis XV, and, interestingly, a re-creation of the marble Ambassadors' Staircase that no longer exists at Versailles. The most extraordinary thing about Ludwig II is that while he built and decorated on a palatial scale, he used his castles as studioli, retreating there alone to kindle his imagination.

While Ludwig built and decorated on a palatial scale, he used his castles as studioli, retreating there alone to kindle his imagination. Staircase of the Ambassadors, Schloss Herrenchiemsee.

Mention of Richard Wagner (1813–81) demands a word on that master's work. His music dramas, performed in their purpose-built Festival Hall in Bayreuth, completed the transformation of participants into auditors. On pp. 181–82 I mentioned the change from medieval entries in which the citizens had an active role to play, to those of the absolutist rulers of the sixteenth century which were pure spectacle. Wagner's operas were such spectacles, and the absolute ruler was himself, unaided even by a librettist. We also noted the innovation of the Uffizi Theater with its proscenium arch, marking off the domain of the actors from the auditorium, whereas former shows had taken place in courtyards, town squares, and private apartments. At Bayreuth the division was dramatized by the same innovation as Ludwig II used in his Grotto: electric lighting. This meant that all the lights in the auditorium could be controlled simultaneously, plunging them into darkness before a lit stage. The significance of this is that by making the bodies of the audience invisible, attention is riveted on what is happening on the stage. The cinema, which had its beginnings in a theatrical world strongly influenced by Wagner's innovations, takes the process to its logical conclusion. If the artist is successful, one forgets that one has a body, and one's consciousness is supplanted by the sights and sounds of the art-work. When the work is of archetypal or

mythical content, and when it is reinforced by music of such power as Wagner's, the sympathetic auditor may well feel transported to another world, where events are of cosmic dimensions. The result is the same as with other epic and mythic works: we begin to see ordinary existence through their categories.

As for secret doctrines concealed in gardens, this is arguable in the Renaissance but undeniable in the Enlightenment and early Romantic periods. The secrets were now those of Freemasonry, as in Mozart and Schickaneder's *Magic Flute* (1791), the model for artworks with initiatic programs. The masonic gardens had bosquets, follies, and grottoes symbolizing parts of the Lodge or grades of initiation. Their meaning might be proclaimed in revolutionary inscriptions, such as the police objected to in Niccolò Puccini's Florence garden in the 1820s; or they might be concealed underground, as in the Templar Chapel with its giant "Baphomet" figure in the Vigardazere Garden at Saonara.[35]

The Greek Revival, circa 1760–1830, was in a different spirit from the neoclassicism of the Renaissance. It was not a rediscovery of the antique so much as a symbolic choice, standing for Reason and Enlightenment in revolt against the absolutism represented by the Baroque style. Neoclassicism was least successful in painting, because all efforts suffered by comparison with the Old Masters. It had a happier career in sculpture: its chief masters Canova and Thorwaldsen led the kind of double life that Renaissance sculptors had led before them, carving classical mythologies one year and papal tombs the next. Its greatest success was in architecture, especially in the American Republic. The last major work of the Greek Revival, titanic and absurd at the same time, was the "Walhalla" built by Ludwig I of Bavaria (reg. 1824–48) to the east of Regensburg, to contain the busts and statues of German heroes (no heroines admitted). The site above the Danube is magnificent; the execution impeccable. The absurdity is that it is a replica of the Parthenon of Athens, as if to say that when German heroes die, they go to Olympus.

The Kunst- und Wunderkammer evolved into the public museum, pioneered by Athanasius Kircher's collection at the Jesuit College in Rome and Elias Ashmole's collection, which he left to the University of Oxford. The original type survived in court and royal circles. Louis XIV's son the Grand Dauphin was an ardent collector, not too proud to scour the Paris curiosity shops for *objets d'art*. His collection at Versailles became such an attraction to visitors that he had to find another suite of rooms to live in.[36] In Saxony, the Electors had been passionate collectors since the mid-sixteenth century. Their Wunderkammer in Dresden expanded until Augustus the Strong built the "Green Vaults" for it in 1724–27. Still

The last major work of the Greek Revival, titanic and absurd at the same time. Interior of Walhalla, near Regensburg.

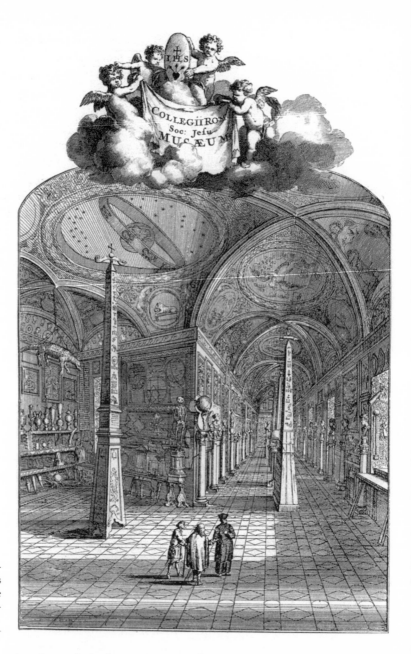

The Kunstkammer evolved into the public museum, pioneered by Athanasius Kircher's collection at the Jesuit College in Rome. Kircher's Museum, contemporary print.

in place, these have separate chambers for Books, Goldsmiths' work, Ivory, Bronze, Enamel, Jewelry, Silver, Armor, and a *Previsensaal* for miscellaneous objects.[37] This was an unusually late instance, for by then a division had formed between "fine arts" (sculpture and painting) and "applied arts," otherwise known as "decorative arts" or merely "crafts." One cause of the split, and of the prestige of the former, came from princes wanting to have examples from the Old Masters of the Italian Renaissance. The fashionable sign of their taste and wealth was no longer a Kunstkammer

but a Picture Gallery. Besides, no one believed in unicorns any more, or cared to mount their coconut shells in silver gilt.

Most remarkably, the neoclassical and romantic eras saw the return of a type of philosopher that had hardly existed since Roman times: the pagan esotericist. With the possible exception of Giordano Bruno, the Hermetic and Neoplatonic philosophers of the Renaissance had retained the Judeo-Christian revelation at the core of their world view; likewise the theosophers who followed in the footsteps of Jacob Boehme. The philosophical options during the Age of Reason were reduced to belief, which meant some form of Christianity, and unbelief, which ranged from Deism to out-and-out atheism. Suddenly there appears a complete anomaly in the person of Thomas Taylor (1758–1835), the "English Platonist" whom I have already quoted. Whereas Ficino's life's work was to make Greek philosophy readable in Latin, Taylor's was to translate it into English. Like Edward Gibbon, author of *The Decline and Fall of the Roman Empire*, Taylor saw the triumph of Christianity as a disaster, but he had an alternative spiritual reality to put in its place. Not even Ficino had read the late Neoplatonists Iamblichus, Porphyry, Proclus, Damascius, and Simplicius with such zeal and empathy. Taylor's life of poverty, obscurity, and single-minded devotion to the gods was nothing short of heroic. The academic world treated him as nonexistent, and his only memorial was the gratitude of a discerning few. These included the English Romantic poets and their twentieth-century heirs (notably W. B. Yeats and Kathleen Raine); the American Transcendentalists (Emerson, Thomas Johnson, Kenneth Sylvan Guthrie); and the Theosophists (H. P. Blavatsky, Alexander Wilder, G. R. S. Mead).

A second esoteric pagan, equally obscure in his lifetime, was Taylor's contemporary Fabre d'Olivet (1767–1825). Raised in the rational mold of French Protestantism and the Enlightenment, Fabre d'Olivet found his way to Pythagoras (translating and commenting on the *Golden Verses*) and to the new discoveries of Indian and Chinese philosophy. He wrote a universal history on esoteric principles which flashes with insights into the mechanism behind historical events, and into the stupidity of human beings when a provident cosmic order is all around them. Fabre d'Olivet's major work was an analysis of the Hebrew language and a nonsectarian translation of the opening books of Genesis, raising the text from the realm of particularist religion to that of universal philosophy. In his last years he founded an initiatic order resembling Freemasonry, but taking its symbolism from Agriculture rather than from Architecture and the Bible. He was one of the founding fathers of French occultism, which, however, reverted to its esoteric Christian and Kabbalistic roots under the influence of Eliphas Levi, Saint-Yves

Goethe contrived over the years to turn the Ilm Valley into a modest Cytherean realm. The Roman House in the Park, Weimar, mid-nineteenth century print.

d'Alveydre, and Papus.

The third esoteric pagan of this era is infinitely better known: he is Johann Wolfgang von Goethe (1749–1832). From his early engagement with alchemy to the Second Part of *Faust*, all his work shows a man committed to a spiritual quest without religious boundaries. His life is a chronicle of openness to the world and all it has to offer. Such was his prestige and influence that his every discovery and enthusiasm opened new vistas for his countrymen and his era, to become part of the German imagination. Like Poliphilo, he received initiations through architecture into the imaginal world of the past: first into the Gothic heritage through Strasburg Cathedral, and then during his Italian journey. Another initiation came through Eros, which, whether frustrated or fulfilled, was the mainspring of his creative energy. As far as his means allowed, he made his house in Weimar into a Kunstkammer, with collections of *naturalia, artificialia,* and antiquities. He also made a symbolic garden. Where the River Ilm winds through the valley, Goethe gradually transformed the landscape into a modest Cytherean realm. After passing the garden house in which the poet spent his bachelor years, the wanderer is invited to pause and consider a sphinx in a little grotto, with a miniature waterfall; a house of bark, like the first crude shelters of the Silver Age; an altar encircled by a snake, dedicated to the *genius loci*; another one with a thrice-garlanded sphere; a temple in Doric style. It is a place where the Poliphilic mood can still be sensed, if never fully recaptured in this tardy and tawdry age.

In conclusion, I turn to some more esoteric aspects of my subject, and first to the question of the persistence of pagan academies or initiatic Orders. There is evidence, tantalizingly slight but worthy

of mention, that one of these persisted throughout the period I have been covering. In the mid-nineteenth century, the Masonic historian and Hermeticist J. M. Ragon translated a manuscript of about 100–150 years earlier,[38] which purported to tell the history of a "Pythagorean Order" since the fall of the Roman Empire. It is a fascinating document, which begins on firm enough ground with the well-corroborated history of the School of Athens. Founded by Plato himself, this philosophical academy lasted for nine hundred years, until all the pagan institutions were suppressed by Emperor Justinian in A.D. 529. The surviving philosophers found a refuge at the court of Chosroes I the Great, King of Persia, after which they were able to return to the Peloponnese under the new name of *pednosophoi*, children of wisdom. The history next turns to the preservation of the initiatic tradition in Muslim countries and in Byzantium. It is not surprising to read that the Pednosophers were favored by Caliph al Mamoun (reg. 813–33), the patron of revived Greek learning among the Arabs; nor that they were headed in the eleventh century by the Byzantine Platonist Michael Psellus (d. c. 1078). Also as one might expect, the Order was brought back into Italy by George Gemistos Plethon, and consigned by him to the protection of Cosimo de' Medici and Borso d'Este. Constantino Lascaris succeeded Plethon as head of the Order, whose intitiates included Cardinal Bessarion and many members of the Roman Academy whose misfortunes have been described on pp. 11–13. Lascaris fled to the court of King Matthias Corvinus of Hungary, where he died. After the revival of the Roman Academy following Pope Paul II's death, the Order entered a phase of expansion. Gian Andrea Lascaris was its head from 1497–1535, during which time he founded branches in Florence, Rome, Perugia, Lucca, Naples, Forli, Faenza, and several other cities of Italy. He also started an academy in Germany, with less success, and one in France which was protected by Louis XII and François I.

The Order of Pednosophers consisted of four grades, the first of which was originally open to women and youths as well as to men, and was based on the myth of Deucalion and Pyrrha, who repopulated the earth after the flood. (We will recall that this was a theme of the Grotta Grande in the Boboli Gardens.) The neophytes were expected to be morally irreproachable and to cultivate song, music, and poetry. That, unfortunately, is all that Ragon's document tells us. The French commentator Jean Mallinger adds that the essential doctrine of the Order was that of reincarnation, and that Plato had revealed some of it in the Myth of Er. It also taught "the Pythagorean conception of a harmonic Universe, whose mathematical symphony has its Ineffable Center in God. Thus Science and Religion are combined in a single cosmic reality." Ragon indicates

that the Pednosophers held themselves aloof from religion and its contradictions:

> one might think that the Pednosophers were attached to the paganism that an entirely spiritualized religion [i.e. Christianity] had overturned, but this would be an error. They were too wise and too wary to sacrifice their peace to those errors that they had all helped to destroy. For them, both religions were equally distant from the truth, which alone deserved their devotion.[39]

It sounds from this scant information as though the Order was an essentially philosophic one, giving initiation into a *gnosis* or way of knowledge that bypassed the religions. The history of the Order in the Renaissance era continues:

> But the peace that the Pednosophers enjoyed for so many years was fatal to them. Too confident in their numbers and in the quality of their membership, they transgressed the precautions that had protected them up to then. The jealousy of the Brothers of lower grades caused Pope Urban VIII [reg. 1623–44] to close the Academies. No refuge was left to the Pednosophers: the Grand Duke of Tuscany[40] abandoned them and at the same time Philip IV of Spain and Naples [reg. 1621–55] rejected them. All of these coercive measures were taken under the instigation of the Inquisition, which persecuted the *Friends of wisdom and truth*.[41]

Ragon's manuscript states that the only thing that saved the Order at this point was its survival outside Italy, especially in England, thanks to Sir Thomas Bodley who had been initiated in Forli in 1554, and headed an English academy on his return. In both England and France, the Order disguised itself as a tobacco-lovers' club, calling itself the "Tabaccologists" or the "Snuff-Takers." It appears to have withered away and become extinct by the end of the eighteenth century, but Ragon's informant suggests that it could always be revived.

Ragon's manuscript and even Mallinger's unverifiable commentary have enough circumstantial detail to deserve open-minded attention, though as every student of esoteric movements knows, the great ones of the past cannot protest when they are posthumously enrolled in order to promote someone's beliefs or adherences. (The recent instance of the "Priory of Sion" is an example.) That is why in this book I have stopped short of any theories of conspiracy or initiatic transmission, restricting myself to the visible evidence for something not requiring Orders or rites.

CHAPTER 11

That "something," which I have called the pagan dream, is not the same as the Pythagorean-Platonic philosophy, though it may be a gateway to the latter. The key to understanding it is the concept of the *mundus imaginalis*, the World of the Imagination. From a subjective point of view, this is the place in our mind where we store significant images. These form a hierarchy, like the ladder of the Tarocchi. At the bottom are the images that are personal and exclusive to ourselves, heavily influenced by our family, home, education, and station in life. Next come images that are shared within our own culture: historical figures and events, ones derived from widely-known fiction and the arts. Above this is the mythological level, where reside the images belonging to our particular religion. Next come images shared by every human being, such as parts of the body, mother, tree, mountain, and the time cycles that we visualize as day and year. Lastly are the images that border on the abstract, like the tones, numbers and forms studied by the Pythagoreans.

If this makes sense to anyone today, it is probably thanks to the influence of Carl Gustav Jung (1875–1961), who coined the term "collective unconscious" as the locus for the images that we share with other people. Jung was more cautious when it came to the question of their origins and ontological status. Since he was trying to establish his psychology on scientific principles, his working hypothesis was that the archetypes of the collective unconscious had become fixed or imprinted on our minds through the repeated experience of our myriad forbears. Thus the physical world, glossed by our own subjectivity, could suffice as an explanation of all phenomena.

There is another hypothesis concerning the World of the Imagination with which Jung was undoubtedly familiar: the point of view that grants it independent, objective existence. This is associated in recent times with Henry Corbin (1903–78), professor at the Sorbonne and Jung's colleague at the Eranos Conferences.[42] In contrast to Jung, Corbin was a retiring scholar with an extremely recondite field of study, medieval Persian theosophy. He did not have patients or disciples, but worked to make available, first in French then in other languages, a wealth of spiritual philosophy and visionary experience. The Persian theosophers were much concerned with the Imaginal World (called *Hurqâlya*), which they recognized as objective, though without a material substratum. Experience— admittedly of a rare kind—had taught them that there is an independently-existing world that is accessible through the inward senses (of which vision is usually the strongest), and that the places and personages encountered there have a real, objective existence that can be corroborated by others.

Corbin's writings offered a new incarnation of the *mundus imaginalis* to European readers. By presenting the Persian authorities on the subject, he was able to avoid making a statement of faith and thus violating scholarly etiquette, but his erudition enabled him to show how widespread the idea of the Imaginal World was, both in time and across cultures. After reading his works it was clear that *not* accepting its objectivity was the more abnormal position, historically speaking. It had been taken for granted by Plato and the Neoplatonists, the kabbalists, the Christian theosophers and mystics, and the spiritual masters of Sufism. But not only by these—for it did not need Corbin or the Platonists of Persia to tell artists and poets where their images came from. The invocation of the Muses, in whatever form, was an acknowledgement that the artwork is given in its essentials from a higher level of reality. Where was Michelangelo's *David* before it was forced out of the marble? Where were blind Milton's *Paradise Lost*, or deaf Beethoven's late string quartets? "Laid up in Heaven," as Plato said, and waiting to be drawn down through a laborious birth.

Great artists, like medieval Persian theosophers, have never had any doubt about the objective reality of the Imaginal World, but it took less than a century for philosophers to consign the notion to the wastebasket of history. For a long time there was no organized opposition to this tendency beyond the blazing evidence of the artists themselves—admittedly fewer and fewer, as Romanticism gave place to Modernism and the gates of perception were willfully closed. During the 1970s and 1980s the English poet Kathleen Raine (b. 1908) emerged as spokeswoman for the *mundus imaginalis*, not as metaphor but as fact. As a Blake, Yeats, and Thomas Taylor scholar, Raine traced the survival of this perennial idea, and bore witness to it in her own poetry and in her support of like-minded poets and artists. She founded the Temenos Academy in London as a rallying standard for artists and thinkers committed to the Arts of the Imagination, in defiance of the modernist consensus that dominates the arts and Academe.

For Corbin, and even more for Raine as a poet, the intermediate realm is real and of paramount importance. In the eloquent words of Thomas Taylor, "From this intelligible world, replete with omniform ideas this sensible world, according to Plato, perpetually flows, depending on its artificer intellect, in the same manner as shadow on its forming substance."[43] What is more, it is not subject to the downward slide of earthly history. Even though access to it is more difficult today than in ancient times, or even than in the Renaissance, this objective realm of archetypal images remains as a perennial source of inspiration. Thus the true artist or poet

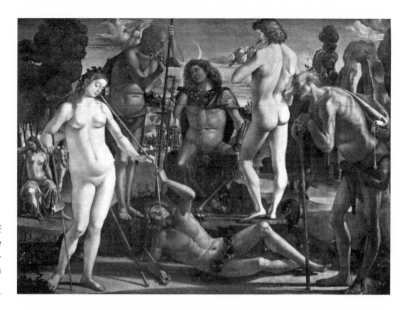

The evidence suggests that the artists of the Renaissance regained access to the particular mansion that contains the images of Greco-Roman paganism. Luca Signorelli, *The School of Pan.*

cannot afford to be a complete cultural pessimist, because that would be to admit defeat at the hands of the shadow-realm. She continues inwardly looking or listening at the ancient springs, in the company of all those who have drunk there before her.

The connection of these ideas to the movement described in the preceding ten chapters will not have escaped the reader. In the first chapter, I mentioned how artists of the fifteenth and sixteenth centuries lived alternately in two imaginal worlds, one Judeo-Christian and the other Greco-Roman. Each religion has its own repertory of images, and its own visionaries who have painted them in words or pictures. The images are particularizations of higher beings, states, and processes that cannot themselves be sensed or put into words. They belong to a metaphysical level even above the imaginal hierarchy as I have sketched it; but since this is so inaccessible, they have clothed themselves with myths and images appropriate to different eras and races. It is these myths and images that constellate in the "many mansions" of the Imaginal World.

If we allow the hypothesis of the Imaginal World, the evidence suggests that the artists of the Renaissance regained access to the particular mansion that contains the images of Greco-Roman paganism. These are the "banished creatures of mythology who had always existed and who now crept back in the welcoming Renaissance air," as Michael Levey beautifully expresses it, writing about Signorelli's *School of Pan.*[44] Although the process is impossible to pin down, I think that it happened mainly in the 1460s and 1470s, contemporaneously with Ficino's translation of Hermes and Plato and his development of the idea of the *prisca theologia,* and that it was responsible for the coming together of classical subject matter

with classical style.

Kathleen Raine was well aware that her work to restore the "Arts of the Imagination" realized some of the hopes of the Anglo-Indian scholar and curator Ananda Kentish Coomaraswamy (1877–1947), who had set out the principles of "traditional" art, that is, art based on metaphysical realities. For Coomaraswamy, the art of Europe, and most else of value, ended when the medieval world-order collapsed in the fifteenth century and gave place to the Renaissance, to be followed by the Reformation, the so-called Enlightenment, democracy, socialism, scientific materialism, and the unholy trinity of Darwin, Marx, and Freud. Around 1930 he wrote

> there are two different Europes, the one "modern" or "personal," the other "Christian." The former, roughly speaking, begins with the Renaissance, the latter includes the "Primitives" and a part of Byzantine art; but the two Europes have always overlapped and interpenetrated.[45]

Being the child of an Indian father and an English mother, educated in England and settling in Boston, Coomaraswamy could see the problem from several angles. Formed in circles descending from William Morris, he found his mission in the defense of traditional arts and crafts against the squalid soullessness of the industrial world. As an authority on the arts and philosophies of Asia, he recognized Europe as having once belonged to the human family, until it abandoned its own spiritual roots and began to throw its deadly weight around the globe. Although he wrote almost nothing on the subject, I suspect that Coomaraswamy saw the Roman Empire as already part of the "modern" and "personal" Europe that he deplored.

Were the Renaissance impulses that I have been describing responsible for the state we are in today? The other two principal Traditionalists, René Guénon (1886–1951) and Julius Evola (1898–1974), thought so. Like Coomaraswamy, they were cultural pessimists for whom all of recorded history has followed a downward path, away from a primordial state in which spiritual realities were known, not merely believed in (much less disbelieved). Neither of them paid much attention to the *mundus imaginalis*, under any name. They were more inclined to mistrust it as a deceptive zone between the physical and the metaphysical, like the notorious "astral world" of Theosophy. It is not surprising that they disdained the Renaissance, but this alone does not explain the emotion with which they and their epigones attacked it.

René Guénon, like Coomaraswamy, was a defender of the tra-

ditional Christian order of the Middle Ages against subsequent Western developments. Having no sensitivity whatever to the arts, he viewed the Renaissance as a crucial episode in the spiritual decline of the West:

> what people speak of as the Renaissance was really the death of many things; on the pretext of a return to Graeco-Roman civilization it merely took over the most outward part of that civilization, since what was relatively external had alone been able to be expressed in written texts; moreover, an incomplete restoration of this kind was bound to be very artificial in character, since it implied the use of forms whose real life had gone out of them centuries before.[46]

Thus Guénon dismisses such masters as Nicholas of Cusa, Ficino, and Pico della Mirandola as if they were nothing but pedantic classical philologists. But Guénon's agenda was always anti-classical: the rediscovery of Plato and the Neoplatonists failed to move him. Like all those who see the historical process in moralizing terms, Guénon had to classify every phenomenon as good or bad, and the Renaissance, inasmuch as it marked the end of the Middle Ages, could only have been "bad."

One might expect a friendlier attitude from the Roman philosopher Julius Evola, as the author of a defiant volume defending "Pagan Imperialism" and an artist, of sorts, in his youth. But he censured it for not having gone far enough:

> According to some, the Renaissance represented a revival of the ancient classical civilization that allegedly had been rediscovered and reaffirmed against the dark world of medieval Christianity. This is a major blunder. The Renaissance either borrowed decadent forms from the ancient world rather than the forms of the origins permeated by sacred and superpersonal elements, or, totally neglecting such elements, it employed the ancient legacy in a radically new fashion. During the Renaissance, "paganism" contributed essentially to the development of the simple affirmation of man and to fostering the exaltation of the individual, who became intoxicated with the products of an art, erudition, and speculation that lacked any transcendent and metaphysical element.[47]

Evola's work on alchemy, *The Hermetic Tradition*, shows how aware he was of the transcendent element in Hermeticism, and willing to cite authorities from the fifteenth through the seventeenth centuries. He could see transcendence in the writings of Cesare della Riviera and Michael Maier, but not, apparently, in the paint-

Decadent forms from the ancient world invade the Christian sanctuary. ABOVE and RIGHT: Carvings on the choir stalls, Mainz Cathedral, sixteenth century.

ings of Titian and Parmigianino, nor in the erudition and speculation of the Florentine Academicians. Like Guénon, Evola had a dualistic and moralizing attitude to history. On no account could any credit be given to progress or to the emancipation of the individual, except that of the "superior man" whose individual exaltation knew no bounds. Once the barrier was erected, everything had to fall on one side or another. This led Evola, potentially a friend of paganism, into some odd cohabitations, for instance with Catholic integralists nostalgic for the most repressive aspects of the Middle Ages, as if turning back the clock were the only alternative to modern depravity.

Another Traditionalist, Frithjof Schuon (1907–98), rises to polemical heights as he toes the party line on the Renaissance in *The Transcendent Unity of Religions*:

> From the time of the Renaissance, which represents a sort of 'posthumous revenge' on the part of classical antiquity, European 'idealism' flowed into the exhumed sarcophagi of the Graeco-Roman civilization. By this act of suicide, idealism placed itself at the service of an individualism in which it thought to have rediscovered its own genius, only to end up, after a number of intermediate stages, in the most vulgar and wild affirmations of that individualism. This was really a double suicide: firstly the forsaking of medieval or Christian art, and secondly the adoption of Graeco-Roman forms which intoxicated the Christian world with the poison of their decadence.[48]

Schuon, too, was an amateur painter, and not innocent of "wild and vulgar affirmations" of his own individualism. His emotional outburst shows how deeply the Traditionalists' *ex cathedra* judgments were rooted in their own psychologies, and especially in a sense of alienation from the modern world, with which I can readily empathize. It is their simplistic moralizing to which I object. It blinded them to the nuances of history, for instance to the fact that this medieval Christendom for which they were so nostalgic was already recognized by Dante as rotten to the core; or to the notion that Greco-Roman forms might have brought with them a breath of life from what was, after all, a traditional civilization in its own right.

Titus Burckhardt (1908–84), scion of a family distinguished in art and art criticism, treats the movement in more measured terms, admitting that the Renaissance and Baroque eras "had a scale of human values incomparably higher than anything that can be met with today."[49] He shows the influence of his Swiss compatriot Jung in analyzing the psychological roots of the movement:

CHAPTER 11

at the time of the Renaissance artists of genius were "revealed" almost everywhere, suddenly and with an overflowing vitality. The phenomenon is analogous to what happens in the soul of one who abandons a spiritual discipline. Psychic tendencies that have been kept in the background suddenly come to the fore, accompanied by a glittering riot of new sensations having all the attractiveness of possibilities not yet fully explored; but they lose their fascination as soon as the initial pressure on the soul is relaxed. Nevertheless, the emancipation of the "ego" being thenceforth the dominant motive, individualistic expansivity will continue to assert itself; it will conquer new planes, relatively lower than the first, the difference in psychic "levels" acting as the source of potential energy. That is the whole secret of the Promethean urge of the Renaissance.[50]

Burckhardt's judgment rests on a native puritanism that rejects the horizontal domain of expansion (what Hinduism calls *rajas*) in exclusive favor of the vertical ascent and ascesis (the Hindu *sattva*). That is his prerogative. Although we should not draw too many conclusions from his use of the term "Promethean," a glance at the myth in question will not be amiss. Prometheus was of the race of the Titans; he disobeyed Zeus and brought fire and life to mankind. Zeus in his turn was not merely a disobedient son to Saturn, but castrated and usurped his father, bringing the Age of Gold to an end. Saturn had done no less to his progenitor Ouranos. Who was right and who was wrong in all of this? No one. Viewed metaphysically, it symbolizes the process of manifestation. Viewed historically, the myth tells of the succession of cosmic ages, each having its own character and bringing its own gifts and dangers. Viewed psychologically, it symbolizes the process by which we become individuals in our own right. Several of the Traditionalists did this very thing themselves, cutting their ties with their paternal religion of Christianity and converting to Islam.

I feel called to defend the Renaissance against this concerted attack by a group of philosophers who, if insignificant in the wider world, wield considerable influence among esotericists. It is a friendly defense, for I owe much to their writings. But for all their universality and wisdom, none of them had the slightest appreciation for the fifteenth-century attempt to reopen a channel to the imaginal world of ancient paganism, backed by a revival of Neoplatonic and Hermetic philosophy. It was a quixotic dream of a restored polytheism, in which worship could be paid to the gods or goddesses of one's choice. To see such a dream realized, one only has to look to India, where temples to the various Hindu deities coexist, where sanctity is recognized irrespective of sect or cult,

and where a millennial philosophical tradition makes nonsense of theological squabblings. The more philosophical minds of Hinduism, like the Neoplatonists, are aware that the gods are but aspects or emanations of the One; but this does not prevent them from also enjoying their specificity and even worshipping their images. A polytheistic religion can afford to be relativized and subsumed in a greater metaphysical whole. Monotheisms cannot, because they depend on belief in historical events such as the Covenant on Sinai, the Incarnation and Resurrection, the descent of the Quran. The Academicians of Florence and Rome, burning with enthusiasm for the Ancient Theology, strove to reconcile it with Judeo-Christian monotheism, but it was a forced marriage. The latter could never surrender its exclusivist or supremacist claims, while to the philosophically-minded pagan, those historical events are both implausible and irrelevant. From the chasm of this realization, the Platonists of the Renaissance had to draw back. The dream faded like the frescoes in some abandoned palace, leaving the European stage free for the Christians to fight it out amongst themselves.

All of this is far away from twenty-first century realities. But for that very reason, the past begins to seem to some of us like our native country, and we feel more at home in that insubstantial but real world, to one of whose realms this book has been dedicated. It is not as though we escape into a passive state of fantasy, like drug addicts who cannot function in ordinary life. The past distills itself into the *mundus imaginalis*, which surrounds us like the resources of our memory, deepening our responses, showing us myths and archetypes which give meaning and focus to our individual destinies. It also bestows a sensitivity to beauty, that quality most spurned by the century that is thankfully past. Children are naturally aware of this, and eager to absorb wisdom through mythology and the encounter with archetypes: hence the success of Disneyland. But we can offer something better than a commercialism aimed at the lowest common denominator. The creative wealth of the ages, the arts and music once reserved for an aristocratic elite, are now open to all who have the ears, eyes, and inclination. While the collectors and artists of the Renaissance seized at every fragment of classical antiquity, to weave it into their own being and their creations, we are infinitely richer in potential. In a stroll through a museum we can appropriate both classical antiquity and its Renaissance revival, nor do we have to reject the Middle Ages that came in between. We can contemplate the Christian myths as well as the pagan ones, and appreciate the values that each brought into the world. We are free to believe, or not to believe, in any of them. And this is to say nothing of the non-European cultures whose legacies are spread out before us. Yet in gratitude for this

plenum, this superfluity of the past and the overwhelming superiority of its treasures, we may sometimes wonder what we will leave to our descendants, five hundred years from now. Are we creating anything of lasting value, or are we, for all our material success, mere spiritual parasites living off the capital of our ancestors? What is today's equivalent of the pagan dream, what riches of the imaginal world are we revealing for the future delectation of our kind?

Genealogies

Selective genealogies of the principal families featured in this book, and their interrelationships.

E. = Emperor; K. = King; AD. = Archduke; GD. = Grand Duke; D. = Duke; M. = Marquis

HABSBURG

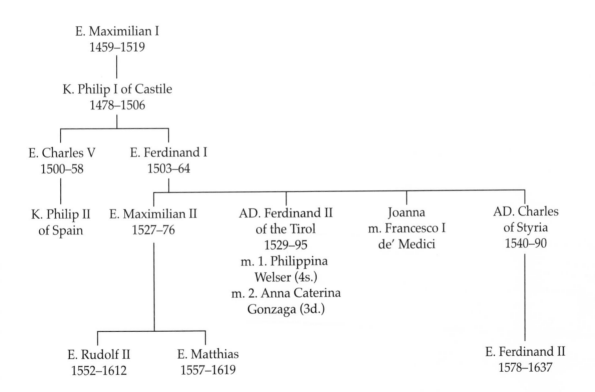

E. Maximilian I
1459–1519

K. Philip I of Castile
1478–1506

E. Charles V
1500–58

E. Ferdinand I
1503–64

K. Philip II
of Spain

E. Maximilian II
1527–76

AD. Ferdinand II
of the Tirol
1529–95
m. 1. Philippina
Welser (4s.)
m. 2. Anna Caterina
Gonzaga (3d.)

Joanna
m. Francesco I
de' Medici

AD. Charles
of Styria
1540–90

E. Rudolf II
1552–1612

E. Matthias
1557–1619

E. Ferdinand II
1578–1637

GONZAGA & ESTE

GONZAGA
M. Lodovico II 1412–78

M. Federico I
1441–84

Card. Francesco
1444–83

Elisabetta
m. Guidobaldo
da Montefeltro

M. Francesco II
1466–1519 =

M.–D. Federigo II
1500–40

D. Francesco III
1533–50

D. Guglielmo
1539–87

Anna Caterina
M. Ferdinand II
of the Tirol

D. Vincenzo I
1562–1612

ESTE
M. Niccolò III 1383–1441

M. Leonello
1407–50

M.–D. Borso
1413–71

D. Ercole I
1431–1505

Isabella
1479–1539

Ippolito I
Cardinal
1479–1520

D. Alfonso I
1476–1534
m 2. Lucrezia Borgia

Ippolito II
Cardinal
1509–72

D. Ercole II
1508–59

(by Laura Dianti)
Alfonso

D. Alfonso II 1533–97
m.1 Lucrezia
de' Medici
m2. Barbara
of Austria

Cesare
m. Virginia
de' Medici

Margherita = m.3

MEDICI

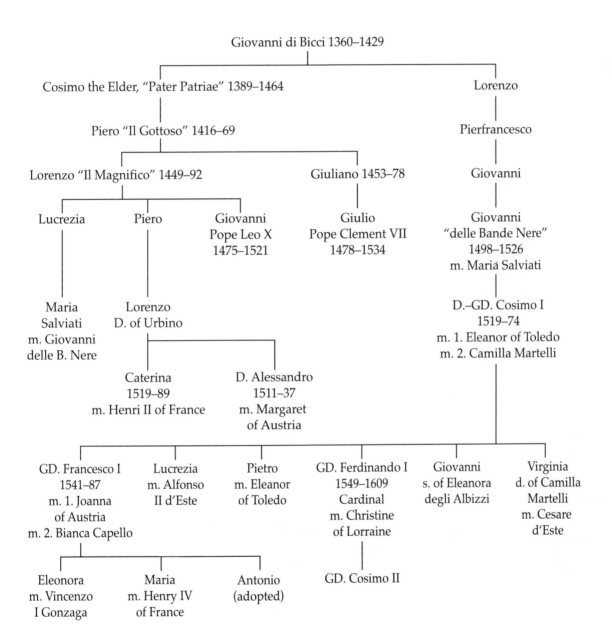

Giovanni di Bicci 1360–1429

Cosimo the Elder, "Pater Patriae" 1389–1464 — Lorenzo

Piero "Il Gottoso" 1416–69 — Pierfrancesco

Lorenzo "Il Magnifico" 1449–92 — Giuliano 1453–78 — Giovanni

Lucrezia — Piero — Giovanni Pope Leo X 1475–1521 — Giulio Pope Clement VII 1478–1534 — Giovanni "delle Bande Nere" 1498–1526 m. Maria Salviati

Maria Salviati m. Giovanni delle B. Nere — Lorenzo D. of Urbino — D.–GD. Cosimo I 1519–74 m. 1. Eleanor of Toledo m. 2. Camilla Martelli

Caterina 1519–89 m. Henri II of France — D. Alessandro 1511–37 m. Margaret of Austria

GD. Francesco I 1541–87 m. 1. Joanna of Austria m. 2. Bianca Capello — Lucrezia m. Alfonso II d'Este — Pietro m. Eleanor of Toledo — GD. Ferdinando I 1549–1609 Cardinal m. Christine of Lorraine — Giovanni s. of Eleanora degli Albizzi — Virginia d. of Camilla Martelli m. Cesare d'Este

Eleonora m. Vincenzo I Gonzaga — Maria m. Henry IV of France — Antonio (adopted) — GD. Cosimo II

Notes

Chapter 1: Seduction by the Gods

1. Gundersheimer, 208–9.

2. Febvre, 460.

3. *Credo quia absurdum est* (I believe because it is absurd), ascribed to Saint Augustine, based on Tertullian, *De Carne Christi*, 5.

4. E.g. by distinguished iconographers and intellectual historians such as Aby Warburg, Erwin Panofsky, Paul O. Kristeller, Edgar Wind, Fritz Saxl, Ernst Gombrich, Jean Seznec, etc.

5. Letter from Niccolò Loschi to his brother, probably 1434, in Sabbadini, 182–83.

6. See Clark, esp. 11, 13.

7. *Republic* 9.592b.

8. Burckhardt 1960, 65.

9. See Smith, 219.

10. Andres, Hunisak, & Turner, 300.

11. See Krautheimer, 52–53, on the relation of the Hercules to Ghiberti's *Isaac*.

12. Andres, Hunisak, & Turner, 366.

13. Greenhalgh, 179.

14. See Baskins for a balanced account of previous fantasies about the bronze David.

15. Clark, 48.

16. *Symposium* 210; *Phaedrus* 251c.

17. Schultz, 66.

18. See Siro Innocenti's description of the chapel in *Cappelle del rinascimento a Firenze*, 86.

19. The attribution is contested; the style is not.

20. Białostocki, 41.

21. The subject is treated exhaustively, with many illustrations, in Cumont.

22. Białostocki, 42.

23. I owe these observations to the Plethon scholar Christopher Bamford.

24. For a sketch of the milieu, see Lefaivre, 104–5. Kretzulesco-Quaranta 1986, 29–45, is a wonderfully conspiratorial account. I rely mainly on Palermino.

25. Agostino de' Rossi, quoted in Calvesi 1996, 189.

26. Pastor, *History of the Popes*, London, 1899, IV, 44–45, quoted in Palermino, 117n.

27. See Bätzner, 48, and P. F. Brown, 121, on this "perhaps imaginary" outing.

28. On Callimachus's career, see Białostocki, 9, 42, 47; Palermino, 127.

29. Białostocki, 44, gives a map showing the locations of some 90 of them.

30. Białostocki, 4.

31. On which see Kretzulesco-Quaranta 1986, 252–54.

32. Cox-Rearick 1995, 326–27.

33. Cox-Rearick 1995, 339.

34. Smith, 187.

35. See Klossowski, which is a whole book dedicated to this topos.

36. See the essays by various authors in Cavalli-Björkman.

37. See Verheyen 1977, 111.

38. Wells-Cole's study is an eloquent illustration of the situation in Britain.

Chapter 2: The Strife of Love in a Dream

1. Goldschmidt, 10.

2. The copy in the Palazzo Bagatti Valsecchi, Milan, has a gray wash added to give depth to the illustrations.

3. *Hypnerotomachia*, fol. g3; English translation, 109.

4. *Hypnerotomachia*, fol. r8'; translation, 279–80.

5. *Hypnerotomachia*, fol. b6'; translation, 36–37.

6. *Hypnerotomachia*, fol. b3; translation, 29–30.

7. *Hypnerotomachia*, fol. r7–r7'; translation, 277.

8. *Hypnerotomachia*, fol. m8'; translation, 200.

9. *Hypnerotomachia*, fol. z2; translation, 363.

10. *Sine Cerere et Bacchus friget Venus*, Terence, *Eunuchus*. A Christian interpretation could be "without generosity, no charity." Cavalli-Björkman in *Prag Um 1600*.

11. *Hypnerotomachia*, fol. C1'; translation, 414.

12. *Hypnerotomachia*, fol. F2'; translation, 464.

13. Kretzulesco-Quaranta 1986, 368.

14. *Republic* 7.514a–517c; *Phaedo* 107c–114c.

Chapter 3: Re-ordering the World

1. Pernis & Adams is a study of the rivalry of these two lords.

2. Latin text from Seznec, 135n.

3. Portoghesi, 3.

4. Stokes, 241.

5. Homer, *Odyssey* 13.102–12, tr. Thomas Taylor (circa 1787), in Raine & Harper, 297–98.

6. Shapiro, I, 7, 30; II, 226–27.

7. Shapiro, I, 120.

8. Shapiro, II, 126.

9. Shapiro, II, 126–29.

10. Mori, 27–29.

11. According to Wohl, 52, their iconography follows that of the Belfiore Studiolo (see Ch. 5).

12. Shapiro, II, 222.

13. On Porphyry's *De antro nympharum* as transmitted by Macrobius *In somnium Scipionis,* see Gersh, II, 518, 565–95.

14. Pernis & Adams, 74.

15. On the applicability of Porphyry to Renaissance gardens, see Castelli, 160–62; Miller, 13–15.

16. See Decker et al., 27–28.

17. These letters may correspond to the names of Tarot suits, thus: **A**ttutti [trumps], **B**astoni [wands], **C**oppe [cups], **D**enari [coins or pantacles], (**E**)**S**padone [swords]. See Westfehling, 43.

18. On nymphs as Muses, see MacDougall, 49–50.

19. Seznec, 137.

20. Seznec, 200–201.

21. That is, the shape of the cosmos as made by Plato's Demiurge in *Timaeus* 36b.

22. See Giovannoni, 13; Westfehling, 46; Seznec, 138–39, who gives the source of this theory in H. Brockhaus.

23. *I Tarocchi detti del Mantegna,* 5.

24. See Nicholas of Cusa. A board for the game survives, along with Cusanus's library, in St. Nikolaus Hospital in Bernkastel-Kues, Germany.

25. Westfehling, 45.

26. Giovannoni, 28.

27. *I Tarocchi detti del Mantegna,* 129.

28. Nicholas of Cusa, 37.

29. Colvin, 21–41; Phillips, esp. 79–81.

30. Levenson et al., 13–20.

31. Levenson et al., 17.

32. See Colvin, 4–9.

33. Colvin, 4.

34. Gundersheimer, 206.

35. See Cox-Rearick 1984, 169.

36. On Aby Warburg's original discovery of the decans, see Fratucello & Knorr; for the astronomical key, see Magoni.

37. *Phaedrus* 246e–247a, tr. T. Taylor.

38. *Phaedrus* 248c.

39. Gundersheimer, 206, 248–49.

40. Gundersheimer, 259–60.

41. Gundersheimer, 261.

Chapter 4: The Enchantment of Public Spaces

1. Mori, 18, 21; see also Seznec, 73–74, with references given there.

2. Seznec, 130–32; Mori, 23.

3. Mori, 29.

4. Mori, 24–25.

5. Mori, 36–38, with references to Saxl's publication of the horoscope and to later discoveries.

6. Cox-Rearick 1984, 192.

7. Cox-Rearick 1984, 197.

8. What follows is based on Signorini.

9. *De Hysmines et Hysminia amoribus,* by Eumathios Makrembolites. This was noted by P. Moretta in 1918.

10. The standard work remains Hartt.

11. See Hartt, I, 85–86.

12. Verheyen 1977, 15.

13. On this visit, see Hartt, I, 105–6.

14. See Hartt, I, 115–22.

15. See Verheyen 1977, 25–26.

16. Hartt, I, 138.

17. On Fontainebleau, see Cox-Rearick 1995.

18. Dating varies. This is given by Wohl, 47, who sees Salviati's work as the epitome of the "ornate classical style."

19. Lensi Orlandi 1977, 138.

20. Lensi Orlandi, in Bardeschi, 79.

21. Lensi Orlandi, in Bardeschi, 81, 83.

22. Cox-Rearick 1984, 273.

23. See Ragon and Mallinger; also the present book, 251.

24. The dedicatee was Pierfrancesco Riccio. The translation, by a pupil of Ficino, dated from 1463. Reprints in 1547, 1548, 1549. See *Dizionario biografico degli Italiani*, VIII, 201, and *Pimandro* in the Bibliography.

25. Lensi Orlandi, in Bardeschi, 77.

26. This tradition is best accessible in English in Evola et al., 2001.

27. Vasari, VIII, 85; my translation.

28. See Cox-Rearick 1984, 276–78.

29. Vasari, VIII, 19–20.

30. Lensi Orlandi 1977, 145.

31. On the Belvedere, see Fučíková in *Rudolf II and Prague*, 3–4; Simons in ibid., 85–86; Hausenblasová & Šroněk, 125, 176–78; Fučíková in *Prag um 1600*, II, 59–62.

32. On this expedition, see Pánek in *Rudolf II and Prague*, 270–72.

33. *Allgemeine Deutsche Biographie*, VI, 697f.

34. Simons in *Rudolf II and Prague*, 86, 88 n. 38.

35. Hausenblasová & Šroněk, 176, 178.

36. Fučíková, in *Prag um 1600*.

37. Dauxois, 264–65, 306–7.

38. On the Star Castle, see Fučíková in *Rudolf II and Prague*; *Bila Hora*, 53–55; Stejskal. I am grateful to Mike Jay for procuring an English translation of Stejskal's book.

39. His original drawing is shown in Stejskal, 50.

40. Scholem, 366.

41. Fučíková, in *Rudolf II and Prague*, 7; Simons in ibid., 86.

42. See McHam 1994, 81–82.

43. For some examples, see Baldass et al., 26–29.

44. There is as yet no comprehensive study of the iconography of the Star Castle. Baum contains drawings of the principal stucco reliefs, with a brief introduction.

45. Jansen in *Prag um 1600*, II, 142.

46. Baum, Introduction.

Chapter 5: Private Microcosms

1. Thornton, 8, 57.

2. For many illustrations, technical analysis, and history, see Flade.

3. Thornton, 57.

4. Cheles, 54–55.

5. Cicero, *ad. fam.* 7.23.2; quoted in Liebenwein, 168 n.9.

6. Gundersheimer, quoting A. Decembrio, 1540.

7. Campbell, 29.

8. Campbell, 32, 169 n. 4.

9. According to Giordana Mariani Canova, in Alexander, 22.

10. Thornton, 57; Campbell, 29, 35–36.

11. Thornton, 57, dates Tura's repainting to 1479 under Ercole. Mariani Canova, in Alexander, 22, attributes the Belfiore studiolo to Borso. Campbell, 169 n. 4, dates the repainting between 1458 and 1463 (hence under Borso), but allows that Calliope may have been "altered" by Tura in 1481 (under Ercole).

12. Campbell, 55.

13. Campbell, 44.

14. Campbell, 31, 44–45.

15. Beccadelli, 5.

16. Campbell, 31.

17. Heikamp & Grote, quoting the poem of Piero Parenti.

18. Thornton, 49.

19. Edwards, 75.

20. Pernis & Adams, 17.

21. Cheles, 13.

22. Cheles, 24 n. 32.

23. Cheles, 13, 24.

24. Schröter, 301–2.

25. Schröter, 303. The tambourine player is also playing, but her instrument is presumably sanctified by its mention in the Psalms.

26. Flade, 60; Cheles, 61n.

27. Liebenwein, 90.

28. Cheles, 87.

29. Quoted by Liebenwein, 15.

30. Raggio and Wilmering, 10. Justus of Ghent is also a candidate. On the problem of attribution, see Cheles, 35 n. 2.

31. From Cheles, 19–20, who favors this arrangement which he credits to Pasqual Rotondi.

32. Liebenwein, 96.

33. Raggio and Wilmering, 30.

34. Raggio and Wilmering, 31.

35. Raggio and Wilmering, 33.

36. For modern reconstructions of Isabella's rooms, see Cattaneo, 33.

37. Liebenwein, 113.

38. Verheyen 1971, 10.

39. Liebenwein, 119.

40. Verheyen 1971, 18.

41. Cox-Rearick 1984, 194. Further details in Sheard, caption to no. 14.

42. Verheyen 1971, 38.

43. Verheyen 1971, 120–23.

44. Castelli, 156–57.

45. Liebenwein, 117.

46. Battisti, 211–12.

47. The fullest treatment of Francesco and his studiolo is by Berti.

48. Quoted in Berti, 58; my translation.

49. Bardeschi, 15–16; my translation.

50. Battisti, 215.

51. Liebenwein, 157.

52. Liebenwein, 156.

53. Berti, 63.

54. Bardeschi, 17.

Chapter 6: Marvels of Art and Nature

1. Battisti, 124.

2. Massinelli & Tuena, 177.

3. Massinelli & Tuena, 22–23.

4. Dacos et al., 1973, 135.

5. Colonna 1499, fol. o3'; 1999, 222.

6. Heikamp & Grote, 52.

7. Heikamp & Grote, 53.

8. This is adapted from Heikamp & Grote, 26–30.

9. Wohl, 180.

10. Rinaldi, 174 n. 21.

11. Butters, 127.

12. Butters, 139.

13. Butters, 87; further details in Beyer & Boucher, 155.

14. Butters, 87–89.

15. Butters, 114.

16. Butters, 149.

17. Butters, 158, 206.

18. Butters, 298.

19. See Jansen.

20. Jansen, 135.

21. On Maximilian's collections, see Fučíková in *Rudolf II and Prague*, 8–13.

22. Lietzmann, 179.

23. Lietzmann, 180.

24. Jansen, 137.

25. See Lindell, 41.

26. Jansen, 180.

27. For descriptions of the Kaiserbrunnen, see Pechstein, and Smith, 206–9.

28. Date from Smith, 208; Pechstein gives 1578.

29. Smith, 209.

30. Pechstein, 235.

31. See Van der Boom in *Prag um 1600*.

32. Not Ottavio's sister Katerina, as some sources have it. See Jansen in *Prag um 1600*, 132.

33. Smith, 235–37.

34. This and the following paragraph are based on Hirn, I, 423–24.

35. Hirn, II, 443–45.

36. Hirn, II, 513.

37. Hirn, I, 364–65.

38. Hirn, II, 475.

39. Hirn, II, 512.

40. Hirn, II, 489.

41. Zangheri in Mosser & Teyssot, 67 n. 4.

42. Hirn, II, 434.

43. Hirn, I, 440–41.

44. On the Ambras Kunstkammer, see Scheicher et al., 1977; Scheicher 1979; Arthaud, 137–51.

45. Bredekamp 1993.

46. *Asclepius* 24.

47. See especially Yates, ch. 2, "John Dee and Vitruvius."

48. *Allgemeine deutsche Biographie*, VI, 697.

49. For what follows, see Hirn, I, 514–17.

50. According to Dauxois, 126.

51. See illustration of the investiture in Hausenblasová & Šroněk, 138–39.

52. This process began in 1973, with the publication of Evans's book on Rudolf II.

53. Commemorated in *Rudolf II and Prague*.

54. See Fučíková in *Prag um 1600*.

55. Located and described by Bukovinská in *Rudolf II and Prague*, 200. Hausenblasová & Šroněk, 175, de-

scribe a somewhat different arrangement.

56. Bukovinská, 203.

57. Findlen in *Rudolf II and Prague*, 212.

58. Findlen, 211.

59. Findlen, 215.

60. Quoted in Findlen, 216.

61. This and the following observations from *Eros und Mythos*, 16–17.

Chapter 7: Grotesqueries

1. Dacos 1969, 4.

2. Dacos 1969, 60.

3. For analysis of these styles, see Dacos 1969, 62–78.

4. See Wohl, 136–37.

5. See Wells-Cole, 40–41.

6. Sheard, no. 123.

7. Edwards, 8, 13. The bathroom is illustrated in the exhibition catalogue *Quando gli dei si spogliano*.

8. Edwards, 28–30.

9. Edwards, 28, quoting the journal of Johannes Fichard.

10. Edwards, 76.

11. Edwards, 78.

12. Edwards, 35–38; Dacos 1969, 101.

13. Dacos 1969, 113.

14. Dacos 1969, 126.

15. Dacos 1969, 177.

16. Kretzulesco 1994. The chapter in question is "L'antro delle ninfe a Soragna," 135–73.

17. See *Soragna*, xiii.

18. Illustrated in Kretzulesco 1994, 146, 158.

19. Kretzulesco 1994, 162; my translation.

20. Kretzulesco 1994, 150.

21. Carrier, 31.

22. Carrier, 36.

23. Kemp, 179–80.

24. Levey, 164. See also Shapiro, I, 121ff., on the Amorino as *genius loci* or *lar*.

25. See Gazetti in *Zauber der Medusa*, 75.

26. *Hypnerotomachia*, fol. d8'; English translation, 72.

27. Sheard, commentary to no. 109.

28. See the interrelated articles collected in MacDougall, especially ch. 3, "Waterworks: Fountains, Nymphaea, and Grottoes," and the study of the whole topic by Naomi Miller.

29. Luchinat, 144–45.

30. Luchinat, 150.

31. Battisti, 69.

32. Lazzaro 1995; see also the extended study by Ballerini.

33. It is now in the museum above the temple.

34. Kretzulesco-Quaranta 1986, 277.

35. Dauxois, 209; my translation.

36. For recent technical and historical details, see Ballerini & Medri, 215–60, 294–96.

37. On Buontalenti and Francesco, see Andres, Hunisak, & Turner, II, 1125.

38. Medri in Ballerini & Medri, 215–16.

39. This and many other details from Gurrieri & Chatfield, 37–40.

40. Sometimes called *Theseus and Helen*.

41. Circa 1558; see Berti, 271.

42. Fagiolo, 139.

43. Fagiolo, 119.

44. An illustration is in Benzi & Montanaro, 276.

45. Author of *Le bellezze della città di Firenze*, 1591.

46. Medri, 223.

47. Medri, 224–25.

48. Medri, 226; my translation.

49. Quoted in Berti, 309.

50. Berti, pls. 11–12.

51. "How awesome is this place!" Genesis 28.17.

Chapter 8: Garden Magic

1. See Coffin 1960, 94–97, on the arguments for Ligorio as chief architect.

2. On this anti-classical figure, see Lazzaro in McHam 1998, 251.

3. Coffin 1960, 19.

4. Coffin 1960, 80n.

5. See Coffin 1960, 85–87.

6. Summarized from Coffin 1960, 63–64.

7. Coffin 1960, 81.

8. Kretzulesco 1986, 299; my translation.

9. Kretzulesco 1986, 304–5.

10. Kretzulesco 1986, 307.

11. Kretzulesco 1986, 308–10.

12. Kretzulesco 1986, 312.

13. Madonna, 194.

14. Madonna, 198–200.

15. Coffin 1960, 86–87.

16. Madonna, 208.

17. For a deeper study of all these gardens, see Lazzaro 1990.

18. Adorni in Mosser & Teyssot, 93.

19. Rainer Maria Rilke, *Sonnets to Orpheus*, II, 15.

20. The story is well told in Adorni, 94–95.

21. The following is derived from Perucca 1999. See also Perucca 1989.

22. See Coffin 1991, 124–25, Lazzaro 1990, 118–21.

23. Battisti, 143.

24. See Lazzaro 1990, 158–61.

25. See Wilson, 399–406.

26. Wilson, 404.

27. Perucca 1999.

28. He was abetted in these studies by Giovanni Drouet, a member of the papal Curia. See Perucca 1999.

29. Brunon, 171–72.

30. Battisti, 277.

31. See Berti, 93.

32. See Berti, 94–96 and the plan, fig. 97; Hunt 1986, 54.

33. Hunt 1986, 233, n. 17.

34. Berti, 99.

35. See Kaufmann.

36. The parallel was noticed at the time. See Berti, 104.

37. Berti, 94.

38. Berti, 101.

39. See Berti, 98.

40. Mentioned in Battisti, 260.

41. See Donelli.

42. See Pincas, 7.

43. Illustrated in de Caus 1620 but probably not built.

44. Quoted in Wilson, 401.

Chapter 9: Joyous Festivals

1. Mitchell 1986, 158, 197.

2. See Kipling, 71ff., 115ff., 23ff.

3. See Mitchell 1986, 7–8; Strong, 44–45.

4. Martindale, 50.

5. See Mitchell 1990, 13–14.

6. Described in Warburg, 91, 145.

7. Carew-Reid, 113.

8. See Carew-Reid, 118–26 for explicit exegesis.

9. Carew-Reid, 114.

10. Du Colombier, 104; Strong, 46.

11. Martindale, 101.

12. Mitchell 1986, 32–34.

13. Mitchell 1986, 34. See also Mitchell 1979, 119–20.

14. Mitchell 1979, 38.

15. On Charles V's Italian entries, see Mitchell 1986, 133–79; Jacquot, 427–33.

16. From a contemporary report, in Mitchell 1986, 162.

17. Jacquot, 457, 461.

18. Jacquot, 462.

19. Jacquot, 482.

20. Jacquot, 481.

21. See Minor & Mitchell, 97ff., for the text and music of this entertainment. Rousseau, 418–23, also contains colored recreations of the Muses' costumes by Mary Cobb Martin.

22. Rousseau, 420.

23. Minor & Mitchell, 142–43.

24. Rousseau, 419.

25. Rousseau, 421.

26. See especially Strong, 98–125.

27. See the statistics in Edgerton, 237–38.

28. For entertaining details, see Berti, 464–67.

29. Berti, 276.

30. Berti, 148.

31. Zangheri in Mosser & Teyssot, 59.

32. Berti, 279.

33. See Butters, I, 92

34. Berti, 166.

35. The following is summarized from Berti, 48–49; Bardeschi, 12, 25–28.

36. Berti, 148; my translation.

37. See "Beyond the Threshold of Sleep," in Evola et al. 2001, I, 152–55. Peter Kingsley's researches (see Kingsley) suggests an older tradition still.

38. See the account by Baccio Baldini (no connection with the fifteenth-century artist of the same name).

39. See Seznec, 235 n. 56.

40. Baldini, 5, 6; my translation.

41. Baldini, 131–32.

42. Strong, 52.

43. Hirn, I, 36–37.

44. Hirn, II, 478.

45. Hirn, II, 457–59.

46. See Scheicher in Hofmann, 89–90.

47. Hirn, II, 479–480.

48. The following is based on Mitchell 1990; see also Mitchell 1986, 189–96.

49. Mitchell 1990, 45.

50. Mitchell 1990, 43.

Chapter 10: The Roots of Opera

1. Pirrotta 1982, 10–11.

2. Povoledo, in Pirrotta 1982, 286–87.

3. Schröter, 120.

4. This gambit still amused Ferdinand of the Tirol in 1568. See Scheicher in Hofmann, 85.

5. Older authorities tend to give earlier dates, e.g. 1471 or 1472 in Worsthorne, 123.

6. Povoledo, in Pirrotta 1982, 285.

7. Pirrotta 1982, 15.

8. Wind, 163.

9. Donington, 32–33.

10. Sternfeld, 14.

11. See especially Sternfeld, 20–30.

12. Pirrotta 1982, 22.

13. Pirrotta 1982, 36 n. 84.

14. Ficino's hymns have been imaginatively recreated in a recording; see Bibliography under Voss.

15. Giovio, *Elogia*, Venice, 1546, quoted (in Latin) in Walker 1985, VII, 23 n. 21.

16. *Caephalo*, by Niccolò da Correggio. See Pirrotta 1982, 45–46.

17. Schröter, 119.

18. Pirrotta 1982, 42, n. 14.

19. Compare Alberich's three questions to Wotan in Wagner's *Götterdämmerung*.

20. Pirrotta 1982, 49–51.

21. See Povoledo, in Pirrotta 1982, 313–15.

22. H. M. Brown 88ff.; Minor & Mitchell, 245ff., 276ff., 297f., 317ff., 3342ff., 349ff.

23. Pirrotta 1982, 170–71.

24. Pirrotta 1982, 176–82.

25. Pirrotta 1982, 174–75.

26. H. M. Brown, 16ff.; see also Pirrotta 1982, 170; Sternfeld, 75; Donington, 49.

27. Pirrotta 1982, 188.

28. The song is transcribed in Pirrotta 1982, 204–5.

29. Newcomb, I, 33.

30. Pirrotta 1982, 206–7.

31. Pirrotta 1982, 207–10.

32. Transcribed with commentary in Walker 1963.

33. This is the subject of Howard Mayer Brown's study.

34. Saslow, 19.

35. Saslow, 36.

36. Palisca, 218.

37. For the contemporary bibliography, see Saslow, 4.

38. See illustrations of all of these in Blumenthal.

39. Donington, 53–61.

40. Donington, 49.

41. An anonymous, abridged French translation was published under his care in 1546.

42. See McGowan, 230–31.

43. What follows is based on Newcomb, I, 16–27.

44. Newcomb, I, 95–96.

45. Newcomb, I, 90–91.

46. See Palisca, 3–11.

47. See Palisca, 147.

48. Note the etymology of this word.

49. Donington, 88.

50. Saslow, 182.

51. Donington, 108.

52. Pirrotta 1982, 237.

53. Donington, 181.

54. Sternfeld, 25.

55. Hammond, 184.

Chapter 11: Versailles and After

1. Alleau, 126, 125.

2. Aercke, 177.

3. Kretzulesco 1986, 343, quoting Amédée René; my translation.

4. What follows is based on Aercke, 168–83.

5. Aercke, 178.

6. On the latter, see Donington, 303.

7. Aercke, 220–21, n. 105.

8. See Pincas, 260–61.

9. Beside Kretzulesco 1986, 346, see Alleau, 165 *et passim*.

10. Kretzulesco 1986, 346.

11. Kretzulesco 1986, 358.

12. See Berger, 11.

13. Pincas, 118.

14. Pincas, 102

15. Some sources attribute the grotto to Tethys, wife of Oceanus; others to Achilles's mother Thetis. The names sound identical in French.

16. Simone Hoog, commentary in Louis XIV, 75.

17. Pincas, 122.

18. E.g. Pincas, 119.

19. Alleau, 168

20. Alleau, 155.

21. See Van der Kemp, 42–61.

22. On the plan and its symbolism, see Pérouse de Montclos, 376–77.

23. On their dates and variations see Pincas, 30–31.

24. Louis XIV, 19–20.

25. Hoog, Introduction to Louis XIV, 15.

26. Lablaude, 99; Pincas, 174–79.

27. Berger, 39.

28. Berger, 36.

29. Louis XIV, 50–51.

30. Lablaude, 82.

31. See Berger, 45, on the three possible sources within the novel.

32. This was never illustrated. It was destroyed to build the Colonnade. See Lablaude, 76–77.

33. Lablaude, 7.

34. See Blunt, 146–51.

35. See Gastil in Hunt 1996 on these and other Masonic gardens.

36. Mitford, 105.

37. See Menzhausen.

38. Judging from the facsimile in Mallinger, 109.

39. Ragon, 70–71; my translation from the Italian version.

40. Presumably Ferdinando II, reg. 1621–70.

41. Ragon, 78.

42. The most relevant works of Corbin are listed in the Bibliography.

43. "General Introduction to the Philosophy and Works of Plato," in Plato, *Works,* I, p. liv.

44. Levey, 171.

45. Coomaraswamy, 101.

46. Guénon, 9–10

47. Evola 1995, 310.

48. Schuon, 88–89.

49. Burckhardt 1967, 153–54.

50. Burckhardt 1967, 143–44.

Bibliography

Adorni, Bruno, "The Villa Lante at Bagnaia," in Mosser & Teyssot, 91–95.

Aercke, Kristiaan P., *Gods of Play. Baroque Festive Performances as Rhetorical Discourses*, Albany: State University of New York Press, 1995 (Series: The Margins of Literature).

Alexander, Jonathan J. G., ed., *The Painted Page: Italian Renaissance Book Illumination 1450–1550*, Munich & New York: Prestel-Verlag, 1994.

Alleau, René, *Guide de Versailles mystérieux*, n.p.: Editions Tchou-Princesse, 1977 (Series: Les Guides Noirs).

Andres, Glenn, John M. Hunisak, A. Richard Turner, *The Art of Florence*, New York: Abbeville Press, 1988.

Architecture of Western Gardens, see Mosser & Teyssot.

Arcimboldi e l'arte delle meraviglie (texts by Jurgis Baltrusaitis, Maurizio Calvesi, Ester Coen, Francesco Porzio), Florence: Giunti Barbèra, 1987.

Art before the Iconoclasm, see Kloek et al.

Arthaud, Claude, *Enchanted Visions: Fantastic Houses and their Treasures*, New York: G. P. Putnam's Sons, 1972.

Artifici d'acque e giardini, see Ballerini & Medri.

Baldass, Peter von, Rupert Feuchtmüller, Wilhelm Mrazek, *Renaissance in Österreich,* Vienna & Hannover: Forum Verlag, 1966.

Baldini, Baccio, *La Mascherata della genealogia degl'iddei*, New York: Garland, 1976 (reprint of Florence, 1565).

Ballerini, Isabella Lapi, "Niccolò Tribolo e la Grotta degli Animali a Castello," in Ballerini & Medri, 268–83.

Ballerini, Isabella Lapi, & Litta Maria Medri, *Artifici d'acque e giardini. La cultura delle grotte e dei ninfei in Italia e in Europa*, Florence: Centro Di, 1999.

Bardeschi, Marco Dezzi, *Lo stanzino del principe in Palazzo Vecchio. I concetti, le immagini, il desiderio*, Florence: Le Lettere, 1988.

Baskins, Cristelle L., "Donatello's Bronze *David*: Grillanda, Goliath, Groom?" in *Studies in Iconography* 15 (1993), 113–34.

Battisti, Eugenio, *L'Antirinascimento. Fiaba, allegoria, automi, arte profana, astrologia, rationalismo architettonico: storia dell'anticlassicismo nel rinascimento* (1962), 2nd ed., Milan: Garzanti, 1989.

Bätzner, Mike, *Andrea Mantegna 1430/31–1506,* trans. Phyll Greenhead, Cologne: Könnemann, 1996.

Baum, Ph., *Schloss-Stern bei Prag*, Leipzig: E. A. Seemann, 1876.

Beccadelli, Antonio, *Antonio Beccadelli and the Hermaphrodite*, trans. Michael de Cossart, Liverpool: Janus Press, 1984.

Benzi, Fabio, & Caroline Vincenti Montanaro, *Palaces of Rome*, New York: Rizzoli, 1997.

Berger, Robert W., *In the Garden of the Sun King: Studies on the Park of Versailles under Louis XIV*, Washington: Dumbarton Oaks, 1985.

Berti, Luciano, *Il Principe dello Studiolo. Francesco I dei Medici e la fine del Rinascimento fiorentino*, Florence: Editrice Edam, 1967.

Beyer, Andreas, "Funktion und Repräsentation. Die Porphyr-Rotae der Medici," in Beyer & Boucher, 151–67.

Beyer, Andreas, & Bruce Boucher, eds., *Piero de' Medici "il Gottoso" (1416–1469)*, Berlin: Akademie Verlag, 1993.

Białostocki, Jan, *The Art of the Renaissance in Eastern Europe*, Ithaca: Cornell University Press, 1976.

Bila Hora/Weisser Berg, Prague: Olympia, n.d.

Blumenthal, Arthur R., *Theater Art of the Medici* (Exhibition catalogue), Dartmouth: University Press of New England, 1980.

Blunt, Wilfrid, *The Dream King. Ludwig II of Bavaria*, New York: Viking Press, 1970.

Bredekamp, Horst, *Antikensehnsucht und Maschinenglauben*, Berlin: Klaus Wagenbach, 1993.

———, *Vicino Orsini und der Heilige Wald von Bomarzo. Ein Fürst als Künstler und Anarchist*, 2 vols., Worms: Werner'sche Verlagsgesellschaft, 1985 (Series "Grüne Reihe").

Brockhaus, Heinrich, "Ein edles Geduldspiel: 'Die Leitung der Welt oder die Himmelsleiter' die

sogenannte Taroks Mantegnas vom Jahre 1459–60," *Miscellanea di storia dell'arte in onore di J. B. Sarpino,* Florence, 1933, 397–416.

Brown, Howard Mayer, *Sixteenth-Century Instrumentation: The Music for the Florentine Intermedii,* n.p.: American Institute of Musicology, 1973 (Musicological Studies & Documents, 30).

Brown, Patricia Fortini, *Venice and Antiquity: The Venetian Sense of the Past,* New Haven: Yale University Press, 1996.

Brunon, Hervé, "L'artifice animé: sur l'esthétique maniériste de l'automate," in Ballerini & Medri, 164–79.

Bukovinská, Beket, "The *Kunstkammer* of Rudolf II: Where it Was and What It Looked Like," in *Rudolf II and Prague,* 199–208.

Burckhardt, Titus, *Siena, the City of the Virgin,* trans. Margaret McDonough Brown, London: Oxford University Press, 1960.

—————, *Sacred Art in East and West: Its Principles and Methods,* trans. Lord Northbourne, London: Perennial Books, 1967.

Butters, Suzanne B., *The Triumph of Vulcan: Sculptors' Tools, Porphyry, and the Prince in Ducal Florence,* 2 vols., Florence: Olschki, 1996.

Calvesi, Maurizio, "Le fonti dell'Arcimboldi e il verde sogno di Polifilo," in *Arcimboldi e l'arte delle meraviglie,* 38–51.

—————, *La "pugna d'amore in sogno" di Francesco Colonna Romano,* Rome: Lithos, 1996.

Campbell, Stephen J., *Cosimo Tura of Ferrara,* New Haven: Yale University Press, 1998.

Cappelle del rinascimento a Firenze, Florence: Editore Becocci, 1998.

Carew-Reid, Nicole, *Les Fêtes Florentines au temps de Lorenzo il Magnifico,* Florence: Leo S. Olschki, 1995.

Carrier, David, *Principles of Art-History Writing,* n.p.: Pennsylvania State University Press, 1991.

Castelli, Patrizia, "L'antro delle Ninfe," in Ballerini & Medri, 153–63.

Cattaneo Fiorenzo, ed., *Roomscapes: The Decorative Architecture of Renzo Mongiardino,* New York: Rizzoli, 1993.

Caus, Salomon de, *Hortus Palatinus,* Frankfurt, de Bry, 1620.

Caus, Salomon de, *La raison des forces mouvantes,* Frankfurt, de Bry, 1615.

Cavalli-Björkman, Görel, "Mythologische Themen am Hofe des Kaisers," in *Prag um 1600,* I, 61–68.

—————, *Netherlandish Mannerism: Papers Given at a Symposium in Nationalmuseum Stockholm, September 21–22, 1984,* Stockholm: Nationalmuseum, 1985.

Chambers, David, & Jane Martineau, eds., *Splendours of the Gonzaga: Catalogue,* London: Victoria & Albert Museum; Milan: Amilcare Pizzi, 1981.

Cheles, Luciano, *The Studiolo of Urbino: An Iconographic Investigation,* Wiesbaden: Ludwig Reichart Verlag, 1986.

Clark, Kenneth, *The Nude* [1956], Harmondsworth: Penguin Books, 1976.

Coffin, David R., *Gardens and Gardening in Papal Rome,* Princeton: Princeton University Press, 1991.

—————, *The Villa d'Este at Tivoli,* Princeton: Princeton University Press, 1960.

Colonna, Francesco, *Hypnerotomachia Poliphili: The Strife of Love in a Dream,* trans. Joscelyn Godwin, London & New York: Thames & Hudson, 1999.

Colvin, Sydney, ed., *A Florentine Picture-Chronicle; Being a Series of Ninety-Nine Drawings Representing Scenes and Personages of Ancient History, Sacred and Profane, by Maso Finiguerra . . .* London: Quaritch, 1898.

Coomaraswamy, Ananda K., "Introduction to the Art of Eastern Asia" [1932], in *Selected Papers: Traditional Art and Symbolism,* ed. Roger Lipsey, Princeton: Princeton University Press, 1977, 101–24 (Bollingen Series LXXXIX).

Corbin, Henry, *Creative Imagination in the Sufism of Ibn 'Arabi,* trans. Ralph Manheim, Princeton: Princeton University Press, 1969 (Bollingen Series XCI).

—————, *Spiritual Body and Celestial Earth: From Mazdean Iran to Shi'ite Iran,* trans. Nancy Pearson, Princeton: Princeton University Press, 1977 (Bollingen Series XCI:2).

Cosmo incantato di Schifanoia, see Fratucello & Knorr.

Cox-Rearick, Janet, *Dynasty and Destiny in Medici Art: Pontormo, Leo X, and the Two Cosimos,* Princeton: Princeton University Press, 1984.

—————, *The Collection of Francis I: Royal Treasures,* Antwerp: Fonds Mercator, 1995.

Cumont, Franz, *Lux Perpetua,* Paris: Gunther, 1949.

Dacos, Nicole, Antonio Giuliano, Ulrico Pannuti, eds., *Il Tesoro di Lorenzo il Magnifico. I: Le gemme* (Exhibition catalogue), Florence: Sansoni Editore, 1973.

Dacos, Nicole, *La découverte de la Domus Aurea et la formation des grotesques à la Renaissance*, London: Warburg Institute; Leiden: E. J. Brill, 1969 (Studies of the Warburg Institute, vol. 31).

D'Ancona, Paolo, *The Schifanoia Months at Ferrara*, trans. Lucia Krasnik, Milan: Edizioni del Milione, 1954.

Darnall, Margaretta J., & Mark S. Weil, "Il Sacro Bosco di Bomarzo: Its Sixteenth-century Literary and Antiquarian Context," in *Journal of Garden History* 4/1 (1984).

Dauxois, Jacqueline, *L'Empereur des alchimistes: Rodophe II de Habsbourg*, n.p.: J. C. Lattès, 1996.

Decker, Ronald, Thierry Depauls, Michael Dummett, *A Wicked Pack of Cards: The Origin of the Occult Tarot*, New York: St. Martin's Press, 1996.

Di Cesare, Mario A., ed., *The Renaissance Reconsidered*, Binghamton: Center for Medieval and Early Renaissance Studies, 1992.

Donelli, Simona Antellini ed., *La Fontana dell'Organo nei Giardini del Quirinale: Nascita, storia e trasformazioni*, Rome: Fratelli Palombi, 1995.

Donington, Robert, *The Rise of Opera*, New York: Scribner's Sons, 1981.

Du Colombier, Pierre, "Les triomphes en images de l'empereur Maximilien I," in Jacquot, 99–112.

Early Italian Engravings, see Levenson.

Edgerton, Samuel Y., *Pictures and Punishment*, Ithaca: Cornell University Press, 1985.

Edwards, Nancy Elizabeth, "The Renaissance 'Stufetta' in Rome: The Circle of Raphael and the Recreation of the Antique," Ph.D. diss., University of Minnesota, 1983.

Eros und Mythos, Begleitheft zur Ausstellung des Kunsthistorischen Museums, Vienna: Kunsthistorisches Museum, 1995.

Evans, R. W. J., *Rudolf II and His World*, Oxford: Oxford University Press, 1973.

Evola, Julius, and the UR Group, *Introduction to Magic*, trans. Guido Stucco, Rochester: Inner Traditions International, 2001.

Evola, Julius, *Revolt Against the Modern World*, trans. Guido Stucco, Rochester: Inner Traditions International, 1995.

Fagiolo, Marcello, ed., *Natura e artificio. L'ordine rustico, le fontane, gli automi nella cultura del Manierismo europeo*, Rome: Officina Edizioni, 1979.

Farago, Claire, ed., *Reframing the Renaissance: Visual Culture in Europe and Latin America 1450–1650*, New Haven: Yale University Press, 1995.

Febvre, Lucien, *The Problem of Unbelief in the Sixteenth Century: The Religion of Rabelais*, trans. Beatrice Gottlieb, Cambridge: Harvard University Press, 1982.

Fêtes et cérémonies au temps de Charles Quint, see Jacquot.

Findlen, Paula,"Cabinets, Collecting, and Natural Philosophy," in *Rudolf II and Prague*, 209–19.

Flade, Helmut, *Intarsia: Europäische Einlegekunst aus sechs Jahrhunderten*, Munich: C. H. Beck, 1986.

Fratucello, Cinzia, & Christina Knorr, *Il Cosmo incantato di Schifanoia: Aby Warburg e la storia delle immagini astrologiche* (Exhibition catalogue), Ferrara: Palazzo Schifanoia, 1998.

Fučíková, Eliška, "Prague Castle under Rudolf II, His Predecessors and Successors, 1530–1648," in *Rudolf II and Prague*, 2–71.

——————, "Zur Konzeption der rudolfinischen Sammlungen," in *Prag um 1600*, II, 59–62.

Für Aug' und Ohr, see Seipel.

Gastil, Raymond W., "Jappelli's Gardens: 'In Dreams begin Responsibilities'," in Hunt 1996, 274–301.

Gazetti, Maria, "Lascivia oder das Ende Arkadiens," in Hofmann, 72–80.

Gersh, Stephen, *Neoplatonism and Middle Platonism: The Latin Tradition*, 2 vols., Notre Dame: University of Notre Dame Press, 1986 (Publications in Medieval Studies, no. 23).

Giovannoni, Giannino, *Mantova e i tarocchi del Mantegna*, Mantua: Casa del Mantegna, 1981.

Goldschmidt, Ernst Philip, *The Printed Book of the Renaissance: Three Lectures on Type, Illustration, Ornament*, Cambridge: Cambridge University Press, 1950.

Greenhalgh, Michael, *Donatello and His Sources*, New York: Holmes & Meier, 1982.

Guénon, René, *The Crisis of the Modern World*, trans. Marco Pallis and Richard Nicholson, London: Luzac, 1962.

Gundersheimer, Werner L., *Ferrara: The Style of a Renaissance Despotism*, Princeton: Princeton University

Press, 1973.

Gurrieri, Francesco, & Judith Chatfield, *Boboli Gardens*, Florence: Editrice Edam, 1972.

Hammond, Frederick, *Music and Spectacle in Baroque Rome*, New Haven: Yale University Press, 1994.

Hartt, Frederick, *Giulio Romano*, New Haven: Yale University Press, 1958.

Hausenblasová, Jaroslava, & Michal Šroněk, *Urbs Aurea: Prague of Emperor Rudolf II*, [Prague]: Gallery, 1997.

Heikamp, Detlef, & Andreas Grote, *Il tesoro di Lorenzo il Magnifico II. I vasi*, Florence: Sansoni, 1974.

Hirn, Joseph, *Erzherzog Ferdinand II. von Tirol: Geschichte seiner Regierung und seiner Länder*, 2 vols., Innsbruck: Wagner'schen Universitäts-Buchhandlung, 1880.

Hofmann, Werner, ed., *Zauber der Medusa: Europäische Manierismen*, Vienna: Löcker Verlag, 1987.

Hunt, John Dixon, ed., *The Italian Garden: Art, Design and Culture*, Cambridge: Cambridge University Press, 1996.

——————, *Garden and Grove: The Italian Renaissance Garden in the English Imagination, 1600–1750*, Princeton: Princeton University Press, 1986.

Italian Garden, The, see Hunt 1996.

Jacquot, Jean, "Panorama des fêtes et cérémonies du règne. Evolution des thèmes et des styles," in Jacquot, 413–91.

——————, ed., *Fêtes et cérémonies au temps de Charles Quint*, Paris: Centre National de la Recherche Scientifique, 1960 (Les Fêtes de la Renaissance, II).

Jansen, Dirk Jacob, "Example and Exemplar: The Potential Influence of Jacopo Strada on the Development of Rudolphine Art," in *Prag um 1600*, II, 132–46.

Kaufmann, Thomas Da Costa, "'*Gar lecherlich*': Low-Life Painting in Rudolfine Prague," in *Prag um 1600*, II, 33–38.

Kemp, Martin, "'Wrought by No Artist's Hand': The Natural, the Artificial, the Exotic, and the Scientific in Some Artifacts from the Renaissance," in Farago, 176–96.

Kingsley, Peter, *In the Dark Places of Wisdom*, Inverness: Golden Sufi Center, 1999.

Kipling, Gordon, *Enter the King: Theatre, Liturgy, and Ritual in the Medieval Civic Triumph*, Oxford: Clarendon Press, 1998.

Kloek, W. Th., W. Halsema-Kubes, R. J. Baarsen, *Art Before the Iconoclasm: Northern Netherlandish Art 1525–1580*, trans. Patricia Wardle, Amsterdam: Rijksmuseum, 1986.

Klossowski, Pierre, *Diana at Her Bath: The Women of Rome*, trans. Stephen Sartarelli & Sophie Hawkes, Boston: Eridanos Press, 1990.

Krautheimer, Richard, *Lorenzo Ghiberti*, Princeton: Princeton University Press, 1956.

Kretzulesco, Nicola & Emanuela Kretzulesco, *Giardini misterici: Simboli, Enigmi, dall'Antichità al Novecento*, Parma: Silva Editore, 1994.

Kretzulesco-Quaranta, Emanuela, *Les jardins du songe: Poliphile et la mystique de la renaissance*, 2nd ed., Paris: Les Belles Lettres, 1986.

Lablaude, Pierre-André, *The Gardens of Versailles*, trans. Fiona Biddulph, London: Zwemmer, 1995.

Lazzaro, Claudia, "Animals as Cardinal Signs: A Medici Menagerie in the Grotto at Castello," in Farago, 197–228.

——————, "Gendered Nature and its Representation in Sixteenth-Century Garden Sculpture," in McHam 1998, 246–73.

——————, *The Italian Renaissance Garden: From the Conventions of Planting, Design, and Ornament to the Grand Gardens of Sixteenth-Century Italy*, New Haven & London: Yale University Press, 1990.

Lefaivre, Lianne, *Leon Battista Alberti's* Hypnerotomachia Poliphili: *Re-Cognizing the Architectural Body in the Early Italian Renaissance*, Cambridge: M.I.T. Press, 1997.

Lensi Orlandi, Giulio Cesare, "La grande opera in Palazzo Vecchio," in Bardeschi, 72–85.

——————, *Il Palazzo Vecchio di Firenze*, Florence: Martello-Giunti, 1977.

Levenson, Jay A., Konrad Oberhuber, Jaquelyn L. Sheehan, *Early Italian Engravings from the National Gallery of Art*, Washington: National Gallery of Art, 1973.

Levey, Michael, *Early Renaissance*, Harmondsworth: Penguin Books, 1967.

Liebenwein, Wolfgang, *Studiolo: Die Entstehung eines Raumtyps und seine Entwicklung bis um 1600*, Berlin: Gebr. Mann Verlag, 1977 (Frankfurter Forschungen zur Kunst, Bd. 6).

Lietzmann, Hilda, "Das Neugebäude und Böhmen," in *Prag um 1600*, II, 176–82.

Lindell, Robert, "Von den Niederländern zu den Italianern," in Seipel, 39–43.

Looking at Italian Renaissance Sculpture, see McHam 1998.

Louis XIV, *Manière de montrer les jardins de Versailles*, ed. Simone Hoog, Paris: Réunion des Musées nationaux, 1992.

Luchinat, Cristina Acidini, "Rappresentazione della natura e indagine scientifica nelle grotte cinquencentesche," in Fagiolo, 142–52.

MacDougall, Elisabeth B., *Fountains, Statues, and Flowers: Studies in Italian Gardens of the Sixteenth and Seventeenth Centuries*, Washington: Dumbarton Oaks Research Library and Collection, 1994.

Madonna, Maria Luisa, "Il Genius Loci di Villa d'Este: Miti e misteri nel sistema di Pirro Ligorio," in Fagiolo, 190–213.

Magoni, Gianluigi, *Le cose non dette sui Decani di Schifanoia: una lettura astronomica*, Ferrara: Corbo Editore, 1997 (Supplement to vol. 73 of "Atti dell'Accademia delle Scienze di Ferrara").

Mallinger, Jean, "Storia segreta dell'ordine dei pitagorici," in *Politica Romana* 2 (1995), 109–19.

Martindale, Andrew, *The Triumphs of Caesar by Andrea Mantegna in the Collection of Her Majesty the Queen at Hampton Court*, London: Harvey Miller, 1979.

Massinelli, Anna Maria, & Filippo Tuena, *Treasures of the Medici*, New York: Vendome Press, 1992.

McGowan, Margaret M., *Ideal Forms in the Age of Ronsard*, Berkeley: University of California Press, 1985.

McHam, Sarah Blake, *The Chapel of St. Anthony at the Santo and the Development of Venetian Renaissance Sculpture*, Cambridge: Cambridge University Press, 1994.

——————, ed., *Looking at Italian Renaissance Sculpture*, Cambridge: Cambridge University Press, 1998.

Medri, Litta Maria, "Considerazioni intorno alle prime fasi costruttive della Grotta Grande nel Giardino di Boboli," in Ballerini & Medri, 215–27.

Menzhausen, Joachim, *The Green Vaults*, Leipzig: Edition Leipzig, 1970.

Miller, Naomi, *Heavenly Caves: Reflections on the Garden Grotto*, New York: George Braziller, 1982.

Minor, Andrew C., & Bonner Mitchell, *A Renaissance Entertainment: Festivities for the Marriage of Cosimo I, Duke of Florence, in 1539*, Columbia: University of Missouri Press, 1968.

Mitchell, Bonner, *1598: A Year of Pageantry in Late Renaissance Ferrara*, Binghamton: State University of New York, 1990 (Medieval & Renaissance Texts & Studies, 71).

——————, *Italian Civic Pageantry in the High Renaissance: A Descriptive Bibliography of Triumphal Entries and Selected Other Festivals for State Occasions*, Florence: Leo S. Olschki, 1979 (Biblioteca di Bibliografia Italiana, LXXXIX).

——————, *The Majesty of the State: Triumphal Progresses of Foreign Sovereigns in Renaissance Italy (1494–1600)*, Florence: Leo S. Olschki, 1986 (Biblioteca dell' "Archivum Romanicum" I/203).

Mitford, Nancy, *The Sun King*, New York: Harper & Row, 1966.

Mori, Gioia, *Arte e astrologia*, Florence: Giunti Barbèra, 1987 (Art Dossier, no. 10).

Mosser, Monique, & Georges Teyssot, eds., *The Architecture of Western Gardens: A Design History from the Renaissance to the Present Day*, Cambridge: M.I.T. Press, 1991.

Natura e artificio, see Fagiolo.

Newcomb, Anthony, *The Madrigal at Ferrara, 1579–1597*, 2 vols., Princeton: Princeton University Press, 1980.

Nicholas of Cusa, *De Ludo Globi. The Game of Spheres*, trans. and intro. by Pauline Moffitt Watts, New York: Abaris Books, 1986.

Palermino, Richard J., "The Roman Academy, the Catacombs and the Conspiracy of 1468," in *Archivium historiae pontificae* 18 (1980), 117–55.

Palisca, Claude V., ed., *The Florentine Camerata: Documentary Studies and Translations*, New Haven: Yale University Press, 1989.

Panek, Jaroslav, "The Nobility in the Czech Lands, 1550–1650," in *Rudolf II and Prague*, 270–86.

Pechstein, Klaus, "Kaiser Rudolf II. und die Nürnberger Goldschmiedekunst," in *Prag um 1600*, I, 232–48.

Pernis, Maria Grazia, & Laurie Schneider Adams, *Federico da Montefeltro and Sigismondo Malatesta: The Eagle and the Elephant*, New York: Peter Lang, 1996 (Studies in Italian Culture: Literature in History, vol. 20).

Pérouse de Montclos, Jean-Marie, *Versailles*, New York: Abbeville, 1991.

Perucca, Mariella, "Giulia Farnese Orsini sposa di Vicino," in *Viterbo delle delizie*, Milan: Franco Maria Ricci, 1989.

—————, Text of Exhibition in Palazzo Orsini, Bomarzo, 1999.

Phillips, John Goldsmith, *Early Florentine Designers and Engravers: Maso Finiguerra, Baccio Baldini, Antonio Pollaiuolo, Sandro Botticelli [and] Francesco Rosselli. A Comparative Analysis of Early Florentine Nielli, Intarsias, Drawings, and Copperplate Engravings*, Cambridge: Harvard University Press, 1955.

Piero de' Medici, see Beyer & Boucher.

Pimandro di Mercurio Trimegisto, Il, trans. Tommaso Benci, Florence: C. Lenzoni, 1548.

Pincas, Stéphane, *Versailles: The History of the Gardens and Their Sculpture*, trans. Fiona Cowell, London: Thames & Hudson, 1996.

Pirrotta, Nino, & Elena Povoledo, *Music and Theatre from Poliziano to Monteverdi*, trans. Karen Eales, Cambridge: Cambridge University Press, 1982.

Pirrotta, Nino, *Music and Culture in Italy from the Middle Ages to the Baroque: A Collection of Essays*, Cambridge: Harvard University Press, 1984.

Plato, *Works*, trans. Thomas Taylor, London: T. Taylor, 1804.

Portoghesi, Paolo, *Il Tempio Malatestiano*, n.p.: Sadea/Sansoni Editore, n.d.

Prag um 1600: Beiträge zur Kunst und Kultur am Hofe Rudolf II, 2 vols., Freren: Luca Verlag, 1988.

Praz, Mario, "The Gonzaga Devices," in Chambers & Martineau, 64–72.

Puppi, Lionello, "Nature and Artifice in the Sixteenth-Century Italian Garden," in Mosser & Teyssot, 47–58.

Quando gli dei si spogliano: Il bagno di Clemente VII a Castel Sant'Angelo e le altre stufe romane del primo Cinquecento (Exhibition catalogue), Rome: Societa Editrice, 1984.

Raggio, Olga, & Antoine M. Wilmering, *The Liberal Arts Studiolo from the Ducal Palace at Gubbio*, New York: Metropolitan Museum of Art, 1996.

Ragon, J. M., "Notizia storica sui pednosofi (figli della sapienza) e sulla Tabaccologia, ultimo velo della dottrina pitagorica," in *Politica Romana* I (1994), 69–81. First published 1859.

Raine, Kathleen & George Mills Harper, eds., *Thomas Taylor, the Platonist: Selected Writings*, Princeton: Princeton University Press, 1969.

Reframing the Renaissance, see Farago.

Rinaldi, Alessandro, "La ricerca della 'terza natura': artificialia e naturalia nel giardino toscano del '500," in Fagiolo, 154–75.

Rousseau, Claudia, "The Pageant of the Muses at the Medici Wedding of 1539 and the Decoration of the Salone dei Cinquecento," in *Theatrical Spectacle and Spectacular Theatre*, 416–57.

Rudolf II and Prague: The Imperial Court and Residential City as the Cultural and Spiritual Heart of Central Europe, Prague, London, Milan: Prague Castle Administration, Thames & Hudson, Skira, 1997.

Sabbadini, Remigio, *Biografia documentata di Giovanni Aurispa*, Noto: Fr. Zammit, 1890.

Saslow, James M., *The Medici Wedding of 1589: Florentine Festival as Theatrum Mundi*, New Haven: Yale University Press, 1996.

Scheicher, Elizabeth, "Höfische Feste," in Hofmann, 81–90.

—————, *Die Kunst- und Wunderkammer der Hapsburger*, Vienna: Molden-Edition, 1979.

—————, et al., *Kunsthistorisches Museum. Sammlungen Schloss Ambras: Die Kunstkammer*, Innsbruck: Kunsthistorisches Museum, 1977.

Scholem, Gershom, *Kabbalah*, Jerusalem: Keter Publishing House, 1974.

Schröter, Elisabeth, *Die Ikonographie des Themas Parnass vor Raffael: Die Schrift- und Bildtraditionen von der Spätantike bis zum 15. Jht.*, Hildesheim & New York: Georg Olms, 1977 (Studien zur Kunstgeschichte 6).

Schultz, Anne Markham, *The Sculpture of Bernardo Rossellino and His Workshop*, Princeton: Princeton University Press, 1977.

Schuon, Frithjof, *The Transcendent Unity of Religions*, trans. Peter Townsend, London: Faber & Faber, 1953.

Seipel, Wolfgang, ed., *Für Aug' und Ohr. Musik in Kunst- und Wunderkammern*, Milan: Skira; Vienna: Kunsthistorisches Museum, 1999.

Seznec, Jean, *The Survival of the Pagan Gods: The Mytho-*

logical Tradition and its Place in Renaissance Humanism and Art, trans. Barbara F. Sessions, New York: Pantheon Books, 1953.

Shapiro, Maurice L., "Studies in the Iconology of the Sculptures in the Tempio Malatestiano," 2 vols., Ph.D. diss., New York University, 1958.

Sheard, Wendy Steadman, curator, Antiquity in the Renaissance (Exhibition catalogue), Northampton: The Smith College Museum of Art, 1979.

Signorini, Rodolfo, Lo Zodiaco di Palazzo d'Arco in Mantova, Mantua: Amministrazione Provinciale di Mantova, 1989.

Simons, Madelon, "King Ferdinand I of Bohemia, Archduke Ferdinand II and the Prague Court, 1527–1567," in Rudolf II and Prague, 80–89.

Smith, Jeffrey Chipps, German Sculpture of the Later Renaissance, circa 1520–1580: Art in an Age of Uncertainty, Princeton: Princeton University Press, 1994.

Soragna, 2nd enlarged ed., Milan: Franco Maria Ricci, 1999 (Series: Grand Tour 8).

Splendours of the Gonzaga, see Chambers & Martineau.

Stejskal, Martin, Hvězda, Prague: Volvox Globator, 1994.

Sternfeld, F. W., The Birth of Opera, Oxford: Clarendon Press, 1993.

Stokes, Adrian, The Stones of Rimini, New York: G. P. Putnam's Sons, 1934.

Strong, Roy, Art and Power: Renaissance Festivals 1450–1650, Berkeley & Los Angeles: University of California Press, 1984.

Tarocchi detti del Mantegna, I, pref. Claudia Cieri Via, nota iconografica by Elena Calandra, Pavia: Edizioni Tarchio de' Ricci, 1992.

Theatrical Spectacle and Spectacular Theatre, see Wisch & Munshower.

Thomas Taylor, the Platonist, see Raine & Harper.

Thornton, Dora, The Scholar in His Study: Ownership and Experience in Renaissance Italy, New Haven: Yale University Press, 1997.

Triumphal Celebrations and the Rituals of Statecraft, see Wisch & Munshower.

Van der Boom, Annemarie C., "Tra Principi e Imprese: The Life and Works of Ottavio Strada," in Prag um 1600, II, 19–23.

Van der Kemp, Gérald, Versailles, new ed., New York: Park Lane, 1981.

Vasari, Giorgio, Le Opere con nuove annotazioni e commenti, ed. Gaetano Milanesi, Florence: Sansoni, 1906; reprinted ibid., 1981.

Verheyen, Egon, The Paintings in the Studiolo of Isabella d'Este at Mantua, New York: New York University Press, 1971.

Voss, Angela ["programme devised and researched by"], Secrets of the Heavens: Seven Hymns of Orpheus to the Planetary Gods . . . , Compact Disk recording, Potton: Riverrun Records, 2000 (RVRCD53).

Walker, D. P., ed. Les Fêtes de Florence (1589): Musique des Intermèdes de "La pellegrina", Paris: CNRS, 1963 (Series: Le Choeur des Muses).

—————, Music, Spirit, and Language in the Renaissance, ed. Penelope Gouk, London: Variorum Reprints, 1985.

—————, Spiritual and Demonic Magic from Ficino to Campanella, Notre Dame: University of Notre Dame Press, 1975 (first ed., 1958).

Warburg, Aby, Gesammelte Schriften, Leipzig: Teubner, 1932.

Wells-Cole, Anthony, Art and Decoration in Elizabethan and Jacobean England. New Haven: Yale University Press, 1997.

Westfehling, Uwe, "Tarocchi" Menschenwelt und Kosmos: Ladenspelder, Dürer und die "Tarocchi-Karten des Mantegna" (Exhibition catalogue), Cologne: Wallraf-Richartz Museum, 1988.

Wilson, Peter Lamborn, "Oneiriconographia: Entering Poliphilo's Utopian Dreamscape—A Review Essay," in Alexandria 5 (2000), 399–449.

Wind, Edgar, Pagan Mysteries in the Renaissance, new and enlarged ed., London: Faber & Faber, 1968.

Wisch, Barbara, & Susan Scott Munshower, eds., Theatrical Spectacle and Spectacular Theatre, University Park: Department of Art History of the Pennsylvania State University, 1990 (Papers in Art History from The Pennsylvania State University, VI/2).

—————, Triumphal Celebrations and the Rituals of Statecraft, University Park: Department of Art History of the Pennsylvania State University, 1990 (Papers in Art History from The Pennsylvania State University, VI/1).

Wohl, Hellmut, *The Aesthetics of Italian Renaissance Art: A Reconsideration of Style,* Cambridge: Cambridge University Press, 1999.

Worsthorne, Simon Towneley, *Venetian Opera in the Seventeenth Century*, Oxford: Clarendon Press, 1954.

Yates, Frances A., *Theatre of the World*, Chicago: University of Chicago Press, 1963.

Zangheri, Luigi, "Curiosities and Marvels of the Sixteenth Century Garden," in Mosser & Teyssot, 59–68.

Zauber der Medusa, see Hofmann.

Sources of Illustrations

Arcimboldi e l'arte delle meraviglie, 1998: 112

Author's photographs (all rights reserved): 10, 11, 39, 41, 69, 70, 73, 91, 110, 111, 127, 128a, 153, 157, 158, 159b, 164, 167, 168, 170, 171, 196

P. Baum, *Schloss Stern bei Prag*, c. 1900: 81, 82

Bernard Berenson, *The Italian Painters of the Renaissance*, 1952: 205, 210, 218

Luciano Berti, *Il Principe dello Studiolo*, 1967: 16b, 101, 103, 104, 105

Wilhelm Bode, *Die italienischen Bronzestatuetten der Renaissance*, 1907: 140

Arthur T. Bolton, *The Gardens of Italy*, 1919: 143, 144, 145, 149, 150, 151, 154, 155, 156, 159a, 161, 169, 175

D. Ž. Bor, *Napříč Říší Královského Umění*, 1995: 201

Tancred Borenius, *Four Early Italian Engravers*, 1923: 9, 130, 139b

Jacob Burckhardt, *The Civilization of the Renaissance in Italy*, 1938: 40a, 64, 100b, 183, 186, 187

Enzo Carli, *Luca Signorelli, gli affreschi nel duomo di Orvieto*, 1946: 129a

Salomon de Caus, *Les raisons des forces mouvantes*, 1615: 163; *Hortus Palatinus*, 1620: 142, 176

Karl Chytil, *Die Kunst in Prag zur Zeit Rudolf II*, 1904: 79, 124, 125

Francesco Colonna, *Hypnerotomachia Poliphili*, 1499, 1546: 24, 25, 26, 29, 30, 31, 33, 34, 35

Sidney Colvin, *A Florentine Picture Chronicle*, 1898: 53, 54, 55, 56, 58, 136, 160, 182

G. Fattorusso, *Wonders of Italy*, 1930: 109, 129

Richard Hamann, *Frührenaissance der italienischen Malerei*, 1909: 60, 88, 128b, 184, 207

Charles Hare, *The Romance of a Mediaeval Warrior*, 1910: 195

Italian Interiors of the Renaissance, n.d.: 66, 76

Jaroslava Hausenblasová & Michal Šroněk, *Urbs Aurea*, 1997: 114

Arthur M. Hind, *Early Italian Engraving*, 1938: 185

Jean Jacquot, *Fêtes et cérémonies au temps de Charles Quint*, 1960: 189, 191

Georg Kinsky, *History of Music in Pictures*, 1930: 192, 206, 221, 222, 224, 225, 227, 228

Athanasius Kircher, *Musurgia Universalis*, 1650: 179

Barney Kirchhoff, *Castles in Germany*, 1967: 180, 245, 246, 247

George Kowdezyk, *Decorative Sculpture*, 1927: 6a

Kretzulesco, Nicola & Emanuela, *Giardini misterici*, 1994: 133

Kristeller, Paul, *Die Tarocchi*, 1910: 46, 47, 48, 49, 50

Le nozze di Costanzo Sforza, 1946: 204

Le Nu féminin dans l'art, n.d.: 4a

Alfred Marie, *Naissance de Versailles*, 1968: 231, 232, 234, 236, 237, 238, 239, 240, 241, 242, 243

Arthur McComb, *Agnolo Bronzino*, 1928: 100a

Metropolitan Museum of Art, New York: 95

Muccini, Ugo, *Stanze del principe in Palazzo vecchio*, 1991: 77

Philadelphia Museum of Art: vi

Pierpont Morgan Library, New York: 137

Propyläen Kunstgeschichte, 1923–28: 4b, 5, 7, 8, 14, 15, 16a, 62, 74, 86, 90, 96, 97, 102, 113, 122, 131, 139a, 199

Agostino Ramelli, *Le diverse e artificiose machine*, 1588: 177

Corrado Ricci, *Il Tempio Malatestiano*, c.1920: 40b, 42, 43, 44

Scala / Art Resource: 93

Julius Schlosser, *Die Kunst- und Wunderkammer der Spätrenaissance*, 1908: 115, 116, 117, 118, 119, 120, 121, 126, 248

Achille Segard, *Jean Gossart*, 1924: 17

Rodolfo Signorini, *Lo Zodiaco di Palazzo d'Arco in Mantova*, 1989: 67, 68

Soragna, 1999: 132, 134

Martin Steskal, *Hvězda*, 1994: 80

Walters Art Museum, Baltimore: 18–19

Aby Warburg, *Gesammelte Schriften*, 1932: 59, 198, 215, 216, 217

Index